Y0-DWC-415

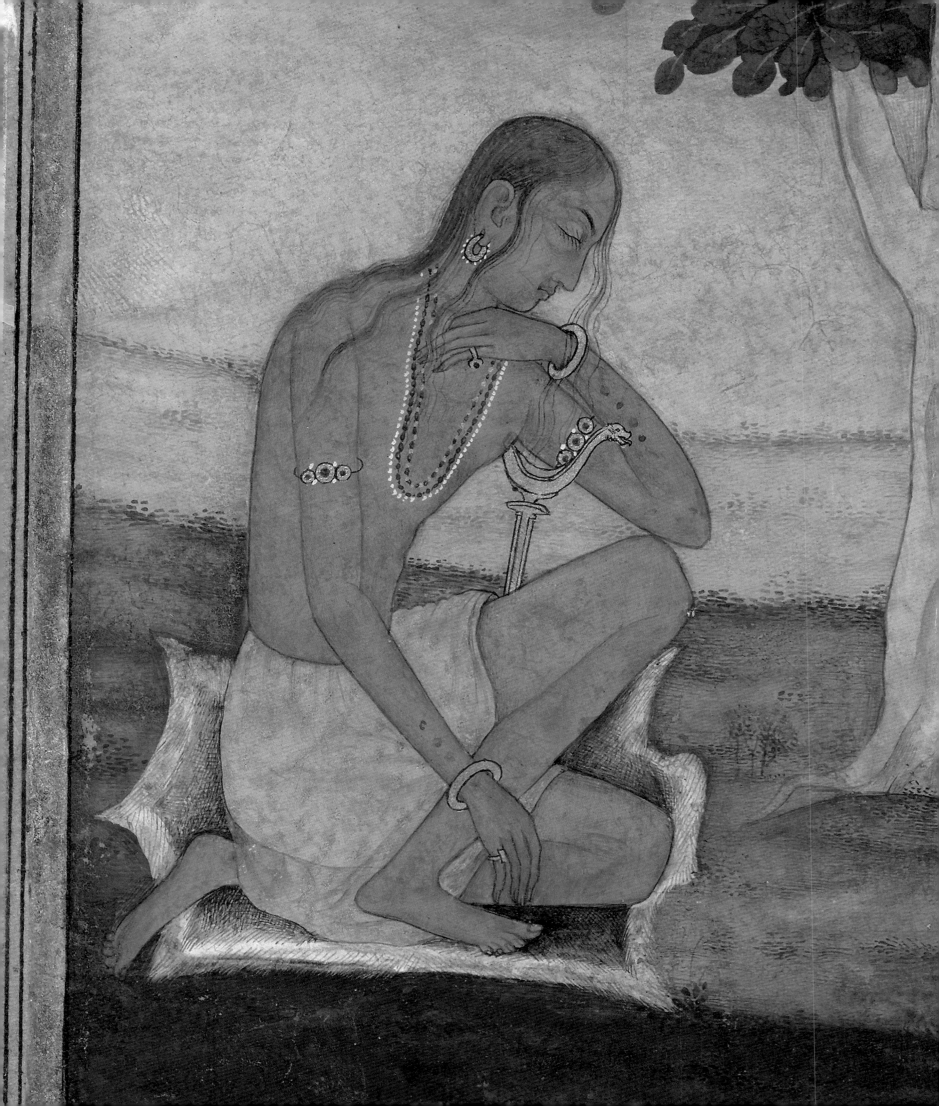

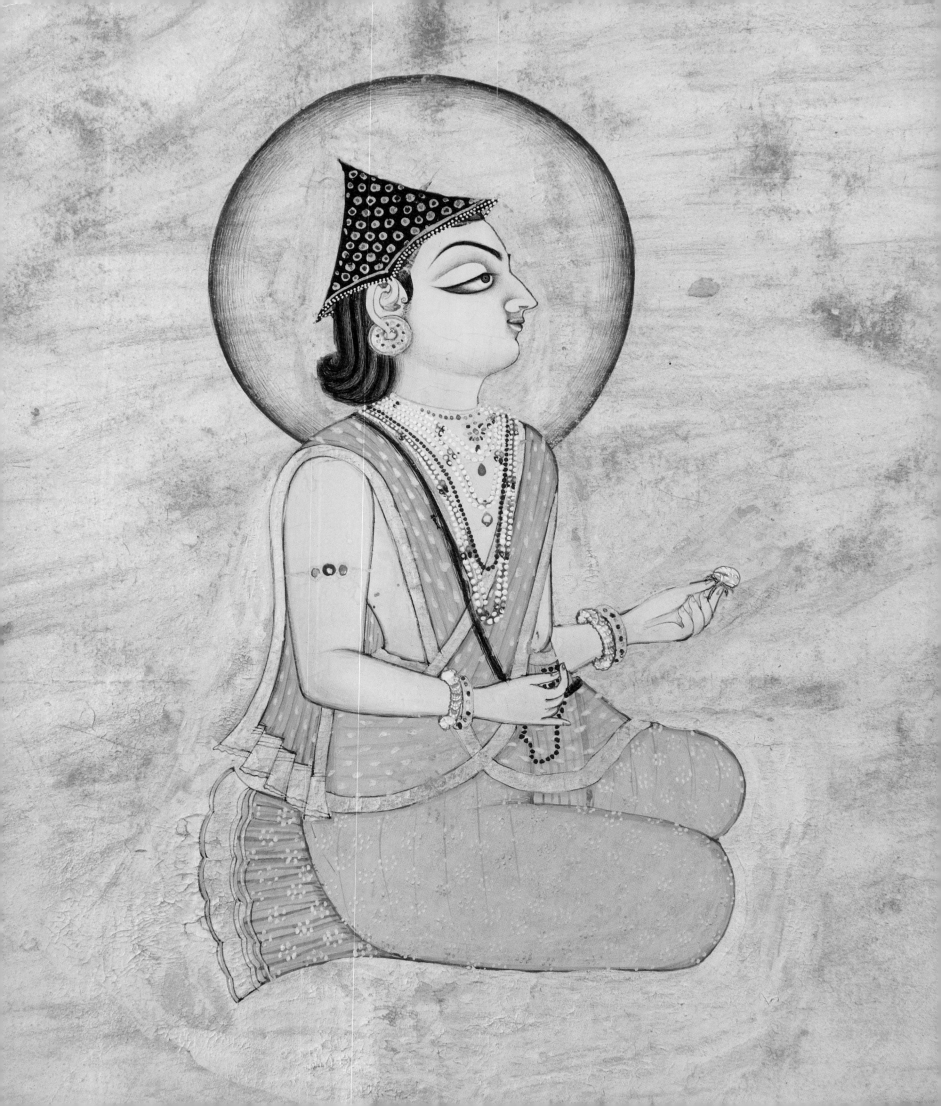

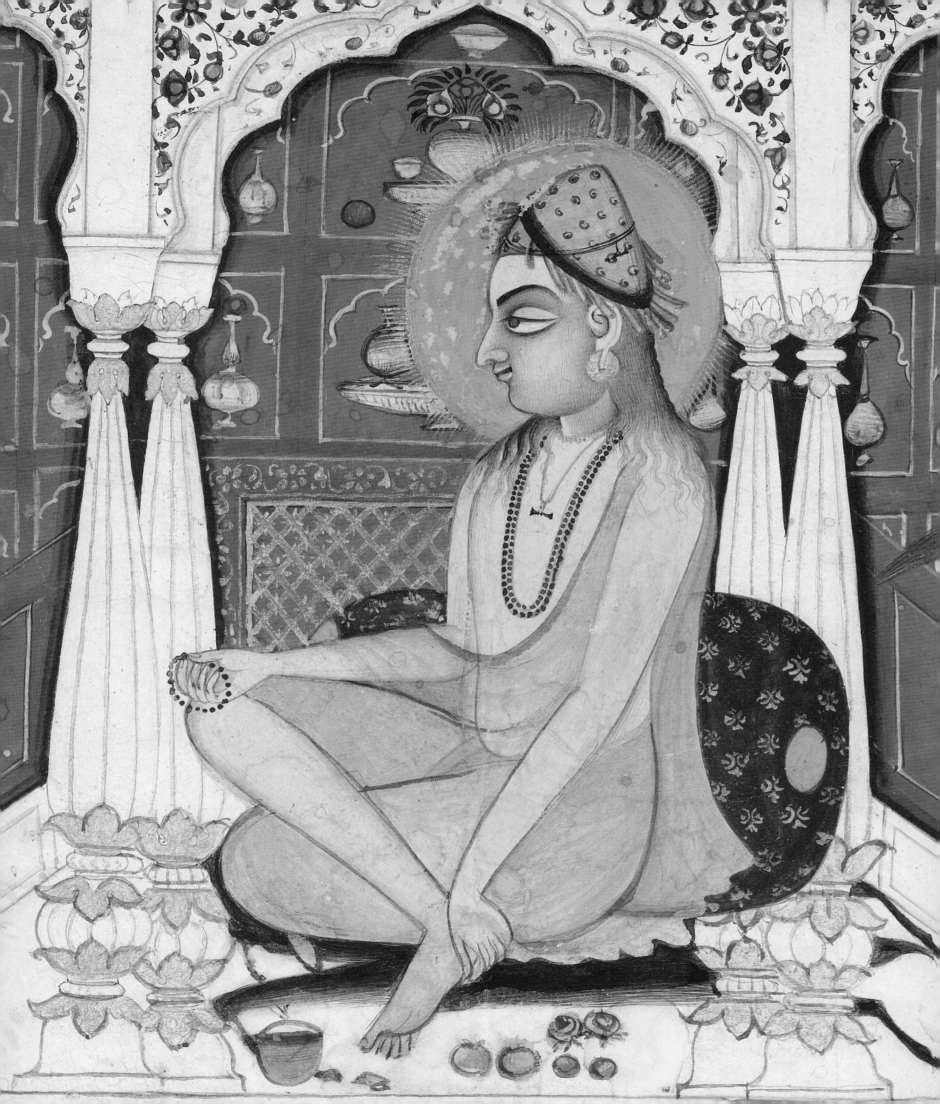

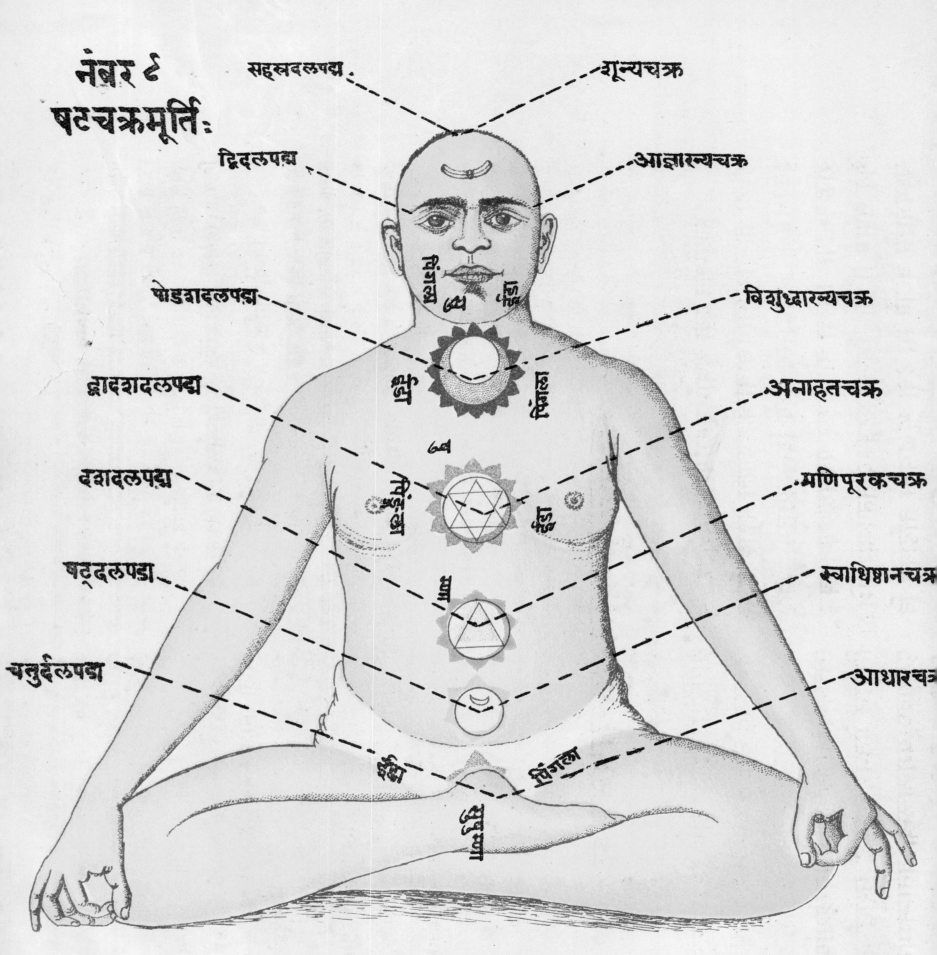

नंबर ८
षट्चक्रमूर्तिः

सहस्रदलपद्म — — — — शून्यचक्र

त्रिदलपद्म — — — — आज्ञाख्यचक्र

षोडशदलपद्म — — — — विशुद्धाख्यचक्र

द्वादशदलपद्म — — — — अनाहतचक्र

दशदलपद्म — — — — मणिपूरकचक्र

षट्दलपद्म — — — — स्वाधिष्ठानचक्र

चतुर्दलपद्म — — — — आधारचक्र

सिद्धासनम्

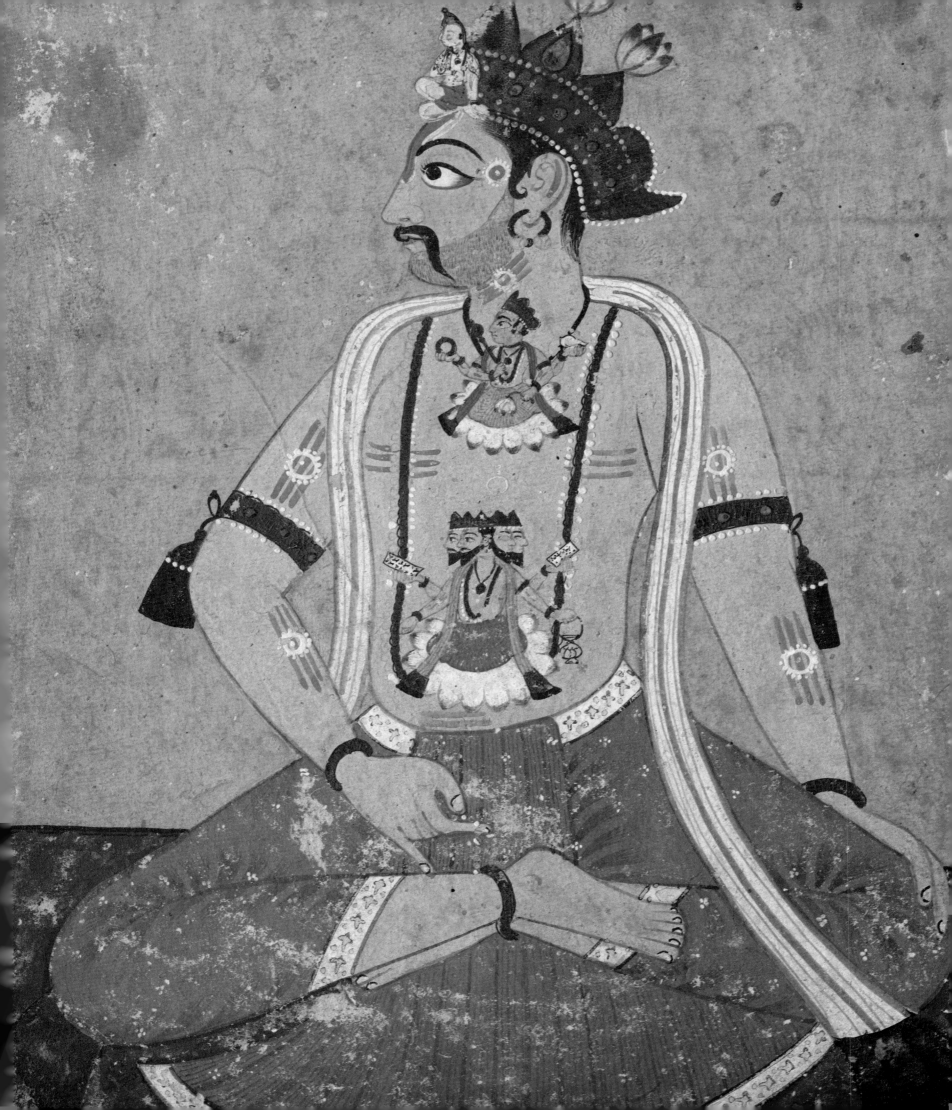

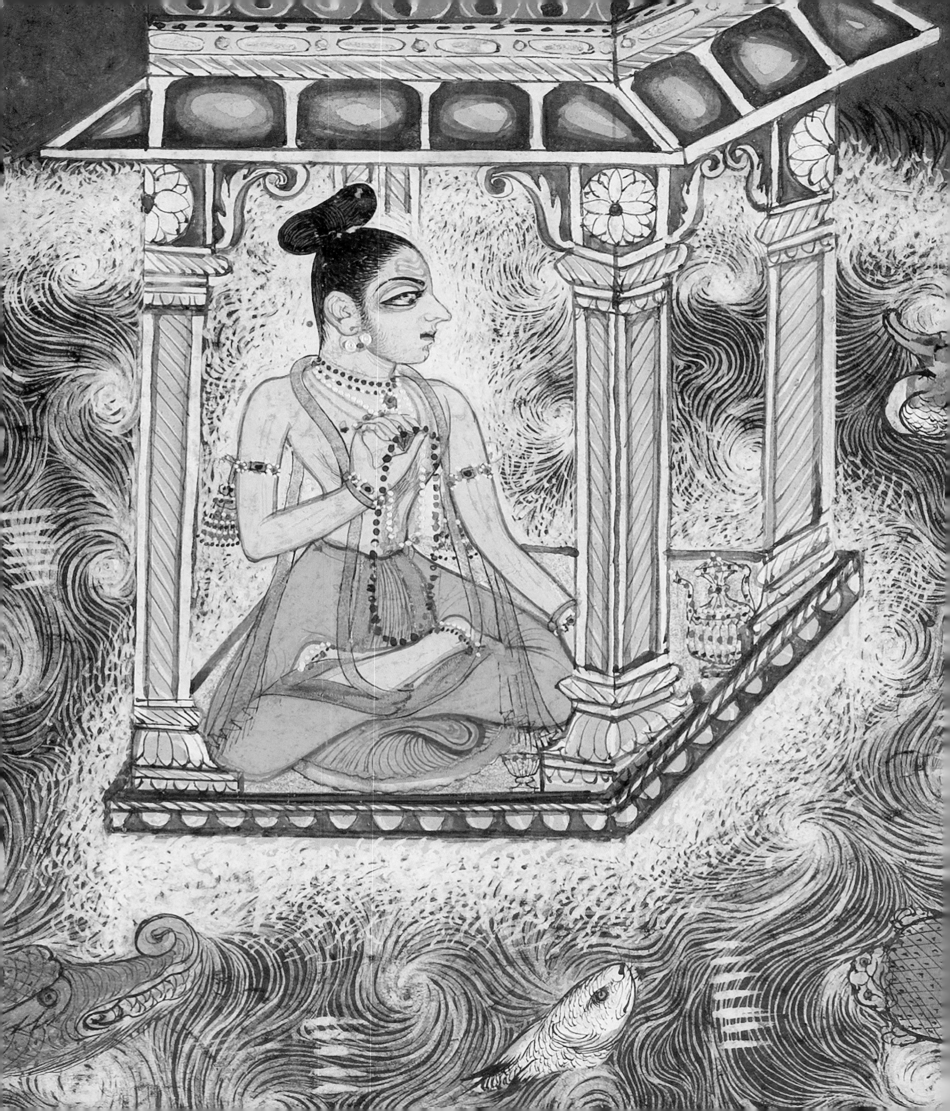

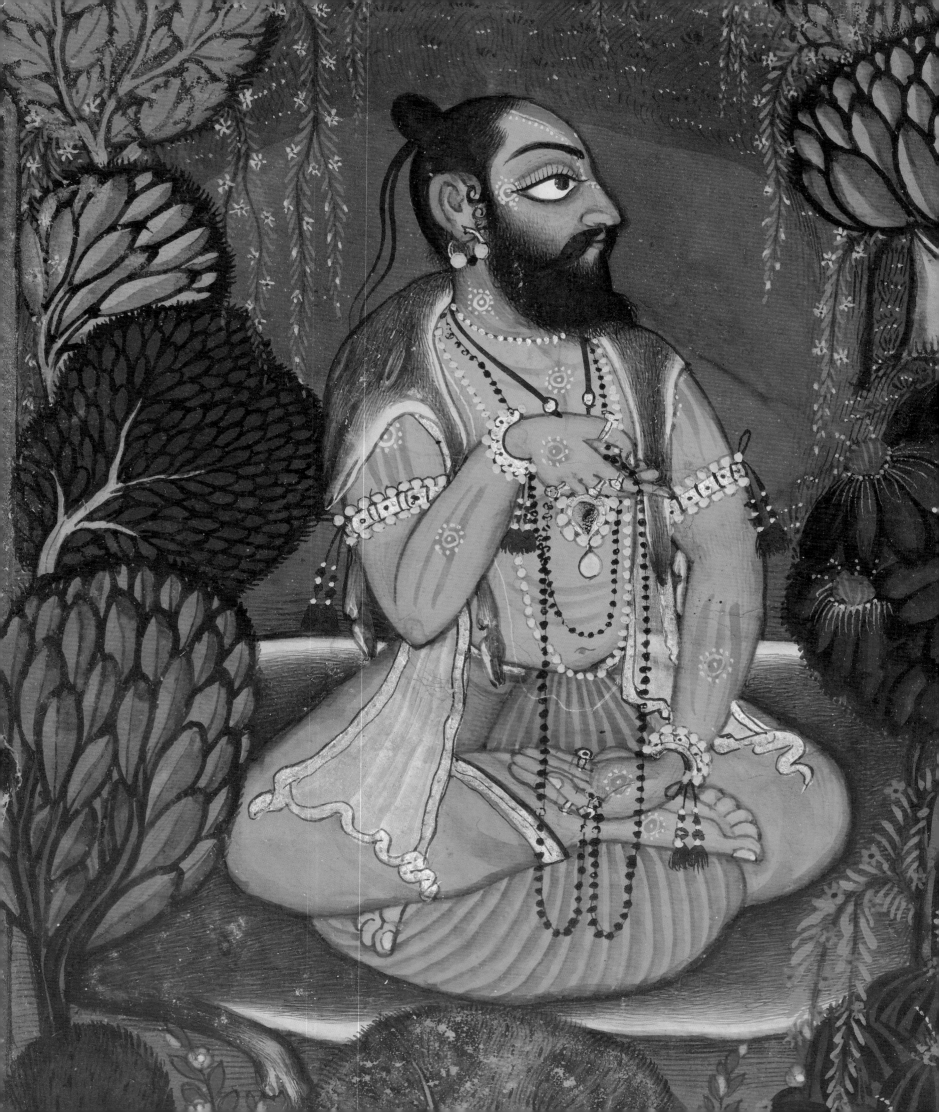

Debra Diamond

yoga | The Art of Transformation

David Gordon White

Tamara I. Sears

Carl W. Ernst

James Mallinson

Joseph S. Alter

Mark Singleton

Sita Reddy

WITH CONTRIBUTIONS BY

Molly Emma Aitken

Christopher Key Chapple

Robert DeCaroli

Jessica Farquhar

B. N. Goswamy

Navina Haidar

Amy Landau

Holly Shaffer

Tom Vick

Arthur M. Sackler Gallery,
Smithsonian Institution, Washington, DC

Published by the Freer Gallery of Art and the
Arthur M. Sackler Gallery on the occasion of
the exhibition *Yoga: The Art of Transformation*,
October 19, 2013–January 26, 2014.
Organized by the Arthur M. Sackler Gallery,
the exhibition travels to the Asian Art Museum
of San Francisco, February 22–May 18, 2014,
and the Cleveland Museum of Art,
June 22–September 7, 2014.

On the cover: *Vishnu Vishvarupa* (detail), India,
Rajasthan, Jaipur, ca. 1800–1820, Victoria and Albert
Museum, London, Given by Mrs. Gerald Clark,
IS.33-2006 (cat. 10b).

Frontispiece details: *Kedar Ragini*, Metropolitan
Museum of Art, 1978.540.2 (cat. 18e); *Three
Aspects of the Absolute*, Mehrangarh Museum
Trust, RJS 2399 (cat. 4a); *Jalandharnath at Jalore*,
Mehrangarh Museum Trust, RJS 4126 (fig. 7, p. 74);
Satcakranirupanacitram, Wellcome Library, P.B.
Sanskrit 391 (cat. 25b); *The Knots of the Subtle Body*,
Cleveland Museum of Art, 1966.27 (cat. 11a); *Gaur
Malhara Ragini*, Museum für Asiatische Kunst,
MIK I 5523 (cat. 18i); *Saindhavi Ragini, wife of Bhairon*,
Chester Beatty Library, In 65.7 (cat. 18h); *Lakshman
Das*, Collection of Kenneth and Joyce Robbins (cat.
20a); *Kumbhaka*, Chester Beatty Library, In 16.25a
(cat. 9h); *The Goddess Bhadrakali Worshipped by the
Sage Chyavana*, Freer Gallery of Art, F1997.8 (cat. 8c).

Cloth edition (ISBN 978-1-58834-459-5) distributed
by Smithsonian Books and may be purchased
for educational, business, or sales promotional
use. For information, please write: Smithsonian
Books, Special Markets, P.O. Box 37012, MRC 513,
Washington, DC 20013.

Typeset in Locator and Eksja
Designed by Studio A, Alexandria, Virginia
Printed in Italy by Arti Grafiche Amilcare Pizzi

Library of Congress Cataloging-in-Publication Data

Diamond, Debra.
Yoga : the art of transformation / Debra Diamond ;
with contributions by David Gordon White ... et al.
p. cm.
"Published by the Freer Gallery of Art and the Arthur
M. Sackler Gallery on the occasion of the exhibition
Yoga: The Art of Transformation, October 19,
2013–January 26, 2014. Organized by the Arthur M.
Sackler Gallery, the exhibition travels to the Asian
Art Museum of San Francisco, February 22–May 18,
2014, and the Cleveland Museum of Art, June 22–
September 7, 2014."
Includes bibliographical references and index.
ISBN 978-0-934686-26-6 (pbk.)
ISBN 978-1-58834-459-5 (hardback)
1. Yoga in art—Exhibitions. 2. Art, Indic—Themes,
motives—Exhibitions. I. White, David Gordon.
II. Arthur M. Sackler Gallery (Smithsonian Institution)
III. Freer Gallery of Art. IV. Asian Art Museum of
San Francisco. V. Cleveland Museum of Art. VI. Title.
N7301.D53 2013
709.54'074753—dc23
2013025537

FREER | SACKLER
THE SMITHSONIAN'S MUSEUMS OF ASIAN ART

Sponsors

This publication is made possible
with the generous support of:

ART MENTOR FOUNDATION LUCERNE

Furthermore:
a program of the J.M. Kaplan Fund

Yoga: The Art of Transformation is organized
by the Arthur M. Sackler Gallery of the
Smithsonian Institution with support from:

WHOLE
FOODS
MARKET

Art Mentor Foundation Lucerne
Ebrahimi Family Foundation
Catherine Glynn Benkaim
Together We're One crowdfunding campaign

Media sponsor:

yoga JOURNAL

Contents

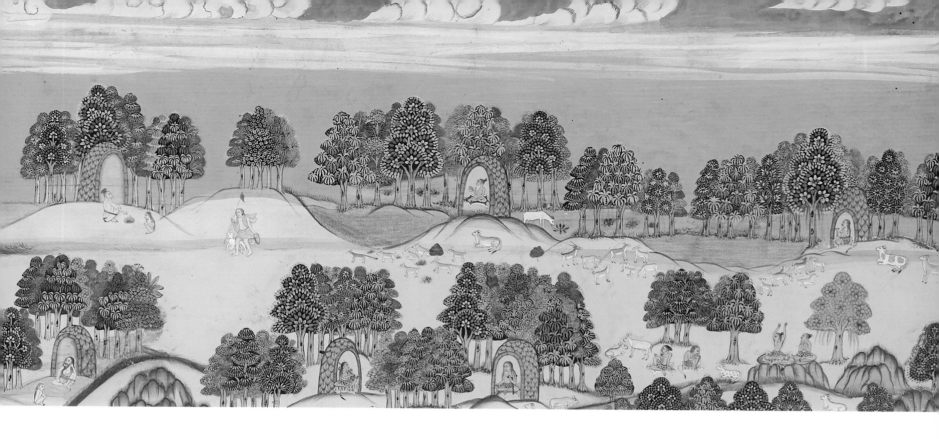

Catalogue

Reference Material

Foreword

Yoga: The Art of Transformation invites wonder at India's extraordinary artistic heritage. It also inaugurates a field of scholarly inquiry. By examining yoga as an enduring practice that adapts to changes in place and time, this exhibition seeks to illuminate a central, though still imperfectly understood, facet of Indian culture. The scope of this project is ambitious, determined by the wealth of objects—ranging from temple sculptures to medical textbooks—that manifest yogic constructs and the perceptions of its practitioners. These objects constitute a visual archive which offers abundant evidence that yoga is more than a philosophical school, a purely Hindu tradition, a spiritual science, or an exercise regimen. By bringing together radically disparate objects, *The Art of Transformation* prompts us to look beyond such calcified categories as wonder and resonance, high art and popular culture, indigenous and exogenous, authentic and exploited, and to consider how yoga unfolded in history.

Let me invite you to contemplate two objects in the exhibition. One is a magnificent sculpture of the deity Bhairava from a thirteenth-century Hindu temple (cat. 1b), the other a garish early twentieth-century postcard that depicts a yogi on a portable bed of nails (cat. 22g). Although wildly dissimilar, both project yogic identities that were, when they were made, novel. The Bhairava, a masterpiece of carving from the Hoysala dynasty in the Karnataka, demonstrates one of the means through which orthodox Hinduism domesticated the transgressive teachings of Tantric yoga. The postcard's photograph records a recently created performative practice—the aerial yoga, if you will, of its day. Produced by a Baptist missionary society, it was part of a flood of mass-produced images that identified yogis (and Hinduism and India) as superstitious and backward. It is a troubling artifact; however, the aspirations of yogis who posed on spiked beds and the role of mechanical reproduction in creating dubious stereotypes cannot be summarily ignored. They are part of yoga's history.

The Art of Transformation acknowledges the importance of yoga's Hindu traditions, while being fully attentive to the discipline's multiple manifestations within diverse sectarian, religious, courtly, and popular settings. This broad approach sheds light on yoga's core constructs and transformations over some two thousand years on the subcontinent, including its more recent emergence in the transnational arena. Today, yoga is universal. Deeply meaningful to Indians who cherish it as their legacy and to practitioners around the world who recognize its transformative potential, it also lies at the center of heated debates over authenticity and ownership. Shining light on yoga's manifold visual expressions, the exhibition does not define a singular yoga or determine authenticity. Rather, it aspires to enrich dialogue and inspire further learning about yoga's profound traditions and enduring relevance.

To our great delight, the exhibition will travel to the Asian Art Museum in San Francisco and the Cleveland Museum of Art; I warmly acknowledge their directors, Jay Xu and David Franklin respectively, for this latest in a series of collaborations to expand the study and appreciation of Asian art in the United States.

The Arthur M. Sackler Gallery gratefully acknowledges the generosity of lenders to *Yoga: The Art of Transformation*. Fionnuala Croke, director, and Elaine Wright, curator, Chester Beatty Library, Dublin; David Franklin, director, and Sonya Rhie Quintanilla, curator, Cleveland Museum of Art; Maharaja Gaj Singh II and Kr. Karni Singh Jasol of the Mehrangarh Museum Trust, Jodhpur-Marwar; and Martin Roth, director, and Rosemary Crill and Susan Stronge, curators, Victoria & Albert Museum, have been unstinting in their loans of key artworks. In Europe, we also thank Neil MacGregor, director, British Museum; Klaas Ruitenbeek, director, Museum für Asiatische Kunst; Albert Lutz, director, Museum Rietberg Zürich; Mechtild Kronenberg, head of department, Staatliche Museen zu Berlin; Christoph Rauch, head of the Oriental department, Staatsbibliotek zu Berlin; and Ted Bianco, acting director, Wellcome Trust, London. In Australia, we acknowledge Tony Ellwood, director of the National Gallery of Victoria.

Our American lenders are no less appreciated for being closer to home. We sincerely thank Atlantic Art Partners; James H. Billington, Librarian of Congress; Graham W. J. Beal, director, president, and CEO, Detroit Institute of Art; Thomas P. Campell, director and CEO, Metropolitan Museum of Art; Malcolm Rogers, Ann Graham Gund Director, Museum of Fine Arts, Boston; Jake Homiak, director, National Anthropological Archives, Smithsonian Institution; Donald A. B. Lindberg, director, National Library of Medicine; Katie Luber, Kelso Director, San Antonio Museum of Art; Marianne Quinn, secretary, Vedanta Society of Northern California; Benjamin W. Rawles III, president, Virginia Museum of Fine Arts Foundation and Alex Nyerges, director and CEO, Virginia Museum of Fine Arts; and Julia Marciari-Alexander, executive director, Walters Art Museum. The exhibition is also richer for the generosity of several extraordinary private collectors. We sincerely thank Catherine Glynn Benkaim and Barbara Timmer, Robert J. Del Bontà, Gloria Katz and Willard Huyck, Cynthia Hazen Polsky, Thomas and Margot Pritzker, and Dr. Kenneth X. and Joyce Robbins.

Neither the exhibition nor the catalogue could have been realized without the support of foundations, corporations, and individuals. We gratefully acknowledge H. E. Nirupama Rao, India's ambassador to the United States and Smt. Chandresh Kumari Katoch, India's minister of culture, for their assistance. A 2009 Scholarly Studies Grant from the Smithsonian enabled the scholarly colloquia that underlie the project's unprecedented cross-disciplinary focus. Mary and Fred Ebrahimi supported critical research and exhibition preparation over the following years. Art Mentor Lucerne Foundation and Furthermore: a program of the J. M. Kaplan Fund underwrote this publication, which we hope you will find is a delight for both eyes and mind. Whole Foods Market, lululemon athletica, and Catherine Glynn Benkaim and Barbara Timmer provided critical exhibition support. Media partner *Yoga Journal* and our *Together We're One* campaign and its Yoga Messengers were instrumental in raising public awareness.

The seeds for this exhibition were planted, appropriately, when Debra Diamond, our associate curator of South and Southeast Asian art, was working on our exhibition in 2008, *Garden and Cosmos: The Royal Paintings of Jodhpur*. Her scholarship, research, and passion for the material helped create an extraordinary aesthetic experience for multiple audiences. While Debra has led the charge, it is my pleasure to thank the entire staff of the Freer and Sackler. They combine the highest levels of expertise with a passionate commitment to the museums' goals, and have been critical to this project's success. These are challenging times for many museums, ours included, and yet our staff have tackled this ambitious project with unparalleled creativity, demonstrating an equanimity and dedication worthy of true yogis.

Julian Raby
The Dame Jillian Sackler Director of the Arthur M. Sackler Gallery and the Freer Gallery of Art

Acknowledgments

If yoga is individual and embodied, personal bonds and communities have long been central to its transmission and relevance. Thus it is fitting that *Yoga: The Art of Transformation* has been a deeply collaborative project. It has been my great fortune to have worked with superb scholars, teachers of yoga, and museum colleagues to shape the project and its presentation.

I first realized that visual culture had the potential to illuminate yoga's historical manifestations during my dissertation research on Jodhpur paintings related to the Nath lineage, which led ultimately to the 2008–2009 exhibition *Garden and Cosmos: The Royal Paintings of Jodhpur*. In 2008, the broader scope of *Yoga: The Art of Transformation* was hammered out in numerous conversations with Sita Reddy, who argued persuasively for juxtaposing high and popular art, and with Annapurna Garimella, who insisted that the exhibition should simultaneously represent the importance of perfecting the body and acting in the world. Two interdisciplinary colloquia in the summer of 2009 further contributed to the project's development. I am deeply grateful to Joseph S. Alter, Carl W. Ernst, Sita Reddy, Tamara I. Sears, Mark Singleton, and David Gordon White for their initial enthusiasm and continuing involvement as authors or advisors. James Mallinson, who joined the team in 2011, and David Gordon White were patient teachers who read and edited much of the text in this catalogue.

I will never be able to adequately thank all the colleagues, teachers, and friends who have offered insights, corrected errors, graciously opened storerooms, or flooded my inbox with images and texts. However, I cannot fail to mention Vidya Dehejia, whose scholarship on yogini temples is an enduring inspiration, Milo Cleveland Beach, Catherine Glynn Benkaim, Allison Busch, Nachiket Chanchani, Christopher Key Chapple, Rosemary Crill, Barbara Croissant, William Dalrymple, Robert J. Del Bontà, Janet Douglas, Stephen Eckerd, Jessica Farquhar, Swami Vidyadhishananda Giri, John Guy, Shaman Hatley, Carol Huh, Karni Singh Jasol, Padma Kaimal, Cathryn Keller, Dipti Khera, Angelika Mallinar, Daniel McGuire, Sheldon Pollock, Kenneth Robbins, Swami Dayananda Saraswati, John Seyller, Holly Shaffer, Maharaja Gaj Singh II, Sonika Soni, Stanley Staniski, Susan Stronge, Chandrika Tandon, Wheeler M. Thackston, and Elaine Wright. I have benefited enormously from conversations with all fifteen catalogue authors and with Neil Greentree, my partner in all endeavors. Planning the exhibition tour with curators Qamar Adamjee and Forrest McGill at the Asian Art Museum of San Francisco and Sonya Quintanilla at the Cleveland Museum of Art was a joy. Durga Agarwal and Amanda Casgar

graciously opened doors to yoga communities, and Rajan Narayanan (Life in Yoga), Suhag Shukla (Hindu American Foundation), and Linda Lang, John Schumacher, and many other wonderful yoga teachers provided important guidance.

It is an honor to work at the Freer and Sackler Galleries. The project is immeasurably better for the guidance of the museums' director, Julian Raby, and Massumeh Farhad, chief curator. Editor Jane Lusaka, exhibition designers Jeremiah Gallay and Nancy Hacskaylo, and Elizabeth Cheng, Maya Foo, Katherine Fow, Miranda Gale, Andrew Harrington, Howard Kaplan, Nancy Micklewright, Allison Peck, Karen Sasaki, Joelle Seligson, and Hutomo Wicaksono continually bowled me over with their expertise, humor, and creative solutions to seemingly intractable challenges. The meticulous and intelligent assistance of Najiba Choudhury, Mekala Krishnan, and Elizabeth Stein kept me buoyant; thanks are also due to interns Shelby Allen, Madeleine Boucher, Bronwen Gulkis, and Carole LeRoy. Richard Skinner must be applauded for magically lit galleries, skillfully installed by Bill Bound and his production team, and I am grateful to Antonio Alcalá and Carol Beehler for their splendid catalogue design. None of this would have been possible without the tireless fundraising efforts of Katie Ziglar, Jaap Otte, and "Team Koringa"; exhibition staff Cheryl Sobas and Kelly Swain; educators Elizabeth K. Eder and Michael Wilpers; and conservator Jennifer Bosworth. I also respectfully acknowledge those staff members who became more deeply engaged with the project by beginning or recommitting themselves to the practice of yoga.

The affective bonds of yoga community became beautifully apparent while developing *The Art of Transformation*. Critical research, study visits and exhibition planning were made possible by Mary and Fred Ebrahimi, Catherine Glynn Benkaim, and a Smithsonian Institution Scholarly Studies Grant. More than six hundred individuals—both old friends and new well-wishers—came together to support the exhibition. I warmly thank the Freer|Sackler Department of External Affairs, the Yoga Messengers of the *Together We're One* crowdfunding campaign, Ambassador Nirupama Rao, Robert Siegel, Susan Stamberg, *Yoga Journal*, and *Yoga Alliance* for helping to gather this community.

Perhaps my only true insight studying yoga has been that we are all only ever students. Every "discovery" opens new vistas and raises more questions. And, given the current state of research, *Yoga: The Art of Transformation* does not seek to provide a definitive account of yoga's visual culture. Much remains unknown. In the coming year, this emerging field will be further explored in four university courses, conference panels, and a Freer|Sackler symposium, which promise to yield new insights, unexpected connections, and surprising discoveries. I await them, as we all do, with delight.

Debra Diamond
Associate Curator of South and Southeast Asian Art

Indian Subcontinent

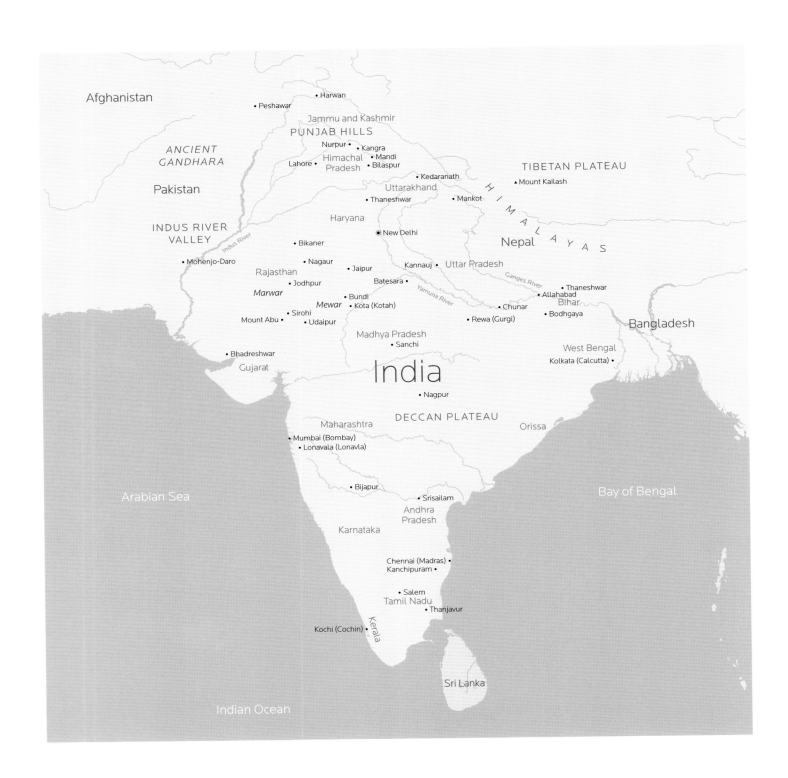

Afghanistan

• Harwan

• Peshawar

Jammu and Kashmir

PUNJAB HILLS

ANCIENT GANDHARA

Nurpur • • Kangra

Lahore • • Mandi

Himachal Pradesh • Bilaspur

Pakistan

• Kedaranath

TIBETAN PLATEAU

▲ Mount Kailash

Uttarakhand

• Thaneshwar

• Mankot

H I M A L A Y A S

INDUS RIVER VALLEY

Indus River

Haryana

⊙ New Delhi

Nepal

• Bikaner

• Mohenjo-Daro

• Nagaur

Rajasthan

• Jodhpur

Marwar

• Jaipur

Kannauj •

Uttar Pradesh

Ganges River

• Thaneshwar

Batesara •

• Allahabad

Yamuna River

Bihar

Mewar

• Bundi

• Kota (Kotah)

• Chunar

• Bodhgaya

Bangladesh

Mount Abu •

• Sirohi

• Udaipur

• Rewa (Gurgi)

Madhya Pradesh

• Sanchi

West Bengal

Kolkata (Calcutta) •

• Bhadreshwar

Gujarat

India

• Nagpur

DECCAN PLATEAU

Orissa

Maharashtra

• Mumbai (Bombay)

• Lonavala (Lonavla)

Arabian Sea

• Bijapur

• Srisailam

Andhra Pradesh

Bay of Bengal

Karnataka

Chennai (Madras) •

Kanchipuram •

• Salem

Tamil Nadu

• Thanjavur

Kochi (Cochin) •

Kerala

Sri Lanka

Indian Ocean

A Note on Transliteration

Within the essays and entries, we transliterated Sanskrit, Persian, and Indian regional language words according to standard diacritical conventions. For maximum comprehension, we retained standard or phonetic spellings for words that are familiar to many readers (e.g., chakra instead of *cakra*), and employed English suffixes (e.g., sutras, tantric) and commonly accepted English spellings for both contemporary and historical places. However, we have retained the historical names of cities for published books and prints.

Within the footnotes, we used diacritics that will enable interested readers to most easily locate primary sources and scholarly texts.

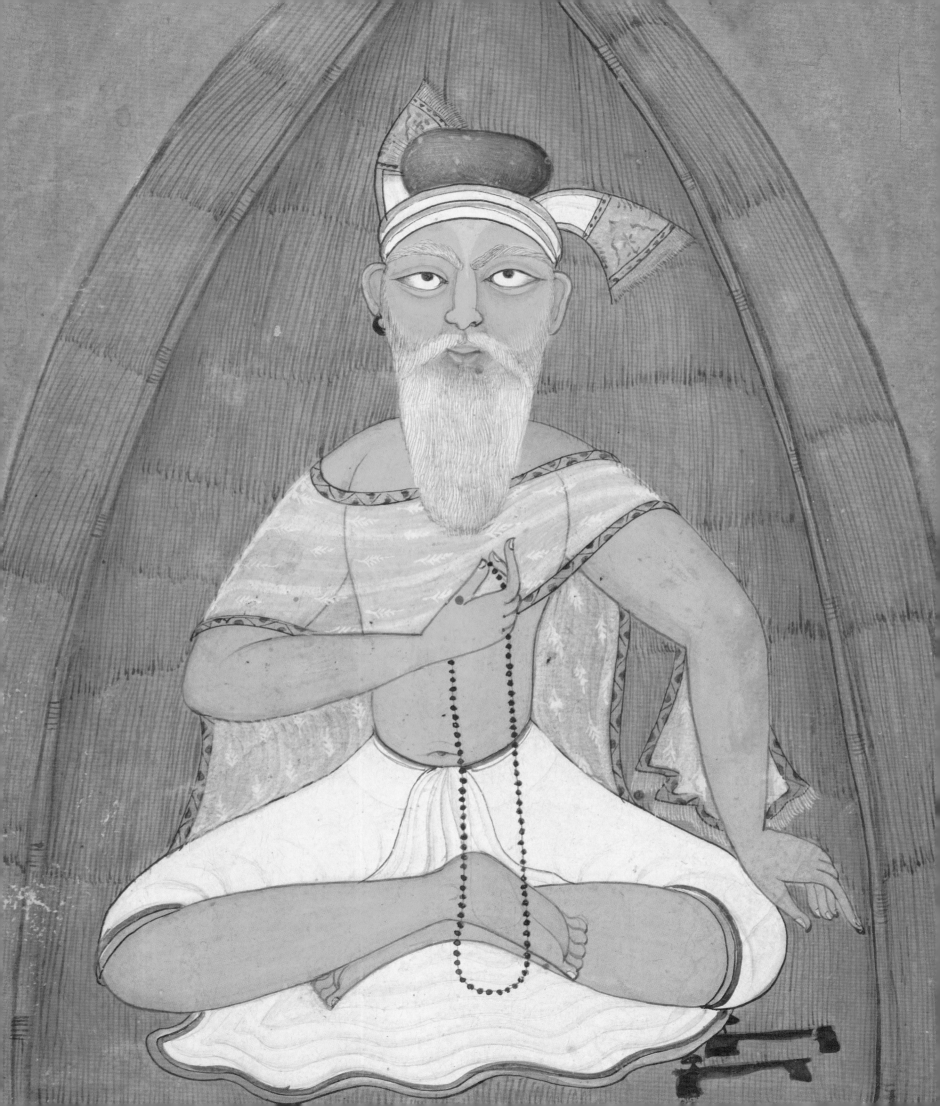

Debra Diamond

Yoga: The Art of Transformation

Yoga emerged in India as a means to transcend suffering. Over generations, countless individuals seeking enlightenment or empowerment refined its metaphysics and techniques. Today, it is widely recognized around the world as a source of health and spiritual insight. But few outside scholarly and advanced practitioner circles are familiar with yoga's rich, protean diversity—its varied meanings for both practitioners and those who encountered and interacted with them—over the last 2,500 years.

This narrowing of yoga's breadth lies partly in the malleability of the term, for "every group in every age" redefined yoga and reshaped its means and goals.[1] Our firmest evidence for yoga's origins lie in North India. Between the fifth and the third centuries BCE, self-aware renouncers realized that their bodies and minds contained the potential to perceive reality correctly and rise above the suffering of existence. Known as *shramanas*, *munis*, and *yatis*, they radically reshaped their relationship with ordinary life to devote themselves to meditation and austerities.[2] Over time, practitioners of yoga built upon this foundation, incrementally honing the techniques of physical and metaphysical transformation. They not only drew upon their own insights, they also responded to philosophical developments and the changing social, religious, and political landscapes of India. By the seventh century CE, the core concepts, practices, and vocabulary of almost every yoga system were established, though "variations and expansions" continue to the present day.[3] Like a rope composed of many different threads—some of which are present at any given moment, but none of which are always there—yoga's history has been one of continual modifications and transformations.

Treatises and commentaries written between the third century BCE and the present day offer a coherent overview of yoga's philosophical depth and developments. In contrast, objects and images foreground how yoga, despite the inherently individual experience at its core, has always been embedded in culture.[4] Made by professional artists working for sectarian groups, royal and lay patrons, or within commercial networks, these artworks are situated at the interface of yogic knowledge with received visual traditions and the interests of diverse communities.[5]

Yoga: The Art of Transformation considers what visual culture can tell us both about yoga as an embodied process of transformation and its varied manifestations in history. This dual focus recognizes that perfecting the mind-body and being an agent in the world were (and are) simultaneous and intertwined activities.[6] The project thus examines works that illuminate, in historically

specific ways, yogic concepts, practices, and social interactions as well as their circulation within the popular imagination.

Although the visual corpus of yoga potentially extends across Asia and the world, *Yoga: The Art of Transformation* focuses on India's wonderfully abundant archive. Created over some two millennia in diverse religious and secular contexts, these works open windows onto yoga's centrality within Indian culture and religion, its philosophical depth, its multiple political and historical expressions, and its trans-sectarian and transnational adaptations. The pictorial tradition, which has never been holistically explored, reveals that yoga was not a unified construct or the domain of any single religion, but rather decentralized and plural. While most objects emerged out of Hindu contexts or depict Hindu practitioners, Jain, Buddhist, Sikh, and Sufi images illuminate patterns of trans-sectarian sharing. Illustrated philosophical treatises and diagrams convey various conceptions of the yogic body. Representations of divinized gurus, fierce yoginis, militant ascetics, and romantic heroes epitomize the fluidity of yogic identity across "sacred" and "secular" boundaries and elucidate patterns of interaction between renunciants (or renouncers) and householders. Photographs, missionary postcards, magic posters, medical illustrations, iconographic manuals, and early films shed light on the enormous shifts in yogic identity and reception during the nineteenth and early twentieth centuries. Widely circulated, these printed materials chart the transnational denigration of yoga during the colonial period and its response, the creation of modern yoga in India.

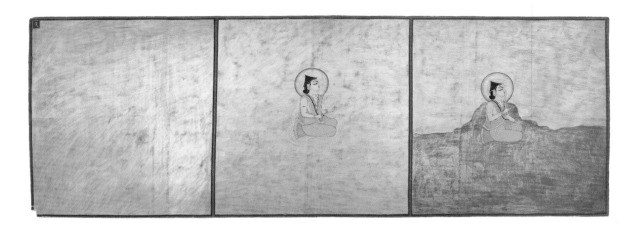

Significant aspects of yoga were too transgressive or internalized to have found their way into visual form, and not all visual traditions survived the passage of time.[7] With 143 objects (and fifty illustrations in the essays)—a pond in the ocean of yoga's visual culture—this exhibition catalogue cannot claim to be comprehensive. Instead, it seeks to enrich our understanding of yoga's plural configurations by examining key constructs, the mechanisms through which yoga became deeply and diversely engrained within Indian culture, and the contexts within which the modern practice emerged.

Melting, Expansion, and Radiance

If *Yoga: The Art of Transformation* seeks to uncover histories of yoga and how they evolved dynamically in response to religious and sociopolitical landscapes, it is also designed to allow for direct encounters with splendid works of art. Its focus on sculptures and paintings that invite aesthetic delectation has particular relevance. One of India's greatest philosophers, Abhinavagupta, wrote in the tenth century that sensitive viewers—those who can literally taste the essence (*rasa*) of art—experience an aesthetic pleasure akin to the bliss of expanded consciousness.[8]

Abhinavagupta's *rasa* theory is steeped in Kashmiri Shaivism, which itself draws on two intellectual traditions central to yoga's development: Advaita Vedanta, in which the ultimate goal is

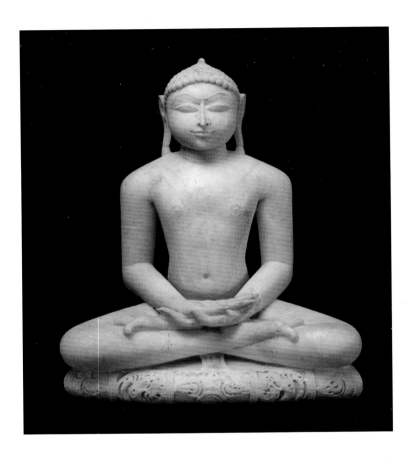

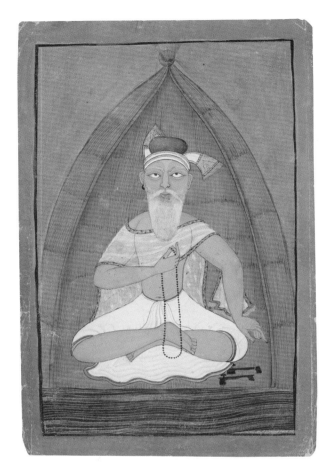

Fig. 2 (left)
Jina. India. Rajasthan,
dated 1160. Virginia
Museum of Fine Arts[b]

Fig. 3 (above right)
*Meditating Sikh
Ascetic*. India, Jammu
and Kashmir, probably
Mankot, ca. 1730.
Catherine and Ralph
Benkaim Collection

Fig. 4 (bottom)
Siddha Pratima Yantra
(detail). Western
India, 1333. Freer
Gallery of Art[c]

to experience the unity of the self with the Absolute (*brahman*), and Tantra, which prescribes rituals for attaining this luminous awareness. In describing a spectator's response to drama, Abhinavagupta observed that a viewer with emotional capacity (*sahridaya,* literally, one with heart) loses sense of time, place, and self. Thus transcending the limitations of ego-bound perception, the sensitive viewer has a foretaste of enlightened detachment, which takes the form of "melting, expansion, and radiance."[9]

Representing the Yogic Body

Reflecting the importance of the body in yoga as well as the centrality of the figure in Indian art, yogic representations center largely on the human form.[10] Premodern yoga treatises, such as the fifteenth-century *Light on Hatha* (*Hathapradipika*), describe the yogic body as steady, healthy, and supple.[11] Vidya Dehejia has observed that "the ideal of the yogic body is visibly evident in all Indian sculptures in their smooth non-muscular torsos, expanded chest and shoulders, and relaxed stomachs."[12] Artists' treatises contain no specific guidelines for representing the yogic body, but we find that sculpted deities, enlightened beings, and yogic masters—even those who have undergone severe austerities—typically have healthy and idealized bodies that convey their attainment.[13] In contrast, only the fasting Buddha, a few fierce goddesses, and some human practitioners have attenuated limbs bearing traces of self-mortification.

If classical Indian aesthetic theory, of which Abhinavagupta is the most influential author, did not explicitly address visual art, it did establish a horizon of expectations among cultured audiences that permits some general observations. Melting, expansion, and radiance are almost uncannily represented in artworks made in vastly different periods, places, and materials, such as a folio from a Jodhpur manuscript that depicts enlightened beings floating in shimmering fields of gold (fig. 1, cat. 4a). Philosophers focused on the aesthetic emotion of quiescence (*shanta rasa*) frequently note that the presence of meditating ascetics (i.e., in dramatic performances or literary compositions) will trigger the emotional response of luminous detachment. And all treatises agree that aesthetic emotion arises only when characters conform to generalized types, an imperative seemingly echoed in the smoothly idealized bodies of innumerable Hindu, Buddhist, and Jain icons.

In the Jain tradition, for example, Jinas (great liberated souls) are invariably represented meditating to convey how they attained omniscience and provide a model for devotees.[14] Through rigorous symmetry and rhythmically abstracted forms, a twelfth-century Jina from western India simultaneously embodies the complete cessation of the mind's fluctuations and alert energy (fig. 2, cat. 5d). The warmly radiant marble evokes the luminosity that imbues the realized body of a Jina; its whiteness signifies a soul unfettered by karma. Like the marble Jina, a Sikh yogi (or Udasi) meditates in lotus posture (*padmasana*) with his eyes raised in inward concentration (fig. 3 and page 24). To depict the Udasi *and* the intensity of his practice, the artist mobilized the flaring forms, crisp contours, and bold palette of eighteenth-century paintings from Mankot, a small kingdom in the Himalayan foothills of northwest India, accentuating the centered stability and upward energy of the ascetic's posture by echoing its form in the curved shape of the reed hut.

Other images convey more specific conceptions of the yogic body. Many reveal how Hindu yogis marked their physical bodies to purify and prepare themselves for practice and to signal their status as renunciants, signify their sectarian affiliation, or emulate divine archetypes (especially Shiva and Bhairava; see cats. 1a–c). Representations of the subtle body delineate the energy stations (chakras) that are crucial knowledge for hatha yoga practitioners, while juxtapositions of subtle and anatomical bodies chart yoga's insertion into Western medical discourse (see cats. 12a–c and 25b). Advanced Jain practitioners (*siddha*s) who had achieved disembodied liberation were sometimes represented as an absent presence, perceptible only as the negative space cut from a sheet of copper (fig. 4,

cat. 5e).In even more abstract ways, geometric diagrams (yantras) and sacred syllables (mantras)—visually invoked in countless images of yogis holding prayer beads—are powerful equivalents of divine bodies (figs. 3 and 7; see also cat. 9b). Indeed, so central was the construct and transformative potential of the body that many yogic traditions conceptualized higher planes of existence or the entirety of the universe as bodies (see cats. 11b–d).

Identifying Yogic Practitioners

The porous boundaries between practitioners of yoga and other ascetics, as well as the myriad names by which they were historically known, begs an explanation of how they were identified and the terminology employed within this book.

We use "ascetic" for representations made prior to the second- to the fourth-century watershed, when yoga began to crystallize into distinctive traditions, each with its own rigorous metaphysics. Among the earliest images of ascetics are those found at Buddhist sites, such as the relief from the Great Stupa (reliquary mound) at Sanchi, circa 50–25 BCE (fig. 5). It depicts two renunciants—one with a yoga strap (yogapatta) around his knees—seated in front of their leaf-capped huts. Although the narrative context of the panel is unknown, the forest retreat and the ascetics' scanty garb distinguish them from the robed Buddhist monks who appear in other Sanchi reliefs. They would have been understood as renunciants who sought release from the cycle of rebirth through meditation and austerities.

Favoring caution, we also use "ascetic" or "sage" for individuals whose practice most probably included yoga and for legendary figures who were re-identified as yoga practitioners in later historical contexts. An eighteenth-century painting from Mankot, a kingdom in the Pahari foothills of northwest India, demonstrates how yoga's transformative potential shaped already established identities. It represents the seven sages (saptarishi) extolled within Hindu sources as the authors of the Vedas and the stars in the Big Dipper (fig. 6).[15] Because they were popularly believed to have attained their semidivine status through exceptional devotion and extraordinary ascetic feats, it is not surprising that the Mankot artist represented them by drawing upon the appearances of local holy men. Clustered around a smoldering campfire, the lotus-eyed sages constitute a localized and historically contingent typology of ascetic practice that includes an orthodox Hindu wearing a sacred thread and resting his outstretched arm on a ritual vessel (Vasishta, center right) and a dusky practitioner of hatha yoga inverted in a headstand (Bharadvaja, bottom register).[16] Though hatha yoga took form long after the sages became legend, the painting reveals the extent to which transcendence-seeking ascetics existed together in the Mankot collective consciousness as members of allied traditions.

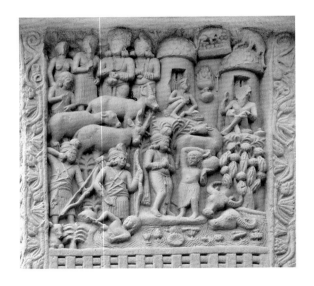

Fig. 5
Great Stupa at Sanchi. India. Madhya Pradesh, Sanchi, ca. 50–25 BCE[d]

Fig. 6
The Seven Great Sages. Attributed to the Master at the Court of Mankot. India, Jammu and Kashmir, Mankot, 1675–1700. Government Museum and Art Gallery, Chandigarh[e]

"Yogi" first appears between the second and fourth centuries as a term for Hindu ascetics seeking omniscience through the cultivation of body and mind. Later historical sources also generally identify renunciants "who may or may not practice the techniques commonly understood to constitute yoga" as yogis. We therefore use yogi to designate figures with the long, matted *jata* (dreadlocks) and ash-covered bodies of Hindu ascetics, such as those who cluster around a campfire in a genre scene painted circa 1625 for a Mughal emperor (fig. 9). Govardhan, who excelled in the naturalistic style favored by the Mughal court at this time, depicted them as renunciants who live apart from society yet have communal bonds, following a path that includes meditating in lotus posture and reciting sacred verses (one holds prayer beads). Two superb character studies—the holy man cocooned in long *jata* who gazes gently into the distance and the

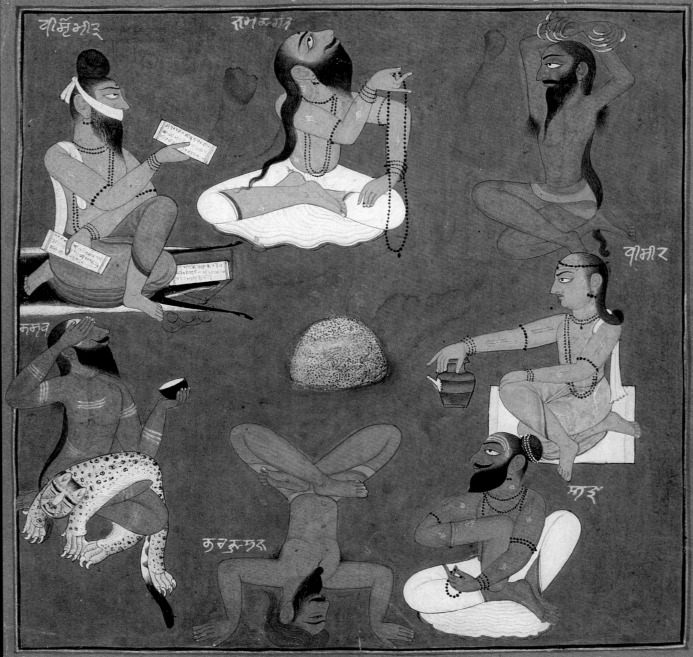

one at left who glares fiercely at us—convey how yogis were understood, in this period, as both spiritual figures and beings with the potential for destructive displays of supernatural power.

Govardhan's holy men may have self-identified with any number of general terms for Hindu renouncers, including yogi. Throughout the catalogue, we apply more specific designations when they are known or more appropriate. These other appellations refer to ascetics associated with particular religious traditions (e.g., Hindu sadhus or Muslim fakirs) or indicate gendered identities (e.g., female sadhvis and yoginis), sectarian affiliations (e.g., Nath or Dasnami), or levels of accomplishment (e.g., guru, teacher, or *siddha*, literally, perfected one).

Many of these terms were used interchangeably and over time, almost all gained multiple and even contradictory meanings. The valence of yogi ranged from positive to derogatory and from general to specific (e.g., when it became a term of self-identification for members of the Nath sectarian order). Moreover, yogi and fakir were often transposed in Indo-Islamic and colonial contexts.[17]

Both mortal women and goddesses associated with yoga were often known as yoginis, a term that conveyed different meanings in diverse sociohistorical contexts. Yoginis emerged around the eighth century within esoteric, often transgressive, rites as the human consorts of Tantric practitioners. The construction of stone yogini temples across the subcontinent between the tenth and fourteenth centuries marked their reinscription as goddesses. Sponsored by kings who sought yoginis' powers to protect their kingdoms, the Hindu temples were often situated to invite the visits of both Tantric adepts and broader communities. Inside were stone icons with the idealized bodies and frontal faces of Hindu deities. Their attributes—like the skull cup, snake and crocodile earrings, and wildly radiating hair of the yogini from Kanchipuram in Tamil Nadu (fig. 7, cat. 3a)—marked them as dangerous. Based upon the icons' material form and scattered texts, art historians have long identified them as fierce goddesses.[18] Recently discovered treatises about the temples, which describe Tantric adepts serving as ritual officiants and devotees offering food and flowers (as they would within orthodox temples), confirm the yoginis' divine identities.[19] Combining aspects of Tantric and mainstream Hindu practice in unprecedented fashion,[20] the temples demonstrate how material culture can shape (rather than merely illustrate) traditions.

New meanings of yogini arose as yoga entered other courtly and commercial arenas. Paintings from the Bijapur Sultanate (in Central India) that were made in the decades bracketing 1600 are among the copious evidence that Indo-Islamic rulers propitiated yoginis[21] (cats. 3b, 3c). Four centuries later, Koringa, a *magicienne* billed as "the only female yogi in the world," astonished audiences in France, England, and the United States by wrestling crocodiles and reading minds (fig. 8; see also cats. 23b, 23c). Born Renée Bernard in southern France, she assumed an Indian identity to enhance the allure of her act. Her untamed hair, seated posture, and bare torso uncannily recall the iconography of the Sackler Gallery yogini.[22] Whether Koringa saw any of the Kanchipuram sculptures when they were taken to C. T. Loo's gallery in Paris in 1927,[23] or whether she picked upon on exotic signifiers that had floated freely across Europe since the mid-nineteenth century is unknown.[24] Though Koringa was no yogini, her assumed identity is significant to yoga's history, because it was partly against such stereotypes that modern yoga delineated its core traditions.

Essays and Catalogue Entries

Written by scholars from the fields of art history, philology, religion, and sociology, the essays and catalogue entries in this book constitute an interdisciplinary conversation about the visual culture of yoga. The inevitable differences in emphases, terminology, and periodization provide insight into the diverse scholarly histories and primary sources that contribute to our rapidly evolving knowledge of yoga.

The essays provide deeper contexts for objects that are central to yoga's visual culture. To broadly orient readers, David Gordon White's introductory essay assesses yoga's origins, lays out the continuities and differences between classical and Tantric traditions, and demonstrates how contemporary definitions of yoga have been colored by negative perceptions from centuries ago. The subsequent essays are in rough chronological order. Tamara I. Sears explores the porous boundary between yogic adept and deity by examining the ideal and real places in which yoga was practiced; her study illuminates how medieval Indian imagery and architecture were fundamental in transforming Hindu aspirants into divinities. Carl W. Ernst traces the rich but lesser known engagement of Muslim thinkers with yoga and elucidates important intellectual and practical spheres in which significant aspects of yoga's visual culture emerged after the sixteenth century. The development of today's most important sectarian orders is assessed by James Mallinson, whose essay combines philological, visual, and ethnographic analysis for new insights into Mughal painting and yoga's histories. Joseph S. Alter sheds light on yoga's transformation into an Indian system of physical fitness and self-development by examining how Swami Kuvalayananda and other key figures navigated tradition, modernity, and nationalist aspirations in the late nineteenth and early twentieth centuries. Mark Singleton provides a case study in the globalization of yoga. Surveying the United States over the last century and a half, he examines the countercultural, glamorous, and commercial contexts through which yoga became deeply rooted within American culture.

Following the essays, thematically grouped catalogue entries explore key yogic practices, identities, and perceptions that entered the visual record. Some entries focus on tightly related groups, such as Jain images or medical illustrations.

Other entries extend across temporal, regional, and religious boundaries in order to more fully elucidate yogic concepts and historically situate differences. Respecting yoga's protean manifestations, the authors have paid particular attention to strategies of translation (across practice, text, and image); moments of cross-cultural contact or innovation; patronage imperatives; and arenas of reception. They give equal consideration to formal qualities and materiality to illuminate the distinctive languages and communicative power of visual culture. It is our hope that the juxtaposition of image and text throughout the catalogue will contribute to the reader's experience of *chamatkara*, the astonishment or wonder that Abhinavagupta identified as common to both aesthetic experience and enlightenment.[25]

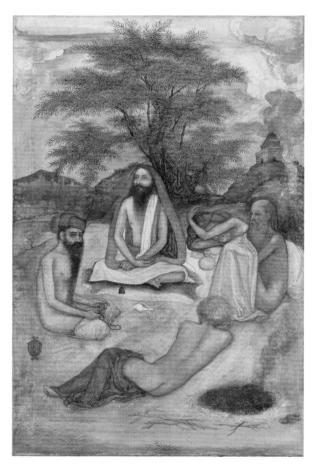

Fig. 9
Five Holy Men, folio from the Saint Petersburg Album. Attributed to Govardhan. India, Mughal dynasty, ca. 1625–30. Formerly collection of Stuart Cary Welch, current location unknown[9]

Notes

Notes on the captions

a. Selected publications include Debra Diamond, *Garden and Cosmos: The Royal Paintings of Jodhpur* (Washington, DC: Arthur M. Sackler Gallery, 2008), pp. 174–75, cat. 40.

b. Selected publications include Joseph Dye, *The Arts of India: Virginia Museum of Fine Arts* (Richmond: Virginia Museum of Fine Arts, 2001), pp. 152–53, cat. 31; and Michael Brand, *The Vision of Kings: Art and Experience in India* (Canberra: National Gallery of Australia, 1995), p. 76, cat. 50.

c. Selected publications include Pratapaditya Pal, *The Peaceful Liberators: Jain Art from India* (New York: Thames and Hudson, 1994), p. 124, cat. 14.

d. This image has been identified by John Huntington (http://groups.yahoo.com/group/Indo-Eurasian_research/message/7621).

e. Selected publications include B. N. Goswamy, *Pahari Masters: Court Painters of Northern India* (Zurich: Artibus Asiae Publishers, 1992), pp. 106–7, cat. 40.

f. Selected publications include *An Exhibition of the Sculpture of Greater India* (New York: C. T. Loo and Co., 1942), cat. 38; Vidya Dehejia, *Yogini Cult and Temples: A Tantric Tradition* (New Delhi: National Museum, 1986), p. 181; Padma Kaimal, *Scattered Goddesses: Travels with the Yoginis*, ed. Martha Ann Selby, Asia Past and Present (Ann Arbor: Association of Asian Studies, 2012), p. 29, fig. 2.

g. Selected publications include *The Stuart Cary Welch Collection. Part One: Arts of the Islamic World* (London: Sotheby's, April 6, 2011), pp. 114–15, cat. 94; Stuart Cary Welch, *A Flower from Every Meadow: Indian Paintings from American Collections* (New York: Asia Society, 1973), pp. 104–5; Milo Cleveland Beach, *The Grand Mogul: Imperial Painting in India, 1600–1660* (Williamstown: Sterling and Francine Clark Art Institute, 1978), pp. 120–21, cat. 41.

Notes on the text

1. David Gordon White, *Yoga in Practice* (Princeton, NJ: Princeton University Press, 2012), p. 2.

2. Release from the cycle of rebirth differs from the aim of rebirth in heaven, the goal of even earlier Brahmanical ascetics as articulated in the Vedas. Geoffrey Samuel, *The Origins of Yoga and Tantra: Indic Religions to the Thirteenth Century* (Cambridge, UK: Cambridge University Press, 2008), p. 119 in particular and more broadly pp. 119–65.

3. White, *Yoga in Practice*, p. 12.

4. Even renunciation is shaped, in part, by how it rejects social norms.

5. Those yogic practitioners who made yantras and mandalas (sacred diagrams), ritual implements, and humble dwellings likely employed impermanent materials, and the role of monastic elites in designing architectural programs is unknown.

6. I am grateful to Annapurna Garimella for first suggesting this dual focus.

7. Tantric treatises from the seventh to the ninth century, for example, describe antinomian practices restricted to initiated adepts; some of these Tantric rituals required supports (such as geometric diagrams, or yantras) but they were made from ephemeral materials. And the material culture of Buddhist yogic practice in India, which may have been substantial, did not survive the passage of time.

8. *Locana* 2.4: "This enjoyment is like the bliss that comes from realizing [one's identity] with the highest Brahman, for it consists of repose in the bliss which is the true nature of one's own self …" in Daniel H. H. Ingalls, Jeffrey Moussaieff Masson, and M. V. Patwardhan, *The Dhvanyaloka of Anandavardhana with the Locana of Abhinavagupta* (Cambridge, MA: Harvard University Press, 1990), p. 222.

9. *Ibid. Locana* 2.4 in Ingalls, Masson, and Patwardhan, *The Dhvanyaloka of Anandavardhana*, p. 222.

10. For the idealized and adorned human body across visual art, literature, inscriptions, and poetry see Vidya Dehejia, *The Body Adorned: Dissolving Boundaries Between Sacred and Profance in India's Art* (New York: Columbia University Press, 2009).

11. *Hathapradipika* 1.17 lists the qualities of *sthairyam*, *arogya* (literally, freedom from disease), and *angalaghanam* (literally, lightness of limb).

12. Vidya Dehejia and Daryl Yauner Harnisch, "Yoga as a Key to Understanding the Sculpted Body," in *Representing the Body: Gender Issues in Indian Art*, ed. Vidya Dehejia (New Delhi: Kali for Women in association with The Book Review Literary Trust), pp. 68–81. Dehejia builds upon Stella Kramrisch's pioneering work on the Indian sculptural aesthetic as a manifestation of a cultural ethos in which yoga was central. Kramrisch first suggested that the controlled breathing (*pranayama*), which dissolved the gross body into "the weightless 'subtle body' … was given concrete shape by art, in planes and lines of balances stresses and continuous movement" (p. 75). Dehejia, however, more specifically assesses yogic postures in sculpture.

13. Michael W. Meister, "Art and Hindu asceticism: Śiva and Vishnu as masters of Yoga," *Art and Archaeology of Southeast Asia: Recent Perspectives* (New Delhi: Indira Gandhi National Centre of the Arts and Aryan Books, 1996), p. 315.

14. Sonya Quintanilla, *History of Early Stone Sculpture at Mathura, Ca. 150 BCE–100 CE* (Leiden: Brill, 2007), pp. 97–141.

15. "The seven sages, all sons of Brahma" is inscribed on top border in *takri* characters; their names appear on the recto. From the upper middle, clockwise, they are: Jamadagni, Gautama, Vasiṣṭha, Atri, Bharadvāja, Kaśyapa, and Viśvāmitra. B. N. Goswamy and Erberhard Fischer, *Pahari Masters: Court Painters of India*, Artibus Asiae Supplementus 38, cat. 40, pp. 106–7.

16. More precisely, he appears to be a Dasnāmi Sannyasi; for Dasnāmi iconography, see James Mallinson's essay in this volume.

17. See David Gordon White's essay in this volume, n. 17.

18. See, for example, Vidya Dehejia's seminal book *Yogini Cult and Temples: A Tantric Tradition* (New Delhi: National Museum, 1986).

19. Shaman Hatley, "Goddesses in Text and Stone: Temples of the Yoginis in Light of Tantric and Purāṇic Literature," in *History and Material Culture in Asian Religions*, ed. Benjamin Fleming and Richard Mann (Oxford, UK: Routledge, forthcoming).

20. Hatley, ibid.

21. Debra Diamond, "Occult Science and Bijapur's Yoginis," in *Indian Painting: Themes, History and Interpretations (Essays in Honour of B. N. Goswamy)*, ed. Mahesh Sharma (Ahmedabad, India: Mapin Publishing, forthcoming).

22. In another poster, for the Bertram Mills Circus in the 1930s, crocodiles and snakes are depicted below Koringa's (disembodied) head, recalling the earrings of the Kanchipuram yogini.

23. Padma Kaimal, *Scattered Goddesses: Travels with the Yoginis*, no. 8 of *Asia Past and Present*, ed. Martha Ann Selby (Ann Arbor, MI: Association of Asian Studies, 2012), p. 73.

24. See cats. 23a–e on fakirs, fakers, and magic in this volume.

25. *Camatkāra*, cited in David L. Haberman, *Acting as a Way of Salvation: A Study of Rāgānugā Bhakti Sādhanā* (New York: Oxford University Press), 1988, p. 21.

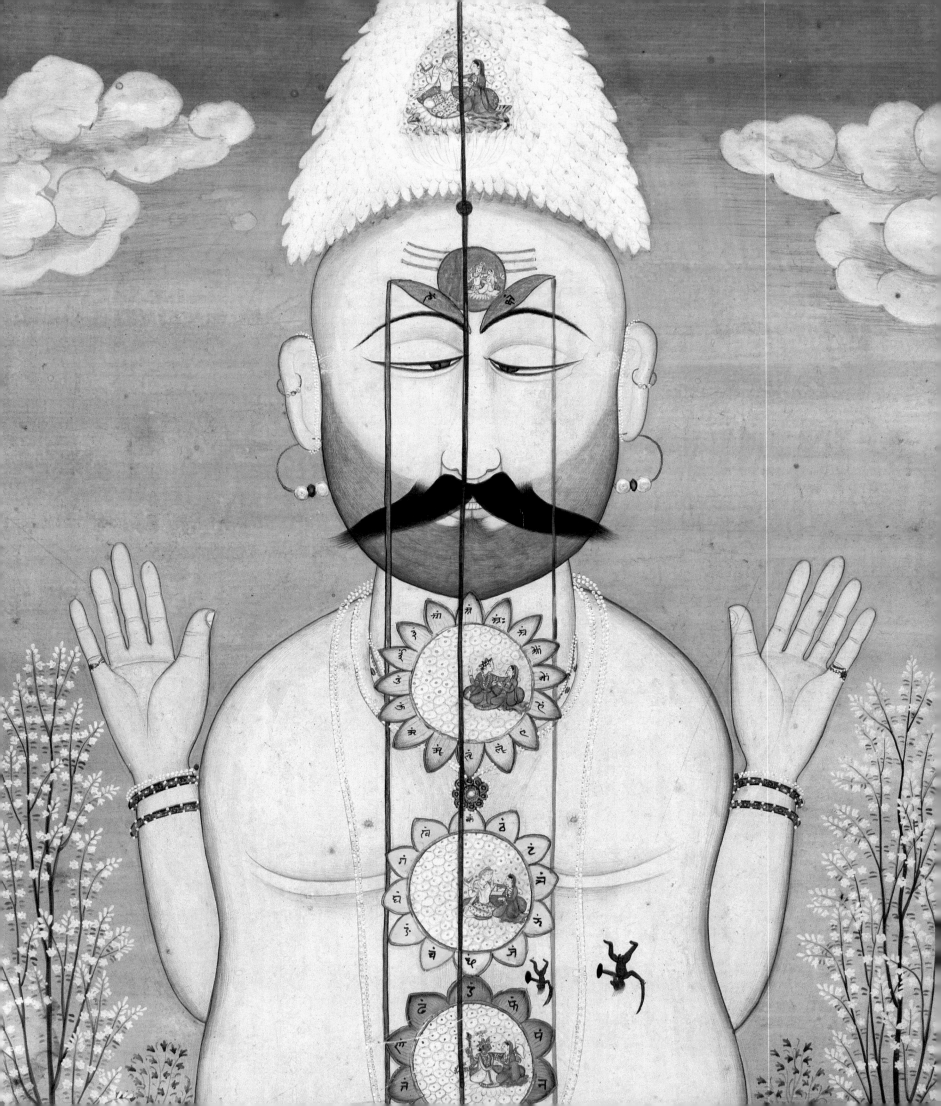

David Gordon White

Yoga in Transformation

A vibrant and highly creative segment of global society—identifiable by their distinctive beliefs, behavior, clothing, and language—modern-day practitioners of yoga may be said to constitute a subculture, "an identifiable subgroup within a society or group of people, especially one characterized by beliefs or interests at variance with those of the larger group."[1] It may be argued that the ancient and medieval practitioners of yoga also constituted a subculture. In the modern case, the larger group comprises the mainstream cultures of an increasingly globalized urban society. In the ancient and medieval case, the larger group was, for the most part, the mainstream culture of South Asia.

What do these two yoga subcultures have in common? Most modern yoga practitioners tend to assume that, apart from clothing styles, modern accessories, or adaptations (yoga with dogs, laughter yoga) on the original Indian template, very little has changed. Most believe that the perennial elements of yoga practice—its spiritual foundations; postural practice; the goals of a healthy mind and body; and yoga as a means to self-transformation, harmonizing with nature, and discovering the transcendent within—remained the same in India through the millennia before their introduction to the West. In fact, yoga grew out of several often unrelated South Asian traditions that were combined over the centuries into a small number of unified traditions. Over the past 120 years, these traditions have been adapted by both Indian and Western culture brokers into the many yoga "brands" familiar to modern practitioners: Raja Yoga, Kriya Yoga, Vinyasa Yoga, Ashtanga Yoga, Anusara Yoga, and so forth. In other words, the complex of transformative practices that we know as yoga today is itself the product of some four thousand years of transformation.

Early Developments

According to a commonly held assumption, the earliest evidence we have for yoga is a clay seal from the Indus River Valley archaeological site of Mohenjo-Daro, dated to the latter portion of the third millennium BCE. What one sees on the seal is a "yogi" seated in a cross-legged posture (fig. 1); however, since we find ancient images of figures in identical postures from such far-flung places as Scandinavia and the Near East, we cannot assume that any of them were intended to represent yoga practitioners. Furthermore, in the earliest literary references to yoga, found in the circa fifteenth-century BCE *Rig Veda*, the word *yoga* did not denote either meditation or the seated posture, but rather a war chariot,

comprising the wheeled vehicle, the team of horses pulling it, and the yoke that held the two together. (The Sanskrit word *yoga* is linguistically related to the English *yoke*.) According to ancient Indian warrior traditions, as attested in early strata of the Hindu epic the *Mahabharata* (circa 200 BCE–100 CE), a hero who died fighting on the battlefield would be borne up to heaven and transformed into a god when he pierced the sun on a vehicle called a "yoga."[2]

Later strata of the *Mahabharata* (circa 200–400 CE) record another, more familiar, use of the term *yoga*, which developed in Hindu, Buddhist, and Jain circles during the latter half of the first millennium BCE. During this period, wandering ascetics developed a system of practices for controlling the body and breath as a means for stabilizing the mind (figs. 2 and 3). While these practices were referred to as "meditation" in early Buddhist and Jain sources,[3] the Hindu *Kathaka Upanishad*, a scripture dating from about the third century BCE, describes them within the context of a set of teachings on yoga. In these teachings, the link between meditation as a means for reining in the mind and the "yoga" of the ancient chariot warrior is a clear one. We read that the disciplined practitioner who has "yoked" the "horses" and "chariot" of his body and senses with the "reins" of his mind rises up to the world of the supreme god Vishnu.[4]

Three other points made in the *Kathaka* laid the groundwork for much of what came to constitute yoga in the centuries that followed. First, its teaching on yoga introduced a subtle physiology, calling the body a "fort with eleven gates" and evoking the soul or Self as a "person the size of a thumb" who, dwelling inside, is worshiped by all the gods.[5] This and other Upanishads also introduced the breath channels (*nadi*s) that would become so fundamental to the transformative practices of the medieval tradition of hatha yoga. Second, the *Kathaka* identified the individual Self with the Universal Self (*brahman*): this non-dualist metaphysics would be taken up in several later yoga traditions, beginning with those revealed by the supreme god Krishna in the 200–400 CE *Bhagavad Gita*, a late portion of the *Mahabharata*.[6] Finally, the *Kathaka* introduced the hierarchy of mind-body constituents—the senses, mind, intellect, and so forth—that comprise the foundational categories of *samkhya*, the dualist metaphysical system grounding the circa 325 CE *Yoga Sutras* (YS).[7]

The Yoga Sutras and Allied Traditions

The *Yoga Sutras* of Patanjali was a pivotal compilation of all of these prior yoga and meditation traditions, which it framed within the broader context of a unified and rigorous metaphysics. As was the case in nearly every other Indian religious and philosophical system, the underlying purpose of the YS's metaphysics was to resolve the problem of suffering existence. And, like most of those other systems, the YS viewed the mind as both the crux and the potential solution to that problem. Because the mind is attached and addicted to the ego-self and the material, death-laden body with which it identifies, it is blind to the Self's true identity, which is immortal and unfettered. However, if the mind can be untethered from the body and the senses, and made to turn inward, toward the luminous Self, it can be freed from its dysfunctional habits. The principal means to this end is meditation, and the YS's program of meditation tracks closely with those found in earlier Buddhist, Jain, and Hindu works.

While most of the YS is a disquisition on the nature of the universe and the Self, the workings of the mind, and the way to salvation, it also contains practical and "supernatural" components that mirror contemporary developments in both Buddhism and Jainism and anticipate later yoga systems. Here, Patanjali's presentation of eightfold (*ashtanga*) yoga may be contrasted with an alternative set of practices known as sixfold (*shadanga*) yoga.[8] Both systems have five components in common: the progressive stages of breath control (*pranayama*), withdrawing the senses (*pratyahara*), meditation (*dharana*), fixing the mind (*dhyana*), and perfect contemplation (*samadhi*). What distinguishes the two is the insertion of seated postures (*asana*) in the YS, in the place of rational inquiry (*tarka*) or recollection

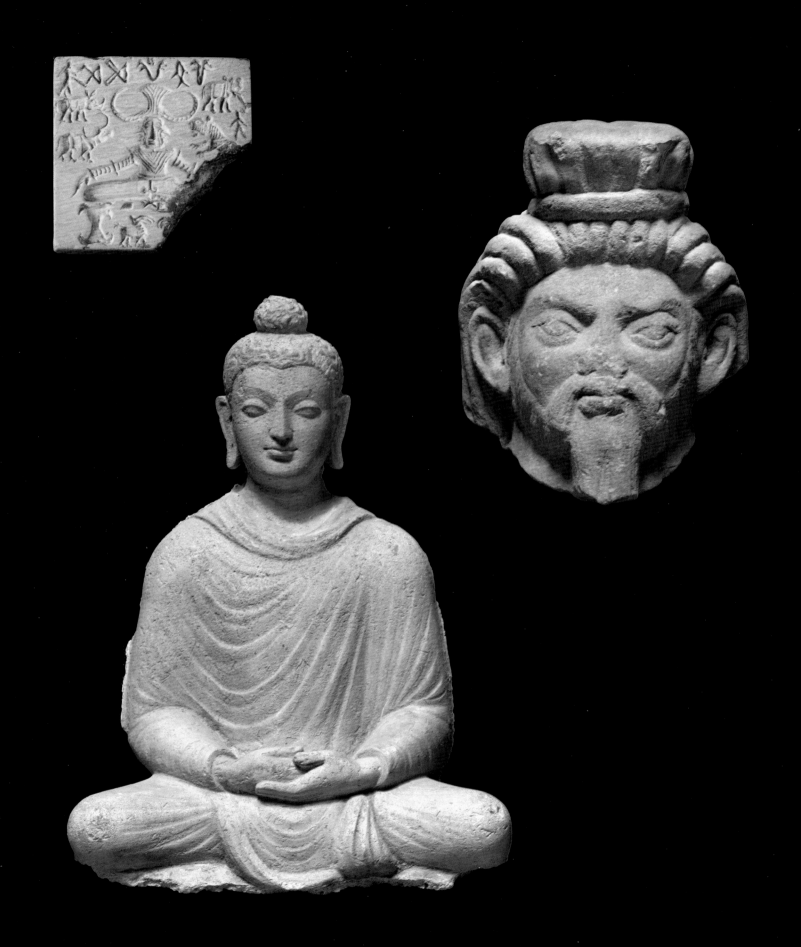

(*anusmrti*) in the sixfold system. In addition, the YS foregrounds this group of six with two bodies of ethical practice: the inner and outer restraints (*yama* and *niyama*). These two may have been inspired by Jain monastic vows from an earlier time; furthermore, early Jain works also present the way to liberation as an ascending path of ever-deepening meditative states.[9]

Nearly the entirety of the YS's third book is devoted to the so-called "supernatural powers" (*vibhuti*) acquired through the practice of yoga. These include the power to know past lives, to read people's minds, to enter into other creatures' bodies, and to fly.[10] According to the YS's metaphysics, they are entirely natural abilities, inherent in a practitioner whose mental functions have expanded beyond the limits of the physical body. Identical accounts of these sorts of powers are found in early Buddhist and later Hindu literature, which also correlate consciousness-raising on a cognitive level to an actual visionary ascent through ever-expanding realms of cosmic space.[11] Other Hindu, Buddhist, and Jain sources also refer to the ability of yogic practitioners to imitate the powers of gods and Buddhas, whose cosmic bodies fill the entire universe (see cat. 10a).[12]

Tantric Yoga and Hatha Yoga

Two centuries after the YS, a new current of religious thought emerged in Buddhist and Hindu circles in South Asia. Scriptures called the Tantras identified self-deification and supernatural power as the goals

of religious life, employing "yoga" as an overarching term for the entire range of Tantric practice.[13] One means to achieve this end was through a transformative process in which male practitioners tapped into and appropriated the boundless energy of the divine feminine (fig. 4 and page 34).

According to several Tantric scriptures, this inner energy was concentrated in the sexual fluids of women who embodied the creative power of the great Goddess. They were known as Yoginis, Female Messengers (*Dutis*), Mothers, Great Seals (*Mahamudras*), or simply Goddesses.[14] In initiation and other Tantric rites, the principal sacraments—often consumed by practitioners in nocturnal, cremation-ground rituals—were alcohol, meat, and the sexual fluids produced through ritualized sex.[15]

Over time, these ritual practices were internalized, with the Tantric practitioner's female consorts becoming the goddesses of his subtle body.[16] In Hindu works, these multiple Tantric goddesses coalesced into a serpentine energy most often called Kundalini (She who is coiled).[17] Practitioners gradually innovated the body of techniques known as hatha yoga[18]: through a combination of fixed postures, breath control, locks (*bandhas*), and seals (*mudras*), the hatha yogi transformed his body into a hermetically sealed system within which breath, energy, and fluids were stabilized and forced upward through the central channel of the subtle yogic body. Linking this to all earlier forms of yogic practice was its final outcome: supernatural powers, including the power of flight and bodily immortality.

While there are several possible readings for the word *hatha,*[19] the most plausible is that it denoted the "force" of its practices in effecting the transformation of the body.[20] The most important foundational technical works on the subject are attributed to a twelfth-century figure named Goraksha or Gorakhnath. These include Sanskrit-language treatises and a vernacular corpus of mystic poetry on yogic experience.[21]

Yogis

According to tradition, Gorakhnath founded the ascetic order known as the Naths (Lords).[22] In his poems, he simply refers to himself and his followers as yogis, and both he and his fellow yogis were the subject of a rich body of legend.

Well before Gorakhnath's time, several early and important works—including the *Bhagavad Gita, Maitri Upanishad, Yoga Sutras, Yoga Vasistha,* and a Jain work titled *The Bhaktis*[23]—had employed the term *yogi* to denote the ideal subject or agent of yoga practice. In these works, the yogi was portrayed as a person broadly embodying the virtues of conventional types of yoga practice: med-

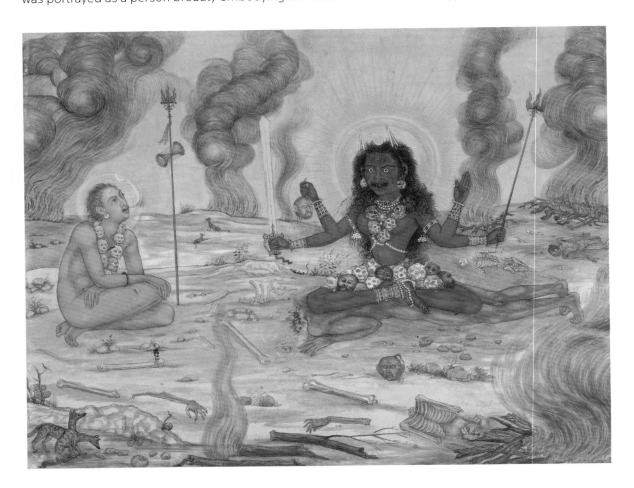

itating, renouncing, wandering, and seeking to find God within (fig. 5). This is the image most modern people have of India's yogis: peaceful, meditative holy men, living in harmony with nature in hermitages and caves, and on mountaintops. With the advent of Tantra, however, this idealized image of the yogi was replaced by a darker one, which has persisted down to the present day in rural South Asia.[24]

In the fantasy and adventure literature of medieval South Asia, the consorts of the Tantric yogis, often called yoginis, were cast as their lovers, with their rites described as wholesale orgies taking place on cremation grounds in the dead of night: "Yogis, drunk with alcohol, fall upon the bosoms of women; the Yoginis, reeling with liquor, fall upon the chests of men."[25] This was, however, a dangerous game, because, as the Tantric texts themselves unambiguously state, persons not empowered by Tantric initiations to consort with them generally became "food for the Yoginis." These yoginis were generally identified with the creatures of the charnel grounds—not human women at all, but carrion-feeding jackals and vultures that devoured the bodies of the dead, whose flesh fueled their powers of flight. Through his initiation, however, the Tantric yogi became transformed into a "second Shiva,"[26] who, like

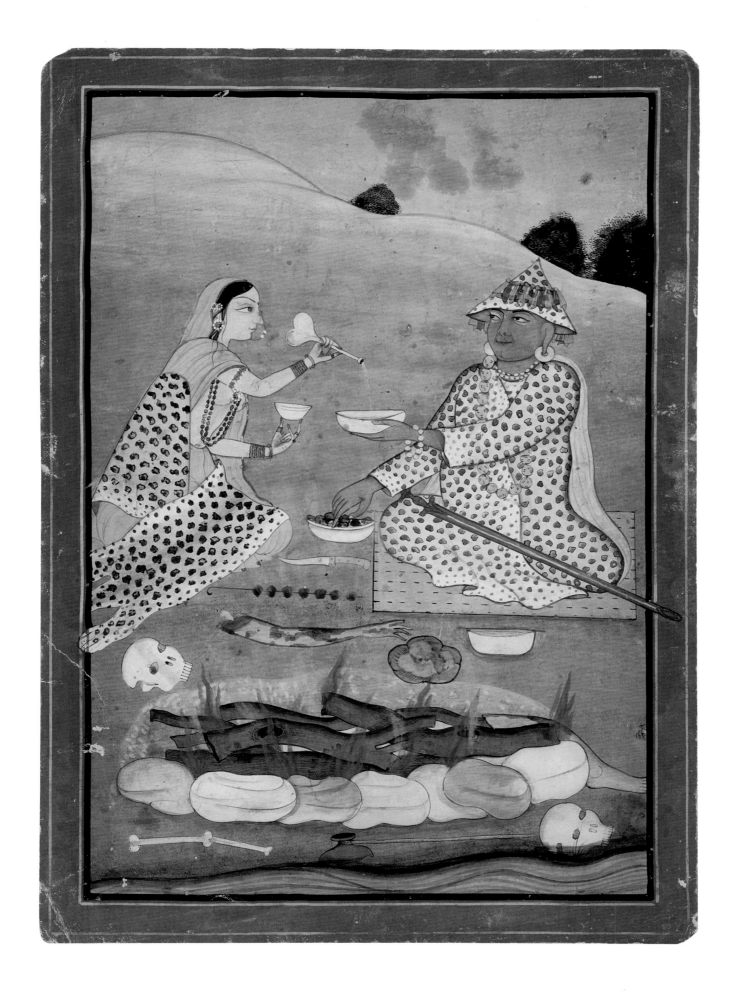

the great god himself, was able to control the hordes of yoginis who formed his macabre entourage. More than this, he was able to see through their horrific appearances and visualize them as embodiments of Shiva's divine consort, the lovely and terrible goddess Bhairavi.[27] A remarkable 1630 Mughal painting seems to depict just such a transformation (fig. 6). In a cremation ground, a Tantric yogi—whose transformation into a "second Shiva" is indicated by the glow of the crescent moon surrounding his head—is shown pronouncing mantras, represented by the puff of flame emitting from his mouth. Through his mantra, the goddess Bhairavi, who had previously haunted the cremation ground in the form of one of the jackals pictured in the foreground, shows herself to him in her true form, as a ravishing, albeit horrific goddess-cum-yogini. Here, the artist has ingeniously adorned Bhairavi's hair with arrow points to indicate her transformation from a jackal, whose pointed ears they mimic.

Often, Tantric yogis were described as amassing worldly powers at the expense of other people. A prescriptive account of this practice, called "subtle yoga," is found in the *Netra Tantra*, a ninth-century Hindu Tantra, whose eleventh-century commentary asserts that a person "becomes a yogi when his activities result in [control over] the movement of every limb of the person [whose body has been] invaded by him."[28] Nothing more or less than a battery of techniques for entering into and taking over other people's bodies, the theory and practice of subtle yoga fused teachings from the YS with Tantric subtle body constructs. On the one hand, the YS authorized such practices,[29] and on the other, the energies and channels of the subtle body made them technically possible. While such powers could be used for good—to initiate and thereby assure the salvation of a Tantric novice—they were most often portrayed as a predatory technique.[30]

No doubt due to the notoriety of such practices, the Tantric yogi became a stock figure in medieval literature, playing the villainous evil wizard who worked his nefarious designs on kings, princes, and innocent maidens, but was undone in the end by his own evil (fig. 7). Even today, parents in rural South Asia may scold naughty children with the words, "Be good, or the yogi will come and take you away."

Yoga and Yogis in the Modern World

Prior to the nineteenth century, when European explorers and empire-builders began to learn of yoga's philosophical depth, most Western writers described the yogis and fakirs they encountered as degenerates engaging in sexual excesses or as weapon-carrying mercenaries. Indeed, by the eighteenth century, armed "ascetics" formed the great bulk of the north Indian military labor market. A number of generals in these armies styled themselves after Shiva, the Lord of Yogis, such as the royal warrior described in a medieval chronicle:

> [A]ppearing like the Lord of Yogis, [he] was armed with a dagger; his ensigns were an axe in his hand and a tall trident, and a leather cloak. With a coil of matted hair on his head, and a musical horn, and ashes of cow dung, he was altogether like Hara [Shiva], the destroyer of all. With a powerful voice he cried and from his odd eye he scattered masses of fire. On his throne he might be seen [sitting] in the midst of his own congregation [of yogis], bearing on his head the moon with the nectar of the immortals.[31]

A seventeenth-century painting from the Deccan portrays a warrior in just such a guise, wearing the patchwork robe of a yogi (albeit finely tailored here), with the tiger skin and crescent moon halo indicating his identity with Shiva (fig. 8). So powerful were these armed ascetics that throughout the final decades of the eighteenth century, the British found themselves pitted against a yogi insurgency that would come to be known as the Sannyasi and Fakir Rebellion.[32]

For much of the eighteenth century, the British East India Company was also stymied by yogis in its attempts to regulate and control north Indian commerce. Cartels of Hindu ascetics and mercenaries exploited their status as "holy men" to transform pilgrimage routes into networks of trade; by the 1780s, yogis had become the dominant money-lenders and property-owners of several north Indian trading hubs. Some translated their economic clout into political dominance. In 1768, power-brokering Nath Yogis were instrumental in the unification of Nepal and the founding of the Gurkha (named after Gorakhnath) dynasty.[33] In 1803, Nath Yogis did the same in Jodhpur, in western India, outmaneuvering the British in the process.[34]

In 1823, the British Orientalist Henry Thomas Colebrooke "discovered" the YS and with it the textual foundation of India's yoga traditions. Seven decades later, Swami Vivekananda (see cats. 24a-h) introduced yoga to the Western masses as "one of the grandest of sciences," which had been nearly lost to the world through the machinations of tantric yogis, "who made it a secret [to keep] the powers to themselves."[35]

With the separation of Indian yoga from India's yogis, the doors were thrown open to the brave new world of the modern yoga subculture.

Notes

1. *Oxford English Dictionary*, 2nd ed., s.v. "subculture."

2. David Gordon White, *Sinister Yogis* (Chicago: University of Chicago Press, 2009), pp. 48–54, 60–61, 67–71.

3. Johannes Bronkhorst, *The Two Traditions of Meditation in Ancient India* (Delhi: Motilal Banarsidass 1993), pp. 1–5,19–24.

4. *Kāṭhaka Upaniṣad* (KU), 3.3–9, in Valerie Roebuck, *The Upaniṣhads* (London: Penguin Books, 2003).

5. KU 4.12; 5.1,3

6. KU 5.5, 8–10; *Bhagavad Gītā* 4.1–7.30; 10.1–12.20, in *The Bhagavadgītā in the Mahābhārata, A Bilingual Edition*, ed. and trans. J. A. B. Van Buitenen (Chicago: University of Chicago Press, 1981).

7. KU 3.10–11; 6.7–8. On the date of the *Yoga Sūtra*, see Philipp André Maas, *Samādhipada: Das erste Kapitel des Pātañjalayogaśāstra zum ersten Mal kritisch ediert* (Aachen, Germany: Shaker Verlag, 2006), pp. xv–xvi.

8. Patañjali's discussion of eightfold yoga is found in YS 2.28–3.3. Sixfold yoga is discussed in the *Maitri Upaniṣad* (6.18) and other Hindu sources, as well as the Buddhist canon of the "Highest Yoga Tantras." On this, see Vesna Wallace, "The Six-phased Yoga of the *Abbreviated Wheel of Time Tantra (Laghukālacakratantra)* According to Vajrapāṇi," in *Yoga in Practice*, ed. David Gordon White (Princeton: Princeton University Press, 201), pp. 204–22.

9. On these possible Jain influences, see Christopher Key Chapple, *Yoga and the Luminous: Patañjali's Spiritual Path to Freedom* (Albany, NY: SUNY Press, 2008), pp. 96–99.

10. YS 3.18,19, 21, 33, 38, 39, in Barbara Stoler Miller, *Yoga, Discipline of Freedom* (Berkeley: University of California Press, 1996).

11. On early Buddhist systems, see Robert Gimello, "Mysticism and Meditation," in *Mysticism and Philosophical Analysis*, ed. Stephen T. Katz (London: Sheldon Press, 1978), pp. 182–86. On later Hindu systems, see White, *Sinister Yogis*, pp. 99–108.

12. White, *Sinister Yogis*, pp. 167–90.

13. Such was the case in the Buddhist "Yoga Tantras" and "Highest Yoga Tantras" as well as in the Hindu *Mālinīvijayottaratantra*, which cast its entire path to salvation as "yoga." Somadeva Vasudeva, *The Yoga of the Mālinīvijayottaratantra* (Pondicherry: Institut Français de Pondichéry, 2004).

14. For example, in the Hindu *Kaulajñānanirṇaya* and the Buddhist *Caṇḍamahāroṣana* and *Hevajra Tantras*. For discussions, see David Gordon White, *Kiss of the Yoginī: "Tantric Sex" in Its South Asian Contexts* (Chicago: University of Chicago Press, 2003), pp. 106–14; and David Snellgrove, *Indo-Tibetan Buddhism. Indian Buddhists and Their Tibetan Successors*, vol. 1 (Boston: Shambhala, 1987), pp. 256–64.

15. Today, this is popularly and reductively known as "Tantric Sex."

16. David Gordon White, "Yoginī," *Brill's Encyclopedia of Hinduism*, vol. 1 (Leiden: Brill, 2009), p. 825.

17. In Buddhist Tantras, the names Avadhūtī and Cāṇḍālī (terms for the "outcaste" women who often served as Tantric consorts) were most commonly used.

18 David Gordon White, *The Alchemical Body: Siddha Traditions in Medieval India* (Chicago: University of Chicago Press, 1996), pp. 184–334.

19. The term is first encountered in the eighth-century Buddhist *Guhyasamāja Tantra*; Jason Birch, "The Meaning of *haṭha* in Early Haṭhayoga," *Journal of the American Oriental Society* 131, no. 4 (2011), p. 535.

20. Birch, "Meaning," p. 548.

21. For a listing of yogic, tantric, and alchemical works attributed to Gorakhnāth, in both Sanskrit and vernacular languages, see White, *Alchemical*, pp. 140–41. For a detailed discussion of the *Gorakṣaśataka*, see James Mallinson, "The Original *Gorakṣaśataka*," in *Yoga in Practice*, ed. David Gordon White (Princeton: Princeton University Press, 2011), pp. 257–72.

22. They are also known as Nāth Yogis, or *kānphaṭas* ("split-eared") for the distinctive way they wore their signature earrings, through the cartilage of the ear. In Buddhist and Jain sources, these yogis were most often called *siddhas* ("perfected beings") or Nāths, while Islamic authors identified them as yogis, *pīrs* ("masters"), or fakirs ("poor men"). Ronald Davidson, *Indian Esoteric Buddhism. A Social History of the Tantric Movement* (New York: Columbia University Press, 2002), pp. 173–340; White, *Alchemical Body*, pp. 19, 80–81, 84–85, 331–32; and Simon Digby, *Wonder-Tales of South Asia: Translated from Hindi, Urdu, Nepali and Persian* (Jersey: Orient Monographs, 2000), pp. 221–33.

23. John E. Cort, "When Will I Meet Such a Guru? Images of the Yogī in Digambar Hymns" (unpublished paper, Jaina Studies Conference, School of Oriental and African Studies, London, March 2010). Traditionally, the third of the twelve "Bhaktis" in these works is titled the "Yogī Bhakti." As Cort notes, the dating of "The Bhaktis" is problematic, with the earliest Prakrit-language versions likely predating the sixth century.

24. In the world of medieval Hindu Tantra, there was a certain division of labor, which distinguished between practitioners whose gnostic meditative practice led to identity with the divine, i.e. self-divinization, as opposed to those whose goal was supernatural power in the world. Here, the former were known as *jñānīs* ("knowers"), and the latter yogis. This is not to say that Tantric yogis were uninterested in the *jñānīs*' transformative knowledge: they simply maintained that it could be attained directly through Tantric initiation, by drinking the "fluid gnosis" of their female consort's sexual emissions. White, *Kiss of the Yoginī*, pp. 106–14.

25. Somadeva Vasudeva, "The Transport of the Haṃsas: A Śākta Rāsalīlā as Rājayoga in Eighteenth-Century Benares," in White, ed., *Yoga in Practice*, p. 250.

26. White, *Alchemical Body*, pp. 312–14.

27. White, *Kiss of the Yoginī*, pp. 247–51.

28. *Netra Tantra* 20.28–36, with the commentary of Kṣemarāja. For a discussion, see White, *Sinister Yogis*, pp. 161–64.

29. *Yoga Sūtra* 3.38: "From loosening the fetters of bondage to the body and from awareness of the body's fluidity, entering into the body of another."

30. White, *Sinister Yogis*, pp.161–66.

31. A. F. Rudolf Hoernle, trans., *The Prithirāja Rāsau of Chand Bardāi*, Bibliotheca Indica, n.s., no. 452 (Calcutta: Baptist Mission Press, 1881), pp. 49–50.

32. White, *Sinister Yogis*, pp. 220–26, and William Pinch, *Warrior Ascetics and Indian Empires* (Cambridge: Cambridge University Press, 2006), pp. 82–102.

33. Véronique Bouillier, "The King and His Yogī: Pṛthivīnārāyaṇ Śāh, Bhagavantanāth and the Unification of Nepal in the Eighteenth Century," in *Gender, Caste and Power in South Asia: Social Status and Mobility in a Transitional Society*, ed. John P. Neelsen (Delhi: Munshiram Manoharlal, 1991), pp. 1–21.

34. White, *Kiss of the Yoginī*, pp. 168–69; and *Sinister Yogis*, pp. 219, 239. See also Debra Diamond, Catherine Glynn, et al., *Garden and Cosmos: The Royal Paintings of Jodhpur* (Washington, DC: Arthur M. Sackler Gallery, 2008), pp. 31–49, 141–71, 280–86.

35. Swami Vivekananda, *Raja-Yoga: Conquering the Internal Nature* (Calcutta: Advaita Ashram, 1896; rev. ed. New York: Ramakrishna-Vivekananda Center, 1973), p. 18.

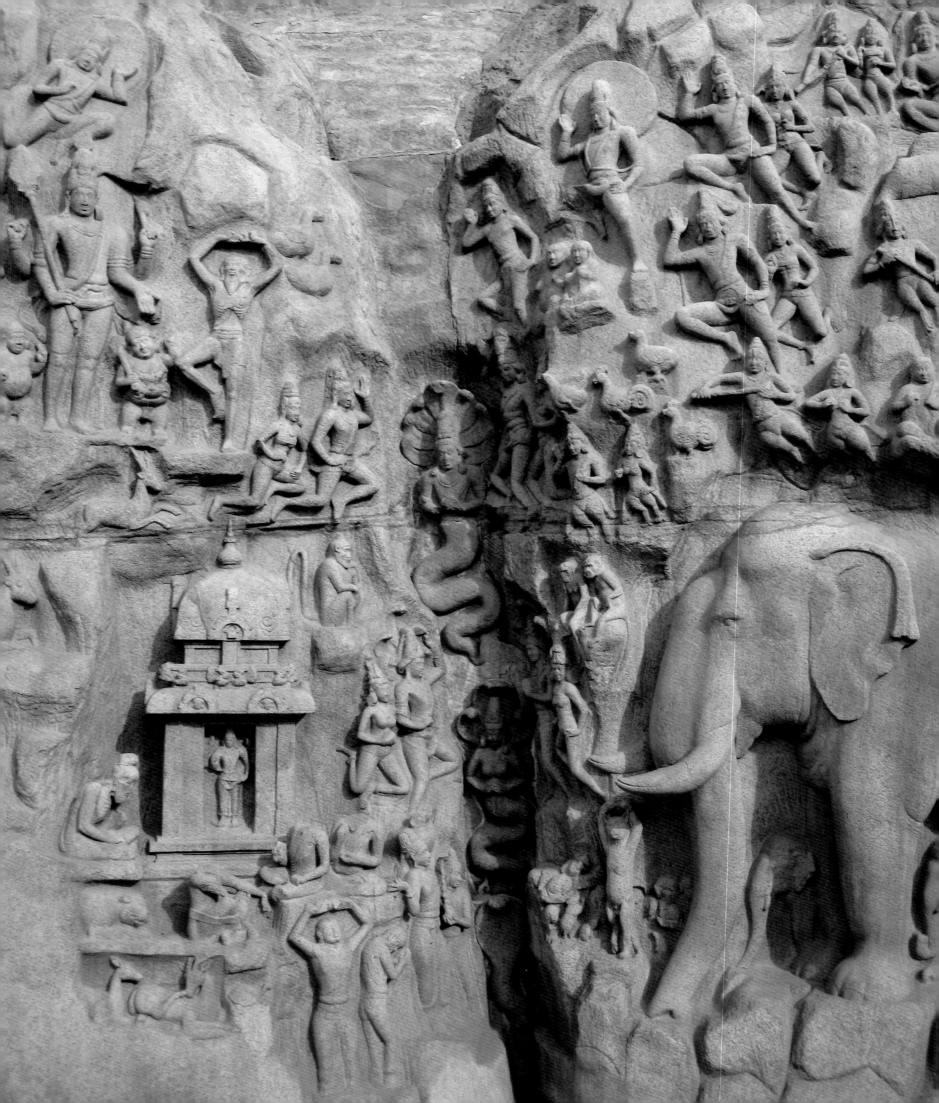

Tamara I. Sears

From Guru to God: Yogic Prowess and Places of Practice in Early-Medieval India

It is hard to imagine the history of Indian art without envisioning a meditating yogi or sage deep in contemplation, seated in lotus pose or standing in the absolute stillness that is achieved only upon final emancipation from worldly bonds. Among the most enduring of India's visual tropes, the image of the yogic master signifies far more than it shows. In the past, yoga was not a publicly available practice that could be studied either casually or with varying degrees of seriousness. Rather, it was a highly exclusive ritual activity that could lead either toward liberation or to the acquisition of powerful magical abilities, otherwise known as *siddhi*s. While the path to obtaining *siddhi*s was potent enough to turn a sage into a sorcerer, the path to liberation often constituted a dramatic ontological shift at the level of the soul. Because knowledge of yoga gave the practitioner the potential to transcend the realm of human existence and enter a state akin to becoming divine, it was restricted to highly accomplished gurus and their most dedicated pupils.

The transformative potency of yoga was not limited to human practice. By the early centuries of the first millennium, Hindu gods too came to be represented as masters of the discipline. Deities were understood to be living presences who made and remade the world through the power of yoga. Like their human counterparts, they drew strength from yoga, in the form of a fiery heat (or *tapas*) that enabled them to act efficaciously in the world. Shiva was seen as the quintessential sage who, seated on the lotus at the center of the cosmos, created the world through his practice. Vishnu took on the form of Nara, an ideal sage, whose ascetic practice was represented visually as producing Narayana, or the form responsible for cosmic generation (fig. 2).[1] By the turn of the first millennium, prominent gurus and yogis had become canonized as divine incarnations and remained alive and present in their images long after their lifetimes on Earth.

Mythological Landscapes and the Poetics of Practice

One of the best known depictions of yoga's power is found in a relief sculpted across the vast façade of an unfinished rock-cut temple in the southern Indian village of Mamallapuram, not far from the shores of the Bay of Bengal, facing toward the sea (fig. 1). Created in the seventh century during the reign of the Pallava kings, the monument has long presented a striking visual enigma, as its imagery suggests more than one story.[2] Some have interpreted it as representing the descent of the Ganges River through

Fig. 1
Descent of the Ganges. India, Tamil Nadu, Mamallapuram, ca. 7th century

the intervention of King Bhagiratha, who became an ascetic and performed penance to obtain Shiva's assistance in bringing the river goddess Ganga down from the heavens so that he could appropriately perform the final rites for his dead ancestors. Others have argued that it better fits an account from the *Mahabharata* in which the Pandava Prince Arjuna wandered the wilderness as an ascetic, seeking Shiva in order to acquire a magical weapon that would help him recover his lost kingdom. What is striking is not the differences in the two narratives but their primary points of convergence on the level of composition and theme. (For more on Prince Arjuna, see cat. 10a.)

Both narratives center on a king or prince who becomes a sage in order to ultimately fulfill his worldly duties. Through the performance of bodily austerities and meditation, he is able to directly encounter the supreme god, who, appeased by the sage's yogic prowess, grants him a boon that redresses past wrongs and restores cosmic order. In both interpretations, the key moment can be located in the relief's upper left quadrant, where we encounter a penitent sage performing a rigorous yogic practice. The iconography of the sage's stance has been interpreted as representing either the penance of gazing into the sun (*suryopasthana tapas*) or the penance of the five fires (*panchagni tapas*) performed to conquer passion, anger, greed, attachment, and jealousy.[3] Here, the external iconography evokes the internal process: the sage's eyes and arms are raised to the sky as he stares up into sun. Once he is king, the sage becomes a true ascetic, marked as such by such iconographic features as his long beard and matted locks of hair (*jata*), the noticeable gauntness of his body, and his simple attire, consisting only of a loincloth and sacred thread (*yajnopavita*). Besides him stands none other than the god Shiva, fully manifest in anthropomorphic form, marked as both a deity, possessing four arms and a sacred trident, and a powerful ascetic, sporting similarly matted locks of hair. The efficaciousness of the practice is indicated most clearly by the iconography of Shiva's response: the supreme god's lower left hand extends outward in a boon-granting gesture (*varada mudra*), communicating to the viewer that the sage has been successful in procuring his desired favor.

The lush and sacred setting for both stories can be understood as an ideal landscape for yoga, populated by gods, sages, and animals of the forest, and watered by the Ganges River situated in the cleft at the relief's center. While the ascetic performing penance in the relief's upper left quadrant demonstrates the ability to access Shiva on a heavenly plane, the scene just below constitutes a landscape of yogic aspiration and emphasizes the importance of practice in the human world (fig. 1). The action unfolds around a hermitage so idyllic that even normally inimical animals, seen here as lions and deer, can reside peaceably side by side. The most prominent human figure, a solitary sage in a moment of deep meditation, sits leaning forward, facing the Vishnu temple that dominates the scene. Below and to the right is a group of three seated sages. The first wears a yoga strap (*yogapatta*) prominently around his legs. Further below and toward the river, at the center of the relief, are others worshiping at the river. The first of this group, to the viewer's far left, stands upright in *urdhvabahu* (raised arm) pose, which, in this context, functions as a less masterful mirror of the *panchagni tapas* performed by the ascetic high above. It may well be that we are witnessing multiple iterations of the same sage, caught at different moments in the process of perfecting his practice.

Scholars have offered various interpretations of the figures in this lower portion of the relief. One reading identified the overall setting as the Badari hermitage, home of Vishnu's incarnation as Nara and Narayana, which too was positioned near the banks of the Ganges. Textual accounts of Arjuna's penance, which were known to the relief's patrons, described Arjuna as worthy of wielding Shiva's weapon because Arjuna had been Nara in one of his previous lives. If this were the case, it seems certainly meaningful that the temple housing the icon is directly below, and the sage is performing penance before Shiva above, which creates a visual analogy between the perfected human practitioner and an icon of god.[4] Proponents of the Descent of the Ganges story have since posited the alternative theory that the solitary meditating figure to the left of the temple may represent

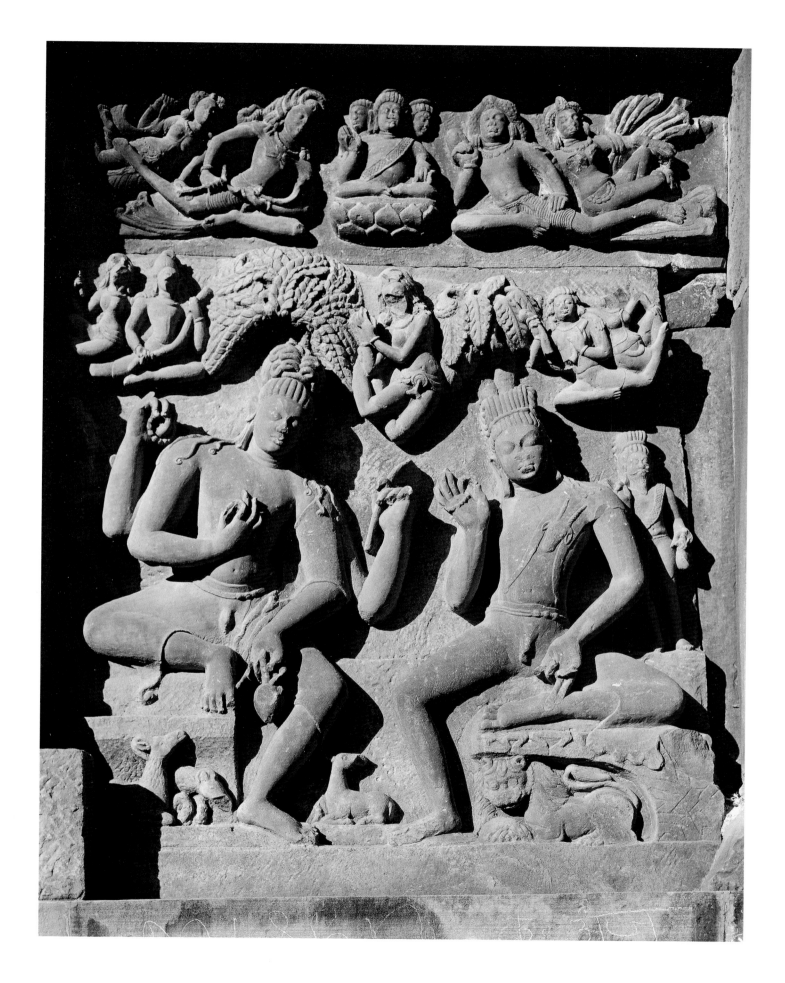

Bhagiratha thanking the god Vishnu in his form as the sage Kapila, who set in motion the events leading to the quest.

In addition to emphasizing the ways in which yoga could set the world in good order, the relief at Mamallapuram includes one final scene that reminds us that not every yogi was necessarily honorable. To the immediate right of the river-cleft, just opposite the figures praying at the banks near the forested hermitage, is a small but carefully delineated figure of a yogic cat, standing upright in imitation of the human practitioners on the left. Like the perfected sage in the upper left quadrant, he is depicted as an ascetic with a protruding ribcage. But his practice yields a very different effect. He is not accompanied by Shiva or Vishnu, but by a flock of worshipful mice blindly holding their paws together in *anjali mudra*, or the gesture of devotion. Rather than representing the power of yoga to illuminate truth, this vignette emphasizes the danger of false gurus whose practice is directed primarily toward quelling their own worldly hungers.[5] While the trope of the hypocritical cat was quite common in well-known classics such as the *Hitopadesha*, the trope of the false guru, particularly associated with antisocial Tantric groups like the Kapalikas, was frequently found in dramatic parodies such as the *Mattavilasa* (Drunken Games) and the *Bhagavadajjukīya* (The Hermit and the Harlot), which were popular in the nearby Pallava court at Kanchipuram.[6]

Establishing Real Places for Yogic Practice

The ideal landscapes associated with yoga were not merely poetic tropes confined to the spheres of visual and literary representation. They were real places of natural beauty whose sanctity encouraged the establishment of temples and ascetic abodes. It is no coincidence that the small Vishnu temple in the Mamallapuram relief closely resembled contemporary temples built at the same site, which unlike the capital at Kanchipuram, functioned both as idyllic retreat and growing port town. Elsewhere in India, the seventh and eighth centuries witnessed the formalization of new kinds of Hindu monasteries (*mathas*), presided over by head gurus whose authority was rooted in their mastery of sacred scriptures and yoga. By the turn of the first millennium, monasteries had grown significantly through royal patronage, and in some cases had become large-scale multifunctional centers, serving variously as colleges, rest-houses, charitable distribution centers, hospices, and foci for worship.[7] Despite the increasing institutionalization of ascetic practice, great attention was given to establishing places that could provide an idyllic locale for austerities and yoga.

Figs. 3a–d
Plan and views of Shaiva Monastery. India, Madhya Pradesh, Chandrehe, ca. 973

A good case in point can be seen in the survival of a Shaiva monastery in the village of Chandrehe, located in the modern-day central Indian state of Madhya Pradesh (figs. 3a–d). Situated not far from the banks of the holy Son River, the monastery was intended to serve as a quiet and peaceful retreat. An inscription still affixed to the front verandah reveals a delightfully complex history.[8] According to the inscription, the "spacious and lofty" monastery was built in 973 by a guru named Prabodhashiva, who intended it to accompany a temple established a generation earlier by Prashantashiva, his spiritual teacher and predecessor. Prashantashiva, in turn, had intended the site to be one of two remote hermitages; the other one was located along the Ganges River at the famed pilgrimage city of Varanasi (Banaras or Benares).[9]

Both of the hermitages established by Prashantashiva were meant to be places of peaceful respite from

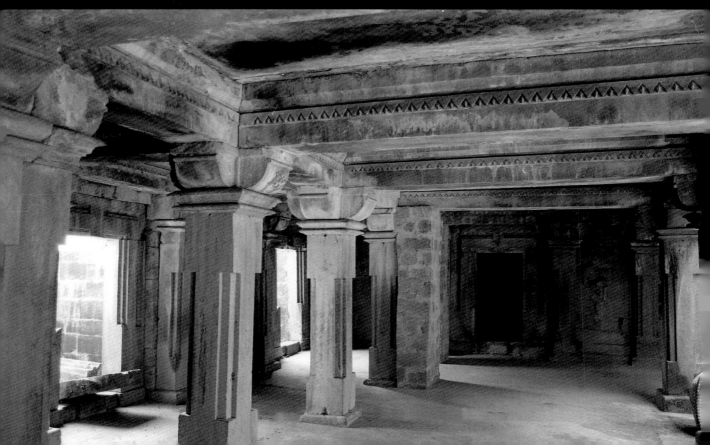

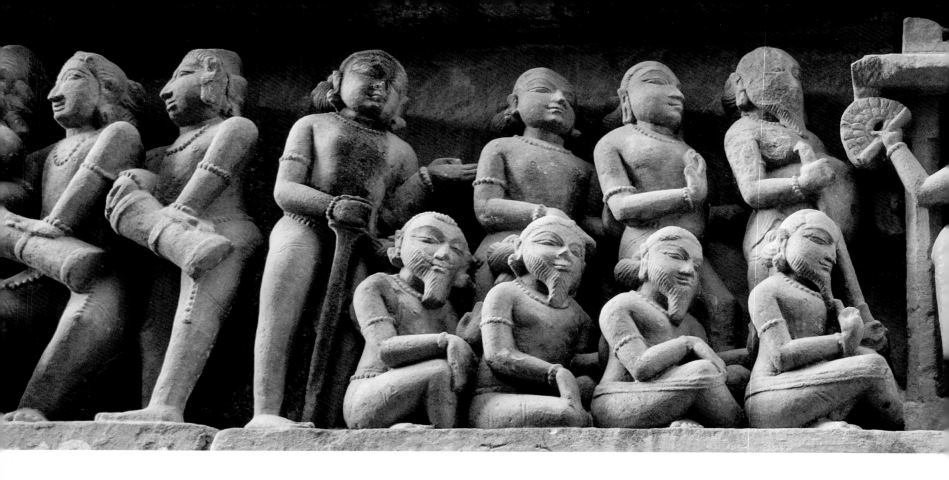

the more centralized monastery at Gurgi, which had been built a generation earlier "at an enormous expense" by the emergent Kalachuri King Yuvarajadeva I (reigned 915–45) in conjunction with a large royally sponsored temple.[10] At Gurgi, resident sages inevitably became involved in the administration of state religious affairs. But the retreats at Varanasi and Chandrehe were reserved for "*siddhas*" and "tranquil *yogins*," who were intent on destroying all obstacles to achieving clarity of mind and success at meditation, with the goal of reaching final liberation.[11] Fittingly, both Prashantashiva and Prabodhashiva were described in ways that emphasized their yogic prowess. In the Gurgi inscription, Prashantashiva was praised as a highly learned sage "who had mastered [all] the *asanas*" and "who felt the inner joy" that comes from keeping his "steady mind absorbed in the meditation of Shiva seated in the midst of the lotus of his heart."[12] The text from Chandrehe similarly described the sage Prabodhashiva as "practicing austerities even in his boyhood on the bank washed by the river [Son]" and as having "realized God through the performance of religious austerities and meditation, and living on fruits [*priyala* and *amalaka*], greens, and lotus roots [*shaluka*]."[13]

The yoga practiced at Chandrehe was not one of the radical variations associated with esoteric Tantric sects, but rather part of a more mainstream strand. Prashantashiva and Prabodhashiva belonged to a prominent lineage, the Mattamayuras or Drunken Peacocks, within a broader, pan-Indic, religious tradition known as Shaiva Siddhanta and associated with a body of ritual manuals, the *Shaiva Agamas* (or, more broadly, Tantras).[14] Although today Shaiva Siddhanta is widely associated with southern India, it may have emerged as early as the eighth or ninth century in the northern region of Kashmir, and then spread through Central India in subsequent centuries.[15] In the *Shaiva Agamas*, yoga formed one of four major categories referred to as "four feet" (*chatushpada*), the other three of which included knowledge (*jnana*), action (*kriya*), and proper conduct (*charya*). Together, these four were understood as essential components in the attainment of liberation. *Jnana* led to a state of union with God (*sayujya*); *kriya* brought about a nearness to God (*samipya*); yoga helped one attain the form of God (*sarupya*); and *charya* ensured that the soul attained residence in the region of God (*salokya*).[16] Within Shaiva

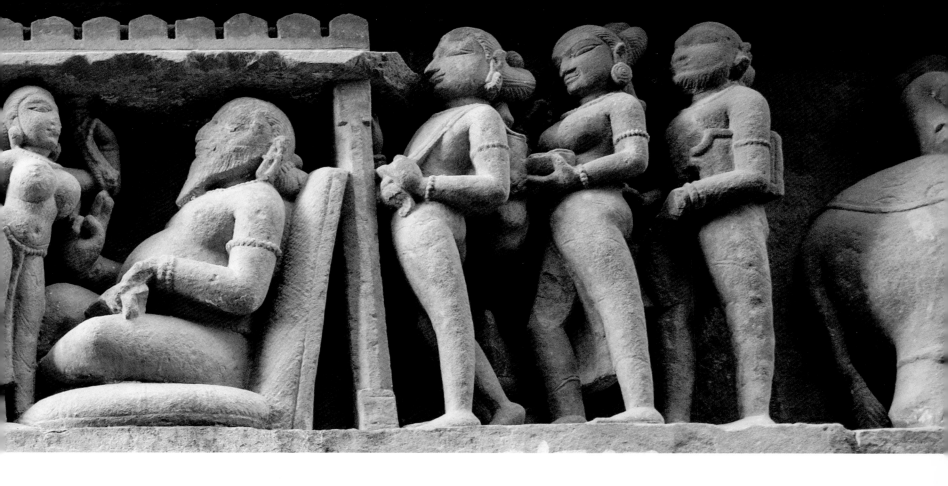

Siddhanta, yoga was a distinct discipline or an individual practice, taught only to those initiated at the right level, and it was considered essential for the achievement of final liberation. The power of yoga to help one attain immortality after death was articulated beautifully in a contemporary inscriptional verse from a related site, where the head guru, described as "the foremost among Shaivas ... went [to his rest] in the place of Shiva, the eternal station, through yoga."[17]

Situated near the banks of holy rivers, the Ganges and Son respectively, Varanasi and Chandrehe may have been envisioned as ideal spaces for performing yoga. While Varanasi was a holy city long associated with a sacred geography, Chandrehe offered a forested setting not entirely unlike that depicted in the lower left quadrant of the relief at Mamallapuram. Even as Prabodhashiva was actively making the monastery more accessible to travelers—through an infrastructure of roads and bridges, described as "a wonderful way through mountains [and] across rivers and streams, and also through forests and thickets,"[18]—Chandrehe remained fairly removed, even in modern terms. The real geography of the site may have resonated quite well with the poetics of its inscription, which described Chandrehe as a place where "herds of monkeys kiss the cubs of lions [and] the young one of a deer sucks at the breast of the lioness," and where "other hostile animals forget their [natural] antipathy [to one another]; for the minds of all become tranquil in penance-groves."[19]

Such a locale may have evoked not only the poetics of ideal landscapes but also the pragmatics of practice as articulated in Shaiva ritual manuals. The *Sarvajnanottara Agama*, for example, dictates that

the student, pure, after performing his bath and ablutions, should bow his head to Shiva, salute [his lineage of] preceptors of yoga, and [then] engage in yoga in an empty building, or in a delightful monastery, or in an auspicious temple. Or [he may practice] on the bank of a river, in a desolate spot, an earthen hut or in a forest; [provided it is] sheltered, windless, noise-free and unpopulated, free from obstacles to yoga, free from doubt [about its ownership] and not too hot.[20]

Fig. 4
Guru and Disciples,
Lakshmana Temple.
India, Madhya
Pradesh, Khajuraho,
ca. 954

Chandrehe offered both a "delightful monastery" and an "auspicious temple," located near the bank of a river in a fairly secluded and forested landscape. Moreover, it was a place that remained thoroughly under the ownership and purview of the resident monastic community, a place where one could practice highly potent rituals without fear of interruption at a critical moment. It may well be that such monastic sites formed the real world analogue for visual and literary representations of landscapes populated by sages practicing yoga.

Portraying Divine Teachers

The development of monastic communities such as the one at Chandrehe corresponded with the increasing proliferation of sculpted images of gurus actively engaging in the dissemination of religious teachings (fig. 4). Known as *shikshadana* scenes, such images typically featured a guru—usually shown with a large belly indicating the retention of breath, and seated upon a special cushion or throne—facing a group of disciples who express their devotion through *anjali mudra*. Sometimes he was accompanied by male and female attendants holding ritual implements; at other times he was surrounded on all sides by his students. Often the guru would hold his hands in the *dharmachakra mudra*, indicating the act of teaching, or touch the head of a disciple, suggesting perhaps a more personal act of devotion or even possibly the conferral of initiation.[21] The scenes were typically framed as distinct architectural spaces. The entrance was sometimes indicated through the presence of an armed gatekeeper, and the guru's spot was frequently differentiated through the presence of a pillared hall or overhanging canopy.

In addition to emphasizing the prominence of the guru, *shikshadana* scenes evoke the structure of ascetic communities in ways that were analogous to the real space of the monastery. Within the dwelling at Chandrehe, for example, were spaces specially designated for a range of ritual activities,

Figs. 5 and 6
Lakulisha in a central wall niche. India, Madhya Pradesh, Batesara, ca. 8th century

Carl W. Ernst

Muslim Interpreters of Yoga

Yoga is perhaps the most successful Indian export in the global marketplace of spirituality. In terms of religious associations, it is most often juxtaposed with the Hindu and Buddhist traditions, though it is also presented today as a generic or stand-alone form of spiritual or physical practice. Because of the way that modern identity politics have played out in recent years, most people may be quite surprised to find yoga connected with Islam in any way. Yet there is a long and complex history of Muslim interest in yoga, going back 1,000 years to the famous scholar al-Biruni (died 1048), who not only wrote a major Arabic treatise on Indian sciences and culture, but also translated a version of Patanjali's *Yoga Sutras* into Arabic.[1]

Over the centuries, other Muslim figures followed al-Biruni in seeking to understand the philosophical and mystical teachings found in India. Such efforts were part of a long tradition of intercultural engagement that resulted in a vast series of translations of Indian texts into the Persian language, the lingua franca of government and culture throughout much of the Middle East, Central Asia, and South Asia. This translation movement—which covered subjects ranging from the arts and sciences to politics and metaphysics for roughly eight centuries—is comparable in scope and significance to the translation of Greek philosophy and science into Arabic, or the translation of Buddhist texts from Sanskrit into Chinese and Tibetan.[2]

Alongside this wide-ranging interest in Indian culture was a more specialized focus on the meditative practices and occult powers of Indian ascetics and mystical adepts known as yogis (or *jogis*, in North Indian pronunciation). A good part of this interest was very practical, and it is obvious from royal chronicles and travelers' accounts that a number of Muslims were intrigued by the benefits to be found in the wonderworking practices of yogis.[3] This fascination is especially noticeable in the case of Muslim rulers in South Asia; like other kings, they were always eager for any kind of special knowledge or power (such as astrology, magic, or medicine) that would give them an edge. Thus when the fourteenth-century North African traveler Ibn Battuta was in Delhi, he observed Sultan Muhammad ibn Tughluq interviewing a yogi who was successfully demonstrating his ability to levitate in the air. In a similar fashion, the Mughal emperor Jahangir regularly met with the Hindu ascetic Gosain Jadrup, as depicted in his memoirs (fig. 1). Since narratives about the amazing powers of yogis pervaded much of India's popular literature, it is not surprising that Muslims in South Asia were familiar with and sought greater acquaintance with this lore. It is fair to say that Muslim interest in yoga ranged from the quest for

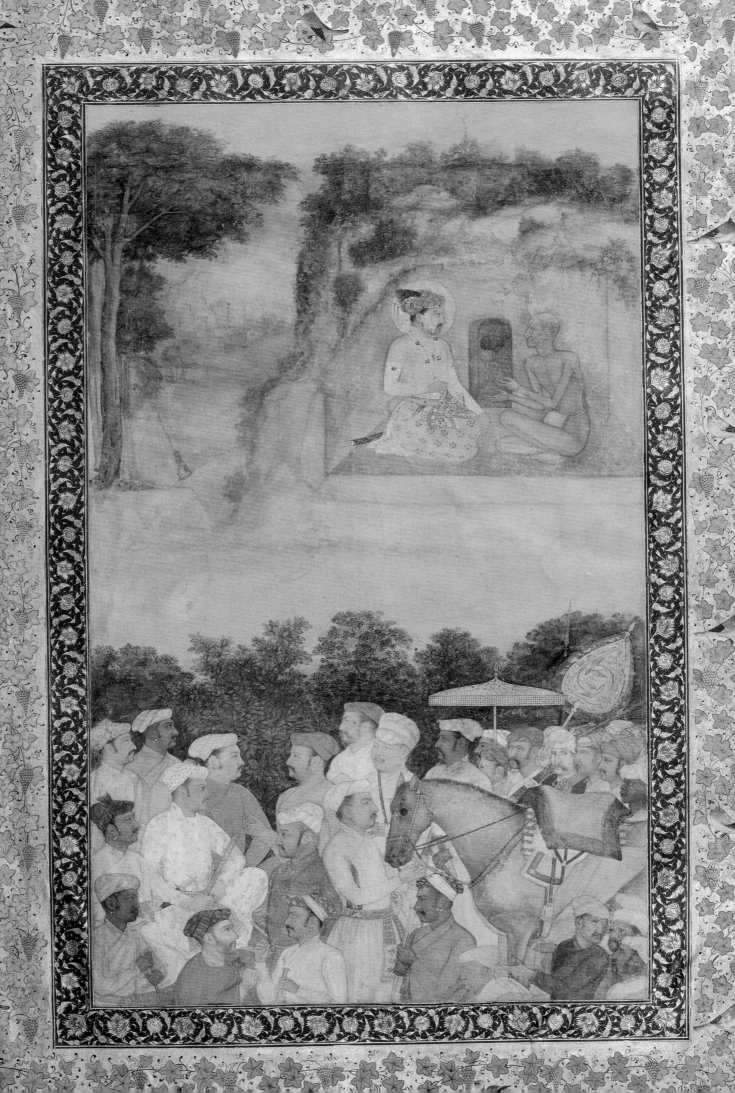

philosophical knowledge to engagement with spiritual practices to simply the desire for occult powers. Indian ascetics were assimilated to the model of the Muslim fakir or dervish. They were labeled with those Persian terms, and they frequently appeared in illustrated Mughal histories, Persian translations of Sanskrit texts, and album paintings.

On the philosophical side, the primary framework for understanding Indian religions was the Ishraqi form of Neoplatonic thought known as Illuminationism, developed by the Persian thinker Suhrawardi (died 1191). In this formulation, the degrees of being that emanate from the divine source of the cosmos are identified as more or less intense manifestations of light. At the same time, following the philosophical theory of prophecy articulated by the philosophers Farabi and Ibn Sina, religions were considered to be symbolic explanations of philosophical truths in forms that the uneducated masses could comprehend. From this perspective, it was not difficult to view yogic or Vedantic teachings as one more example of the adaptation of philosophy to local traditions. There are quite a few indications of the popularity of the Illuminationist philosophy among intellectuals in Mughal India, some of whom indeed speculated on Indian religious thought and practice.[4] Some Vedantic texts were quite popular in

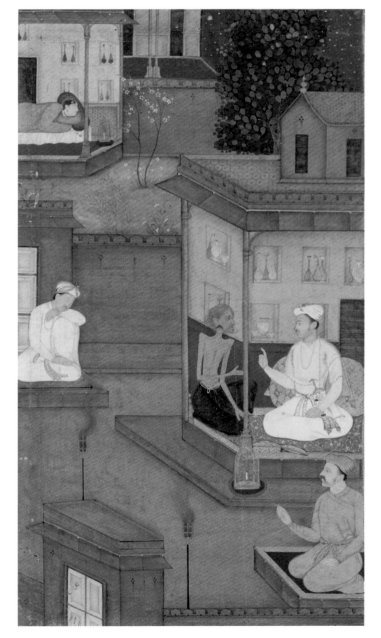

Persian translations, particularly the *Yoga Vasishta*, one copy of which features an important series of illustrations (fig. 2).[5]

From the perspective of Sufism (Islamic mysticism), yoga was also a subject worth exploring. These two traditions often have been brought together in a consideration of comparative mysticism, and many scholars have assumed that Sufism must have been derived from yoga in some way or other. First proposed in the late eighteenth century by early Orientalists, starting with Sir William Jones, this theory rested upon a deep conviction that all Eastern doctrines are ultimately the same, along with the axiomatic assumption that Islam was a harsh and legalistic religion incompatible with spirituality. It is in fact impossible to make a convincing historical case that Sufism somehow originated from Indian sources; Islamic mysticism is actually Islamic, and it took shape primarily in Baghdad and Khorasan before arriving in India around the eleventh or twelfth century.[6] Yet by a curious coincidence, just as the Sufis arrived, ascetics practicing hatha yoga assumed new roles of dramatic importance in the theater of Indian religions. Because those yogis had undergone ritual death and were not bound by the purity restrictions of upper-caste Hinduism, they were free to drop in on the open kitchens that were often maintained by Sufi masters at their retreats in India, much like the "charitable serai" depicted in the Hindi Sufi romance *Mrigavati* (fig. 3). For this reason, from an early date we have numerous examples of conversations and reflections on yoga in the writings of Indian Sufis. Sometimes, this is limited to the observation that breath control is a helpful adjunct to meditation. But in other cases, it is obvious that Sufis paid close attention to more sophisticated yogic teachings involving the subtle physiology of chakras and the power of mantras, which were arguably

Fig. 1 (opposite)
Jahangir converses with Gosain Jadrup, from the *Jahangirnama*. Attributed to Payag. India, Mughal dynasty, ca. 1620. Musée du Louvre

Fig. 2
The King and Karkati Discuss Brahman, from the *Yoga Vasishta*. By Iman Quli. India, Allahabad, 1602. Chester Beatty Library

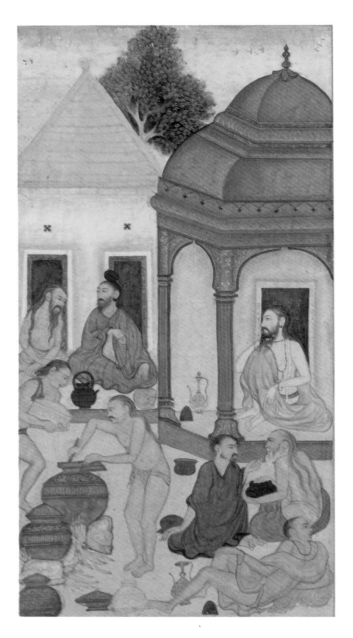

Fig. 3
The feast of the yogis
from the *Mrigavati.*
India, Allahabad,
1603–4. Chester
Beatty Library

quite similar to the subtle centers (*lata'if*) of Sufi meditation and the *zikr* formulas consisting of the Arabic names of God. Indeed, one of the most important Sufis, Mu`in al-Din Chishti (died 1236), founder of the Chishti Sufi order in India, is credited with the authorship of a widely circulated Persian text on yoga and meditation, variously known as the *Treatise on the Human Being* or the *Treatise on the Nature of Yoga*, among other titles. There is some question about the authorship of the text, since none of the manuscripts are older than the seventeenth century, and Mu`in al-Din's successors maintained that he wrote no books of any kind. Nevertheless, the popularity of this work in Sufi circles—and its association with the supreme spiritual experiences of a founding figure of Indian Sufism—reinforced the notion that yoga in some respects was fundamentally compatible with Sufism, or at least could be interpreted in that way.[7]

The first major Persian text devoted to the subject of yoga was composed by an anonymous author in the fourteenth century, with the Hindi title, *The Fifty Verses of Kamarupa* (*Kamaru panchasika*).[8] The title alludes to Kamarupa (the kingdom of Assam in northeastern India), traditionally considered the source of magic and wonders; it also invokes scriptural authority in a rather mysterious fashion. The text's date and wide circulation is established by the appearance of an excerpt in an important Persian encyclopedia compiled in Shiraz by Sharaf al-Din Amuli (died 1353). Appearing in the category of natural sciences, the quoted sections dealt with breath control for predicting the future and meditative practices involving the chakras.[9]

The Italian traveler Pietro della Valle acquired a complete version of the text (now preserved in the Vatican Library) while traveling in southern Persia in 1622; the fact that he obtained this manuscript from a group of provincial Persian intellectuals indicates that it was still popular outside of India. This fuller text reveals, in addition to the material on breath control and chakra meditations, extensive practices involving the summoning of sixty-four yoginis, whom the translator refers to as "spiritual beings" (*ruhaniyat*). Particular prominence is given to the goddess Kamak Devi (Sanskrit: Kamakhya), who was associated in various Indo-Islamic texts with the symbolism of plantain and cave, which appear in a painting of a yogini from the court of Bijapur (fig. 4). While the tradition of yogic physiology is present in the text to some extent, the main concern is the practical benefit to be gained by summoning the yoginis by using powerful mantras that can deliver to the practitioner whatever he desires. The translator maintains that he rendered this material from the most famous book of the Hindus (although no trace of it appears to survive in any Indian language), and he attempts to use the language of Islamic literary scholarship (and other Islamizing touches) to give credibility to what seem to be oral teachings. The key terms that he uses to describe these practices are "magical imagination" (Arabic: *wahm*) and "ascetic discipline" (Persian: *riyazat*); the latter term is the regular Persian equivalent for yoga (*jog*).[10] Della Valle claimed to have employed the practices described in the text with some success, and announced his intention to translate it into Italian, though he never seems to have accomplished that task.

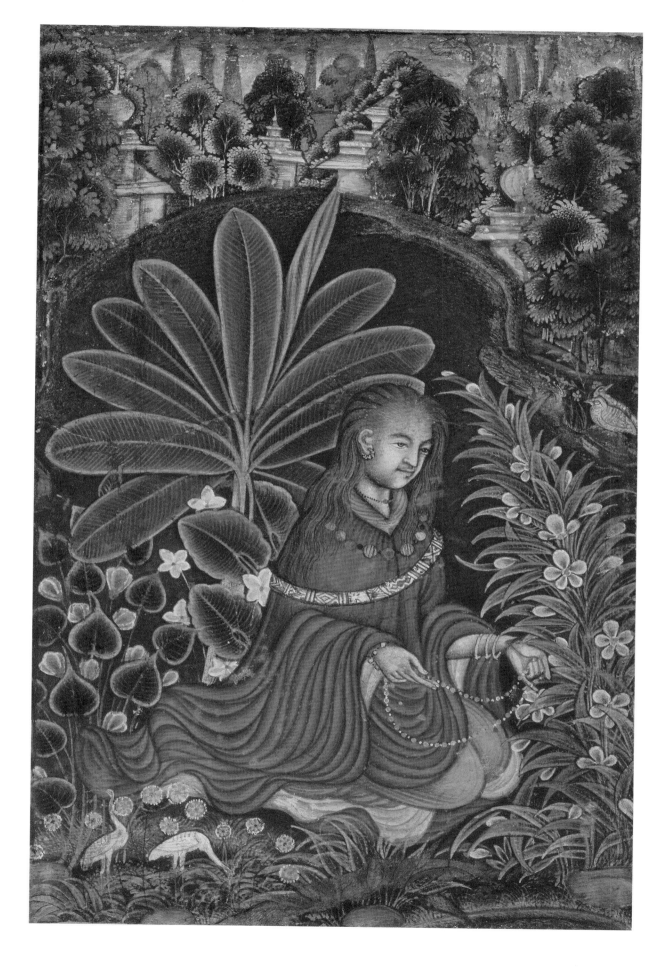

But by far the most important work on yoga by a Muslim author is an Arabic text known by several different titles: *The Mirror of Meanings for the Comprehension of the Human World*; *Do-It-Yourself Medicine*; and, most commonly, *The Pool of the Water of Life* (*Hawd ma' al-hayat*, often shortened to *Hawd al-hayat* or *The Pool of Life*). This popular text, composed by an anonymous author, claims to have originated in the transitional moment when Turkish armies conquered the eastern limits of Bengal in 1212. It is ostensibly a translation of a famous Sanskrit work known as *Amritakunda* or *The Pool of Nectar* (although here too there is no trace of any such original text).[11]

The later history of *The Pool of Nectar* is complex. There are two different versions of the Arabic translation, one containing more Indic material and the other demonstrating a noticeable degree of Islamization. The Arabic text was translated into Ottoman Turkish twice and was popular among members of the Mevlevi order (the Whirling Dervishes) in Istanbul in the late nineteenth century. Many manuscript copies in Istanbul libraries are erroneously attributed to the famous Andalusian Sufi master Ibn `Arabi (died 1240), although other copies are simply classified as Indian magic. The next major step in the transmission of these teachings took place in sixteenth-century India, when the noted Sufi master of the Shattari order, Muhammad Ghawth Gwaliyari (died 1563), translated the Arabic version of *The Pool of Nectar* into Persian, under the title *The Ocean of Life* (*Bahr al-hayat*).[12] This expanded and revised version probably drew upon oral communications from contemporary yogis, and there are also signs that it was based on an earlier Arabic version than the text we currently possess. Several copies of the Persian translation are lavishly illustrated, with twenty-one paintings depicting yogic postures; by way of comparison, the Persian text of this chapter is four times as long as the Arabic original, which only describes five postures.[13] Known as *asana*s in yogic traditions, these postures are named by two joined terms, the Hindi *shabda* ("word") and the Persian *dhikr* ("recollection"), in the Persian translation, which suggests that mantra chants rather than physical postures are the key element. But for convenience's sake, I will continue to refer to them as postures. (The oldest illustrated copy, in the Chester Beatty collection, is finely done, while the later manuscripts exhibit a much simpler style; see fig. 5).

Close study of half a dozen manuscripts of the fourth chapter of *The Ocean of Life*, where the illustrations are found, calls for some new observations.[14] There are major verbal discrepancies and even lacunae in the manuscripts; an entire folio is missing from the Chester Beatty manuscript after folio 22.[15] This gap has obscured the fact that the text actually describes twenty-two postures, not the twenty-one that were announced, suggesting the possibility that there may have been another illustration (for the *bodhak* position, whose description is likewise missing). Beyond that, there are wide variations in the names of these practices among the manuscripts (which is all too predictable in scribal transcriptions of difficult technical terms). Even where discrepancies can occasionally be clarified by terms spelled in Devanagari script (as found in India Office, Ethé 2002), the names of positions in *The Ocean of Life* often differ significantly from the names of the same yogic postures found in later Sanskrit texts on hatha yoga, and the descriptions in Persian frequently provide details that are otherwise unavailable. In other words, the text of *The Ocean of Life* provides a valuable historical documentation on yogic practices and terminology that is an important supplement to the Sanskrit tradition.

The last major Persian sources to be considered for documenting the practice and depiction of yoga were not written by Muslim authors, but by Hindu *munshi*s (secretaries) working in the administration of the Mughal Empire, and later for the British. Deeply immersed in the Islamicate and Persianate culture of the time, these Hindu scholars contributed to the gazetteer literature modeled on the *A'in-i Akbari* by the Mughal minister Abu'l Fazl, providing not only revenue statistics for the empire's provinces, but also information about the customs and beliefs of Indian religious groups. From the mid-eighteenth century to roughly 1830, when Persian was the language of colonial administration, British officials commissioned a considerable number of Hindu scholars to write Persian treatises on the religions of India. Several of these Anglo-Persian compositions included depictions of

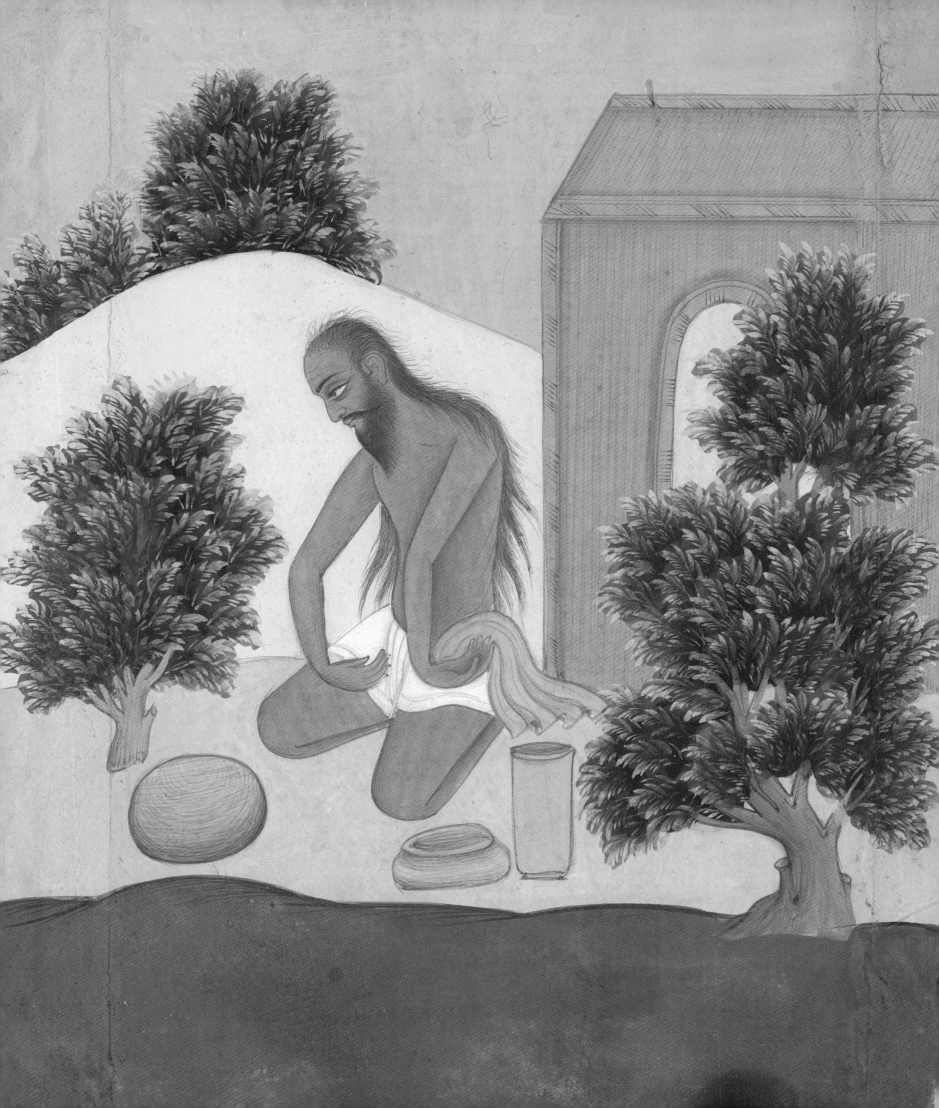

yogis and ascetics in the Company style, providing a sort of field guide to the identification of these groups. Two notable examples are *The Chain of Yogis* (*Silsila-i jugiyan*), composed by Sital Singh in 1800, and *The Gardens of Religions* (*Riyaz al-mazahib*), written by a Brahmin named Mathuranath and commissioned by John Glyn in 1812 as a guide to the religions of Varanasi. The history and character of the portrayals of yogis have yet to be fully explored, but it is safe to say that these late Persian texts connected Mughal understandings of Indian religions to the colonial religious categories enacted by the census, the courts, and Orientalist scholarship.[16]

The long history of Muslim interest in the philosophy and practice of yoga is a helpful corrective to the blinders that we often bring to the understanding of religion today, which is frequently defined in purely scriptural terms without reference to history and sociology. Current ideological oppositions between Islam and Hinduism, which are strongly underpinned by nationalist agendas, leave no room for understanding the intercultural engagements that have taken place across religious lines over the centuries. The transmission of yoga—in Arabic, Persian, Turkish, and Urdu translations and through images—is an important reminder that the history of Indian religions needs to take account of a wide range of sources, including those Muslim interpreters who were so fascinated by yoga.

Notes

1. Bruce B. Lawrence, "Bīrūni, Abū Rayḥān, viii, Indology," *Encyclopaedia Iranica* 4 (1990), pp. 285–87; www.iranicaonline.org/articles/biruni-abu-rayhan-viii.

2. Carl W. Ernst, "Muslim Studies of Hinduism? A Reconsideration of Persian and Arabic Translations from Sanskrit," *Iranian Studies* 36 (2003), pp. 173–95. All my articles cited here are available online at www.unc.edu/~cernst/articles.htm. For further documentation of Persian literature on India, see the Perso-Indica project, http://perso-indica.net.

3. Carl W. Ernst, "Accounts of Yogis in Arabic and Persian Historical and Travel Texts," *Jerusalem Studies in Arabic and Islam* 33 (2008), pp. 409–26.

4. Carl W. Ernst, "The Limits of Universalism in Islamic Thought: The Case of Indian Religions," *Muslim World* 101 (January 2011), pp. 1–19. A notable example is a Persian treatise on Vedanta attributed to the poet Fayzi, *The Illuminator of Gnosis*, which links Greek and Indian wisdom to explain Krishna as the manifestation of the divine reality. See Carl W. Ernst, "Fayzi's Illuminationist Interpretation of Vedanta: The *Shariq al-Maʿrifa*," *Comparative Studies of South Asia, Africa and the Middle East* 30, no. 3 (2010), pp. 156–64.

5. See Wendy Doniger O'Flaherty, *Dreams, Illusion and Other Realities* (Chicago: University of Chicago Press, 1984), and my review of the latter in *Journal of Asian and African Studies* 20 (1985), pp. 252–54.

6. Ahmet T. Karamustafa, *Sufism: The Formative Period* (Berkeley: University of California Press, 2007); Carl W. Ernst, "Situating Sufism and Yoga," *Journal of the Royal Asiatic Society*, 3rd ser., vol. 15, no. 1 (2005), pp. 15–43.

7. Carl W. Ernst, "Two Versions of a Persian Text on Yoga and Cosmology, Attributed to Shaykh Muʿin al-Din Chishti," *Elixir* 2 (2006), pp. 69–76, 124–25; rev. ed. by Scott Kugle, in *Sufi Meditation and Contemplation: Timeless Wisdom from Mughal India* (New Lebanon, NY: Suluk Press/Omega Publications, 2012), pp. 167–92.

8. Kazuyo Sasaki, "Yogico-tantric Traditions in the *Hawd al-Hayat*," *Journal of the Japanese Association for South Asian Studies* 17 (2005), pp. 135–56. Sasaki's reading of this title is more convincing than my earlier suggestion, *Kamrubijaksa* or *The Kamarupa Seed Syllables*.

9. Carl W. Ernst, "A Fourteenth-Century Persian Account of Breath Control and Meditation," in *Yoga in Practice*, ed. David Gordon White, Princeton Readings in Religions (Princeton: Princeton University Press, 2011), pp. 133–39.

10. Carl W. Ernst, "Being Careful with the Goddess: Yoginis in Persian and Arabic Texts," in *Performing Ecstasy: The Poetics and Politics of Religion in India*, ed. Pallabi Chakrabarty and Scott Kugle (Delhi: Manohar, 2009), pp. 189–203.

11. Carl W. Ernst, "Fragmentary Versions of the Apocryphal 'Hymn of the Pearl' in Arabic, Turkish, Persian, and Urdu," *Jerusalem Studies in Arabic and Islam* 32 (2006), pp. 144–88; and "The Islamization of Yoga in the Amrtakunda Translations," *Journal of the Royal Asiatic Society*, 3rd ser., vol. 13, no. 2 (2003), pp. 199–226. None of the Arabic manuscripts is older than the seventeenth century. This work is framed by a complicated narrative about yogis who convert to Islam and introduce Muslim scholars to the *Amrtakunda*, followed by an excerpt from an ancient Gnostic text and a passage from the Illuminationist philosopher Suhrawardi. These texts introduce the practices of yoga, which are recounted in ten successive chapters, including descriptions of yogic postures, control of subtle physiology, the macrocosm and the microcosm, mantras, predicting the time of death, and meditations involving chakras and yoginis. In all likelihood, the author was a sixteenth-century intellectual who drew upon Persian philosophical teachings to explain the religions of India; there is also evidence that he was familiar with the earlier Persian *Kamaru pancasika*, which is mentioned by name in the preface of the best and oldest manuscript of the Arabic text (Paris Ar. 1699). His interpretive strategy was to "translate" yogic references into Islamic equivalents, either by equating mantras with the Arabic names of God or by identifying yogis and deities with the prophets of Islam.

12. Carl W. Ernst, "Sufism and Yoga according to Muhammad Ghawth," *Sufi* 29 (spring 1996), pp. 9–13; Nazir Ahmad, "The Earliest Known Persian Work on Hindu Philosophy and Hindu Religion," in *Islamic Heritage in South Asian Subcontinent*, vol. 1, ed. Nazir Ahmad and I. H. Siddiqui (Jaipur: Publication Scheme, 1998), pp. 1–18.

13. The oldest of the illustrated copies is the Chester Beatty manuscript described elsewhere in this volume. Three other copies, which clearly follow the same illustration program, are found in (1) the University of North Carolina at Chapel Hill, Rare Book Collection (dated 1718); (2) the Salar Jung Museum, Hyderabad (Madhahib Farsi 1, dated 1815); and (3) reportedly in the collection of the late Simon Digby.

14. The manuscripts I have consulted, in addition to the Chester Beatty copy, are India Office, Ethé 2002; Ganj Bakhsh 6298, Islamabad; Liyaqat Memorial Library 46, Karachi; British Library Or. 12188; and India Office, Ashburner 197.

15. Confirming the suggestion of Sir Thomas Walker Arnold and J. V. S. Wilkinson, *The Library of A. Chester Beatty, A Catalogue of the Indian Miniatures*, vol. 1 ([London]: Oxford University Press, 1936), p. 82.

16. Carl W. Ernst, "Anglo-Persian Taxonomies of Indian Religions," keynote address at conference on "Indian Pluralism and Warren Hastings's Orientalist Regime," Tregynon, Wales, July 18–20, 2012.

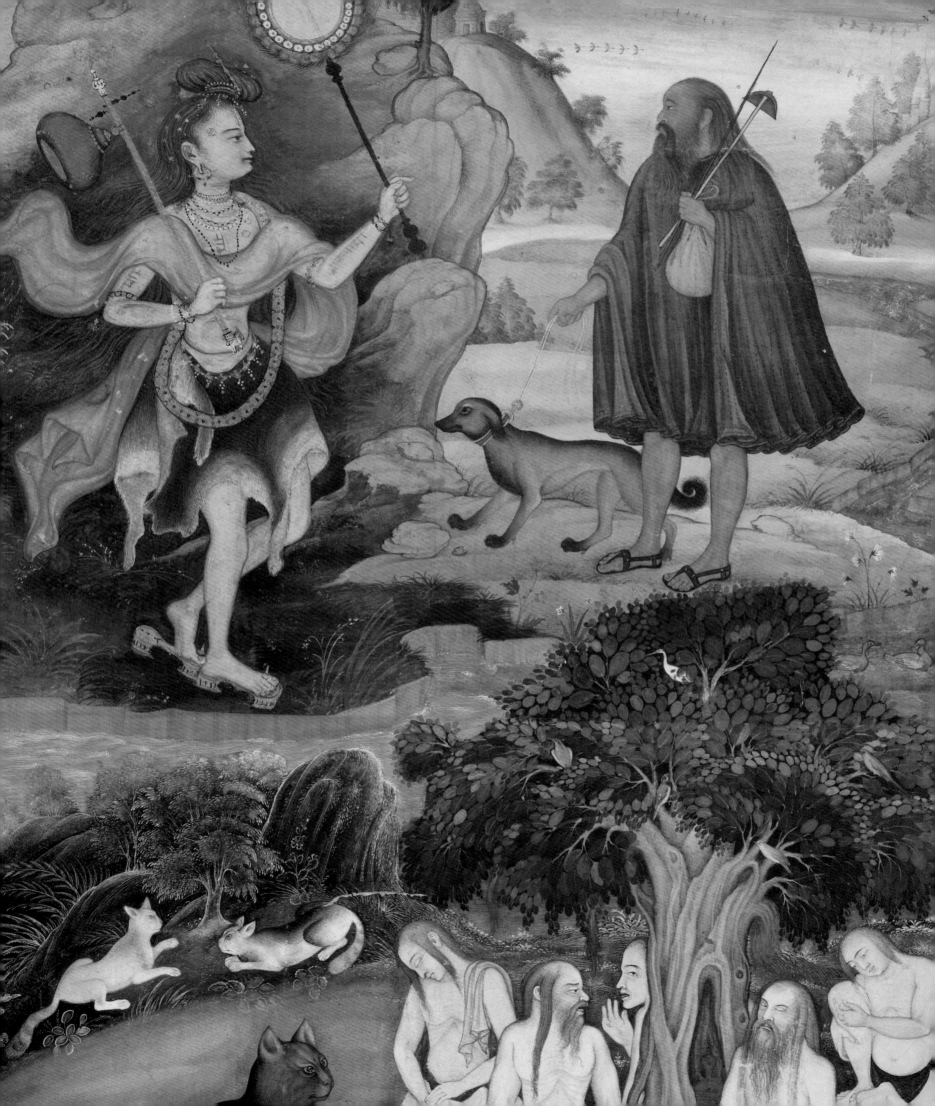

James Mallinson

Yogis in Mughal India

Artists in the ateliers of the Mughal emperors (reigned 1556–1857) produced a wealth of paintings of yogis,[1] drawing their subjects from life or from memory after observing them firsthand. Some were created to depict historical events or specific sites; others became archetypes that circulated over decades in genre scenes and illustrated literary texts, in particular epic romances.[2] Sixteenth- and seventeenth-century Mughal paintings of yogis have enormous value as historical documents. The consistency of their depictions and the astonishing detail they reveal allow us to flesh out—and sometimes rewrite—the incomplete and partisan history of yogis that can be surmised from texts, travelers' reports, hagiography, and ethnography.[3]

The paintings confirm two contrasting features of premodern Indian asceticism suggested by other sources. First, a variety of traditions shared an ascetic archetype and freely exchanged doctrines and practices. Second, increasing sectarianism came to accentuate the differences between the yogi lineages, gradually giving rise to the clearly demarcated ascetic orders of today.

The Ascetic Archetype

Early Mughal paintings bear witness to an ascetic archetype (see cat. 2a) whose elements are attested in sources from the first millennium BCE. Yogis have long matted hair and beards, are naked or nearly so, and smear their bodies with ashes.[4] In addition, Mughal-era yogis display more recent traits and practices: they wear hooped earrings,[5] sit around smoldering fires,[6] and drink suspensions of cannabis.[7]

Both types appear on an early seventeenth-century folio from the Gulshan Album: archetypal ascetics are represented in the lower landscape; the two figures at the top share their basic attributes but are covered with sectarian markers (fig. 1, cat. 19a). The sharing of attributes by what are, as we shall see below, different yogi traditions is paralleled by the lack of emphasis on sectarianism in the texts of the early hatha yoga corpus. A thirteenth-century text, the earliest to teach a yoga explicitly called hatha, declares: "Whether a Brahmin, an ascetic, a Buddhist, a Jain, a Skull-Bearer or a materialist, the wise one who is endowed with faith and constantly devoted to the practice of [hatha] yoga will attain complete success."[8]

Fig. 1
Folio 6b from the Gulshan Album (detail). India, Mughal dynasty, early 17th century. Staatsbibliothek, Berlin

The Two Traditions of Yoga

A close reading of the corpus of Sanskrit texts that taught hatha yoga in its formative period (approximately the eleventh to the fifteenth century) shows that it consisted of a variety of ancient physical techniques aimed at achieving liberation by controlling the breath, mind, and semen. Overlaid onto those techniques were more recently developed Tantric visualizations of the ascent of Kundalini up the body's central column through a series of chakras.[9] This blend of yogic methods became widely accepted as the essence of yoga, but the heirs of the two traditions, even though they both practiced the hybrid hatha yoga, remained distinct. The ancient tradition—whose yoga practice was linked to long-attested ascetic techniques of bodily mortification, such as holding both arms in the air for years on end—was represented by forerunners of the two biggest Indian ascetic orders today, the Dasnami Sannyasis and Ramanandis, while the Tantric tradition was, and is, represented by the Nath Yogis.[10]

Nath Yogis

The development of hatha yoga is closely associated with the master yogi Gorakhnath,[11] who probably lived in South India in the eleventh or twelfth century.[12] Nath hagiography has Gorakhnath establishing the Nath order, but external historical sources provide no evidence that the order's twelve subdivisions—many of which trace their origins to other yogi gurus—were conceived of as a single entity before the sixteenth century. The same sources suggest that Gorakhnath's hegemony over these disparate lineages was not established until perhaps the eighteenth century.

The Naths of the Mughal era were closely linked with the Sant tradition of holy men and, like many of them, believed in a formless, unconditioned Absolute.[13] This theological openness, which manifested in, among other things, a disdain for the purity laws adhered to by more orthodox Hindu ascetics, allowed them to mix more freely with *mlecchas*, "barbarians," such as the Muslim Mughals. Furthermore, the Naths were not militarized,[14] unlike certain subdivisions of the Sannyasi yogi tradition, whose belligerence would have proved an impediment to interaction with the Mughals. The Naths' greater influence on Sufism and the Mughal court is borne out by the predominance of Naths in Mughal depictions of ascetics[15] and the foregrounding of their doctrines in Persian yoga texts produced during the Mughal period.[16]

Naths appear in two illustrations from a circa 1590 manuscript of a *Baburnama* (figs. 2 and 3) in the British Library. These depict a visit made in 1519 by the future Emperor Babur (reigned 1526–30) to a monastery at Gurkhattri in modern-day Peshawar, Pakistan. The illustrated manuscript was commissioned by Babur's grandson, Emperor Akbar (reigned 1556–1605), who visited Gurkhattri twice in 1581,[17] so the illustrations are likely to depict the monastery and its inhabitants at that later date.[18] Until the 1947 partition of India, Gurkhattri was an important center of the Nath ascetic order, and there is still a Gorakhnath temple there today. While many such shrines have changed hands over time, and Babur's text calls the monastery's inhabitants *jogi*(s)[19]—a vernacular form of the Sanskrit *yogi* that could refer to any ascetic—the illustrations suggest that the site was in the hands of Naths during Akbar's time. Almost all of the ascetics in the illustrations wear horns on threads around their necks (see, for example, fig. 3, specifically, the yogi wearing a *yogapatta* or meditation band around his legs on the left). The single most reliable indicator of membership in today's Nath order is the wearing of such horns,[20] which Naths now call *nad*s but were formerly known as *singi*s, and, as the following evidence suggests, this appears also to have been the case in the medieval period. Yogis wearing horns are identified as Nath gurus in inscriptions on several seventeenth-century Mughal paintings.[21] In medieval Hindi literature, *singi*s are frequently mentioned among the accoutrements of yogis, and often those yogis are identified as followers of Gorakhnath.[22] In keeping with their lack of sectarianism,

Fig. 2 (left)
The Yogis at Gurkhattri in 1505, from *Vaki'at-i Baburi* (The Memoirs of Babur). By Gobind. India. Mughal dynasty, 1590–93. British Library

Fig. 3 (right)
Babur's Visit to Gurkhattri in 1519. By Kesu Khurd. India, Mughal dynasty, 1590–93. British Library

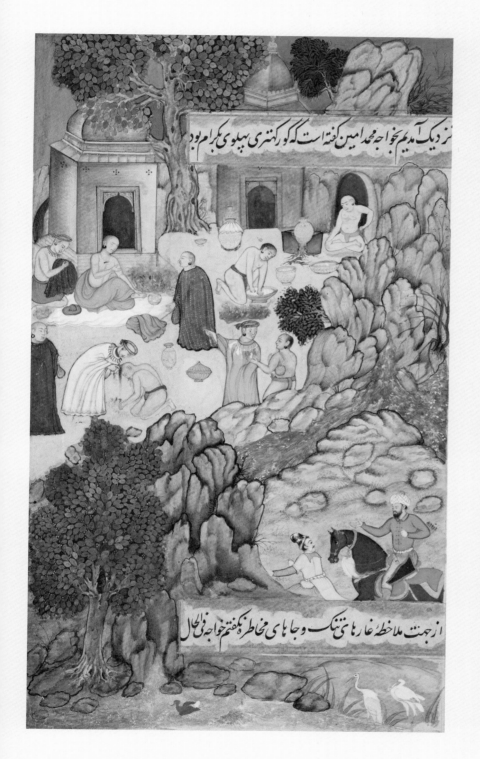

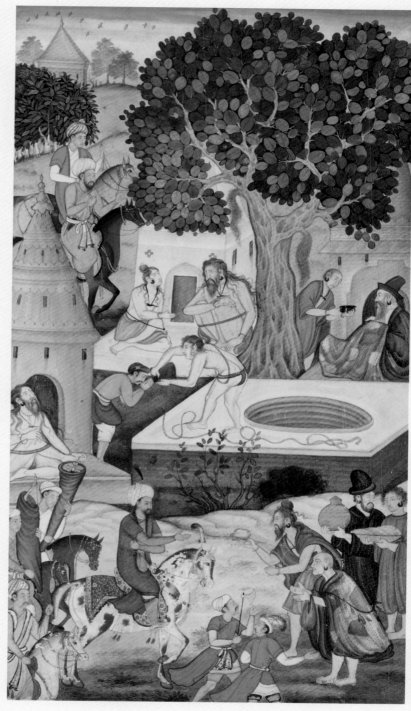

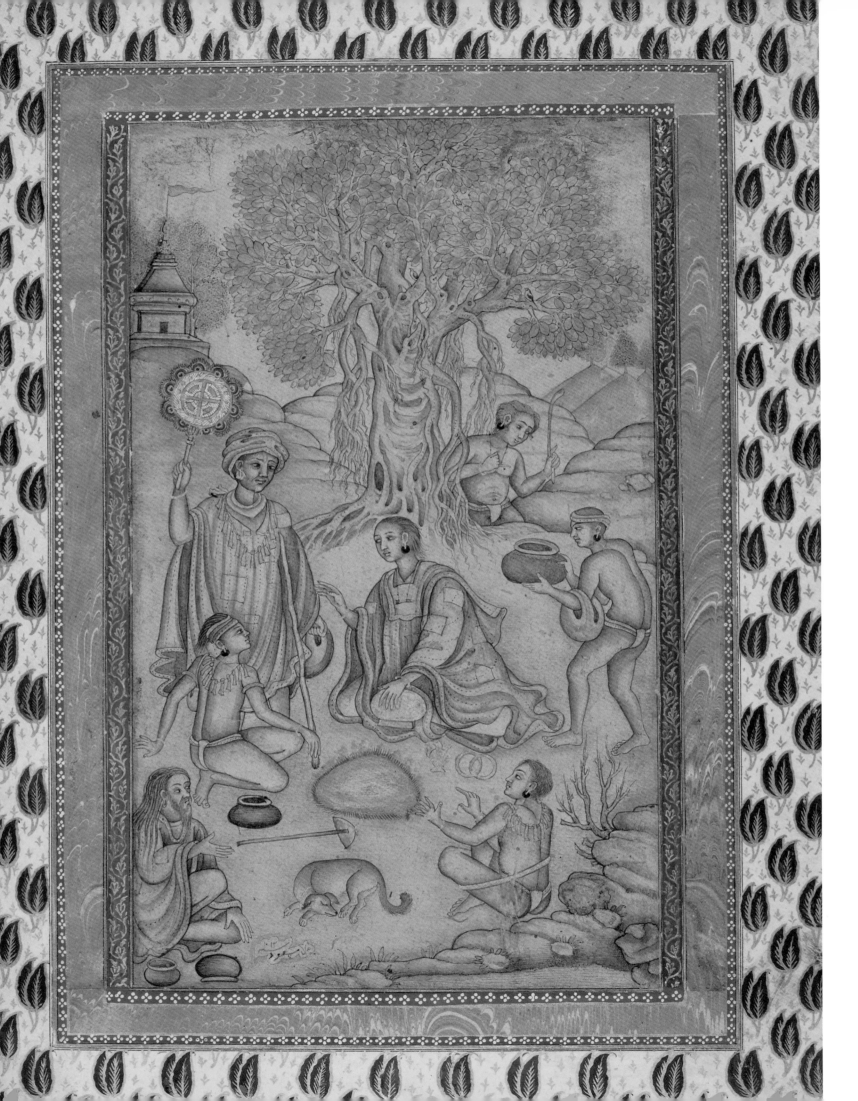

Sanskrit texts on hatha yoga, even those associated with Gorakhnath, make few mentions of sect-specific insignia, and none of *singi*s, but other Sanskrit sources do associate yogi followers of Gorakhnath with the wearing of horns. An early sixteenth-century South Indian Sanskrit drama describes a Kapalika or "Skull Bearer" ascetic as uttering "Goraksha, Goraksha" and blowing a horn,[23] and a Sanskrit narrative from Bengal dated to no later than the second half of the sixteenth century[24] describes the yogi Chandranatha as being awoken from his meditation by other yogis blowing their horns.[25] From the fourteenth to the sixteenth century, travelers to the regions in which the earliest references to Gorakhnath are found[26] often reported the use of horns by yogis.[27]

A Jesuit account allows us to identify the necklace and fillet (headband) worn by three of the ascetics in the British Library *Baburnama* folio (fig. 2) as an attribute of Nath yogis during this period.[28] At the end of the sixteenth century, the Jesuit traveler Monserrate visited Balnath Tilla, a famous Nath shrine in the Jhelum district of Pakistani Punjab, which was the headquarters of the order until the partition of India.[29] Describing the Tilla's monastic inhabitants, Monserrate noted, "The mark of [the] leader's rank is a fillet; round this are loosely wrapped bands of silk, which hang down and move to and fro. There are three or four of these bands."[30] This description seems to conflate two items of apparel often depicted in Mughal paintings of yogis: a simple fillet worn around the head and a necklace, from which hang colored strips of cloth (Monserrate's silk bands).[31]

These indicators of membership of the Nath order—horns, fillets, and necklaces—enable ascetics in a large number of early Mughal paintings—including those in a lightly colored drawing of yogis gathered beneath a banyan tree (fig. 4)—to be identified as Naths.[32] They also make it possible to identify a number of other Nath attributes, which are not found in representations of other ascetics of the period. These include the wearing of cloaks and hats, the accompaniment of dogs, and the use of small shovels for moving ash.

By identifying Nath yogis in Mughal paintings, we may correct mistaken ideas about Nath identity and history. The Naths have been said by some historians to be the first Hindu ascetic order to develop a militarized wing. Yet, corroborating a historical record in which Naths are never named as combatants in the many ascetic battles reported between the sixteenth and eighteenth centuries,[33] no depictions of Naths (Mughal or later) show them fighting or bearing weapons.[34] In contrast, the Dasnami Sannyasis are portrayed armed and fighting bloody battles from the sixteenth century onward (fig. 9).

By now the reader acquainted with the Naths will perhaps have wondered why little mention has been made of their earrings. Today's Naths are known for wearing hooped earrings through the cartilages of their ears, which are cut open with a dagger at the time of initiation (fig. 5). This practice has earned the Naths the name *kanphata*, "split-eared," a name they themselves eschew.[35] Historians of yogis have accepted uncritically the Naths' assertion that the practice originated with Gorakhnath in the twelfth century. The pictorial record tells a different story: it was not until the beginning of the nineteenth century that Naths were depicted wearing their earrings *kanphata*-style. In earlier representations, their earrings were worn through their earlobes. Furthermore, in the Mughal era, this practice was not restricted to Nath Yogis: other ascetics, such as the Sannyasis fighting in figure 9, were also depicted with hooped earrings in their earlobes.

The adoption of *kanphata*-style earrings sometime around 1800 appears to have been associated with Gorakhnath becoming the titular head of the order and is always associated with him

Fig. 4
A Party of Kanphat Yogis Resting around a Fire. India, Mughal dynasty, ca. 1700. British Library, India Office

Fig. 5
Balak Nath Kothari wearing antelope horn *kanphata* earring. Jvalamukhi, November 8, 2012

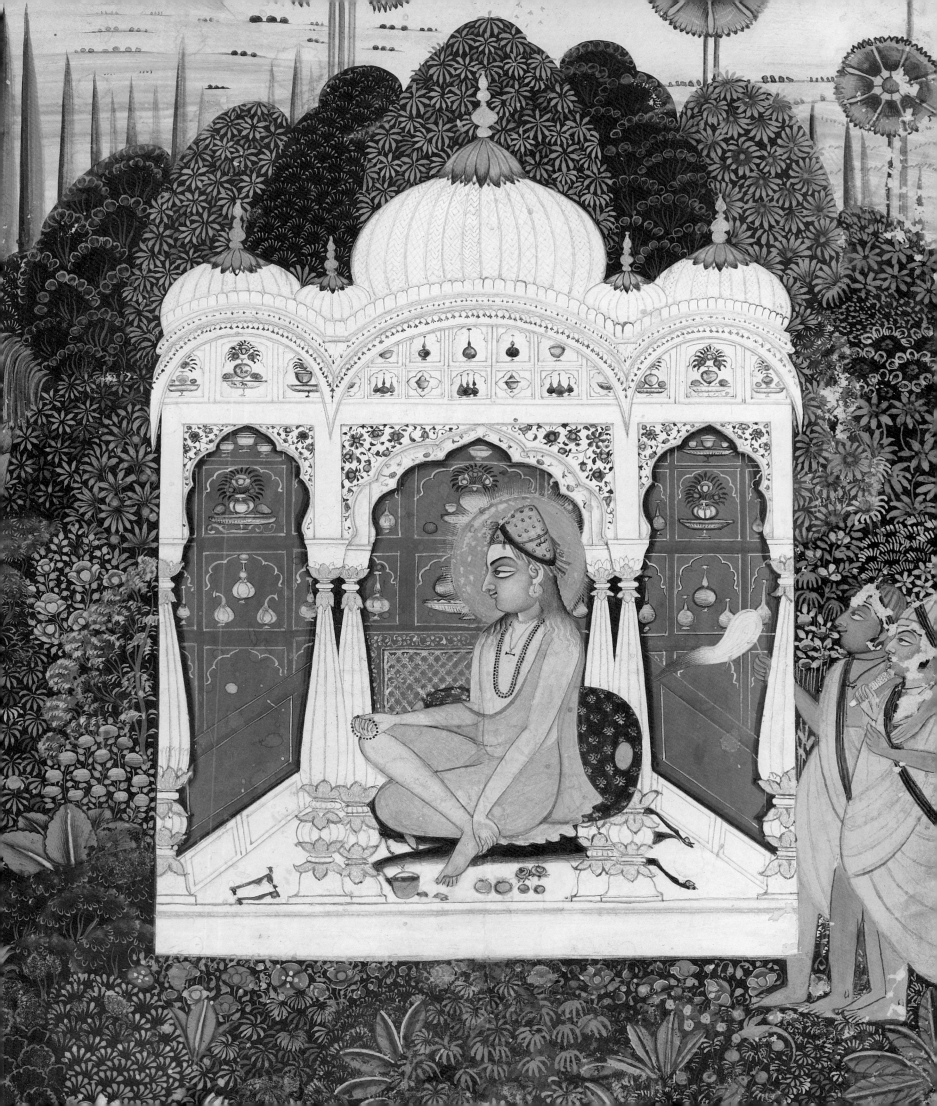

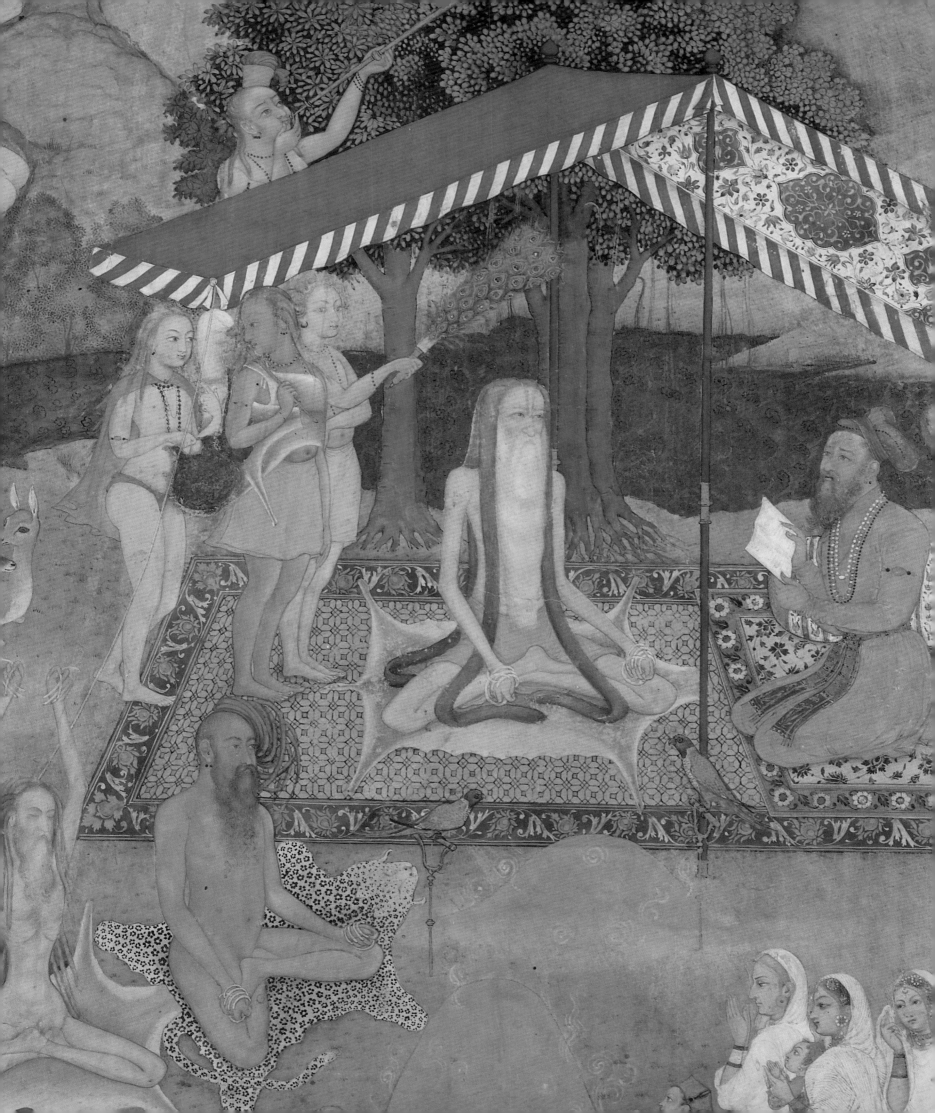

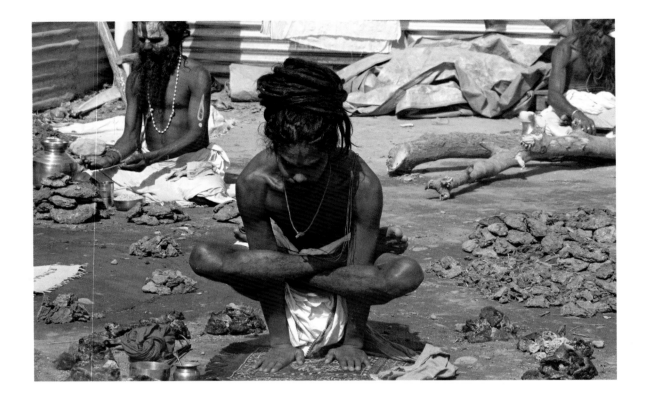

the ancient tradition of renunciation (*sannyasa*). During the seventeenth and eighteenth centuries, the generic name for a renouncer, Sannyasi, became associated with this particular formalized order. When the Ramanandis seceded from the order, in the course of their adoption of ultra-Vaishnavism, their ascetics differentiated themselves from the Sannyasis by calling themselves Tyagis, which is an exact Sanskrit synonym of Sannyasi. In a similar fashion, as a Nath corporate identity solidified in the eighteenth century, the name *yogi* came to be associated exclusively with the Naths and was shunned by the Sannyasis and Ramanandis.

Mughal Painting: Windows onto the History of Yoga and Yogis

There has long been confusion over the identity of the yogis depicted in Mughal paintings. This has resulted from a lack of understanding of the complex and constantly changing makeup of yogi sects in the early modern period, and the concomitant absence of terminological rigor in both Indian and foreign descriptions of yogis from the Mughal period to the present day. Yet a close reading of these pictures together with other historical sources allows us to identify the sectarian affiliations of the yogis depicted, and thereby to cast new light on their history and the nature of the yoga they practiced. The pictures' naturalism and the associated consistency of their depictions mean that seemingly trivial details, such as the position of an earring, are of great significance.

Mughal paintings provide evidence for—and have inspired—many new ways of looking at Indian yogis and their history. Doubtless some of the theories proposed in this essay will be rejected or refined in the light of further research, whether textual, ethnographic, or art historical, but the details shown in these beautiful images, hitherto overlooked in histories of yoga and yogis, need to be addressed by historians. They bear testament to the fluidity of India's religious landscape and the transformations undergone by her yogis as they adapted to the changes around them.

An expanded and more extensively referenced version of this essay, with more illustrations, can be found online at www.asia.si.edu/research.

Joseph S. Alter

Yoga, Bodybuilding, and Wrestling: Metaphysical Fitness

Despite the cognitive dissonance produced by the visual contrast between yoga, bodybuilding, and martial arts, these seemingly disparate domains of practice are intimately linked on a number of different levels. The invention of postural yoga in late nineteenth- and early twentieth-century India[1] is directly linked to the reinvention of sport in the context of colonial modernity and also to the increasing use of physical fitness in schools, gymnasiums, clinics, and public institutions.[2]

Prior to the early nineteenth century, yoga was understood as a practice that focused on the acquisition of power, which involved the manipulation of supernatural and natural elements, both physical and ecological, gross and subtle.[3] As such, metaphysical mysticism and meditation, while important, were always grounded in the more encompassing and complicated problem of materialism. Given that yoga is now conceptualized in terms of balanced holistic health, spirituality, and esoteric mysticism, it is important to appreciate the extent to which a range of premodern and early modern practices were focused on radical embodied ideals of physical and metaphysical self-transformation.

This essay is divided into three sections. After briefly highlighting the structure of early modern ideals and how they reflect an understanding of the body, perception, and nature in relation to physiology, sexuality, and power, I will provide a broad contextualization of modern practice through an examination of the role played by three key figures: Swami Kuvalayananda, Sri Yogendra, and (to a lesser extent) Sri Krishnamacharya. It is directly in relation to these early twentieth-century figures—and a number of others who transformed yoga into a system of Indian physical fitness and self-development—that we can understand how and why athleticism, sport, and yoga came together in modern life. This practice is exemplified by Dr. Shanti Prakash Atreya, philosopher of yoga and mid-century Uttar Pradesh wrestling champion, and Bishnu Charan Ghosh, bodybuilder and Bengali innovator of muscular yoga. Atreya was the son of a professor of Sanskrit at Banaras Hindu University, the institution from which he earned a PhD. Ghosh was the younger brother of Paramahansa Yogananda (1893–1952; fig. 2), whose iconic *Autobiography of a Yogi* (1946) has come to define what many people in the West want to see when they look past the body toward a mystical, otherworldly India. In essence, my argument is that the science of medical physiology and physical education did for the body subject to colonialism and nationalism what alchemy did for bodies animated by the biopolitics of medieval kings, councilors, and world renouncers. Atreya in particular conceptualized the physical power he embodied as a champion Indian wrestler in terms of the material essence of *ojas* (supernatural vitality) and semen, thus

Fig. 1
Five athletes, symbolizing a musical mode (Deshakha raga). India, ca. 1880–1900. Asian Art Museum of San Francisco

inverting and internalizing—in yogic terms—the externalized logic of bodybuilding and muscle control exemplified in *asana* performances.

Because of the canonical status of Patanjali's *Yoga Sutras* and the *Bhagavad Gita*, and because of the way in which yoga involves, but seems to disarticulate, physical discipline and metaphysical speculation, yoga has come to mean a phenomenal range of different things to different individuals and groups. As David Gordon White has shown, the history of yoga is often a history of misinterpretation and the morphing of highly malleable meanings.[4] The way in which Patanjali's somewhat arcane second-century aphorisms leave room for endless, almost unrestricted translation and interpretation helps to explain why yoga has such varied meanings in the public culture of modernity. Significantly, this is very different from understanding the history of ideas and practices that are linked to interpretations of philosophical commentaries on the *Yoga Sutras*, which provide a much clearer and more coherent—if less "popular"—perspective on systematic and logical intellectual transformations and metaphysical developments in practice.[5]

A key point that seems to have been lost in translation, but that helps to explain a number of otherwise incomprehensible details in modern and early modern practice, is what White refers to as yogic perception.[6] As the first commentary on the *Sutras* makes clear, and as other commentaries

Fig. 2
Paramahansa
Yogananda,
founder of the
Self-Realization
Fellowship

would clarify over the course of a millennium, yogic perception is metaphysical in that the senses—sight in particular—change the nature of reality, effecting a synthesis of the process in the material structure of consciousness rather than reproducing a cognitive representation of the world as it appears to be. Yoga is concerned with the material embodiment of a perceptual change in the nature of reality—not a change *of* perception but a change *in* perception. Perception is both means and end, and the body is both the medium and the message. What appears to be magic in the *Yoga Sutras*, and what appears to be the erotic alchemy of sexual transubstantiation in medieval literature is, quite literally, *the* physical and metaphysical matter of perception rather than *a* matter of mental perception.[7]

In this sense, the physical nature of yoga encompasses more than postures and breathing exercises, since mind and thought derive from the same material substance as the rest of the body. Yoga entails practice, which is inherently embodied. In these terms, textual representations of yoga are removed from practice, similar to what occurs when the "love of wisdom" in representations of classical Greek philosophy is extracted from the intimacy of the gymnasium. Yoga is, in essence, what yogis do; and what they were doing, according to texts from the early modern period, was using the material nature of their bodies to exercise various forms of authority in relation to people's perception of power.[8] These included yogis embodying alchemical transubstantiation to change the nature of time; changing the nature of their bodies to change the dynamics of space; entering into other people's bodies to change their perception of reality; and using their own bodies—and people's fear of their down-to-earth supernatural power—to fight as mercenaries to secure gold, silver, and land.[9]

As documented in accounts of practice, early modern yogis were often viewed as sinister characters whose fearsome power was manifest in their ability to weave their own images in the illusion of reality—and weave the illusion of reality into their own images—and convince people that they should be perceived as powerful.[10] In this light, late medieval hatha yoga texts explain how the physical manipulation of the body comes into the play of power. The texts provide a way to understand metaphysical fitness as *the* matter of perception rather than to misperceive what they say about magic and

Mark Singleton

Globalized Modern Yoga

For the first several thousand years of its development, yoga was largely confined to South Asia, i.e., the geographical region corresponding to the modern nation states of India, Pakistan, Bangladesh, Sri Lanka, Nepal, Tibet, and Bhutan. Although there is evidence of exchanges of yogic knowledge and practice outside this region through the centuries, it is only in the modern period that yoga began to be transmitted in a systematic and widespread fashion in other parts of the world. By the beginning of the twenty-first century, yoga had become a truly global phenomenon, with yoga classes available in virtually every metropolis in the world—most prominently in North America, Europe, and Australasia, but also in Central and South America, the Middle East, Asia, and parts of Africa. Yoga is now a household word far from its place of origin, although in its modern forms and modalities it can be quite distinct from the South Asian forebears commonly invoked as their source and authority. There is a great deal of variety in the content and mode of yoga's global transmissions, and variation also in the claimed or actual links to Indian tradition. This article will consider some of the most important historical stages of this globalization process as well as several of the ways in which yoga has adapted and accommodated itself to the modern, transnational world.

The Modern Yoga Renaissance

The latter part of the nineteenth century saw a reconstruction of the cultural and religious foundations of Hinduism by certain sections of the Indian intelligentsia. This reworking of the basic concepts and principles of Indian religious tradition—a result of the encounter with new ideas and concepts from the West—is sometimes referred to as "neo-Hinduism."[1] The Bengali cultural association known as the Brahmo Samaj, founded in 1828 by Rammohan Roy (1774–1833), repositioned Hinduism as a universalist, rational faith that could synthesize ancient Indian religious culture with the insights of contemporary science, philosophy, and comparative religion. Roy propounded an earthly, utilitarian religion and was fascinated by the teachings of Christianity, in particular the tenets of Unitarianism (he helped establish the Unitarian Mission in Bengal in 1821). He was also influential in spreading "Hindu" ideas abroad, including to Emersonian transcendentalists in the United States. It was out of such revisionist enterprises that certain modern, transnational yoga forms took shape.[2]

Fig. 1
Yoga on the National
Mall, Washington, DC,
May 2013

Keshubchandra Sen (1838–1884), who joined the Brahmo Samaj in 1857, was instrumental in furthering the dialogue between neo-Hinduism, Western esoteric and occultist culture, Unitarianism, and American transcendentalism. He also propounded new ways of thinking about yoga.[3] Speaking in 1881, Sen declared,

> We Hindus are specially endowed with, and distinguished for, the yoga faculty, which is nothing but this power of spiritual communion and absorption [...] Waving the magic wand of yoga ... we command Europe to enter into the heart of Asia, and Asia to enter into the mind of Europe, and they obey us, and we instantly realize within ourselves a European Asia and an Asiatic Europe, a commingling of oriental and occidental ideas and principles.[4]

In many respects, Sen's explicitly synthetic conception of yoga as a melding of Asia and Europe predicted yoga's later development and laid the foundations for the influential experiments undertaken subsequently by another Brahmo member, Swami Vivekananda (born Narendranath Datta, 1863–1902).

In 1893, Vivekananda visited the Parliament of the World's Religions in Chicago and was an instant success (see fig. 2 and cats. 24a–h).[5] He was adopted by the esoteric avant-garde of East Coast America and subsequently authored a number of books influenced by this audience and written with them in mind. He became "the first teacher of yoga in the West."[6] His *Raja Yoga* (1896) is one of the most important foundational documents in the history of modern, transnational yoga. It is in part a translation of the *ashtanga* (eight-limb) yoga section of Patanjali's *Yoga Sutras*,[7] and in part an elaboration of practical yoga techniques. De Michelis has argued that Vivekananda's teachings in *Raja Yoga* and elsewhere were strongly influenced by the currents of Brahmo-style neo-Hinduism, and represent an amalgam of Western esotericism, modern European philosophy, and "classical" yoga.[8] Vivekananda was also greatly influenced by the teachings of the now famous Bengali saint, Sri Ramakrishna, who was his guru. Vivekananda's work was to form a blueprint for many of the global experiments in yoga that followed.

Fig. 2
Swami Vivekananda
on the platform of
the Parliament of the
World's Religions,
September 11, 1893.
Vedanta Society, V16

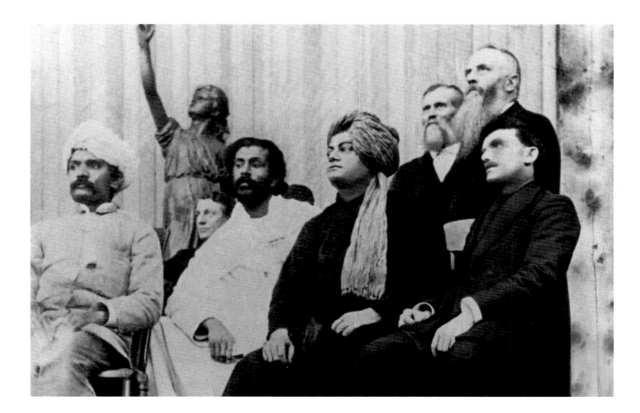

Also vital to the modern, global transformation of yoga was the Theosophical Society, an esoteric spiritual organization founded in 1875 by Helena Petrovna Blavatsky (1831–1891; fig. 3) and Colonel Henry Steel Olcott (1832–1907).[9] Theosophical constructions of yoga were far-reaching, and the society's literary output immense. It is not without considerable reason that Blavatsky could claim in 1881 that "neither modern Europe nor America had so much as heard" of yoga "until the Theosophists began to speak and write."[10] Theosophical yoga author Rama Prasad, in a 1907 Theosophical edition of the *Yoga Sutras*, even went so far as to claim that whatever knowledge Hindus within the society possessed was "due to their contact with and the influence of Western brothers."[11] The society's profoundly influential interpretations of yoga did much to disseminate a Western esoteric understanding of the discipline's theory and practice. It also republished the earliest book-length study of yoga as medicine, by N. C. Paul, thus contributing another significant strand to the development of modern understandings of yoga's function and goals.[12]

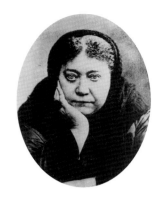

Fig. 3
Madame Blavatsky,
1870

Other immensely influential figures in the global transmission of yoga include: Swami Sivananda (1887–1963), who borrowed significantly from Vivekananda's model of yoga and whose Divine Life Society produced many pamphlets and books that were distributed around the world[13]; Paramahansa Yogananda (1893–1952; fig. 4), who arrived in the United States in 1920 and went on to found the Self-Realization Fellowship and publish one of the most influential books on yoga ever written, the inspirational *Autobiography of a Yogi* (1946)[14]; and Sri Aurobindo Ghose (1872–1950) whose work has also had a profound effect on global conceptions of yoga.[15]

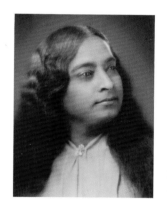

Fig. 4
Paramahansa
Yogananda,
founder of the
Self-Realization
Fellowship

New Thought, Globalized Metaphysics, and Perennialism

Vivekananda's emphasis on universalism, and his openness to popular spiritual currents of the day, made his yoga highly compatible with the heterogeneous array of beliefs and practices that flourished within and around the transcendentalism of Emerson and Thoreau, Mary Baker Eddy's Christian Science, and the hugely popular "Mind Cure" movement, better known as "New Thought." Elements of these popular esoteric doctrines were ubiquitous in practical yoga primers intended for the European and American reading public, and it seems to have been widely taken for granted that positive thinking, auto-suggestion, and the "harmonial," this-worldly belief framework of New Thought were not so much contributions to yoga as its full expression. Conversely, it was largely assumed that yoga was the perennial, exotic repository of these newly (re-)discovered truths. Transcendentalism, Christian Science, and New Thought enacted a popular revolution in personal religious belief. Many assumptions of what it means to practice yoga in the West today can be traced back to these beginnings. Perhaps the clearest example of this merger of popular Western spirituality and yoga is the slew of books Swami Ramacharaka authored between 1903 and about 1917. Ramacharaka was the pen name of prolific Chicago lawyer and New Thought guru William Walker Atkinson (1862–1932).[16]

Yoga has flourished globally within the framework of the "perennial philosophy," a theological position that asserts that, despite differences at the level of ritual, doctrine, and institutional reality, all religions are one at their mystical core. This belief—closely related to the "spiritual but not religious" commitments of Unitarianism, New Thought, and various Hindu revivalist movements—has a history with roots in the more distant past, but which began to predominate after the Second World War, with the publication of Aldous Huxley's *The Perennial Philosophy* in 1945 and Joseph Campbell's *The Hero with a Thousand Faces* in 1949. Huston Smith's *The World's Religions*, which first appeared in 1958 as *The Religions of Man*, also promoted a perennialist vision of religion.[17] Perennialism has enormous global currency today, and provides an underpinning belief system to many expressions of modern yoga, which exist in what Catherine Albanese describes as "an intercepted Asia, caught in complex thickets between separate Asian pasts, Westernized Asian presents, and American polysemous perceptions...."[18]

Yoga and Magic

The yogi was the object of an intense fascination for European occultists, who naturally emphasized the wondrous magical powers that such figures could acquire through yoga, often claiming personal experience and mastery of these techniques. Many early twentieth-century books on yoga emphasize magical powers and are full of fortune-tellers, sorcerers, and miracle workers. They appeal to an esoteric audience's thirst for stories about the yogic magicians of the mystical East, but are rarely reliable when it comes to information regarding the techniques and belief frameworks of traditional yogins. One of the most famous of these Western yoga magicians was Aleister Crowley (fig. 5), who was referred to in Ernest Hemingway's *A Moveable Feast* as "the wickedest man in the world."[19] Crowley's fascination with yoga and Tantra contributed to a generalized identification of them with magic, especially "sex magick."[20]

Yoga, Health, and Physical Culture

The popular postural component of globalized yoga practice, *asana*, tended to be absent from early formulations in the yoga renaissance. This may have been because of the connection between posture and the figure of the hatha yogin, who was often associated with backwardness, magic, and superstition. Hatha yoga in this mode was not in keeping with the modern, scientific, and respectable face of modern, transnational yoga, as presented by Vivekananda and others. The revival of postural yoga

Fig. 5
Aleister Crowley as
Paramahamsa Shivaji

forms from the 1920s and 1930s onward saw *asana* incorporated into the predominant discourse of physical culture, healthism, and "keep fit." In this model, the more esoteric or abstruse Tantric elements of hatha yoga were replaced by an interpretive framework borrowed from modern medicine, health science, body-building, and gymnastics. Innovators like Swami Kuvalayananda (1883–1966) and Sri Yogendra (1897–1989) established the world's first yoga institutes, dedicated to developing yoga as a health and fitness regimen on the one hand, and as a system of medicine on the other. Another influential teacher of the time, Sri T. Krishnamacharya (1888–1989; fig. 6), innovated similar rigorous, health- and healing-oriented modes of posture practice, varieties of which became immensely influential around the world through his famous disciples: B. K. S. Iyengar (born 1918), the eponymous founder of Iyengar Yoga (fig. 7); Sri K. Pattabhi Jois (1915–2009), who taught the dynamic "jumping" system known as Ashtanga Vinyasa; Indra Devi (1899–2002), a Latvian woman who helped to popularize yoga in America with the help of high-profile Hollywood students like Gloria Swanson, Greta Garbo, and Marilyn Monroe (fig. 10); and Krishnamacharya's son, T. K. V. Desikachar. It was due to the efforts of early innovators like Kuvalayananda, Yogendra, and Krishnamacharya that globalized yoga came to be associated so strongly with postural practice (see cats. 26a–26i).[21]

As yoga spread to the West, it interacted with traditions of "spiritual gymnastics" that arose in Europe and America during the nineteenth century, often developed by and for women. These forms of purposive exercise (i.e., exercise done for the sake of cultivating the body, in contrast to manual labor, etc.) used stretching and deep, "rhythmical" breathing to open up the body to divine influences. The theoretical basis for these practices (especially in America) often came from the same "unchurched," para-protestant, spiritual milieus that underpinned New Thought and Christian Science. In both Europe and America, women's exercise was increasingly associated with stretching, as opposed to the more masculine modalities of weight resistance, tumbling, and balancing. Many popular "hatha yoga" classes of the twenty-first-century urban West are in some sense a continuation of these women's gymnastic forms and their "spiritual" framework.[22]

Fig. 6
Sri T. Krishnamacharya
(1888–1989), Chennai,
India, 1988

Fig. 7
Indian yoga master
B. K. S. Iyengar
demonstrates four
postures, 1930s

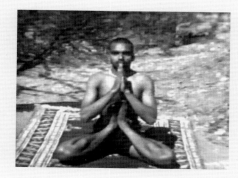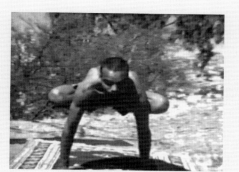

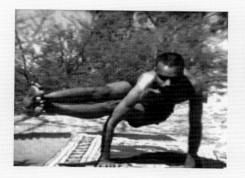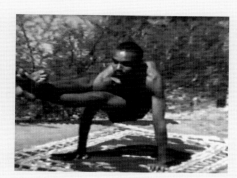

Fig. 8
Swami Muktananda
Arrives in Santa
Monica, California,
1980

Fig. 9
Peace Pilot
(Vishnudevananda),
Palam Airport, New
Delhi, India, October
26, 1971

The 1960s and Counterculture

In the 1960s, the rise of flower power brought yoga to the attention of a generation of young Americans and Europeans. The wholesale embrace of Indian metaphysics and yoga by many countercultural icons—such as the Beatles' spiritual romance with Maharishi Mahesh Yogi (fig. 11)—reinforced yoga's position in the popular psyche and inspired many to join the "hippy trail" to India in pursuit of alternative philosophies and lifestyles. Indian gurus arriving in America from 1965 onward brought a fresh infusion of "Eastern wisdom" into the American psyche. These included Swami Muktananda (1908–1982), founder of Siddha Yoga (fig. 8); A. C. Bhaktivedanta Swami (1896–1977), founder of the International Society for Krishna Consciousness, more commonly known as the Hare Krishna movement; Amrit Desai (born 1932), who in 1965 founded the Yoga Society of Pennsylvania, later renamed Kripalu in honor of Desai's guru, Swami Kripalvandanda (1913–1981); and two disciples of Swami Sivananda: Swami Satchidananda (1914–2002), who founded the Integral Yoga Institute, and Swami Vishnudevananda (1927–1993), who established International Sivananda Yoga Vedanta centers around the world and published the highly influential postural manual *The Complete Book of Yoga* (1960; fig. 9). Increased media attention brought yoga closer to the mainstream, and printed primers and television series throughout the 1960s and 1970s, such as Richard Hittleman's *Yoga for Health* (first broadcast in 1961), encouraged many to take up posture-based yoga in the comfort of their own homes.[23]

Post-1960s

The 1970s and 1980s were a period of consolidation for yoga in the West with the establishment and expansion of a significant number of dedicated schools and institutes. The period also saw a further and enduring rapprochement of yoga with the burgeoning New Age movement, which in many ways represented a new manifestation of yoga's century-old association with currents of esotericism. In con-

Fig. 10
Yoga Curl (Marilyn
Monroe), 1948

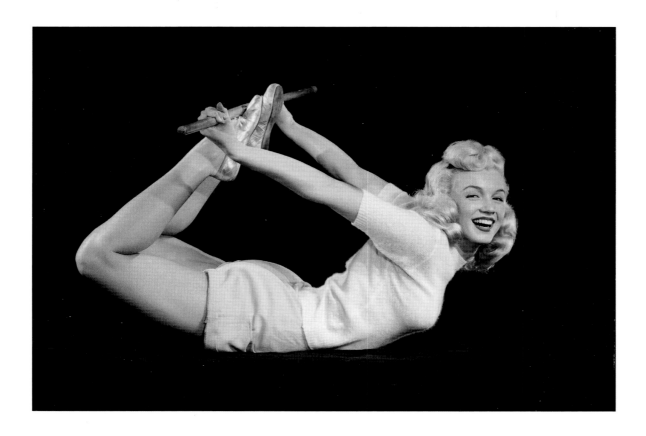

Manifestations of Shiva

1A
Shiva as Bhairava

India, Tamil Nadu, 11th century
Granite, 108 × 47.9 × 28.4 cm
The Trustees of the British Museum,
Brooke Sewell Permanent Fund, 1967.1016.1

1B
Shiva Bhairava

India, Karnataka, Mysore, 13th century
Chloritic schist, 116.6 × 49.23 cm
The Cleveland Museum of Art,
John L. Severance Fund, 1964.369[1]

1C
Bhairava

India, Himachal Pradesh, Mandi, ca. 1800
Opaque watercolor on paper, 27.9 × 17.6 cm
Victoria and Albert Museum, London, IS.45.1954

1D
The Five-Faced Shiva

India, Himachal Pradesh, Mandi, ca. 1730–40
Opaque watercolor on paper, 26.6 × 18.2 cm
Victoria and Albert Museum, London,
Given by Col. T. G. Gayer-Anderson and Maj. R. G.
Gayer-Anderson, Pasha, IS.239-1952[2]

1E
Sadashiva

India, Himachal Pradesh, Nurpur, ca. 1670
Attributed by B. N. Goswamy to Devidasa
Opaque watercolor, gold, and applied beetle-wing
on paper, 19.1 × 18.4 cm
Catherine and Ralph Benkaim Collection[3]

1a *Shiva as
Bhairava*

The Hindu traditions known as Shaiva are based on the teachings of the deity Shiva; their texts are known as Tantras and Agamas. Shaivas understand the revelations of yogic knowledge by Bhairava and Sadashiva, two manifestations of Shiva, as particularly refined and effective.[4]

Bhairava (Sanskrit: horrific) is one of the most widely worshiped Hindu gods.[5] His many identities, which have long coexisted in lived practices and popular perceptions, range from fierce Tantric deity to powerful protector of devotees, temples, villages, and cities. For yogis, the Bhairava who transgresses social norms and bestows superhuman powers is both deity and archetype. In the large corpus of texts known as the Bhairava Tantras, he reveals the teachings of yoga and prescribes initiation rituals in which adepts become immortals with unlimited powers. Yogis expressed their identification with Bhairava by imitating his appearance and his transgressive habits; like the god, they haunted cremation grounds, which provided the ashes they smeared on their bodies and the skull cups that they carried. Carrion-eating dogs were often their companions.[6] Two medieval temple sculptures and an eighteenth-century devotional painting each display some of Bhairava's characteristic attributes (cats. 1a, 1b, 1c). His third eye, waisted drum, trident, and crescent moon signify his association with Shiva; his fangs, flaming aureoles, and skull ornaments and bowls convey terrifying power. Like his Tantric followers, he wears matted locks, and his body is smeared with ashes.

In the superb tenth-century temple sculpture from Tamil Nadu (cat. 1a), Bhairava appears as a naked ascetic with the four arms of a god; his canine companion appears in the place reserved for the gentle bull Nandi in contemporaneous sculptures of Shiva. A gentle smile tempers the dangerous power implied by Bhairava's fangs, his flaming halo of wildly radiating locks, and the skull bowl

held in his lower left hand, (now missing). With an elongated torso and a dignified air, the granite Bhairava epitomizes the restrained aesthetic of eleventh-century Chola dynasty sculptors.

In contrast, a Bhairava from thirteenth-century Karnataka displays the elaborate ornamentation favored by patrons during the Hoysala dynasty (cat. 1b). Its sculptor exploited the softness of freshly quarried schist to create extraordinary details—such as the snake slithering up the shaft and in and out of the deep orifices of the skull atop the *khatvanga* staff—without losing the plump volumes and sinuous stance of the god's body.

Bhairava has numerous manifestations, and his attributes are shared by the guardian deities (*kshetrapalas*) who protect orthodox Shaiva or goddess temples. Therefore Bhairava images often resist precise identification.[7] Whether Bhairava or *kshetrapala*, the quality and size of both the Chola and Hoysala sculptures strongly suggest that they were made for temples commissioned by rulers. Royally patronized temples across India were sites of orthodox (i.e., brahmanic) ritual and personal devotionalism. The Bhairava sculptures thus exemplify the incorporation of fierce Tantric deities within the gentler and more inclusive arena of medieval Indian temple worship. A devotional verse by the Tamil saint Appar captures Bhairava's layered identity as a terrifying and grace-bestowing deity:

Holding the trident
its prongs flashing like the rays of the sun
with resounding drum in hand
he came in the guise of Kala-Bhairava
[black Bhairava]
he ripped apart the elephant's skin—seeing
Uma shrink in fear
his beautiful mouth widened into laughter
... thus did he shower his grace
the beauteous lord of Tirucherai
goal of the Vedas.[8]

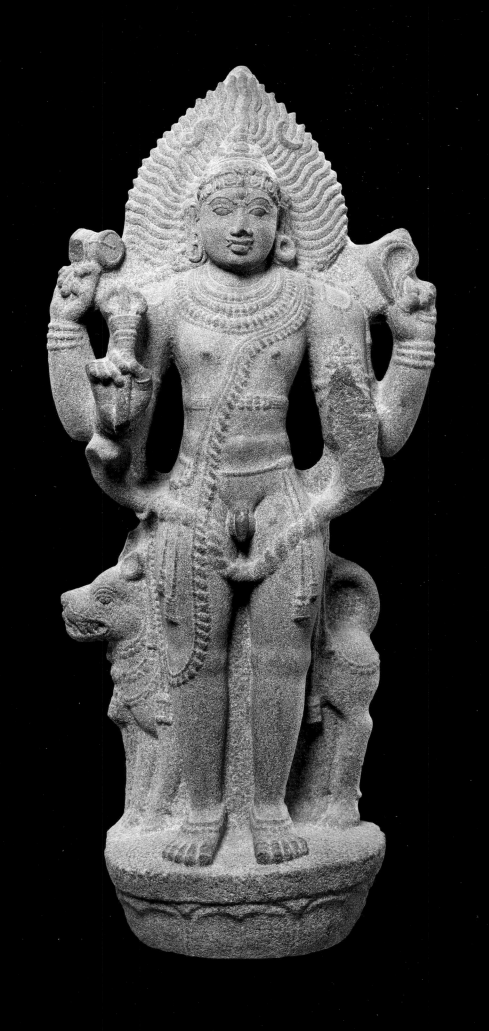

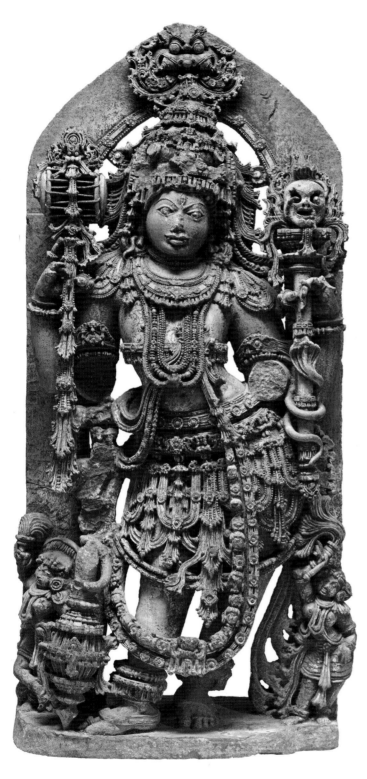

1b *Shiva Bhairava*

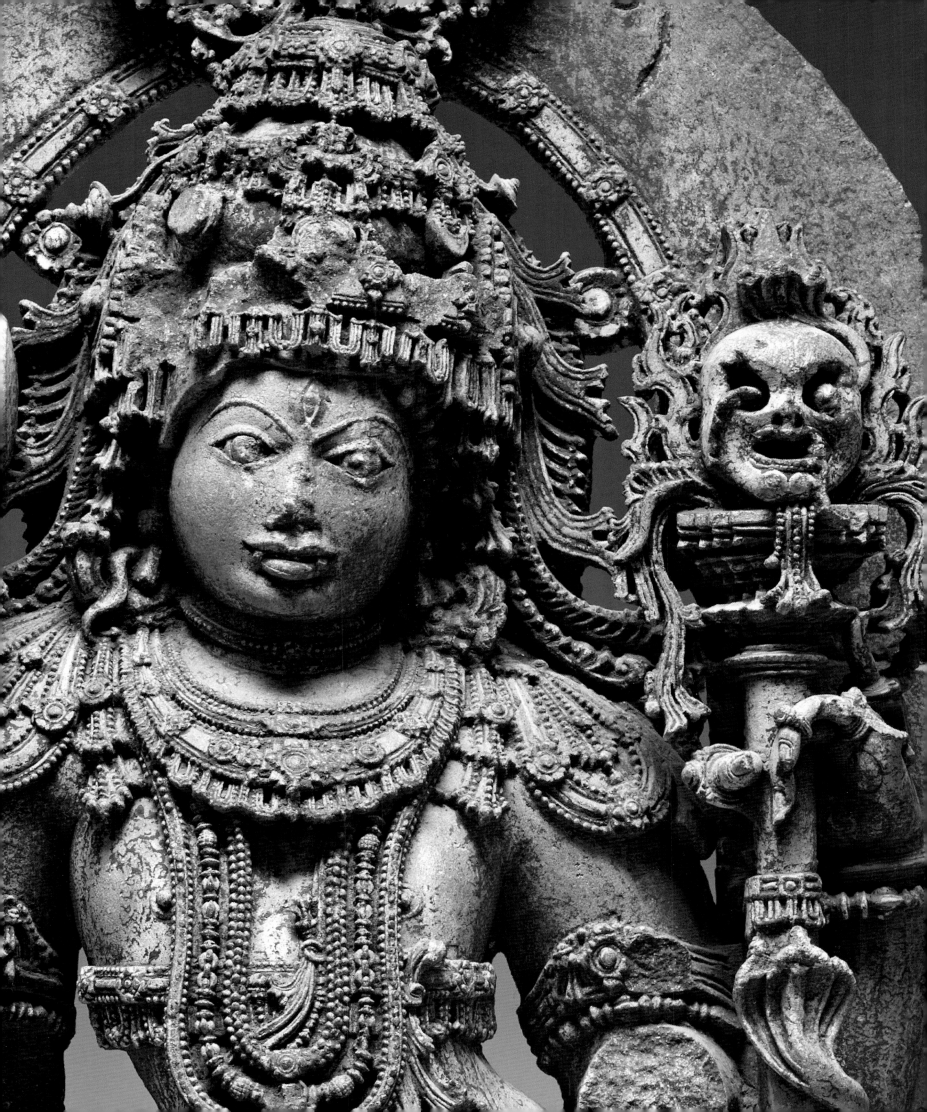

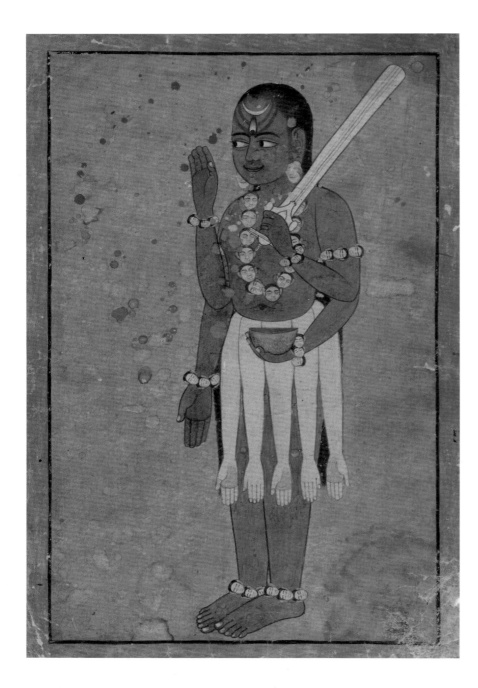

1c *Bhairava*

1d *The Five-Faced Shiva*

For Tantric yogis, Bhairava was both transcendent guru and the god they became through initiation and practice. These living Bhairavas were a pervasive presence within the religious landscape of medieval India, engendering respect and disgust for their deliberately polluting ways. For contemporary audiences who may not have encountered Tantric yogis (though they are still flourishing on the subcontinent), the smear of red ritual paste on the third eye of the Hoysala Bhairava and the whitish surface of the schist, which lends his body the appearance of being ash-covered, intensify the god's uncannily human and horrifying affect.

During the eighteenth century, powerful paintings of Shiva's manifestations as Bhairava and Sadashiva were produced in the Rajput kingdoms of the Punjab hills of northwest India. Those from the Mandi court have bluntly outlined forms, matte surfaces, deep and smoky colors, and an often hyperarticulated stippling technique. The distinctively earthy style, which emerged under Raja Sidh Sen (reigned 1719–27), a Tantric initiate widely credited with magical powers, persists in this slightly oversize devotional image of Bhairava painted circa 1800 (cat. 1c). With Shiva's third eye and crescent moon upon his forehead, and adorned in severed limbs, the four-armed Bhairava holds a sword over his left shoulder and a skull cup filled with blood; his right hands display the gestures of "have no fear" and "generosity."[9] His apron of arms suggests Mandi's location in a broader Himalayan religious arena in which bone aprons were typical garb for Buddhist and Hindu Tantric deities.[10] Spattered with reddish pigment, the painting may have once been placed on an altar and worshiped with ritual paste.

Sadashiva, one of Shiva's most transcendent forms, figures in several yoga traditions. Within the Agama texts of orthodox Shaivism (Shaiva Siddhanta),

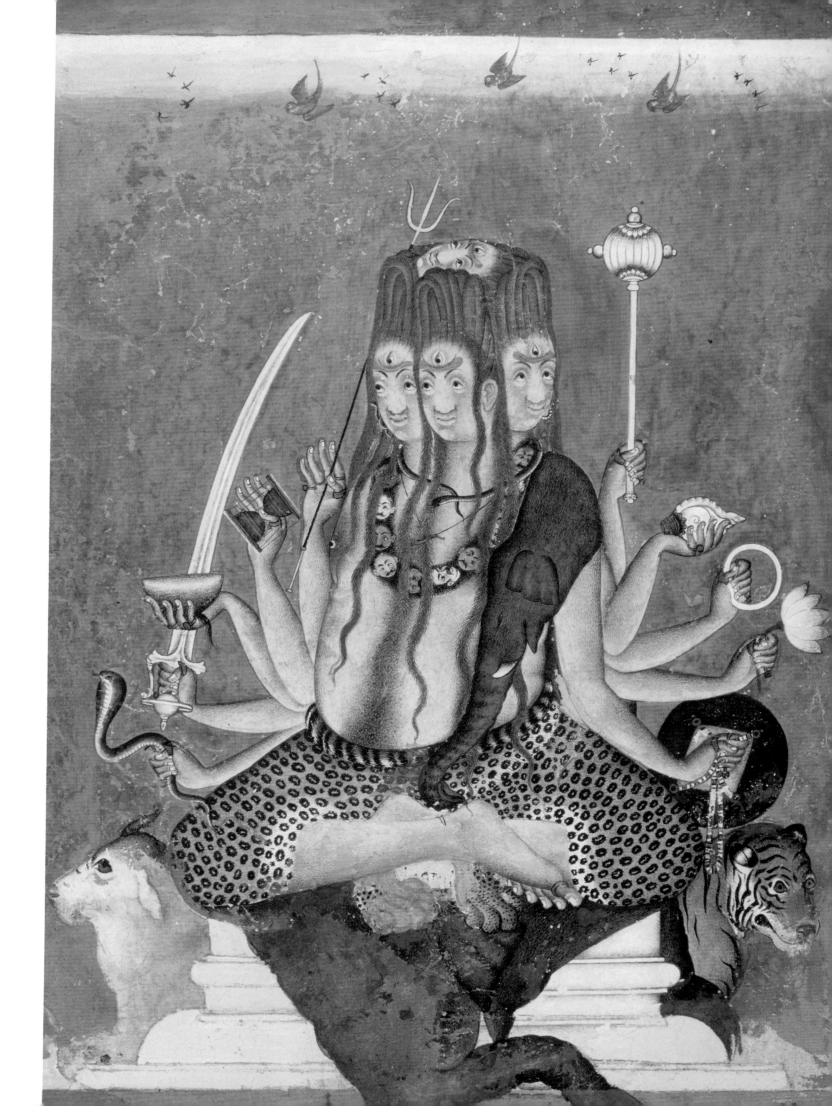

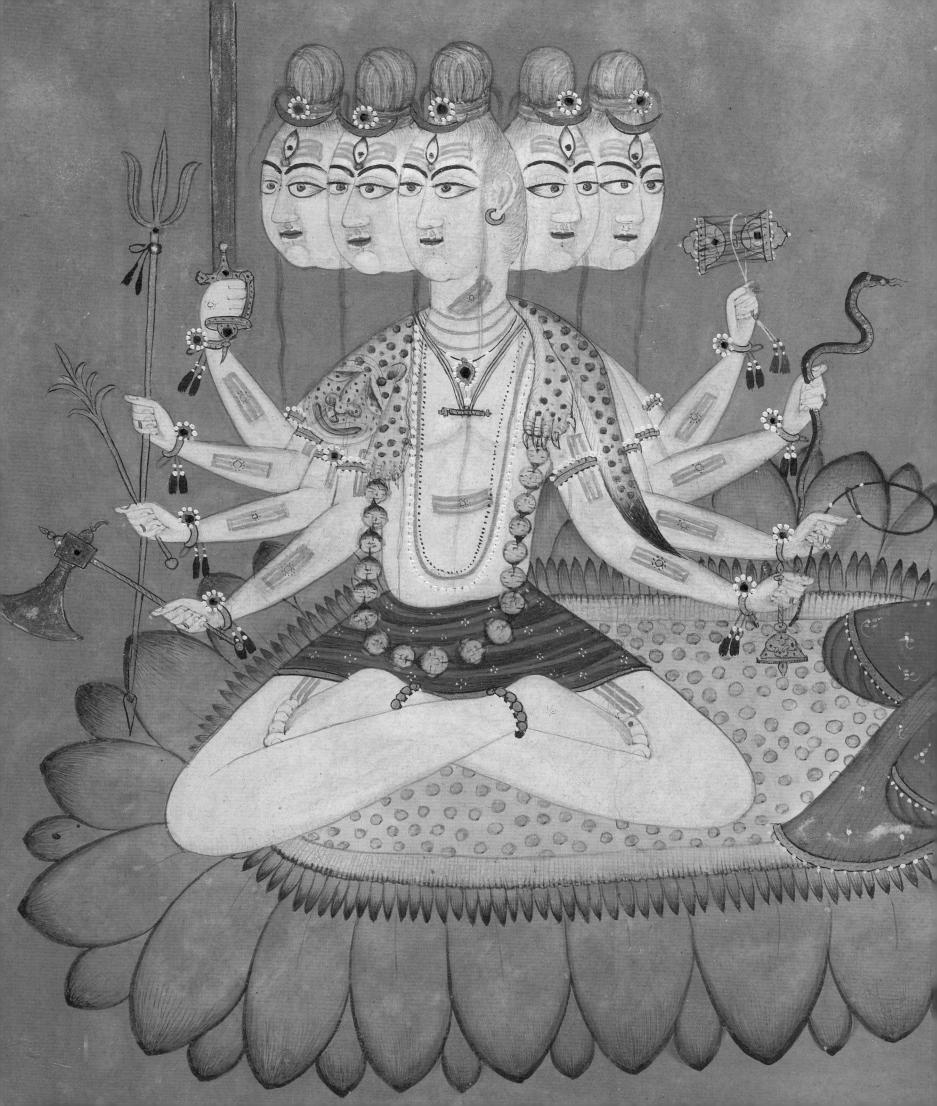

he is the supreme deity and a higher level of the cosmos in which there are no distinctions among person, body, and world.[11] His five heads represent five streams of knowledge, ranging from the highest Siddhanta teachings to the least venerated Vaishnava Tantras.[12] This refined yet idiosyncratic image of Sadashiva from Mandi (cat. 1d) was painted shortly after the death of Raja Sidh Sen in 1727. The artist began the work by loosely setting forms with translucent washes of color (visible in the lower left area because of loss of the painting's topmost layer). He then applied stippled daubs of paint to create fuzzy volumes that eccentrically play off the crisply silhouetted forms. The painting's imagery is equally distinctive: it combines standard iconography with local idioms and what are perhaps the artist's personal emphases. Characteristically, Sadashiva has five heads (the fifth invisible at the back), a third eye, an ascetic's garb, and the attributes (here, clockwise from the top right) of mace, conch shell, discus or noose, lotus, shield, snake, sword, skull cup, drum, and trident. Regional traits include Sadashiva's hirsute corpulence, which is based on Sidh Sen's body type as recorded in his portraits, the horn whistle necklace of a Nath yogi, and a lower garment fashioned from a precious snow-leopard skin.[13] Other elements emphatically invoke canonical Shaiva myths. By including two elephant skins (one draped over the altar and the other over the god's shoulder), the artist reminds the viewer of Shiva's slaying of the elephant demon Gajasura. The long tuft of black hair that dangles from the skull cup is the topknot of a brahmin. Its presence here recalls Shiva/Bhairava's decapitation of Brahma's fifth head.[14] To atone, the god wandered with the head stuck to his hand for twelve years, a penance that yogis of the Tantric Kapalika sect emulated by carrying skull cups as their begging bowls.

One of Sadashiva's most important acts was the transmission of teachings from subtle realms into language that could be accessed by humans.[15] Because the Tantras were typically structured as conversations between a deity and his consort, this marvelous painting from Nurpur (cat. 1e), a Rajput kingdom in the Punjab Hills, evokes Sadashiva's role as the revealer of yogic knowledge. Sadashiva sits with the goddess on a pink-petaled lotus floating against a wine-colored ground. His large, ash-white body dominates the composition, the center of attention for the viewer's attention as well as that of the goddess, whose gaze is fervid and alert. Although the purpose of the painting is unknown, it may have been made as a focus for meditation. DD

1e *Sadashiva*

Portraying the Guru

2A
The Guru Vidyashiva

India, Bengal, 11th–12th century
Stone, 129.5 × 66 × 15.2 cm
Pritzker Collection[1]

2B
Matsyendranath

India, Karnataka, Bijapur, ca. 1650
Opaque watercolor and gold on paper,
16.5 × 20.3 cm
Collection of Kenneth X. and Joyce Robbins

2C
*Gosain Kirpal Girji Receives Sheeshvalji
and His Son*

India, Rajasthan, Marwar or Jodhpur,
mid-18th century
Opaque watercolor and gold on paper,
34.9 × 24.8 cm
Catherine and Ralph Benkaim Collection[2]

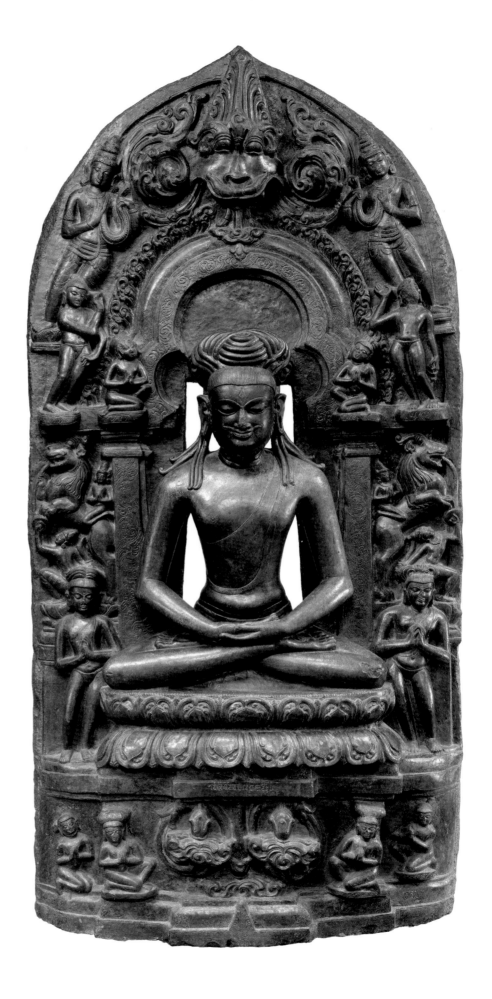

2a *The Guru
Vidyashiva*

Portrayals of venerable yogis have a long history in southern Asia. Images of perfected sages, or masters of meditation, not only were present from a very early moment, they formed the basis for much of India's ancient figural imagery. From the Buddha at Bodhgaya to Satya Sai Baba today, the icon of the guru has served as a reminder of a teacher and recipient of devotion. In Hinduism, it is often hard to discern the line between visual representations of a yogi as a generic auspicious figure and a portrait of a specific human teacher. Beginning around the fifth or sixth century, prominent teachers, such as the Shaiva sage Lakulisha, were deified after death and incorporated into pantheons of major Hindu deities. At the same time, generic images of gurus engaged in the act of religious instruction became increasingly common on temple walls. The two or three centuries following the turn of the first millennium introduced new kinds of images identifiable as portraits of historic human teachers.[3] Often identified by name and *sampradaya* (religious order), they were nonetheless deified and understood to have acted as manifestations of Shiva on Earth while still alive.

A particularly well-preserved example can be seen in an eleventh- or twelfth-century sculpted figure of a Shaiva ascetic teacher, identified as the guru Vidyashiva in an inscription along its base, originally from Bengal (cat. 2a).[4] Framed wonderfully through architecture, the guru sits in his own beautifully rendered pavilion, surrounded by worshipful disciples holding their hands in *anjali mudra*. The frontal format and scale of the relief suggests that it was intended to be a primary icon inserted into a wall niche or shrine. Like contemporary images of deities, the guru sits on a lotus throne in meditation, his legs crossed in the lotus position (*padmasana*). The intermediary spaces are filled with *vyalas* (mythical lions), and attendant demigods (*vidyadharas*) whose

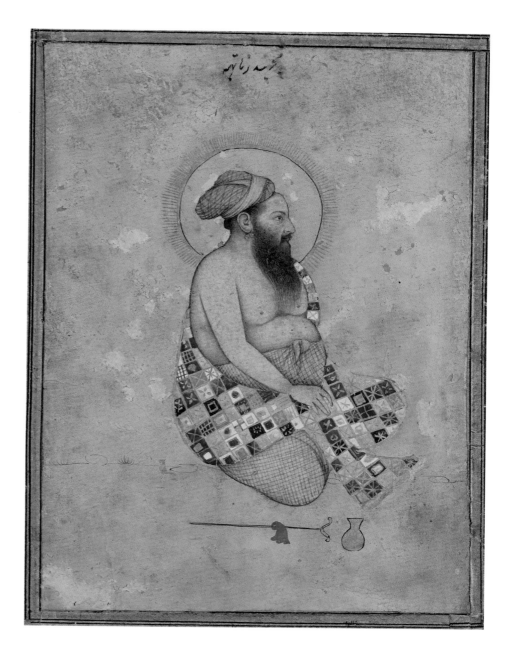

2b *Matsyendranath*

flight upward culminates in a magnificent face of glory (*kirtimukha*), positioned centrally above the guru's head.

At first glance, the bearded sage could be mistaken for a generic Shaiva ascetic with tall, matted hair (*jatamukuta*). However, the inscription on the base indicates that the image is a portrait[5] of a specific sage, Vidyashiva, who lived perhaps a few generations earlier and whose disciples came to be favored by the Pala rulers of northeastern India (circa 750–1174 CE) in subsequent generations.[6] Although once human, Vidyashiva is marked as divine through

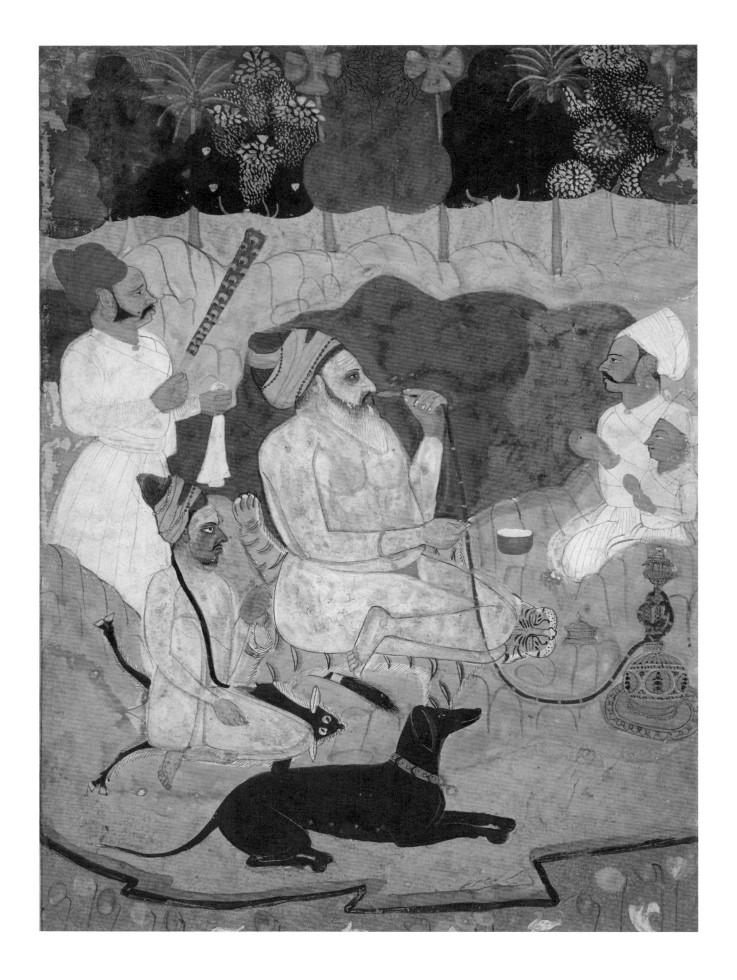

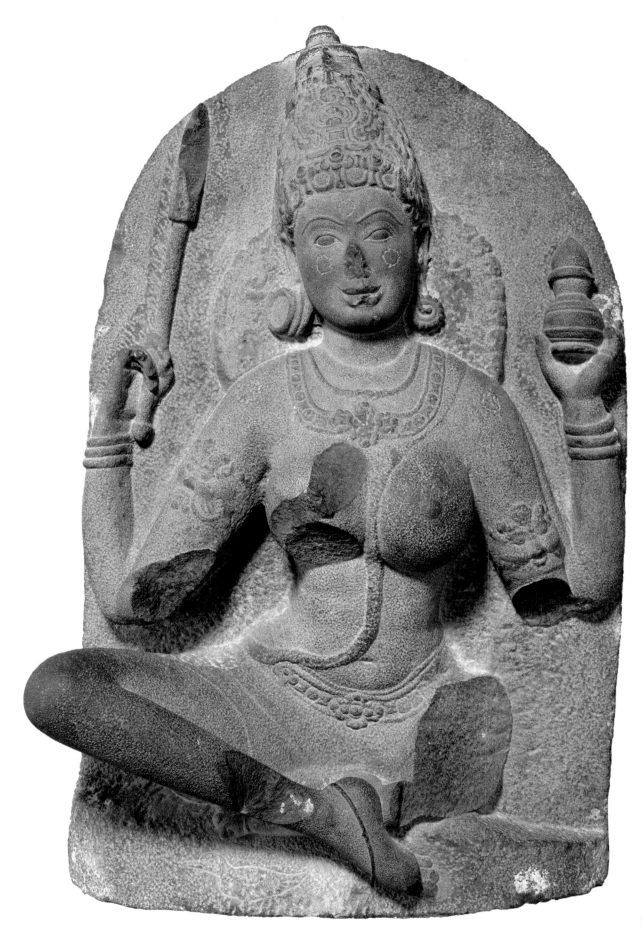

c Yogini

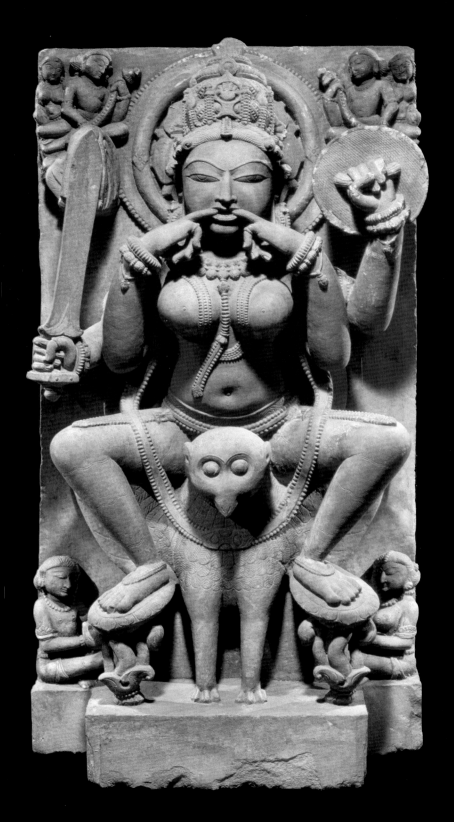

3d *Yogini*

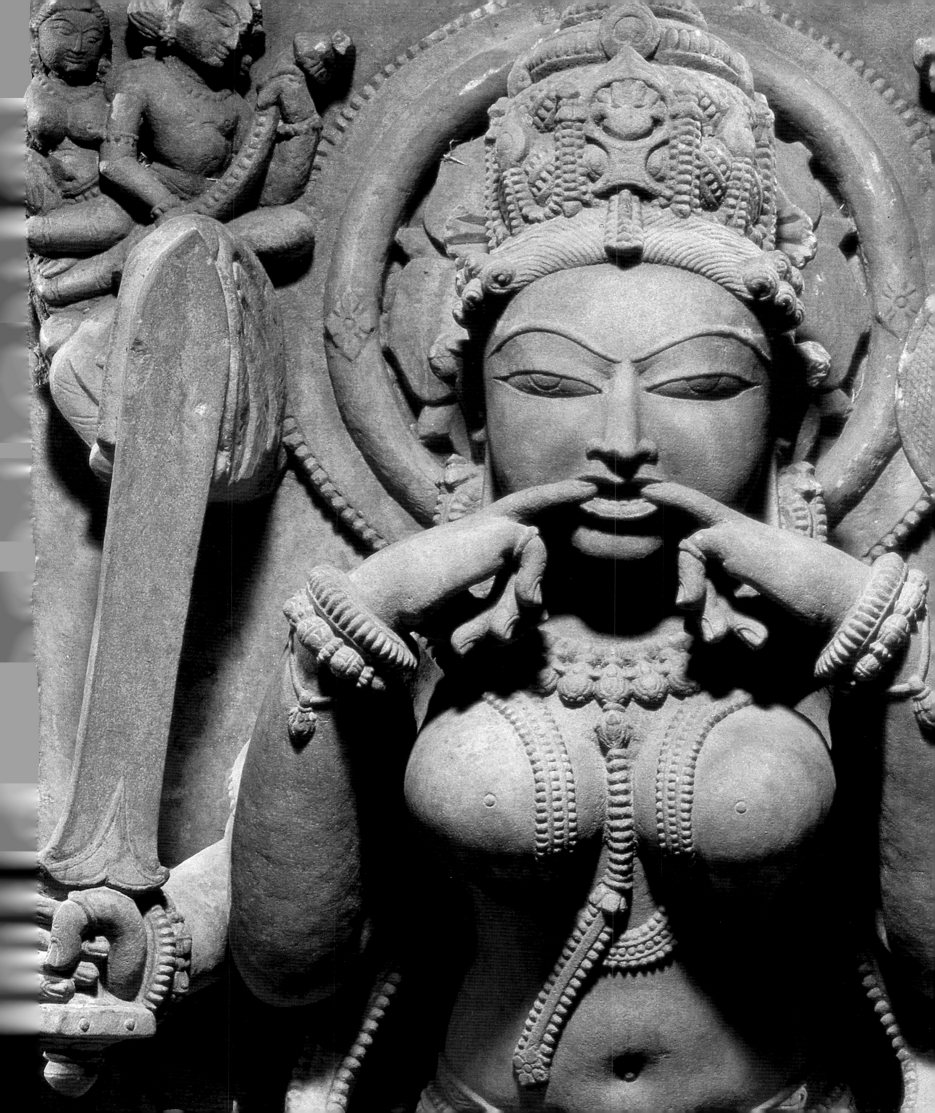

she is likely one of the yoginis whose names roughly translate as "she who makes a loud noise."[16] The sculptor's ability to balance—without fussiness—the yogini's smooth limbs with the very precisely realized cuticles of her fingernails, individually carved little teeth, and crisply delineated owl feathers is masterful. He superbly exploited the softness and warm golden color of sandstone to convey the organic quality of plump flesh; pearl-studded ornaments curve around her body to further emphasize its rounded volumes. A rigorous yet rhythmic geometry—seen for example in the radiating movement outward from her bowlike eyebrows to the circle of tightly curled hair and thick tubular halo—lends dynamism to the whole. Notable too are the sculpture's volumes and shadows: the fully three-dimensional realization of the pearl-edged sash below her elbows allows us to sense the suppleness of her spine, while the calculated undercutting of her mouth makes it appear menacingly deep.

Although Hindu kings ceased to construct yogini temples after the twelfth century, Indian rulers of all religions sought the favor of yoginis so they would intercede in military affairs throughout the medieval period. For Indo-Islamic sultans seeking practical ways to consolidate power between the fourteenth and seventeenth centuries, propitiating yoginis, along with astrology and other divinatory sciences, were common tactics.[17] From at least the fourteenth century onwards, yoginis were known within Islamic intellectual circles as immortal beings who could mediate events on Earth (see "Muslim Interpreters of Yoga" by Carl W. Ernst). In the sixteenth and seventeenth centuries, for example, yoginis were accessed by the Muslim rulers of Bijapur, a sultanate in the Deccan Plateau of central India (cats. 3e, 3f). Securing military victories was the stated goal of yogini propitiation for Sultan Ali 'Adil Shah II (reigned 1557–79).[18] In chapter 6 of his *Stars of the Sciences* (*Nujum*

al-'ulum), dated 1570–71), the sultan described 140 yoginis, an astounding number that exceeds all known Hindu lists.[19] Exemplifying the cultural heterogeneity of Bijapur and the sultan's desire to edify his diverse courtiers, the text collectively identifies them as yoginis and individually retains their Indic names, *mudra*s (gestures), attributes, and yantras (geometric diagrams), but integrates them into the already-established Islamic occult category of *ruhaniya* (earth spirits).

The *Stars of the Sciences* was arguably Bijapur's most ambitious illustrated manuscript, and all 140 *ruhaniya* were depicted both anthropomorphically and geometrically as yantras.[20] Because Hindu astrological and yogini manuscripts were probably diagramatic or unillustrated, the illustrations may constitute the first detailed set of paintings representing yoginis.[21] Following the sultan's text, a court artist depicted the fourth *ruhaniya*, Saha, as a standing crowned woman carrying a water jug and stringed instrument (cat. 3e). Centered against a patterned ground of fluidly drawn foliage clusters, Saha is also copiously draped in gold and pearl ornaments. The adjacent yantra is highlighted on a red field with curling gold clouds. Its central square is inscribed "this chakra is named Saha," and the gold cartouches name the cardinal directions. The manuscript's uniquely comprehensive yogini group and its iconographically replete images reveal a transformation in yogini identity accomplished through the integration of Tantric, Islamic, and local beliefs about divination, the cosmos, and astrology.

Ibrahim 'Adil Shah II (reigned 1579–1627), the nephew and successor of Ali 'Adil Shah II, not only inherited his uncle's splendid *Stars of the Sciences* but also commissioned paintings of yoginis for inclusion within albums.[22] Because the sultan and his courtiers knew of semidivine *ruhaniya,* they may have understood the painted yoginis as agents of otherworldly powers.[23] *Yogini with*

Mynah (cat. 3f) epitomizes the supernal intensity and finesse of Bijapur painting achieved at the court of Ibrahim 'Adil Shah II. Through formal means, its otherworldly affect suggests a being who provided supernatural assistance in worldly affairs. Its artist, "the Dublin painter," created the visionary image through daring manipulations of space, theatrical backlighting, and an improbable palette that plays modulated passages of salmon pink, smoky lavender, and dusky whites off brilliant orange, raspberry, and forest greens. Impossibly elongated, the yogini has the ash-covered skin and the dreadlock (*jata*) topknot of female ascetics associated with the deity Shiva and is laden with jewels like the immortal yoginis described in Persian translations of Tantric texts or illustrated on the pages of the *Stars of the Sciences*.[24] Surrounded by surreally surging hillocks and hugely blooming flowers, she stands quite still, almost spellbound, though her gold sashes furl and the delicate tendrils of hair around her tilted head quiver. Her cool bluish complexion heightens the effect of her heavy-lidded gaze, slight smile, and intimate communion with the mynah. Later Deccani and North Indian paintings of yoginis, such as cat. 18f, romanticize and even eroticize yoginis; early twentieth-century images (cats. 23b, 23c) reveal how yogini powers emerged on the global stage in exotic magic acts. DD

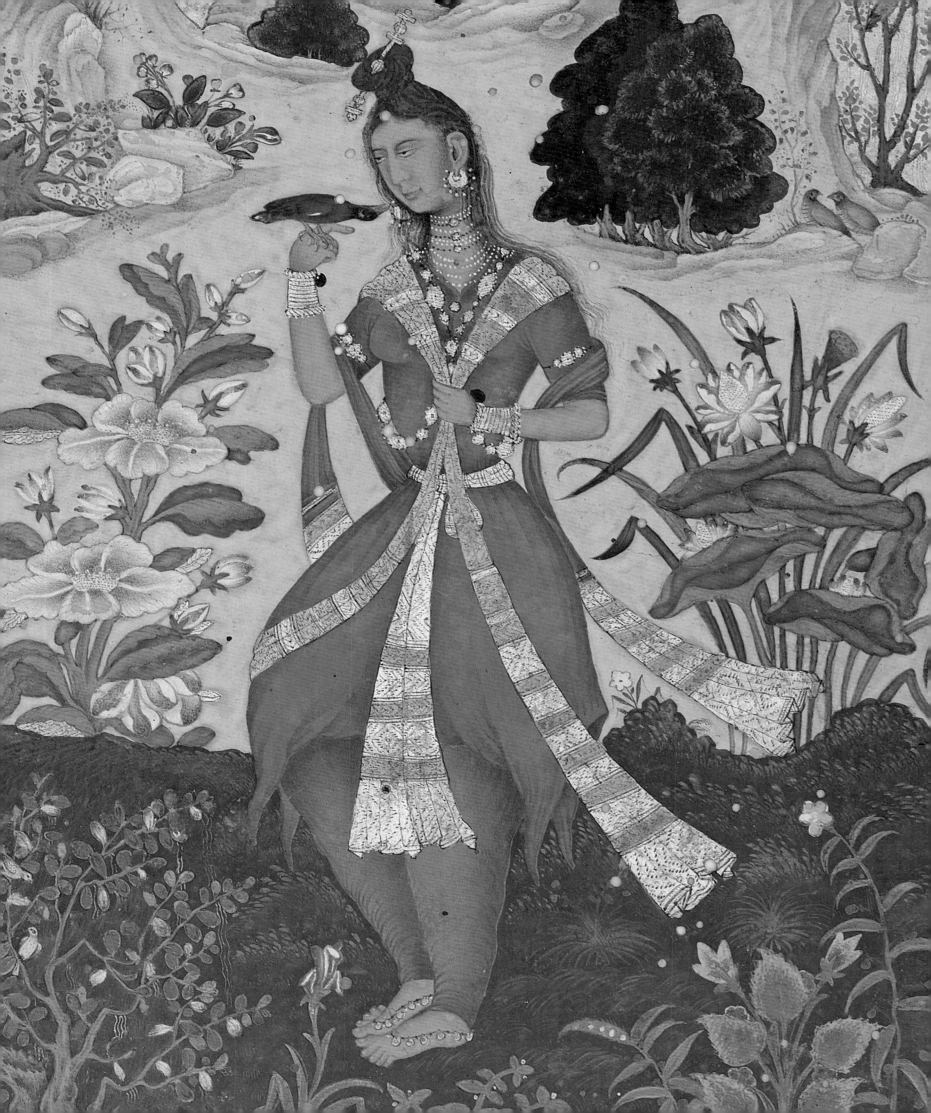

Nath Siddhas

4A–C
Three folios from the *Nath Charit*

Bulaki
India, Rajasthan, Jodhpur, 1823 (Samvat 1880)
Opaque watercolor, gold, and tin alloy on paper,
47 × 123 cm
Merhangarh Museum Trust

4A *Three Aspects of the Absolute*
Folio 1 from the *Nath Charit*
RJS 2399[1]

4B *The Transmission of Teachings*
Folio 3 from the *Nath Charit*
RJS 2400

4C *The Transmission of Teachings*
Folio 4 from the *Nath Charit*
RJS 2401

These hypnotic images open the *Stories of the Naths* (*Nath Charit*), a compendium of legends about the divinized masters of yoga known as *siddha*s (great perfected beings) within the Nath tradition. The Naths are closely associated with classical hatha yoga, which internalized the complex (and often transgressive) rituals of Tantra into the body of the practitioner.[2] Hatha yoga developed between the thirteenth and fifteenth centuries by synthesizing two earlier yogic traditions: one that focused on physical techniques for retaining semen and another based on visualization techniques for raising energy (*kundalini*) through the subtle body (see cats. 11a–c).[3] Early Nath works on yoga rarely reference deities, but over the centuries as the order organized, the Naths gradually became almost wholly oriented toward the Hindu god Shiva.

Stories of the Naths was composed and illustrated in 1823 for Maharaja Man Singh of Jodhpur (reigned 1803–43), an ardent devotee of the *siddha* Jalandharnath and an unstinting patron of the Nath sectarian order.[4] Its cosmological cycle demonstrates a historical development in Nath identity and beliefs. To firmly situate *siddha*s as transcendent beings, the text adapts a Shaiva metaphysics: it re-identifies the limitless Absolute (*brahman*) as a divine Nath and his (i.e., the universe's) first emanations into matter and consciousness as *siddha*s.

Vertical rules divide the monumentally sized folios, each almost four feet in width, into segments representing the *siddha*s as successive emanations of being from a "self-effulgent [Nath] without beginning, limit, form or blemish."[5] To meet the conceptual challenge of evoking the immaterial, Bulaki, a master artist in Man Singh's atelier, began the creation sequence with an undifferentiated field of shimmering gold pigment (cat. 4a, left). The radical abstraction is an innovation of the Jodhpur workshop; although the formless Absolute is a conception central to many Hindu traditions, it had rarely entered the realm of the visual.[6]

Each saffron-clad *siddha* wears the horn necklace and triangular black hat of Nath yogis; the most subtle and respected beings, like "Bliss-form Nath" and Jalandharnath seen in the center and right panels respectively of folio 1 (cat. 4a), also have halos and ashen-blue bodies.[7] Silvery waters flowing from Jalandharnath's body constitute the next, more material, ground of creation, the cosmic ocean in (or perhaps on) which the Naths on folios 3 and 4 (cats. 4b, 4c) companionably converse. Virtually identical, they are depicted as teachers connected in a hierarchical chain of authoritative revelation.[8] In Indian philosophical systems, the greatest spiritual authorities are those who have directly perceived ultimate reality (*pratyaksha*), which is visually indicated here by the left

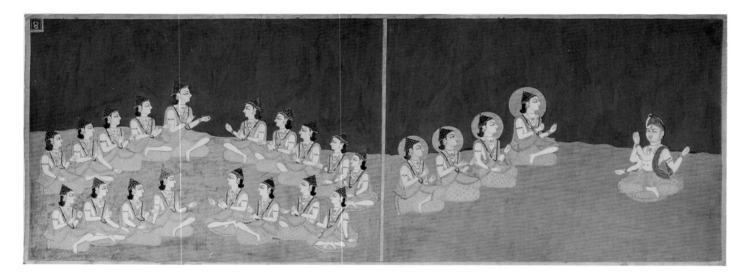

4b (above) *The Transmission of Teachings*, folio 3

4c (below) *The Transmission of Teachings*, folio 4

to right sequence of progressively more material (and hence lesser) emanations.[9] Several Naths touch their forefingers to their thumbs in a gesture of imparting knowledge (*vitarka mudra*); on the far right of folio 4, the deity Shiva joins two of his four hands in worshipful respect.

Bulaki exploited the mesmerizing affect of repetitive forms and gleaming surfaces to convey the transcendent divinity of the *siddha*s. Enigmatically hovering and effortlessly emerging, replicating, and regrouping on the highest cosmic plane, they galvanize what would become a standard Nath conception of *siddha*s and demonstrate the role of the visual in shaping historical transformations. DD

Jain Yoga: Nonviolence for Karmic Purification

5A
Seated Jina Ajita[1]

India, Tamil Nadu, 9th–10th century
Bronze, 18.5 × 14.5 × 9.3 cm
Arthur M. Sackler Gallery, Gift of Arthur M. Sackler,
S1987.16[2]

5B
Jina

India, Rajasthan, 10th–11th century
Bronze with silver inlay, 61.5 × 49.5 × 36.8 cm
The Cleveland Museum of Art, Severance and
Greta Millikin Purchase Fund, 2001.88[3]

5C
Standing Jina

India, Tamil Nadu, 11th century
Bronze, 73.7 × 69.2 × 17.5 cm
Private Collection, LT16[4]

5D
Jina

India, Rajasthan, probably vicinity of Mount Abu,
1160 (Samvat 1217)
Marble, 59.69 × 48.26 × 21.59
Virginia Museum of Fine Arts, The Adolph D. and
Wilkins C. Williams Fund, 2000.98[5]

5E
Siddha Pratima Yantra

Western India, dated 1333 (Samvat 1390)
Bronze, 21.9 × 13.1 × 8.9 cm
Freer Gallery of Art, F1997.33[6]

5F
Jain Ascetic Walking

India, Mughal dynasty, ca. 1600
Opaque watercolor, ink, and gold on paper,
14.7 × 9.8 cm
The Cleveland Museum of Art, 1967.244

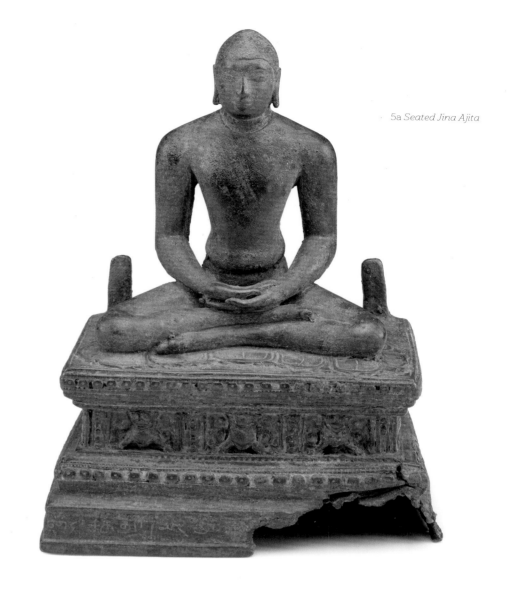

5a *Seated Jina Ajita*

The Jain tradition arose more than 2,700 years ago on India's Gangetic Plain. Its earliest surviving text, the *Acharanga Sutra* (circa 300 BCE),[7] specifies that the path to spiritual liberation requires the careful practice of nonviolence. Jainism acknowledges twenty-four great teachers known as *tirthankara*s (forders of the karmic stream) or Jinas (victors). These great liberated souls successfully conquered the difficulties inherent in the cycle of rebirth and suffering (*samsara*), expelled all fettering karmas, and taught for many years before ascending to the eternal abode of perfect energy, consciousness, and bliss.

The cornerstone of Jain thought and practice can be found in the relationship between soul and karma. Karma in Jainism has physical qualities: it is material, sticky, and colorful. The most difficult karmas densely coat the soul, and hence prevent the soul from manifesting good qualities. Souls are found everywhere: in clumps of dirt, in gusts of wind, in the flames of a bonfire, in the lives of plants, in the bacteria on our skin, and, of course, in all living beings, including insects and humans. Each act of violence toward any one of these souls causes an influx of karma.[8] All souls are born repeatedly until they are reborn as humans who can, through daily meditation and twice-monthly fasting, release karmas, lending brightness and lightness to their visages. The Jains seek to

gradually shed all karmas, allowing ascent of the soul to a state of eternal, solitary blessedness and awareness, known as *moksha* or *kevala*.

Jainism has employed the word *yoga* for more than two millennia and has been in constant dialogue with yoga as a spiritual discipline.[9] In the early Jain tradition, from the time of the *Acharanga Sutra* until the sixth century CE, yoga referred to the process by which material karmas stick to and hence obscure the innate luminosity of the soul. According to Jain physiology, karma sets the body off balance, forming asymmetrical deposits in the connective tissues. Through the steady practice of meditation, one is able to expel these karmas and bring the body back into alignment.

In the sixth century, the Jain scholar Haribhadra Virahanka began to use yoga in its more general sense of "spiritual practice."[10] For nearly 1,400 years, Jains have composed many texts that discuss their religious practice in terms of yoga, such as the *Yogabindu* of Haribhadra Viranhaka, the *Yogadrstisamuccaya* of Haribhadra Yakiniputra (eighth century), and the *Yogashastra* of Hemacandra, which provided one of the earliest descriptions of *asana* and *pranayama* (eleventh century).[11]

From their earliest representation (circa 300 BCE),[12] Jinas have been depicted in meditation, because it is a state in which no violence can be committed. Seated Jinas always appear in the elegant and perfect accomplishment of *padmasana*, the most famous of all yoga postures (known as lotus) with each foot folded onto the opposite thigh. A small ninth-century bronze from Tamil Nadu, probably from a home shrine, represents Ajita, the second Jina, meditating within this posture of perfect stillness (cat. 5a). By reflecting upon this representation of deep repose, aspiring Jains are inspired to bring similar serenity into their own lives. Many Jains assume this or a similar position for at least forty-eight minutes per day, emulating the liberated ones and perhaps chanting praise about their accomplishments.

By disciplining oneself into this pose, in which one is of like measure on each side, karmas will be excreted. Thus sculpted Jinas are always completely symmetrical and harmoniously proportioned. Their bodies are constructed of idealized forms that further convey the commonality within meditative consciousness. The only way to distinguish the twenty-four great teachers from one another is through insignia sometimes found at the base of their thrones or through inscriptions.[13]

Inlaid with silver, a gleaming bronze Jina with an extraordinarily gentle smile radiates not only peace but also the

5b *Jina*

5c *Standing Jina*

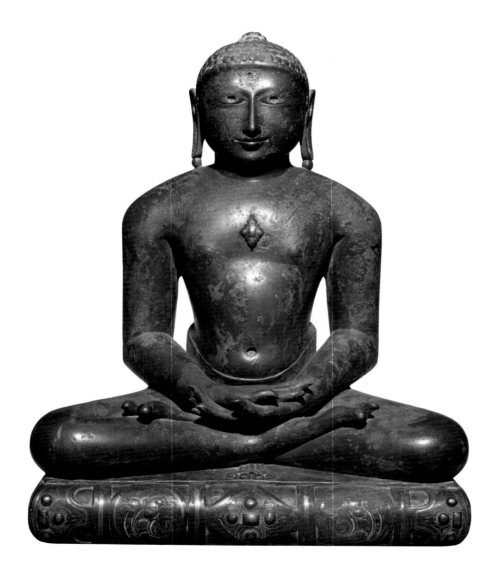

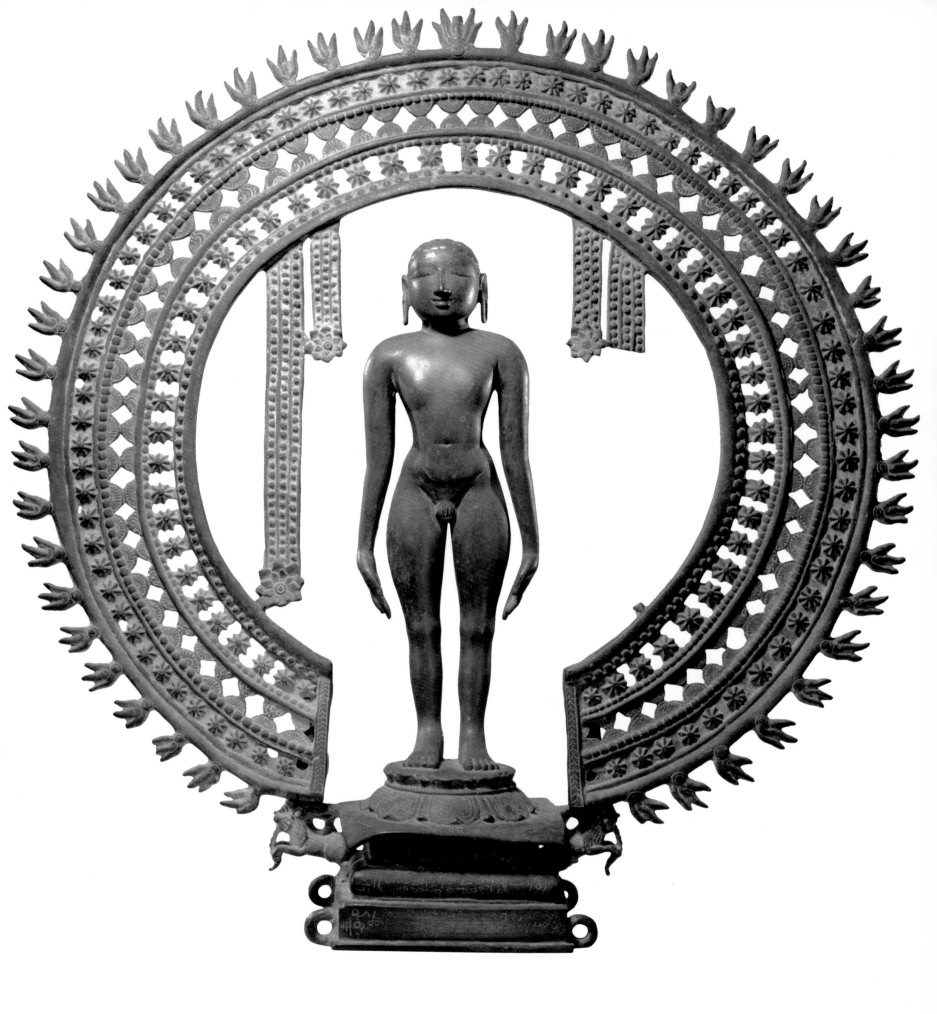

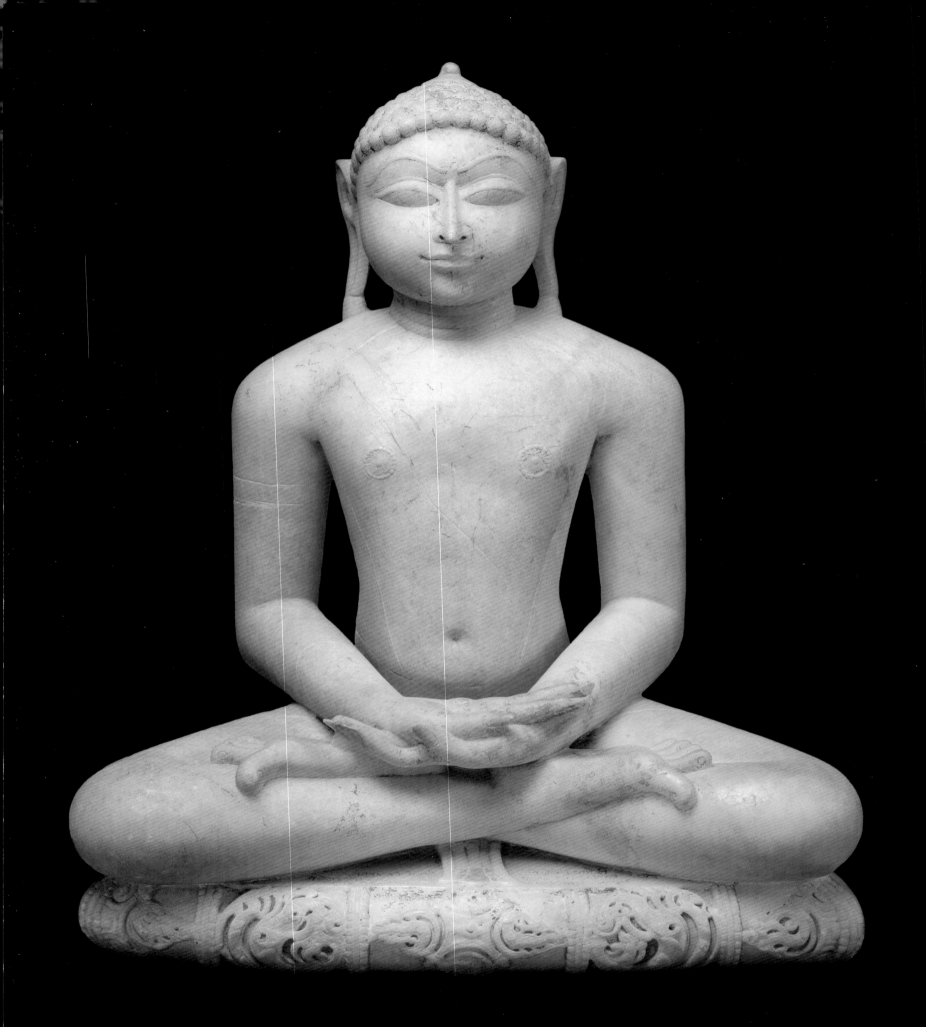

vibrant energy associated with sustained meditation practice (cat. 5b). The raised emblem on his chest, known as an *shrivatsa*, symbolizes love and compassion. His eyes are wide open, indicating the undying consciousness associated with the realized and purified soul.

In western India, where marble is plentiful, Jain temples are often totally constructed of the luminous white stone, evoking the all-important emphasis on purity. A radiant marble Jina (cat. 5d) bears the vestiges of years of daily worship with red and amber powders that are used in the eight-part ritual of Jain worship.[14] Because clothing of any type entails violence, both in its production and its usage, the Jina appears to be naked. He sits on an elaborately decorated pillow that not only signifies the honor in which he was held, but also emphasizes through contrast how the body of a Jina, stripped of ornamentation and garments, articulates the power of nonpossession (*aparigraha*), the ability to flourish even after surrendering all attachments.[15]

Perhaps the earliest extant Jain sculpture is the 2,300-year-old torso from Lohanipur of a naked figure standing in the Kayotsagara pose, which involves manifesting the body upward and is critical for the expulsion of karmas.[16] Even today, Jains are as likely to meditate in the standing Kayotsagara pose as in the seated lotus pose. Epitomizing the perfection achieved by bronze casters in Tamil Nadu during the Chola dynasty, the perfectly smooth and unadorned body of the Jina standing in Kayotsagara (cat. 5c) evokes both the solitary, quiet nature of meditation and the radiant, accomplished state of total freedom (*kevala*). The elaborate aureole, evoking the realm of nature and karma, is distanced from his body, while it symmetrically radiates his energy outward. In this stance, the Jina and the practicing Jain herself embody the very form of the universe. According to Jain cosmology, the world takes the shape of the human body. In the lower realms of the cosmic legs and feet, one can find the various hells. In the middle realm of the torso, one enters the realm of Jambudvipa, the continent that houses the elemental, microscopic, plant, and animal life forms. The realm above the shoulders contains various heavens. And above the head are realms of perfect freedom. Standing still, arms slightly away from the torso and the legs, Jains meditate on the ascent of the soul beyond the confines of the body. During this process, many fettering karmas disperse, cleansing the soul.

Evoking the true nature of a liberated *siddha*, a small bronze shrine (cat. 5e), slightly worn from repeated acts of ritual touching, conveys the presence of consciousness in a fascinating a uniquely Jain manner. Rather than showing the physicality of the body, this depiction of the adept or *siddha* represents his body as a negative space. The sheet of copper that frames the empty space of the body symbolizes the karmic materiality that gives shape and form to the body, while the empty space of the silhouette in Kayotsagara signals immersion in the ineffable space of pure consciousness. The cutout of the inverted crescent adds a lovely flourish, perhaps indicating that the realm of consciousness, normally depicted with the horns of the move turned upward, has gracefully upended itself, descending into the full awareness of the enlightened *siddha*. The whisks on either side give homage to the great accomplishment of surmounting the difficulties of karma, providing the comfort of coolness. The abstract openings below the *siddha* suggest that moments of insight and freedom can occur, inspiring the aspirant with sparks of beauty. In its totality, this bronze shrine invites the meditator to allow the spaciousness of freedom to interlace with the world of materiality.

All Jains, lay or monastic, strive to cleanse their souls of the fettering karmas through adherence to five vows:

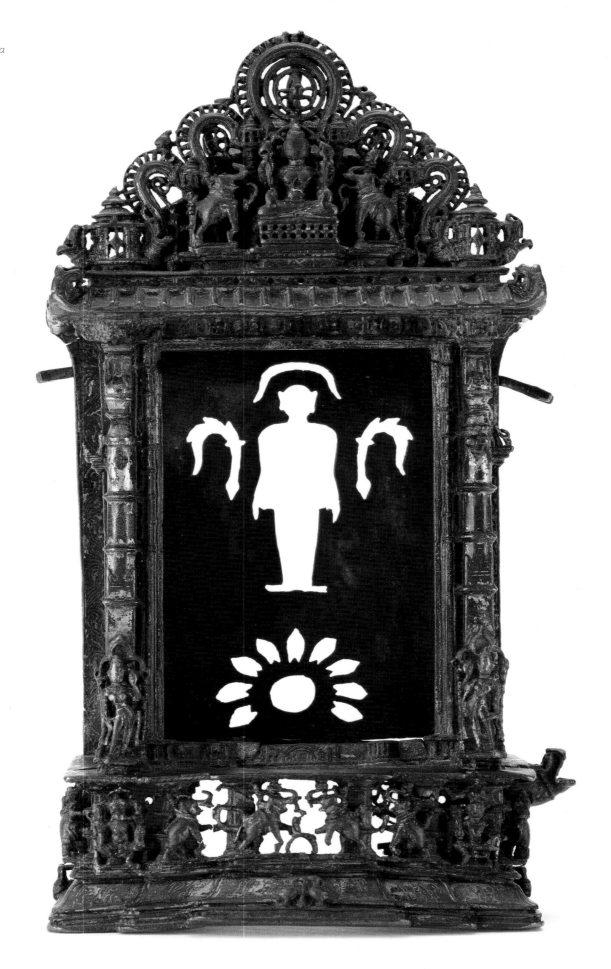

nonviolence, truthfulness, not stealing, sexual propriety, and nonpossession. A sensitively observed image of a Jain monk wandering on foot (cat. 5f), which was painted around 1600, documents several of the ways that these goals were embodied and invites further speculation. Carrying his only possessions—a container in which to receive food freely given, a walking stick, and most likely a book—he is garbed in white, which symbolizes the purest form of karma.[17] His hair has been plucked short in order to reduce possible harm to the bacteria and insect life that can develop within it. The firmly drawn contours of his legs and the sense of feet firmly planted on the dark grassy foreground seem to convey the strength and determination of Jain monks (and nuns) who spend most of their lives walking because any other form of locomotion might harm animals or insects.[18] In contrast, the monk's upper body is only imperceptibly outlined. His diaphanous shawl and wispy locks seem to meld into the misty landscape in a gentle manner that suggests the Jain monastic's vow to exist in the world with as little disturbance of it as possible. Walking is an important part of the Jain spiritual path and of Jain yoga itself, and this image conveys the movement, strength, and determination of Jain monks and nuns.[19]

In the modern era, the Jain and yoga vows of nonviolence and truthfulness found their most renowned expression in the life and work of Mahatma Gandhi. Though a Hindu, Gandhi drew deep inspiration from his Jain friend and teacher Raichandbai. The Jain religious leader Acharya Tulsi also served as an advisor to Gandhi. Tulsi's successor, Acharya Mahapragya, developed a new form of Jain yoga meditation, Preksha Dhyana, that is taught worldwide.

The Jains have played a central role in the history and development of yoga. The study of Jainism continues to shed light on the intricacies of yoga karma theory and the many ways in which yoga can be practiced. By examining these images of wandering monks and Jina figures in seated and standing meditation positions, we are reminded of the insights and inspirations to be gained from this tradition, which is both ancient and very much alive. CKC

Yoga and Tapas: The Buddhists and Ajivikas

6A

Head of the Fasting Buddha

Pakistan or Afghanistan (Gandhara),
ca. 3rd–5th century
Schist, 13.3 × 8.6 × 8.3 cm
The Metropolitan Museum of Art, Samuel Eilenberg
Collection, Gift of Samuel Eilenberg, 1987,
1987.142.73

6B

Fasting Buddha

India, Kashmir, 8th century
Ivory, 12.4 × 9.5 cm
The Cleveland Museum of Art,
Leonard C. Hanna, Jr. Fund, 1986.70[1]

6C

*Base for a Seated Buddha with
Figures of Ascetics*

Pakistan or Afghanistan, ancient Gandhara,
ca. 150–200 CE
Gray schist, 38 × 36.2 cm
The Cleveland Museum of Art, Gift of
Dr. Norman Zaworski, 1976.152

6D

*Tile with Impressed Figures of Emaciated
Ascetics and Couples Behind Balconies*

India, Jammu and Kashmir, Harwan, ca. 5th century
Terracotta, 40.6 × 33.6 × 4.1 cm
The Metropolitan Museum of Art, Gift of Cynthia
Hazen Polsky, 1987, 1987.424.26[2]

Identifying physical evidence for the early practice of yoga poses certain difficulties. The distinctive postures (*asanas*) that are well known in contemporary practice are, with rare exceptions, absent from the early sculptural corpus.[3] This absence is not surprising, given that the oldest textual sources on yoga emphasize inner processes of the mind rather than external actions.[4] Refined mental states are understandably difficult to convey through the visual arts.

Despite these challenges, one fruitful avenue for exploring the topic of yoga in early art might be found in the concept of *tapas*, or inner heat. As described in both yoga manuals and the late Vedic literary tradition, *tapas* is the byproduct of intense physical and mental austerities that manifests as a reserve of potent, purifying, spiritual energy, and as literal heat. One of the most frequently encountered techniques for producing *tapas*, and the purification it engenders, involves undertaking periods of fasting. As early as the *Rig Veda* (1700–1000 BCE), the concepts of heat and hunger were already associated, and the

Shatapatha Brahmana (700–500 BCE) tied these concepts to self-purification while making it explicit that the "practice of *tapas* ... is when one abstains from food."[5]

Such descriptions call to mind a well-known, though rare, emaciated form of the Buddha.[6] Such images have been produced sporadically throughout the history of Buddhism, showing up among the widespread Tantric Buddhist traditions of the Himalayas as well as in East and Southeast Asian contexts. However, it was in Gandhara, which now encompasses parts of northern Pakistan and eastern Afghanistan, that the earliest examples were produced. The *Head of the Fasting Buddha* (cat. 6a) is typical of these early works.

Most scholars have connected these skeletal images with a six-year period of fasting that took place prior to Prince Siddhartha Gautama's attainment of Buddhahood.[7] After abandoning his privileged life at court, Gautama adopted the life of an ascetic and endured years of intense self-mortification alongside a group of like-minded hermits. During this time he surpassed his teachers in rigor and self-discipline, taking the intense traditional practices to self-punishing extremes. The *Maha Saccaka Sutta* of the *Majjhima Nikaya* provides a visceral description, stating that:

because I ate so little, my protruding back-bone became like a string of balls ...

My gaunt ribs became like the crazy rafters on a tumbled down shed.[8]

The passage culminates with the hauntingly poetic image of Gautama reaching for his stomach and feeling his spine beneath the sagging skin.

A diminutive ivory created for personal worship in eighth-century Kashmir (cat. 6b), portrays this period of self-mortification and its eventual conclusion. In three superbly carved vignettes, the sculptor represents Gautama's early

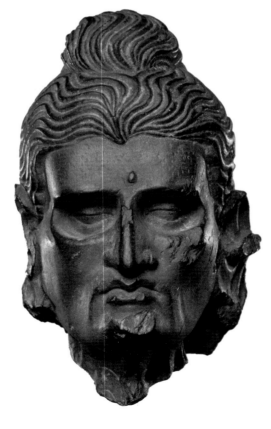

6a *Head of the
Fasting Buddha*

6b *Fasting Buddha*

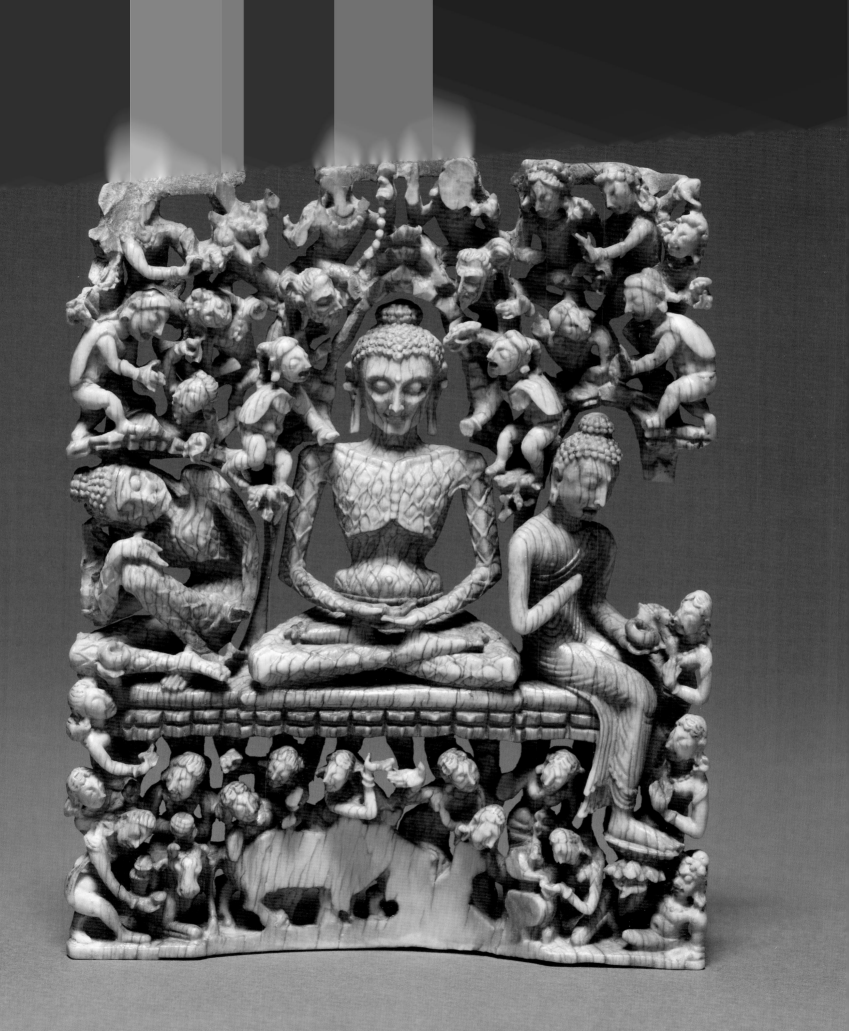

Meditation

8A

Yoga Narasimha, Vishnu in His Man-Lion Avatar

India, Tamil Nadu, ca. 1250
Bronze, 55.2 cm
The Cleveland Museum of Art,
Gift of Dr. Norman Zaworski, 1973.187[1]

8B

Hanuman as Yogi

India, Kerala, Cochin, early 19th century
Teak wood and color, 37.6 × 37 × 9.5 cm
Victoria and Albert Museum, London, IS.2564E-1883[2]

8C

The Goddess Bhadrakali Worshipped by the Sage Chyavana

From a Tantric Devi series
India, Pahari Hills, ca. 1660–70
Opaque watercolor and gold on paper, 21.3 × 23.1 cm
Freer Gallery of Art, F1997.8[3]

*8a Yoga
Narasimha, Vishnu
in His Man-Lion
Avatar*

Meditation as a means to transcend the suffering of existence seems to have emerged in northern India around the fifth century BCE. In the *Yoga Sutras* of Patanjali (second to fourth century CE), it is key to stilling the fluctuations of the mind, which obscure pure consciousness and higher awareness.[4] Patanjali identifies three phases of meditation: the concerted fixing of the mind (*dharana*); effortlessly centered concentration (*dhyana*); and the transformative realization that the seer and the seen are one (*samadhi*).[5] With variations, such as focusing the mind on a deity as revealed by Krishna in the *Bhagavad Gita*, meditation became a pillar of most later yoga traditions.

South Asian artists often represented great sages, enlightened beings, and deities in the act of meditation to convey their spiritual attainment. The most ubiquitous signifiers of meditation, visible in sculptures and paintings throughout this catalogue, are the symmetrical, motionless postures of sitting in *padmasana* or standing with upright spine and arms extended downward. Here, two sculpted images reveal how the iconography of the *yogapatta* (yoga strap) was employed to convey the specifically yogic personae of Hindu gods with multiple identities.[6] The practice of meditating on a deity receives explicit attention in the discussion of *The Goddess Bhadrakali Worshipped by the Sage Chyavana*.

In one of his salvific interventions to restore order on Earth, Vishnu manifested as the half-lion and half-man Narasimha to protect the young devotee Prahlada from his murderous demon-father. The *Bhagavata Purana*, a canonical sacred text, relates that Narasimha then taught Prahlada *bhakti* yoga, the path of worshipful devotion.[7] From the ninth century onwards, South Indian sculptures often depict Narasimha seated with a *yogapatta*.[8] The iconographic type conveys that the divine man-lion is meditating; it may also signify that he is teaching *bhakti* yoga.

Energy flows fluidly through a brilliantly realized bronze Narasimha (cat. 8a), which was created in Tamil Nadu during the Chola dynasty. From the stable base of crossed legs held tautly by a *yogapatta*, the god's tapered waist rises smoothly toward broad shoulders. The leonine ruff encircling Narasimha's neck and the mane curling down his shoulders seamlessly connect the powerful conical mass of his crowned head to the long diagonal of his frontal arms relaxed in meditation. Narasimha's two rear hands bear the flaming chakra disc and conch (now missing) of Vishnu; the large prongs on the base were made to support a separately cast aureole (*mandorla*).

Hanuman, the beloved monkey general of the Hindu epic the *Ramayana*, is most widely worshiped as an exemplary devotee of Rama. The simian god is also recognized as a great yogi (*mahayogi*) with extraordinary powers of healing.[9] These identities are not incompatible. We find, for example, that the *mahayogi* Hanuman is a divine exemplar for the Vaishnava renouncers known as Ramanandis, whose path combines hatha yoga with ardent devotion (*bhakti*) to Vishnu and his incarnation Rama (see cats. 19a–b). Indeed, for Ramanandis, Hanuman is equally an incarnation of Shiva and Rama's paramount devotee.[10]

A vigorously carved teak relief (cat. 8b) represents Hanuman meditating with a *yogapatta* around his knees and his arms and eyes raised adoringly. Its sculptor effectively contrasted the god's sturdy limbs with the laser-sharp folds of swirling garments so that Hanuman's body appears to thrust forcefully forward and upward. Conveying Hanuman's nature as both powerful yogi and ardent devotee, the panel once adorned the ceiling of a temple hall in Kerala.[11]

With pulsating intensity, *The Goddess Bhadrakali Worshipped by the Sage Chyavana* (cat. 8c) depicts the gentle form that the fierce goddess

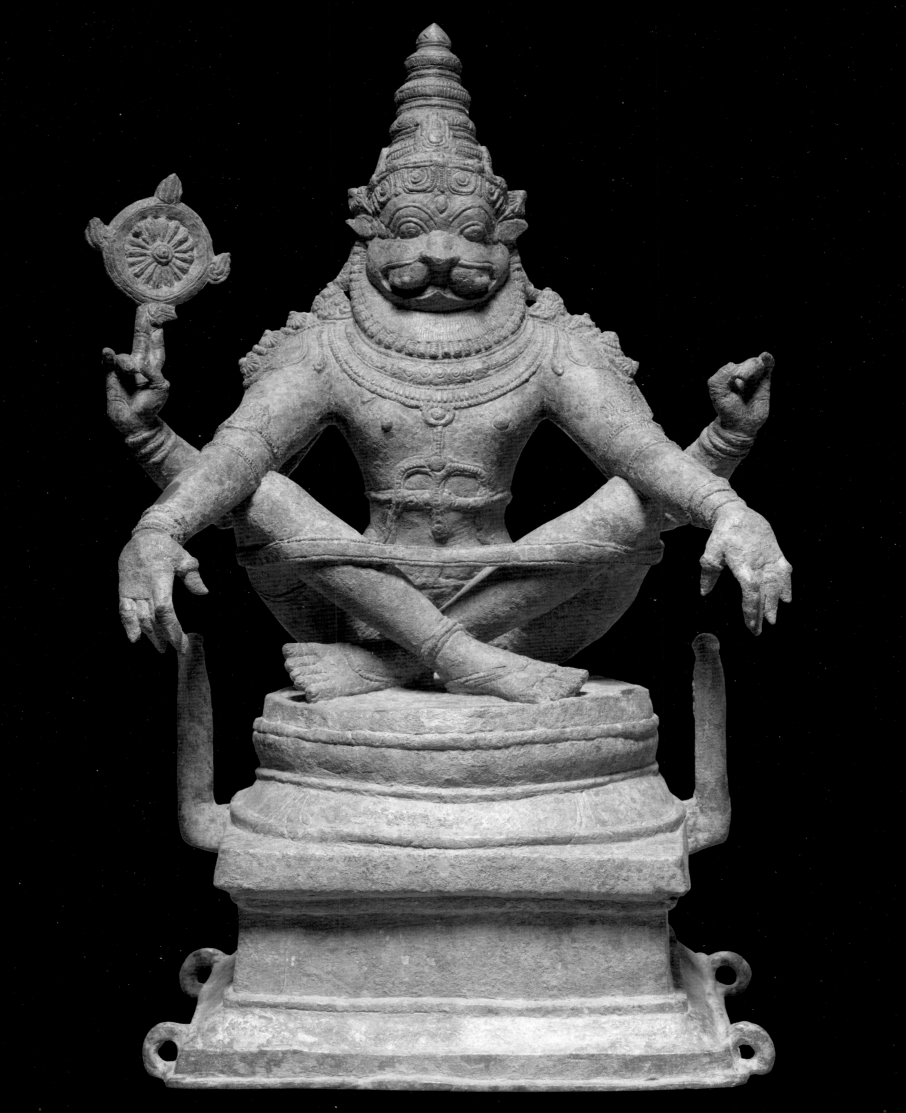

assumed in response to the meditation of the sage.[12] On its left, the bearded Chyavana holds a strand of prayer beads that suggests he is reciting mantras (sacred syllables) as he gazes fixedly at the shimmering golden-skinned goddess. Bhadrakali, her lotus-eye tinged in red, wears a crown adorned with emeralds cut from the iridescent wings of beetles and holds the attributes of the god Vishnu—lotus, conch shell, mace, and discus—in her four hennaed hands. She sits on a bloated corpse that invokes her cremation ground haunt (see cat. 16).

Created for a Tantric practitioner (*sadhaka*) in northwest India during the seventeenth century, the painting is one from a series representing manifestations of the great goddess (Devi).[13] A *dhyana* verse, a description of Bhadrakali that guides ritual visualization to invoke her presence, is inscribed on the painting's verso in *Takri* script.[14] In its totality, the folio thus makes the goddess visible in three ways: to the practitioner who recites the verse while meditating upon her form; to the sage Chyavana (within the painting); and to those who view the image today. DD

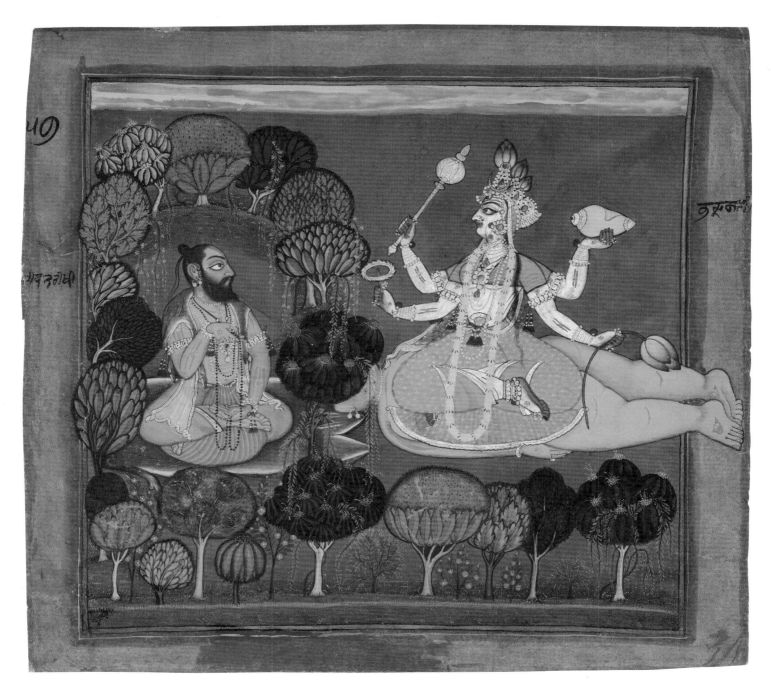

8c *The Goddess*
Bhadrakali
Worshipped by the
Sage Chyavana

Asana

9
Ten folios from the *Bahr al-hayat*
(*Ocean of Life*)

India, Uttar Pradesh, Allahabad, 1600–1604
Opaque watercolor on paper, 22.7 × 13.9 cm (folio)
The Trustees of the Chester Beatty Library, Dublin[1]

9A
Virasana (Persian, *sahajasana*)

13.3 × 7.8 cm (painting)
In 16.10a

9B
Garbhasana (Persian, *gharbasana*)

10.6 × 7.8 cm (painting)
In 16.18a

9C
Nauli Kriya (Persian, *niyuli*)

Attributed to Govardhan
9.5 × 8 cm (painting)
In 16.19a

9D
Headstand (Persian, *akucchan*)

9.6 × 7.8 cm (painting)
In 16.20a

9E
Untitled (Persian, *nashbad*)

13.5 × 7.6 cm (painting)
In 16.21b

9F
Untitled (Persian, *sitali*)

12.6 × 7.8 cm (painting)
In 16.22a

9G
Khechari Mudra (Persian, *khechari*)

10.6 × 8.5 cm (painting)
In 16.24a

9H
Kumbhaka (Persian, *kunbhak*)

8 × 7.8 cm (painting)
In 16.25a

9I
Sthamba (Persian, *thambasana*)

13.6 × 7.8 cm (painting)
In 16.26b

9J
Untitled (Persian, *sunasana*)

11.5 × 7.7 cm (painting)
In 16.27b

Note: The italicized words represent how
the posture was rendered in the Persian text
of the Chester Beatty Library *Bahr al-hayat.*

9g Khechari Mudra

Yoga today is often identified with the practice of a broad range of bodily postures called *asana*s. This identification has been traced to the twentieth century, when new technologies of reproduction circulated both yoga systems and *asana* imagery across the globe.[2] However, the earliest known treatise to systematically illustrate yoga postures,[3] the *Bahr al-hayat* (*Ocean of Life*), dates to the turn of the seventeenth century. This essay examines the specific conditions for the production of this unprecedented treatise and considers its twenty-one *asana*s, which are almost all seated postures for meditation on various unconditioned forms of the absolute, within a broader historical trajectory of the development of *asana*s.

The Sanskrit word *asana* ("aa-suh-nuh") is a noun meaning "seat" or "the act of sitting down" derived from the verbal root *ās*, which means "to sit" or "to remain as one is." Until the end of the first millennium CE, when used in the context of yoga, *asana* referred to simple seated postures to be adopted for meditation. This is true for all formulations of yoga, including those of the classical tradition rooted in Patanjali's *Yoga Sutras* (circa 325–425 CE)[4] and those of the Tantric tradition, whose earliest extant *asana* teachings date to the sixth century.[5]

It is in the hatha method of yoga, which was codified in texts from the eleventh century onward, that the more complex, non-seated *asana*s that have become synonymous with yoga practice gain prominence. Two thirteenth-century texts, the earliest to teach *asana* as part of hatha techniques, proclaim that there are eighty-four *lakh* (8,400,000) *asana*s, but describe only two, both of which are seated postures.[6] The fifteenth-century *Light on Hatha* (*Hathapradipika*),[7] the best known Sanskrit text on hatha yoga and the first to be devoted solely to the subject, describes fifteen *asana*s, of which seven are non-seated positions

for meditation. Some of its verses teach non-seated *asana*s found in earlier works. The peacock posture, *mayurasana*,[8] has the oldest heritage. Its description in the *Light on Hatha* is taken from a thirteenth- or fourteenth-century yoga manual composed in a Vaishnava milieu, i.e., among followers of the Hindu god Vishnu,[9] but can be traced back through other Vaishnava texts to one from approximately the ninth century.[10]

The *Light on Hatha*'s description of the cock posture, *kukkutasana*,[11] also can be traced to earlier Vaishnava works.[12] The practices of hatha yoga are often said to have originated among Tantric Shaivas, i.e., followers of Shiva, but these early references to non-seated *asana*s in Vaishnava works suggest different origins for at least some hatha yogic techniques; the absence of non-seated *asana*s in Shaiva works prior to the *Light on Hatha* further increases the likelihood of them having originated outside of Tantric milieus. In a circa thirteenth-century collection of teachings ascribed to the Kaula Tantric guru Matsyendra,[13] one of the first gurus of the Nath order of yogis, both the peacock and cock are included among the *asana*s of yoga, but they are seated positions quite different from the non-seated postures of the same name found in the Vaishnava tradition.

One of the *asana*s taught in the *Light on Hatha* is the corpse pose, *shavasana*, classed in an earlier work as one of the secret techniques of *laya* yoga, the visualization-based "yoga of dissolution" taught by Shiva.[14] This is an early example of a phenomenon that becomes more and more common, namely the classification as *asana*s of physical practices that did not originate as such. Thus some of the techniques called *mudra*s taught in the earliest texts of hatha yoga, such as *mahamudra* (the great seal) and *viparitakarani* (the inverter), become *asana*s in later works, with the latter, in which the body is inverted, becoming either *sarvangasana*,

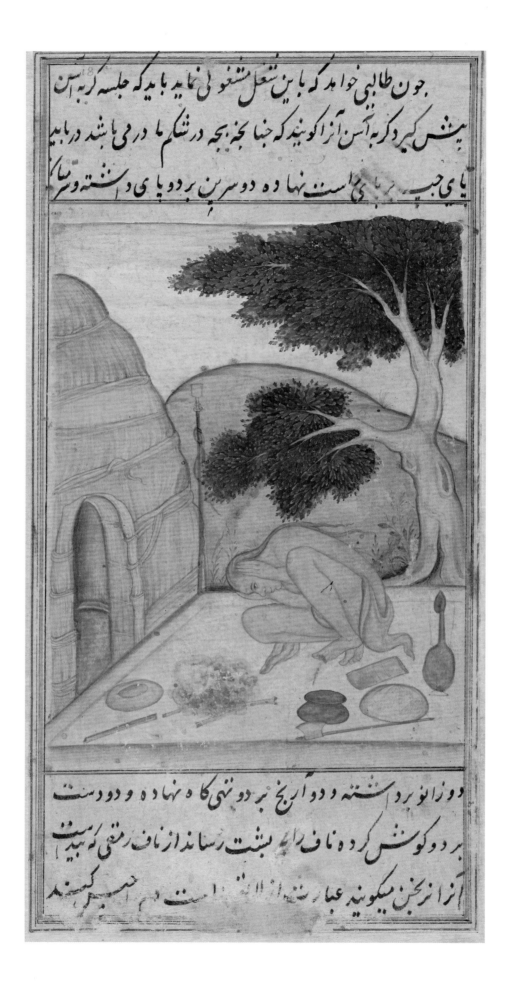

چون طالبی خواهد که باین تشغل مشغولی نماید باید که جلسه کربه اسن
پیش کیرد که به اسن آزا کویند که جنا بجه درشکام ما درمی باشد درباید
یای حبر نبای پاسن نهاده دوسرین بردو یای دسنته وشر پاکم

دو زانو برد اسنته و دو آرنج بر دو تنی کاه نهاده و دو دست
بر دو کوشش کرده ناف را یه ببنت رساند از ناف رمنی که بید
آنرا ازنخن میکویند عبارنه ا الا اسنت دم حسید کمند

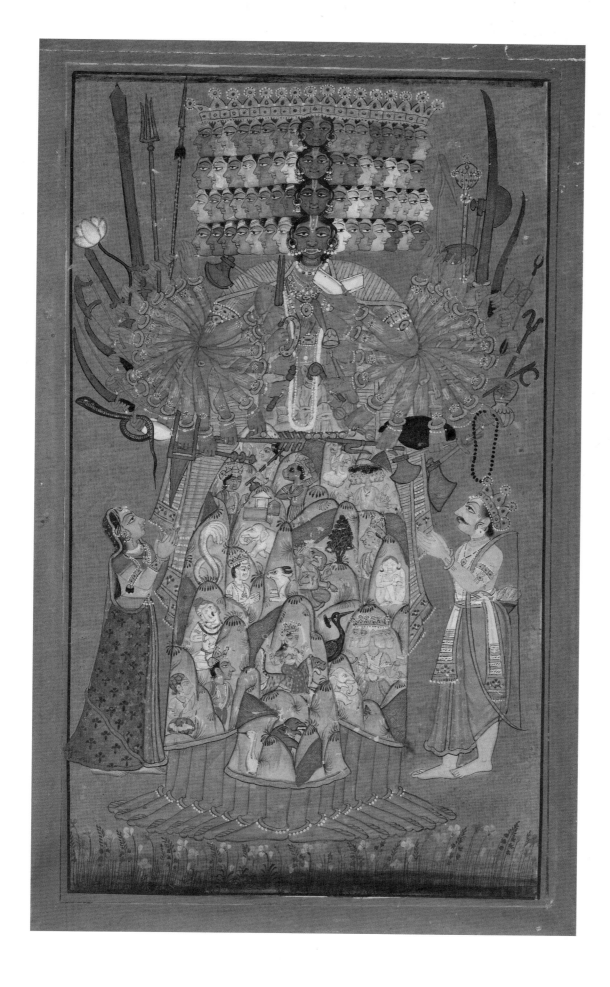

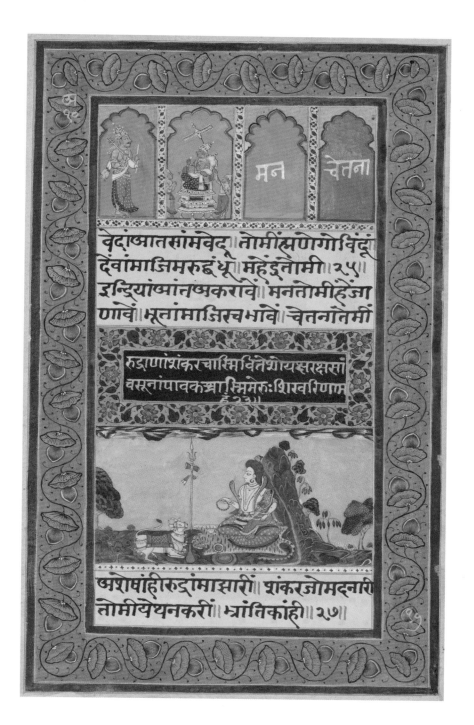

10c *Forms of*
Vishnu

contained within the *Samaveda* as a divine musician and the Vedic deity Indra as an enthroned king. In the niches at right, the words *man* (mind; Sanskrit: *manas*) and *chetana* (consciousness) are written in gold Devanagari script to convey the *Gita*'s litany of who and what Krishna is in the universe. The divine ascetic Shiva, attended by the goddess Parvati and the bull Nandi, meditates on Mount Kailash in the more fully realized Himalayan landscape at bottom.

The folio belongs to an eighteenth-century luxury manuscript of the *Jnaneshvari*, a vernacular commentary on the *Bhagavad Gita* that demonstrates one of the continuous transformations of yoga in history. Composed in the regional language of Marathi in the thirteenth century by the poet-saint Jnanadeva, the commentary is framed as Lord Vishnu's exposition of Shiva's esoteric knowledge. It elucidates and glosses the *Gita*'s Sanskrit verses (here, in gold script) with vernacular explications (here, in black) that include Shiva among Krishna's manifestations as well as hatha yoga teachings, such as techniques for raising Kundalini energy through the subtle body. Made for a Maratha nobleman or merchant, the illustrated *Jnaneshvari* is characterized by a decorative vigor and representational heterogeneity that reflects the spirit of the synthetic commentary, which made hatha yoga accessible to broader (i.e., non-initiated and Marathi-speaking) audiences.

Almost four feet in height, a monumental folio from the *Siddha Siddhanta Paddhati*, an illustrated hatha yoga treatise, depicts an advanced adept (*siddha*) blissfully experiencing his equivalence with the universe (cat. 10d). At the core of hatha yoga is the understanding that everything—from the limitless Absolute to the lowest forms of inert matter—is essentially one, yet is manifested differently. This essential sameness allows the yogic practitioner to progressively convert his gross body into subtle matter and become an even greater being than a god. With the sun and moon (sometimes identified with the *ha* and *tha* of hatha yoga) as his cheeks, the *siddha* stands with his eyes crossed in meditation. Reflecting its patronage by a maharaja, the folio is lavishly gilded, and each of the universe's fourteen worlds is depicted as a white palace city.[14] The artist masters the paradox of representing yogic insight by situating the viewer of the painting as an imperfect witness of the transcendent cosmos. The palace walls, which create the painting's only areas of tangible depth, are simultaneously negated by the flatly rendered figures, the painting's gleaming surface, and the high relief of the yogi's pearls.[15] The image oscillates between surface and depth, between materiality and illusion. What the yogi perfectly knows, the viewer only fleetingly apprehends in the painting's flicker and glare. DD

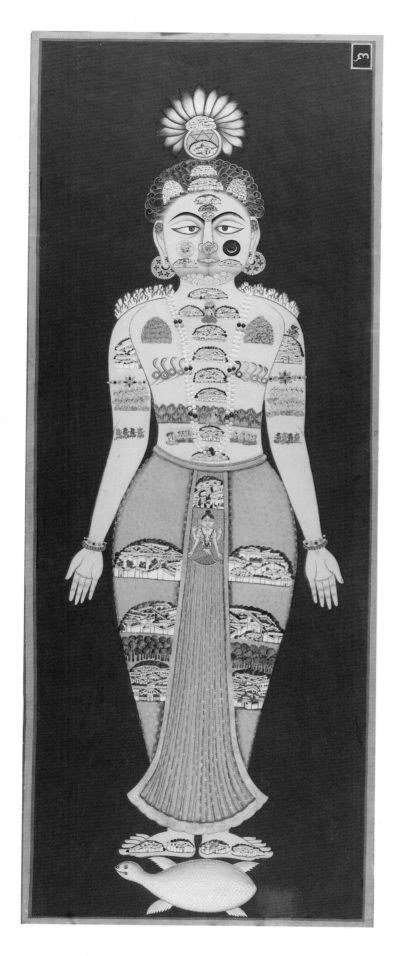
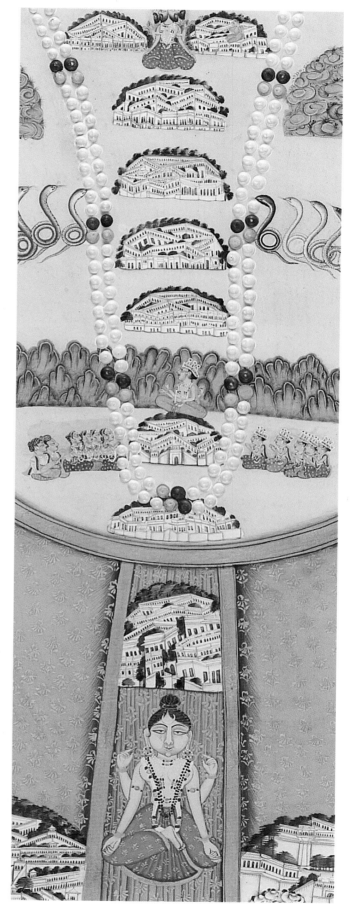

The Subtle Body

11A
The Knots of the Subtle Body

India, Himachal Pradesh, Nurpur, ca. 1690–1700
Opaque watercolor and ink on paper, 20 × 14 cm
The Cleveland Museum of Art, Edward L. Whittemore
Fund, 1966.27[1]

11B
The Chakras of the Subtle Body

Folio 4 from the *Siddha Siddhanta Paddhati*
Bulaki
India, Rajasthan, Jodhpur, dated 1824 (Samvat 1881)
Opaque watercolor and gold on paper, 122 × 46 cm
Mehrangarh Museum Trust, RJS 2376[2]

11C
Scroll with Chakras

India, Kashmir, 18th century
Opaque watercolor, gold, silver, and ink on paper,
376.7 × 17 cm
Victoria and Albert Museum, London, IS.8-1987[3]

The physiology of yoga is centered on the subtle body (*sukshma sharira*), the interface between the individual body composed of gross matter and the formless Absolute (*brahman*).[4] By manipulating the subtle body through meditation, physical practices, or a combination of the two, the yogic practitioner sought to refine his consciousness and become one with the Absolute.[5]

A diagram of the subtle body from Nurpur (Himachal Pradesh) represents the kingdom's ruler, Raja Mandhata (reigned 1661/1667–1700), engaged in yogic practice (cat. 11a).[6] With a lotus-tipped crown and the mustache of a warrior, the king sits with his legs crossed in what may be *siddhasana*, in which the lower heel is pressed against the perineum. In hatha yoga, *siddhasana* was used to raise the breath to pierce three subtle loci known as knots (*granthi*): the *Brahma granthi* located at the base of the spine, the *Vishnu granthi* at the heart, and the *Rudra granthi* between the eyebrows.[7] Here, they are depicted with the conventional iconography of the Hindu gods with whom they are identified—four-headed Brahma, blue-skinned Vishnu, and Rudra (Shiva), who appears as a two-armed yogi with ash-pale skin and a *jata*-topknot adorned with the crescent moon.[8] An unconventional ruler portrait and a rare depiction of the three *granthi*, the Nurpur painting not only suggests that Mandhata was a committed practitioner, it also points to the key role that kings played in creating the visual archive of yoga.

Most hatha yoga systems map the energy centers, or chakras (rather than *granthis*) of the subtle body. Chakras are invariably located in a vertical hierarchy along the body's central channel (*sushumna nadi*), but are somewhat differently conceptualized in various yoga treatises, and can number anywhere from six to fourteen. For example, the *Siddha Siddhanta Paddhati* (SSP), a foundational Nath treatise, describes nine chakras.[9]

Reflecting Nath goals, each chakra is presented as a focus for meditation that yields a specific attainment—such as universal admiration, release from the cycle of rebirth, or supernatural abilities.[10] The canonical text was first illustrated in 1824 at the Jodhpur court during the reign of Maharaja Man Singh (reigned 1803–43), a devotee of the *siddha* Jalandharnath and a patron of the Naths. On its fourth folio (cat. 11b), the nine chakras are arrayed on the body of an adept with his eyes crossed in inward meditation. Monumental in size, finely painted with glowing colors, the chakras shaded to increase their glowing quality, the folio exemplifies Man Singh's conspicuous piety. There is no known visual precedent for this highly abstracted set of chakras, although the evidence of other contemporaneous Jodhpur manuscripts strongly suggests that learned Nath yogis guided the court artists who represented, for the first time, esoteric concepts such as absolute emptiness (*shunya*). Here, *shunya*, the profound void that is the sixth chakra (located near the palate) is depicted as a black circle on the yogi's chin.[11] Other chakras are more figuratively realized: the goddess who sits just atop the serpent-belt securing the yogi's lower garment corresponds to the text's description of the third chakra as Kundalini Shakti seated within five coils.

During the eighteenth and nineteenth centuries, illustrated chakra charts were also produced in the form of long scrolls. In these, the horizontal span of the paper, rather than a human body, serves as the ground on which chakras are aligned along a gently winding *sushumna* channel. Over twelve feet long, a grand scroll from Kashmir depicts twelve chakras and seven underworlds disposed along a narrow golden channel (cat. 11c).[12] The first (and lowest) chakra is conventionally represented with its four sacred syllables on the four red petals of a lotus; at its center Ganapati (Ganesha) sits with his two wives.[13] The third chakra located at the navel reveals how the forms and

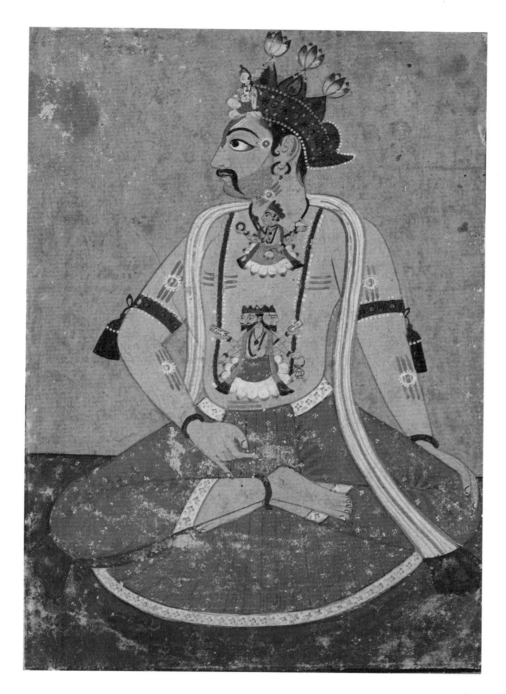

11a *The Knots of
the Subtle Body*

deities of chakras varied across systems.[14] In the SSP, it is the energy center of the goddess Kundalini; in the Kashmiri scroll, it is identified as the divine couple Vishnu and Lakshmi, who are depicted within a ten-petaled golden lotus that also extends along the golden channel to a coil, an embryo in a womb, and a yogic adept.

If they vary in details, both the SSP's fourth folio and the scroll demonstrate the inherent continuity between the subtle and macrocosmic bodies. The SSP stipulates knowledge of the subtle body as a prerequisite for realizing the self as cosmos. In the Jodhpur manuscript, visual similitude links the somatic conceptions, illustrated respectively on folios 4 and 6 (cats. 11b, 10d): the two are the only vertical pages in the manuscript, and both similarly adorned and scaled bodies were created from a single master drawing (no longer extant). The Kashmiri scroll suggests the continuity along its vertical axis and the *sushumna* that connects the chakras to seven underworlds. Located directly beneath the Ganapati chakra, each ovoid world contains two white pavilions in a mountain landscape that is supported by an animal or an enthroned goddess seated within a pink lotus. The scroll concludes with a diagrammatically mapped universe represented as an ethicized hierarchy from its highest heaven to its lowest underworld; the name of each world is written in *Sharada* script within a red circle.

Today, seven is widely accepted as the standard number of chakras, and their symbols are fixed.[15] Differing in number and iconography, these images reveal that a multiplicity of subtle body systems flourished in medieval and early modern India. DD

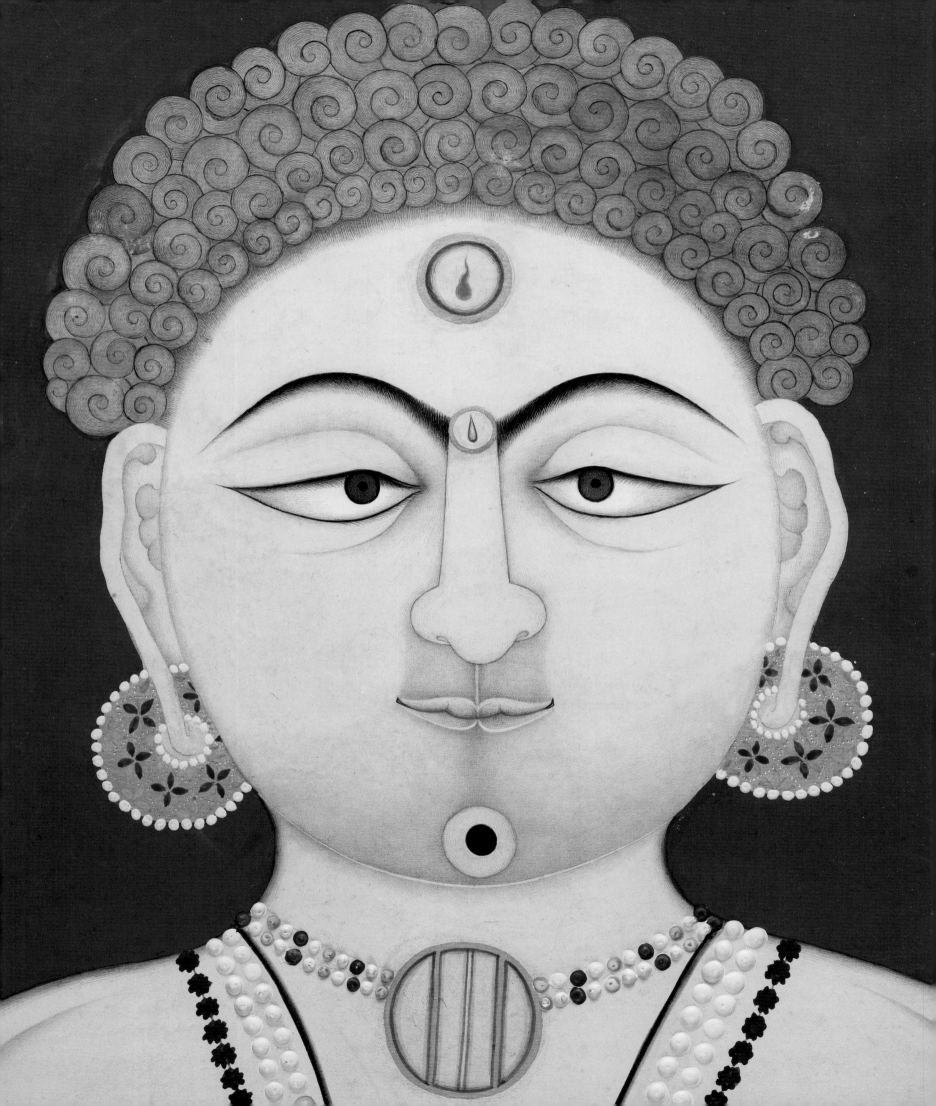

Illusion and Reality in the *Yoga Vasishta*

13
The Sage Bhringisha and Shiva

Folio 304b from the *Yoga Vasishta*
Attributed to Keshav Das
India, Uttar Pradesh, Allahabad, 1602
Opaque watercolor, gold, and ink on paper,
27 × 18.5 cm (folio); 15.9 × 9.9 cm (painting)
The Trustees of the Chester Beatty Library,
Dublin, In 05, f.304b[1]

The *Yoga Vasishta* (*Teachings of the Sage Vasishta*) is an important and highly popular philosophical work composed in Kashmir between the tenth and thirteenth centuries. Eventually, it eclipsed the *Yoga Sutras* as the most widely copied manuscript in all of India on the topic of yoga. The *Yoga Vasishta*'s great attraction surely lies in the fact that it presents its highly abstruse philosophical positions through engrossing stories involving kings, mysterious yogis, powerful women, and a host of other colorful characters.[2] The lesson of these stories is grounded in the *Yoga Vasishta*'s unique philosophy, which combines Advaita Vedanta, Buddhist idealism, and the metaphysics of the Kashmiri Tantric school known as Trika. Advaita Vedanta, which had become the leading philosophical doctrine by the time of the *Yoga Vasishta*, is characterized by its nondualist metaphysics, according to which there is only one self in the universe, the absolute Self known as *brahman*. However, due to cosmic illusion (*maya*) or ignorance (*avidya*), humans believe that they are possessed of unique individual selves that, independent of *brahman*, enliven their bodies.

The *Yoga Vasishta*'s central concern is to explain how, through ignorance, individual minds (or egos) actually project or create the illusory phenomenal world they mistake for reality. The waking reality that the mind experiences is likened to dreams, which appear real when one's mind projects them, or the flights of fancy of the creative imagination.[3] Yet all are fundamentally illusory. The "yoga" of the *Yoga Vasishta* is the practice by which the philosopher-practitioner deconstructs these illusions and recovers the universal reality of the one absolute Self. This yoga is taught through stories, such as the one illustrated here.

The *Yoga Vasishta* was first illustrated in 1602 at the court of the Mughal Prince Salim (the future Emperor Jahangir, reigned 1605–27). Salim, a Muslim, had commanded that the Sanskrit treatise be translated into Persian, the court language, because he recognized it as "one of the famous books of the Brahmins of India" and found it compatible with Sufi mysticism.[4] The luxurious manuscript includes forty-one delicately colored paintings by some of the finest artists who accompanied Salim to his court at Allahabad between the years 1600 and 1605.

In the penultimate book of *The Teachings of the Sage Vasishta,* Shiva—the god that the Trika school identified with the absolute *brahman*—reveals to Bhringisha, an accomplished renouncer, the means for attaining embodied liberation. When this happens, "one dwells in a state released from 'oneness' or 'twoness' ... neither in *nirvana* nor not in *nirvana*, [shining] brightly, outwardly free, inwardly free, free like the piece of sky in a jar."[5] The painter Keshav Das represented Shiva's appearance to Bhringisha as an encounter between a Tantric yogi and a gaunt and aged renouncer[6] (cat. 13). A master of the naturalistic style favored by the Mughals, Keshav Das created a vertical landscape of convincing depth by diminishing the size of distant objects and bathing the furthest vistas in a hazy mist. By placing darker forms directly behind the heads of Shiva and Bhringisha, he made the pair palpably three-dimensional and emphasized the intensity of their mutual gaze. The softly craggy peaks bending toward each other in the middle distance further underscore their communion. If Bhringisha's sunken belly and attenuated limbs recall the earliest images of ascetics (see cats. 6c, 6d), the bony volumes of the sage's skull, the convincing weight of his elbow on his thigh, and the fleshy soles of his upturned feet speak to the Mughal interest in the appearance of the real. In his representation of Shiva, Keshav Das tellingly accentuates the characteristics—bluish, ash-smeared body; topknot of dreadlocks (*jatamukuta*); and tiger-skin

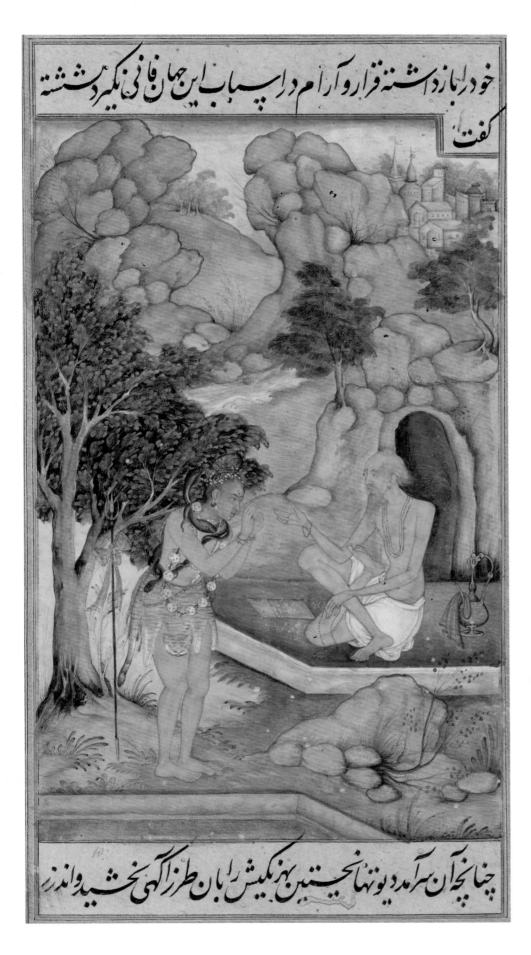

wrap—that the god shares with mortal yogis. He also minimizes the god's divine qualities: Shiva has two arms; his lightly drawn third eye looks like a sectarian forehead mark; and the snakes that writhe around his shoulders and the garland of skulls hanging from his neck seem to be plausibly real, if exotic, ornaments. DD

Ashram and Math

To correctly perceive reality, the yoga practitioner must first settle the body. The *Bhagavad Gita* describes how concentrating the mind begins "on a clean spot [where the yogi] builds for himself a firm seat, neither too high nor too low, covered with cloth, deer-skin or kusha grass."[6] Though yogis might establish their seats anywhere, the inherent power of certain places was understood to increase the fruits of practice. Among the most perennially potent were mountain peaks, the confluence of rivers, remote caves, isolated huts (*kuti*), verdant hermitages (ashrams), and cremation grounds.

Before the mid-sixteenth century, South Asian sculptors and painters only schematically represented spatial contexts, focusing their attention on the human or divine body. But in the Mughal atelier under Emperor Akbar (reigned 1556–1605), painters began to represent believable, at times specific, places as the stages for human activities.[7] As the new interest spread to other courts, artists increasingly depicted yogis within detailed and symbolically charged settings. These pictorial imaginings of place are typically tranquil and verdant. More unusual are images of the large, bustling monastic communities in which many yogis spent some time or lived; the icy landscapes of Himalayan pilgrimage; and the bone-strewn charnel grounds of Tantric practice (see cats. 15a–d, cat. 16). Here, we consider how court painters envisioned the communal spaces of hermitage (ashram) and monastery (*math*) in the early modern period (sixteenth to nineteenth century).

Ashrams are the archetypal refuges for study and contemplation. Their sacred campfires (*dhuni*), straw-roofed huts, and fecund natural settings entered the visual record as early as the first century CE.[8] A magical painting (cat. 14a) from a small Hindu court in the Himalayan foothills depicts yogis leaving their ashram and ascending Mount Kailash to honor Shiva as Yogeshvara (the lord of yogis) and his wife Parvati under a brilliantly starry sky. The ash-white Shiva, whose entourage includes celestial beauties and animal-headed musicians rendered with visionary clarity, affectionately gazes toward the sages for whom he is the yogic archetype. The three ascetics who eagerly lean forward with flower-garland and leaf-cup offerings organically connect the ashram in the lower valley with the clearing in which the gods appear, emphasizing that it too is suffused with the sacred.

Nestled between a gold sky and silvery river, the verdant ashram in a Mughal painting (cat. 14b) invokes the lush riverside locations that were extolled in literature and inscriptions as particularly suited to expanding consciousness.[9] In the clearing, an aged female guru sits on an antelope skin that befits her senior status and quietly converses with a disciple wearing *jata* wrapped neatly atop her head.

Ashrams were and are often segrated by gender, and Mughal paintings of women's ashrams are unusual.[10] In contrast, male ascetics were a popular subject for imperial painters, who often represented Mughal princes and princesses visiting Hindu yogis in sylvan settings. Many were lightly tinted drawings that enabled artists to display their facility in rendering anatomy, as in the delicately shaded and sepia-toned bodies of three ascetics on the right of a seventeenth-century composition (cat. 14c). The youngest, a disciple, charmingly peers out from a doorway of what seems to be small monastic complex.

By the sixteenth century, pilgrimage and trade networks provided monasteries with wealth, political power, and transregional visibility. Akbar's fascination with yogis underlies a pictorial interpretation of his grandfather Babur's 1519 visit to Gurkhattri (cat. 14d), a *math* outside Peshawar (Pakistan), as described in the latter's memoirs.[11] The painting,

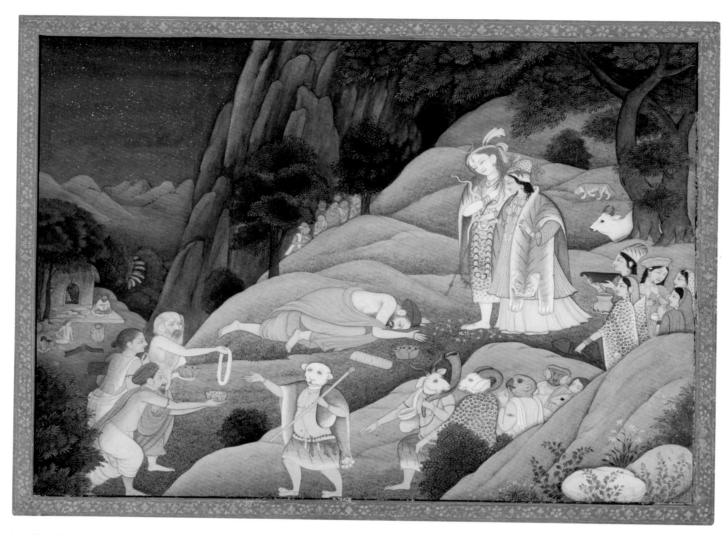

14a *Shiva Blesses Yogis on Kailash*

produced in the imperial workshops of the late sixteenth century, is a gloss on Babur's disappointing visit, when he encountered no yogis and saw only "a small, dark chamber like a monk's cell" with heaps of hair that devotees had offered for religious merit.[12] Deviating from Babur's account, Akbar's painters depicted Gurkhattri teeming with yogis. In an open courtyard, ash-blue and scantily clad yogis companionably await their dinner, as the *math*'s corpulent abbot converses with Babur, his royal guest, on a raised platform. Babur's retinue gesture excitedly as they approach the ascetic community.

Politics and intellectual curiosity at Akbar's court infuse the painting's artistic expansion of Babur's penned narrative. The emperor was inquisitive, respectful of Hindu knowledge, and acutely aware of the challenges of creating broad support in a diverse empire. Throughout his reign, he sought out accomplished sages for personal audiences, provided material support to yogis, and had Sanskrit texts translated into Persian (the language of the court) and beautifully illustrated.[13] With a meeting between the dynasty's founder and a holy man at its center, the image seems to project Akbar's engagements with Hindu traditions, practices, and communities rather than Babur's actual visit. The painting probably reflects the significance of the *math* in Akbar's time, when the Nath ascetic order was starting to formalize. Most of the yogis have no sectarian markings, but one (on the left, with outstreched hands and a red loincloth) wears the deer-horn whistle of a Nath around his neck.[14]

Two impressively large early eighteenth-century paintings from Mewar, a Hindu kingdom (in present-day Rajasthan), document the visits of its king, Maharana Sangram Singh II (reigned 1716–34) to the monastery of his guru, a Shaiva *sannyasi* (ascetic). Known as Savina Khera Math, the monastery was constructed in the first decade of the eighteenth century, when the Mewar ruler Rana Amar Singh II (reigned 1700–10) endowed its first two abbots (*gosains*)

with lands that yielded an annual income. Amar Singh's descendants continued their support and visited Savina Khera on ritually set days for guru worship.[15] In turn, the *gosain*s came with their yogis to court for all important religious rituals; paintings also document their attendance at royal entertainments and court assemblies.[16] The relationship was mutually legitimating: religious devotion was essential to proper Hindu kingship, and royal patronage played a signficant role in the perpetuation of yogic lineages.

Both paintings ingeniously deploy multiple perspectives in a cartographic mode. In cat. 14e, the court artist deployed a planimetric view to articulate the relative locations of each structure in the bustling *math*. Atop this ground plan, outer walls, buildings, pavilions, and figures are rendered in elevation view. Beneath the tree at the painting's center, the maharana, adorned with a gold halo, sits in audience with the yogi Bhikarinath.[17] By the pavilion adorned with sacred tulsi leaves and red flags, the maharana appears again, having the white-haired *gosain* Nilakanth weighed against gold that he will present as a gift to the order. Demonstrating both yogic detachment and the compatibility of different spheres of Hindu religiosity, the *sannyasi*s go about their daily activities, unperturbed by the visiting king, the Brahmin priests in the forecourt performing a Vedic ritual, or the weighing ceremony in the pavilion. Their bodies gray from the application of ash, some rest amicably in the shade; others, including an *urdhvabahu* (one whose austerity is permanently upraised arms) mill about, two meditate with prayer beads in their hands, and one worships a lingam (an icon of Shiva) in a small domed shrine.

Sangram Singh appears again in a boldly abstract yet cartographically precise painting of the semi-arid hunting grounds between the capital city Udaipur and Savina Khera *math* (cat. 14f). The artist vertically aligned the maharana's

procession to chart its southward movement against the scrubby terrain. The stout ruler can be quickly identified by his ceremonial feather standard, a bold black circle with a bright white center. He appears first approaching the *math* on horseback and then again, on foot and with his hands raised (both gestures of respect), as he receives the blessing of the white-haired *gosain*. DD with AL

14c Three Women Present a Young Girl to Aged Ascetics

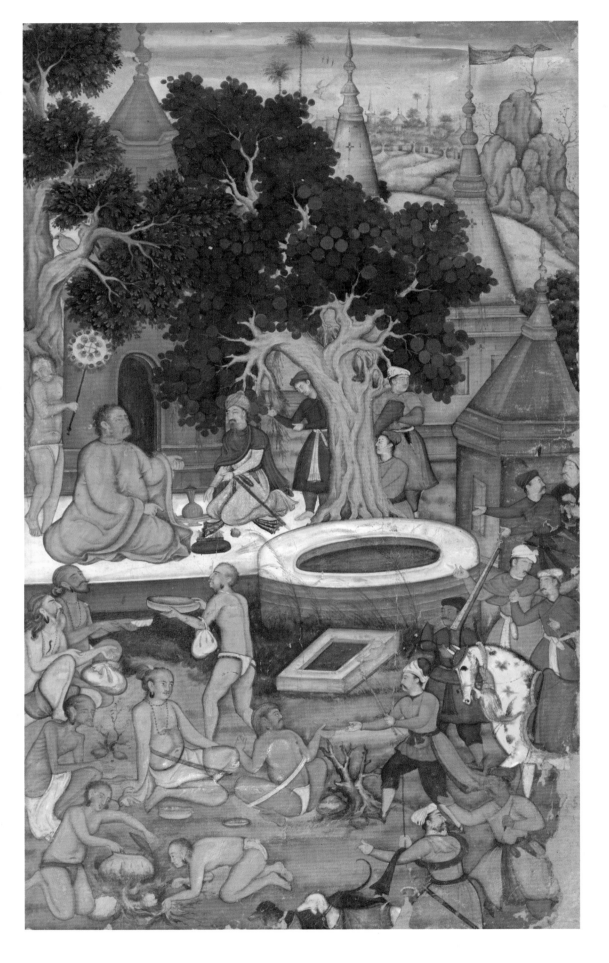

14e *Maharana
Sangram Singh
of Mewar Visiting
Savina Khera
Math* (detail,
following pages)

14f *Maharana Sangram Singh II Visiting Gosain Nilakanthji after a Tiger Hunt*

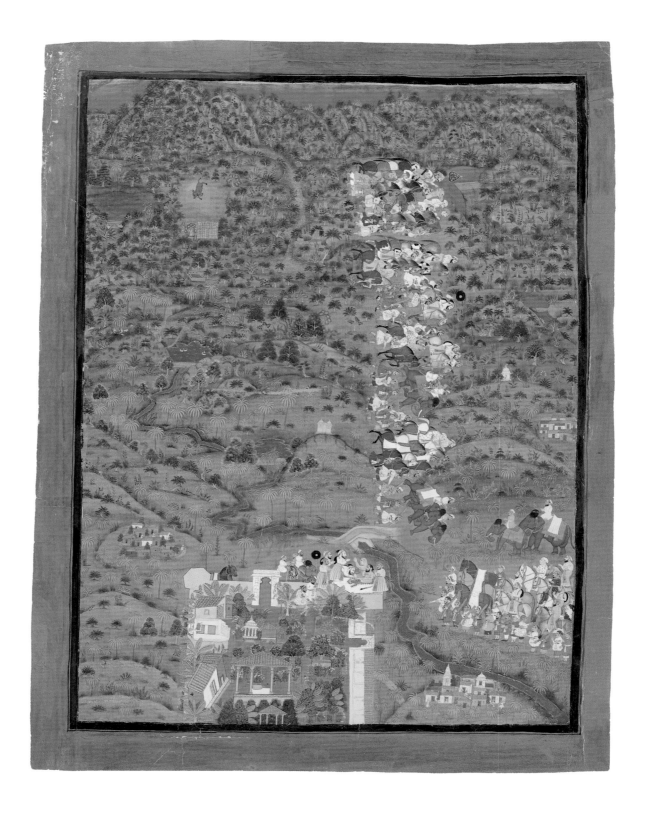

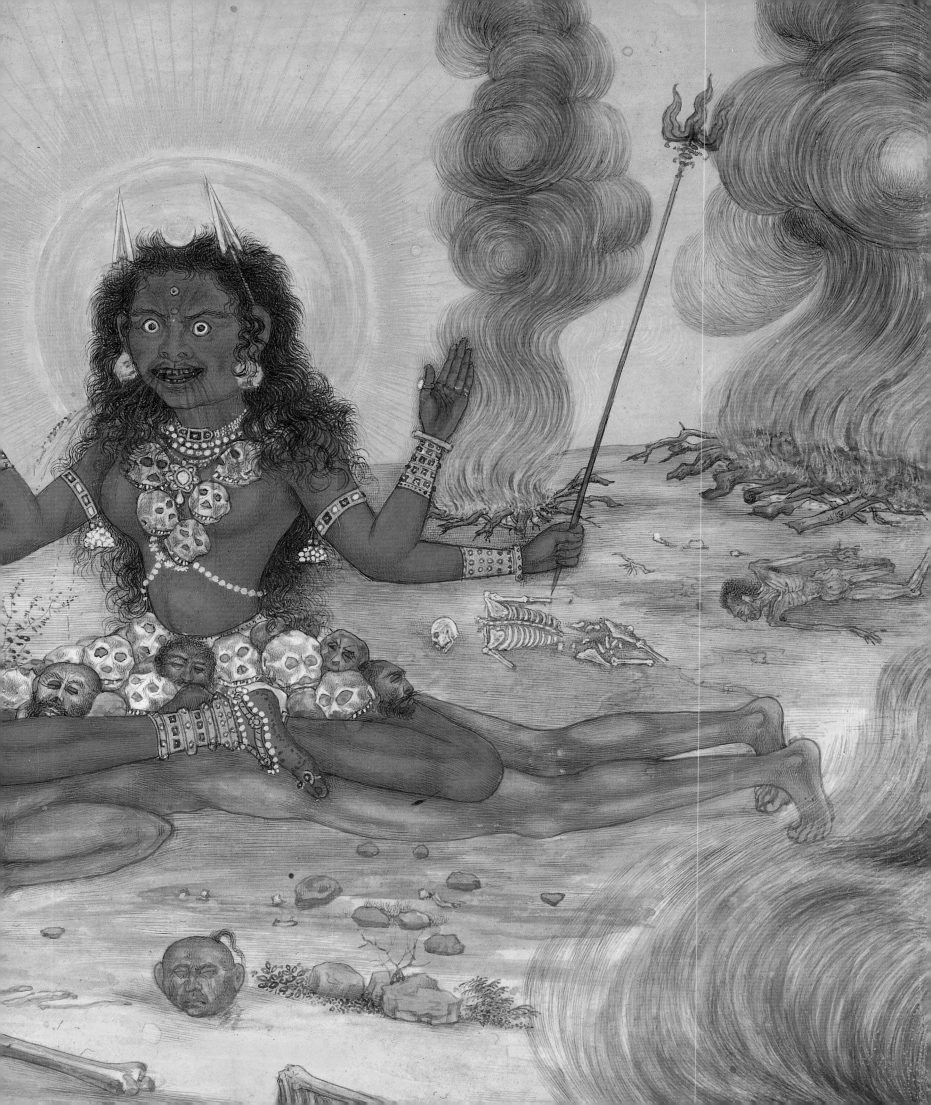

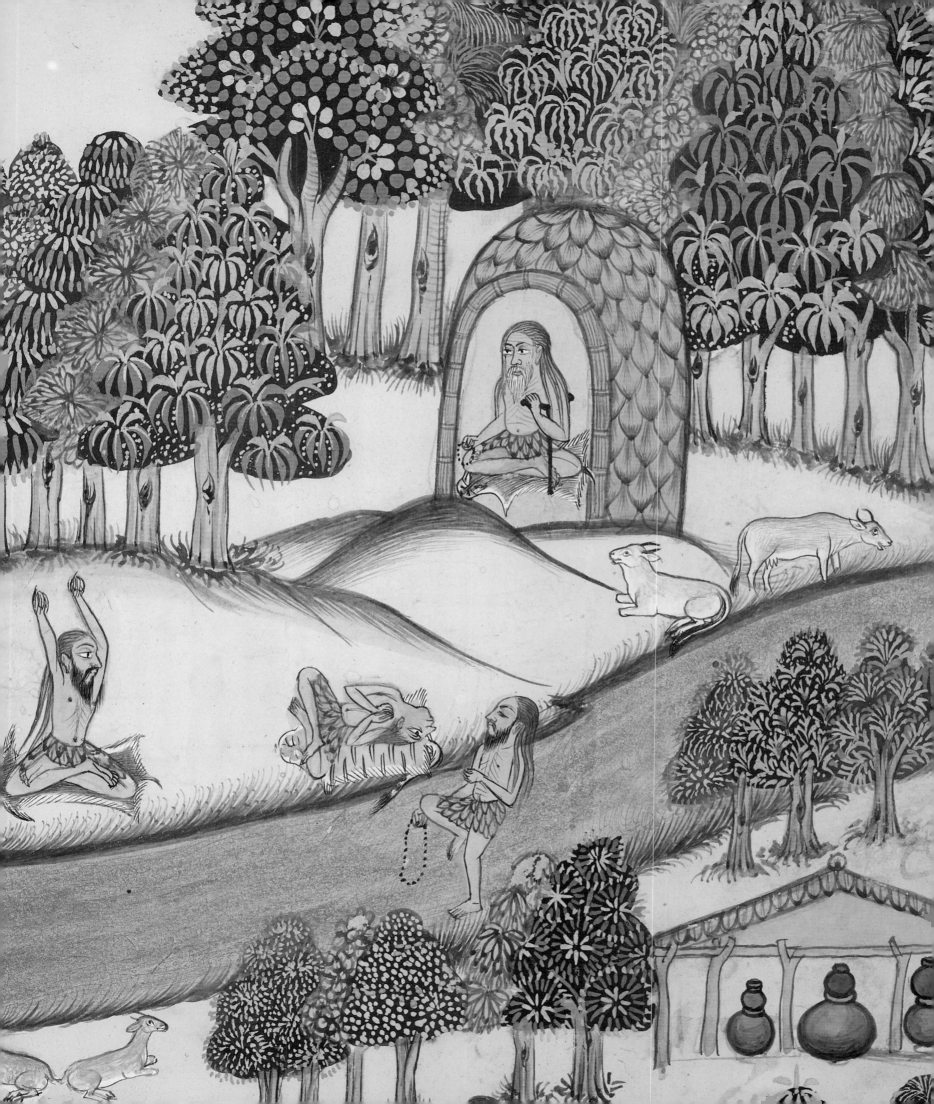

of Hindu and Muslim asceticism, pointing to the slippage between Sufi and yogic identities in both daily life and the literary imagination on the subcontinent.[15]

Sinister yogis with unbounded desire for ever-greater powers (*siddhi*s) were a favorite trope in both folktales and the refined tradition of Sanskrit poetry (*kavya*). Such stories drew upon and fed the fascination and fear engendered by Tantra's more extreme practices.[16] Roguish Tantric yogis identified as wizards (*vidyadhara*), for example, figure in Somadeva's voluminous *Kathasaritsagara* (Oceans of Rivers of Stories). The great Sanskrit story cycle was composed in Kashmir in the eleventh century to lift the sorrows of a queen. Some five hundred years later, Akbar, a great fan of adventure tales (such as the *Hamzanama*), had it translated into Persian and read to him through the night.

Reflecting the anxieties that Tantric practices engendered among broad publics, one story in the *Kathasaritsagara* tells of a Kapalika yogi named Jalapada who tricks a Brahmin's son into helping him become a wizard.[17] In a folio from Akbar's manuscript (cat. 17d), Jalapada sits commandingly atop an outcrop at the composition's upper right.[18] His unwilling disciple, Devadatta, crosses the rocky landscape carrying the bloody embryo of a demurely veiled demon-princess, who sits in the landscape's lower corner with blood pooling beside her slit-open belly. Jalapada consumes the embryo—a literary embellishment of the Tantric practice of conjoining male and female substances to gain supernormal powers—becomes a wizard, and flies off. In a pattern typical of the *Kathasaritsagara* stories, Jalapada is punished for his dastardly ways: his Brahmin disciple ultimately becomes a wizard-king, marries the demon-princess, and dispatches the "wicked Kapalika back to earth."

A far more benign yogic archetype, the yogi-prince, pervades Hindu folk stories, Nath hagiographies, and the romances composed by Sufi poets between the fourteenth and nineteenth century.[19] The *Mrigavati* (Magic Doe-Woman), a classic of early Hindi literature, was penned by the Sufi shaykh Qutban Suhravardi in 1503. Its hero, Rajkunwar, is a Hindu prince who seeks

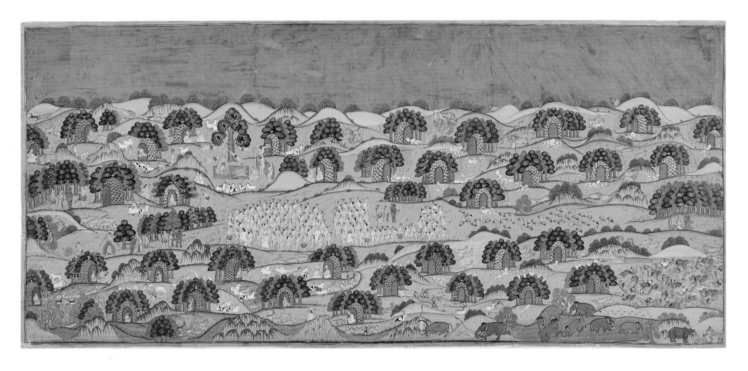

17b *Rama in the Forest of the Sages*

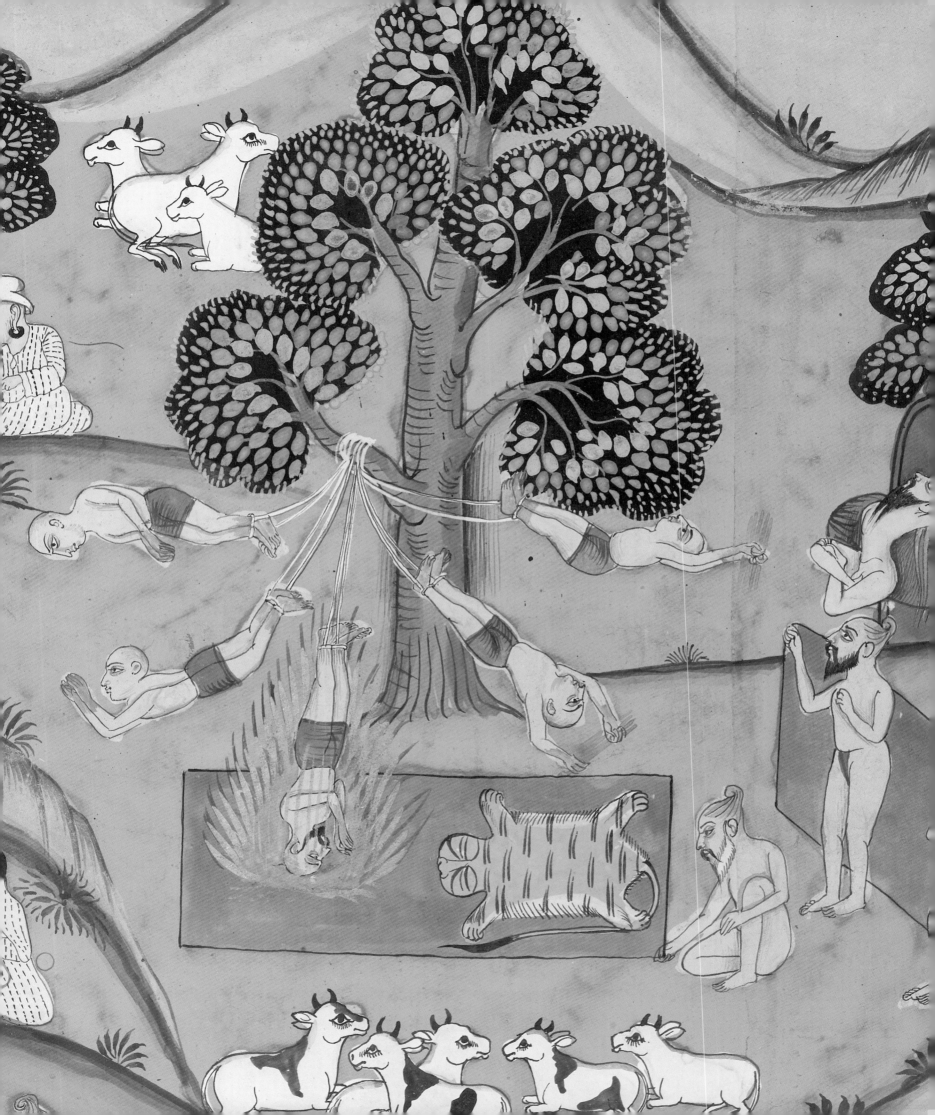

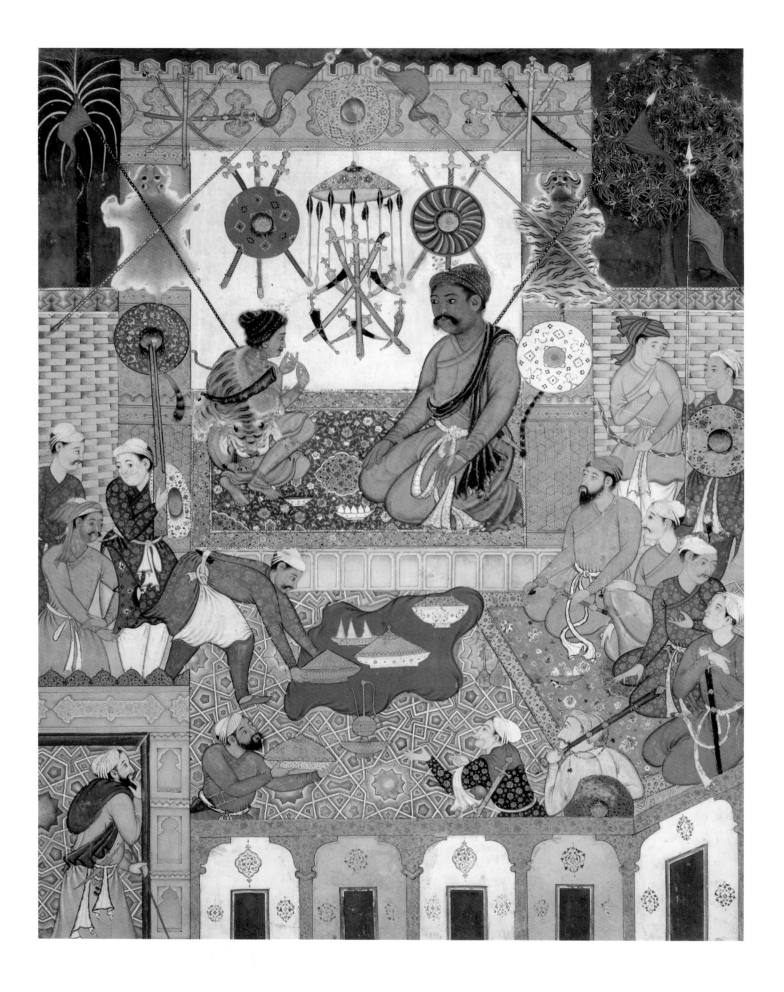

his beloved Princess Mrigavati in the guise of a Nath yogi:

He donned the sandals, the girdle, and patched cloak.

His locks became matted. He assumed the discus,

the yogi's earrings, the necklace for telling his prayers,

the staff, the begging bowl, and the lion-skin.

He wore the clothes of a yogi, the basil beads,

took up the [T-shaped] armrest and the trident,

and rubbed his body all over with ashes.

He blew the horn whistle [singi] and went on the path,

reciting the divinely beautiful one's name as his support.

He took the ascetic's viol in his hand,

and applied his mind to the practices of solitude.[20]

The *Mrigavati* was illustrated for the Mughal Prince Salim (Akbar's son, the future Emperor Jahangir) in 1603–4. Three folios depict the lovelorn prince-turned-yogi embarking on his quest, crossing a vast ocean and evading a monstrous sea serpent (cats. 17e–g). Because several painters worked on the manuscript, the hero's appearance changes from folio to folio, but his yogic disguise consistently includes the ash-blue complexion, *jata* topknot, and cloak of a Hindu yogi, and he is always young and handsome.

The genre of the Sufi romance emerged in North India, where Hindu yogis and Sufis mingled at hostels and lodges, vied for the respect of lay communities, and shared some practices and terminology. Cat. 17h depicts a lodge for wandering holy men, which the prince established to learn the whereabouts of his beloved (see also fig. 3 in "Muslim Interpreters of Yoga"). Inside its walls,

Naths with straggly beards and a black-garbed Sufi gather for a meal. Within this landscape of "competitive appropriation and assimilation," Sufi audiences who heard Qutban's verses would have understood the *Mrigavati*'s yogi protagonist and the text's yogic references (e.g., to the subtle body, mantra, and Tantra) as elements within an allegorical quest for spiritual perfection.[21] In contrast, the painted folios of Salim's manuscript foreground youthful beauty, romantic passion, and heroic deeds. DD

17c (opposite)
*Misbah the Grocer
Brings the Spy
Parran to His
House*

17d *The Tale of
Devadatta*

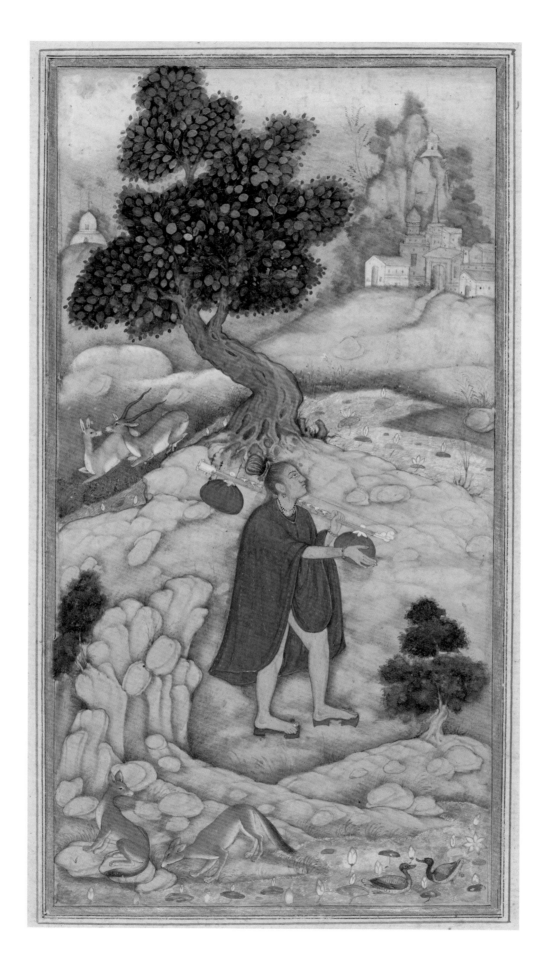

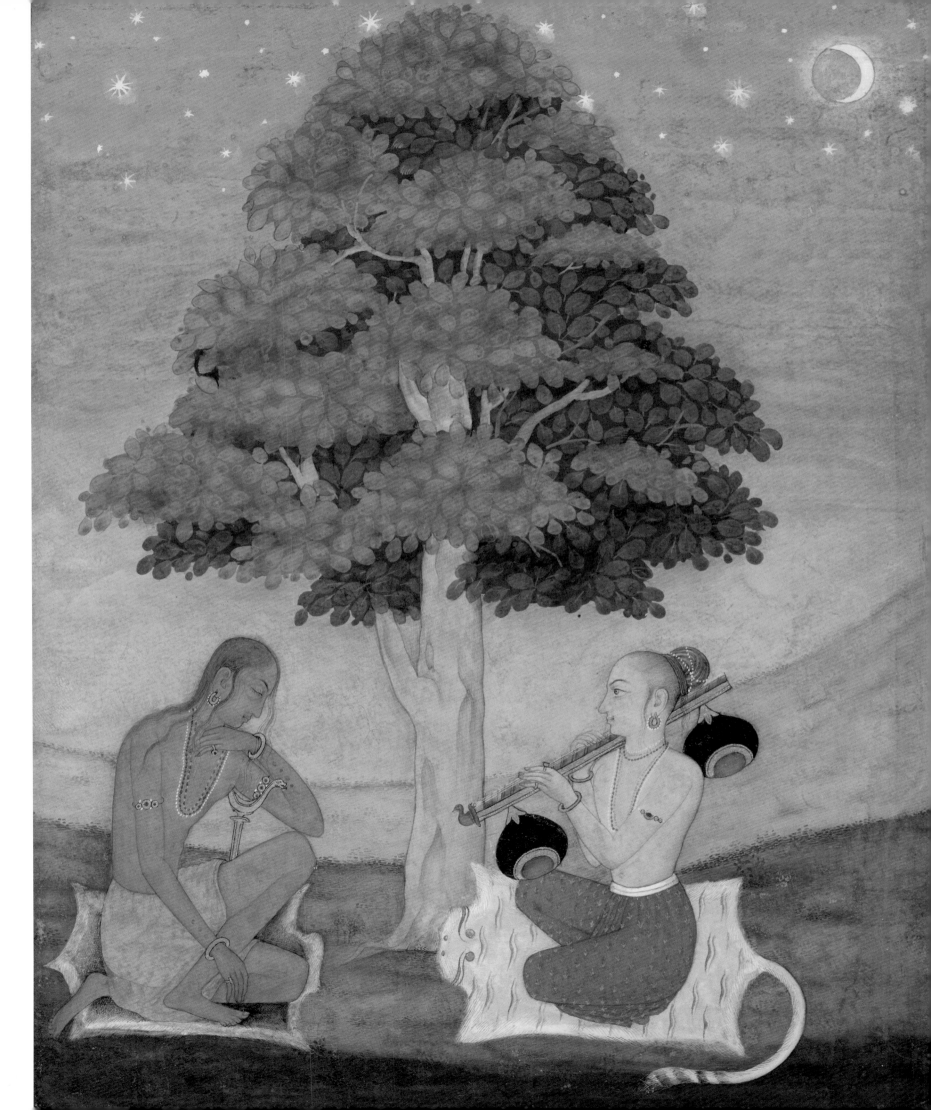

18d *Sarang Raga*

18c *Magha Malar Ragini*

18i *Gaur Malhara Ragini*

"married" to five *ragini* wives for a total of thirty-six *ragas* and *raginis*. Families of musical modes sometimes included sons or *ragaputras* as well. A complete set of *ragas* and *raginis* was called a *ragamala* (or garland of *ragas*). Each *raga*, *ragini*, or *ragaputra* was associated with a verse or verses describing it as a hero, heroine, ascetic, or deity, and with an image that depicted it. The compositions and iconographies of *ragamala* images quickly became fairly fixed and easily recognizable. The composition of Bhairava Raga with his beloved in cat. 18b, for example, appeared repeatedly in subsequent illustrations. Nevertheless, all elements of the *ragamala* were subject to change and many variations exist.[6]

Music was an intrinsic feature of religious devotion in India, as is clear from the yogis and yoginis who play or listen to music there. *Bhakti*—the intense personal devotion to God, which requires no intermediaries and takes the form of powerful human emotions, particularly of erotic love—is often expressed musically. (Saints like Mira Bai, for example, are typically pictured with an instrument in hand, singing their verses of loving praise to God. In addition, the god Krishna was often the hero of *ragamala* verses and pictures, where he was portrayed with a beloved or playing his flute and dancing with his devotees, flavoring the music with divine ecstasy.)

The theme of erotic love frequently intersected with the theme of transcendence in *ragamala* illustrations featuring yogis and yoginis. Megha Malar Ragini is described in some *ragamala* texts as the god of love and in others as an ascetic. Cat. 18c recapitulates the curious collision of longing and renunciation that is so intriguing in *Bhairava Raga* (cat. 18b). A buzzing surge of verdant fecundity, sparked by lightning and fed by a torrid rain, drives the weaver birds to mate, the lotuses to swell and bloom, and the fishes to agitate; even the pavilion seems to twist anxiously and the artist's line to ache for resolution. It is desire that drives the lone ascetic to austerities in this image: separation from the beloved

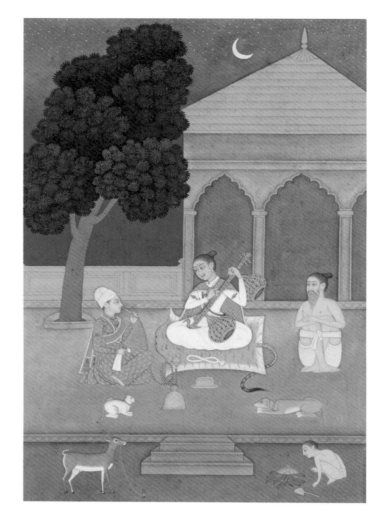

18f *A Yogini in Meditation*

18g *Bhupali Ragini*

is a kind of penance that promises redemption. Saindhavi Ragini (cat. 18h), in a common *ragamala* verse, longs for her lover as well and is maddened by his absence; the verses imply that it is the god Shiva she adores. Though graced by the delicate beauty of a princess, she wears the garb of a yogini; she rests her arm on a stand to support her as she fingers her *mala* (rosary) in prayer and listens attentively to an old sage's music, no doubt hoping to find peace in a spiritual oneness with the god who has deserted her.

Meanwhile, in cat. 18g, Bhupali Ragini's longing in separation makes her a model for the young prince and the sage who listen to her song: "Bhupali, belonging to the quiescent mood,

a woman in the splendor of beauty, lovely, with a face like the moon, a full bosom, her body anointed with saffron, pained by the separation, remembers her beloved."[7] Quiescence is implied by the balance of elements symmetrically arrayed on either side of the heroine and by the gentle grays of the starry night. A crescent moon, as if extracted from the gleaming white of her dress, recalls the verses associated with this *ragini*. In another poet's words, it is "as if she were the moon, carved and flaked."[8] The crescent also recalls Shiva, for whom it is emblematic, implying that the yogini's anguished separation is also a devotional longing for God.

Yet, other images of saints take us beyond the agonies of desire. *Kedar*

Ragini (cats. 18a, 18e) is one of the most peaceful of the musical modes. Typically it is accompanied by a scene of a sage singing to the music of a *vina* before a prince or another holy man. Night has fallen, the moon shines in a deep blue night sky, and the auditor's eyes grow heavy or close. "In penance, adorned, gray [with ashes], dark, a young man beauteous in every limb, [this is] Kedar."[9] *Kedar* comes last in most *ragamala* series, and its somber colors, spare ornament, and mood of release from attachment and struggle bring the musical cycle to a fitting close, as if one were being invited to slide from music into a dreamless beyond.

In the late sixteenth century, numerous illustrated *ragamalas* were made

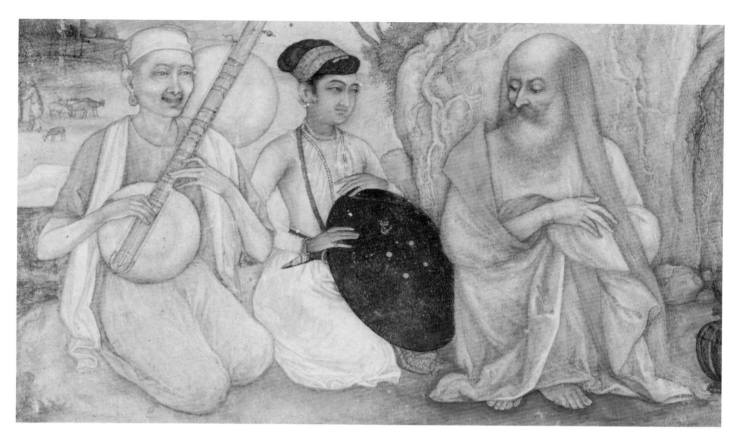

19c *Prince and Ascetics*

folio: on one axis, brown-robed itinerant Naths detached from familial ties are represented; on the other, a mother cow licking her calf invites consideration of the bonds connecting a Nath guru with his young disciple and the mother and child who await his blessing.

The artist who assembled the pages for Jahangir's enjoyment playfully obscured some seams with thickly painted leaves or rocky outcrops while drawing attention to others: a brown dog sniffs at a vertical seam, shallow landscapes abut distant vistas, and visual pairings ricochet within each painting and across both folios. The sophisticated formal organization locates the compositions within a Persian album-making tradition that consciously invited reflection on the meanings of juxtapositions.[5] Scholar Sunil Sharma has described the Mughal's identification of yogis and their social networks, practices, and beliefs in literary and visual genres as proto-

ethnographic because it transcends the gathering of data to convey larger social meanings and interrelationships.[6] Here, the aggregate of Vaishnava and Shaiva yogis alongside scenes of mother animals nurturing their young portrays Hindu ascetics as members of an amicable collective.

Artists in the atelier of Jahangir's son, Shah Jahan, employed a different formal strategy to construct this exquisite page (cat. 19c) as a space that unites diverse social types. Within a bucolic landscape attributed to Govardhan—an artist who excelled in sensitive depictions of holy men; see also fig. 6 in "Yoga: The Art of Transformation"—a musician sings devotional verses to a youthful imperial prince and an aged Hindu renunciant with long dreadlocks. The folio's flower-strewn outer border features perceptive studies of variously quirky and beatific yogis along with a courtier by another Mughal master, Payag. While the

exquisite folio is a paradigm of imperial ideology, its individual elements would have resonated on multiple levels. In Govardhan's painting, for example, the intricately knotted roots of the sheltering tree not only create an aureole of light around the holy man's bald pate, they also draw our attention to the minute portal of his cell. By 1630, even this small motif was deeply implanted within Mughal consciousness as a signifier of yogic attainment. Jahangir, for example, drew an explicit connection between austerities and spiritual accomplishment when informing his audience about the yogi Chitrup (Jadrup in Persian).[7] He approvingly recorded the miniscule dimensions of Chitrup's rock-cut dwelling, and also commissioned several paintings that record his and his father Akbar's visits to the holy man's abode[8]; (see fig. 1 in "Muslim Interpreters of Yoga"). DD

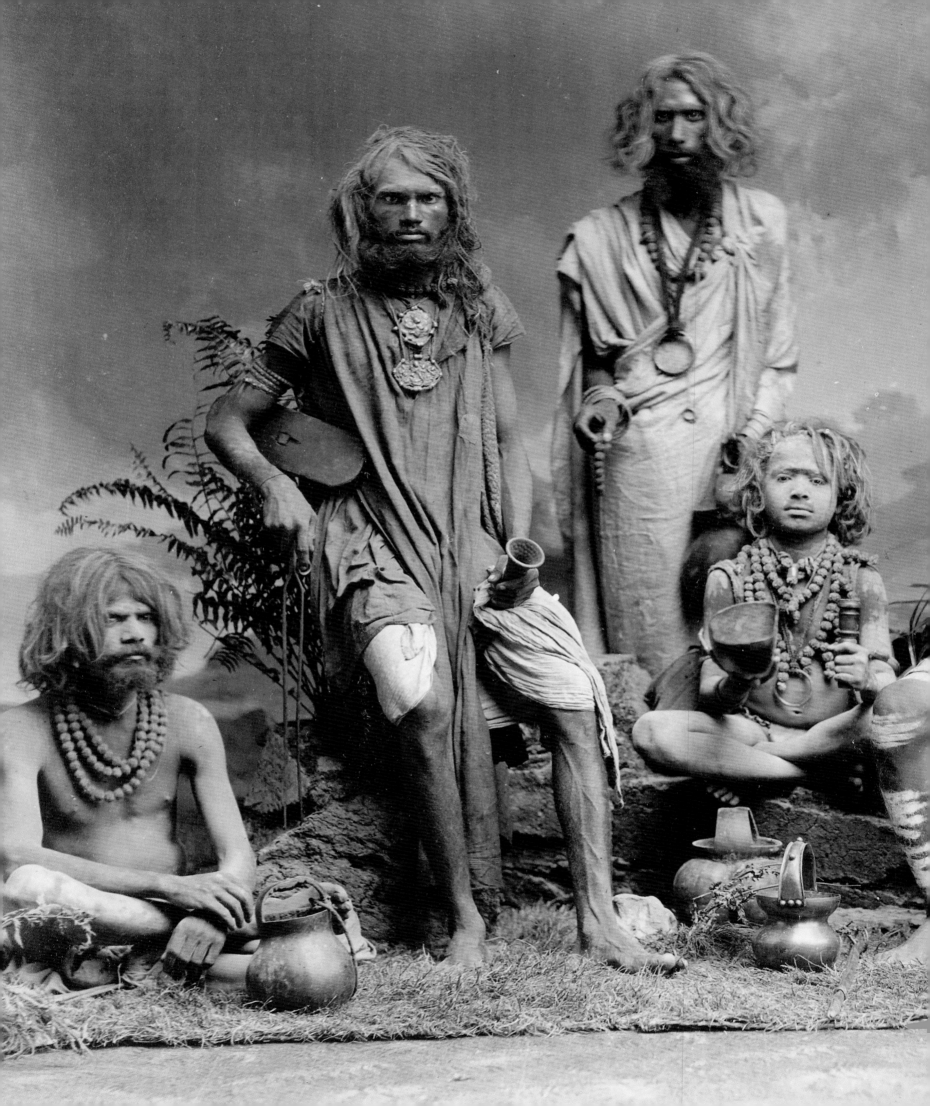

Company Paintings

20A
Lakshman Das

Folio from the *Fraser Album*
India, Delhi, ca. 1825
Watercolor and ink on paper, 25.4 × 14.6 cm
Collection of Kenneth X. and Joyce Robbins

20B
Kala Bhairava

In an album of ninety-one paintings
India, Thanjavur, ca. 1830
Opaque watercolor and ink on paper, 22.6 × 17.6 cm
The Trustees of the British Museum, 1962,1231,0.13.70

20C
Ascetics Performing Tapas

South India, ca. 1820
Opaque watercolor on paper,
23.5 × 29 cm (page)
The Trustees of the British Museum,
Bequeathed through Francis Henry Egerton,
2007,3005.4

20D
"An Abd'hoot"

Balthazar Solvyns (1760–1824)
Hand-colored etching on paper, 52 × 38 × 11 cm
In Balthazar Solvyns, *A Collection of Two Hundred
and Fifty Colored Etchings: descriptive of the
manners, customs and dresses of the Hindoos*
(Calcutta: [Mirror Press], 1799)
National Library of Medicine, WZ 260 S692c

Note: In the listings above, historical titles are
indicated by quotation marks.

In the early nineteenth century, East India Company[1] officials ventured to India, accompanied by centuries of accumulated information directing their perceptions and a desire to document and classify the manners, customs, costumes, and landscape of people and scenes they witnessed, or expected to see.[2] Though some drew and wrote themselves, many patronized Indian and European artists and purchased art available in the bazaar or in local publications. In such works, often termed "Company art," artists offered a complex aesthetic that knowingly incorporated Indian regional painting traditions with European ones, while offering choice subjects tailored to their patrons' interests, such as the fluid category of the yogi.[3] Influenced by Persian, Hindi, and Western texts, Europeans associated yogis with the strange, marvelous, and changeable.[4] In the artworks discussed here, yogis equally slip between portraiture, typology, and divinity, and also reveal the relationship between

20a *Lakshman Das*

20b *Kala Bhairava*

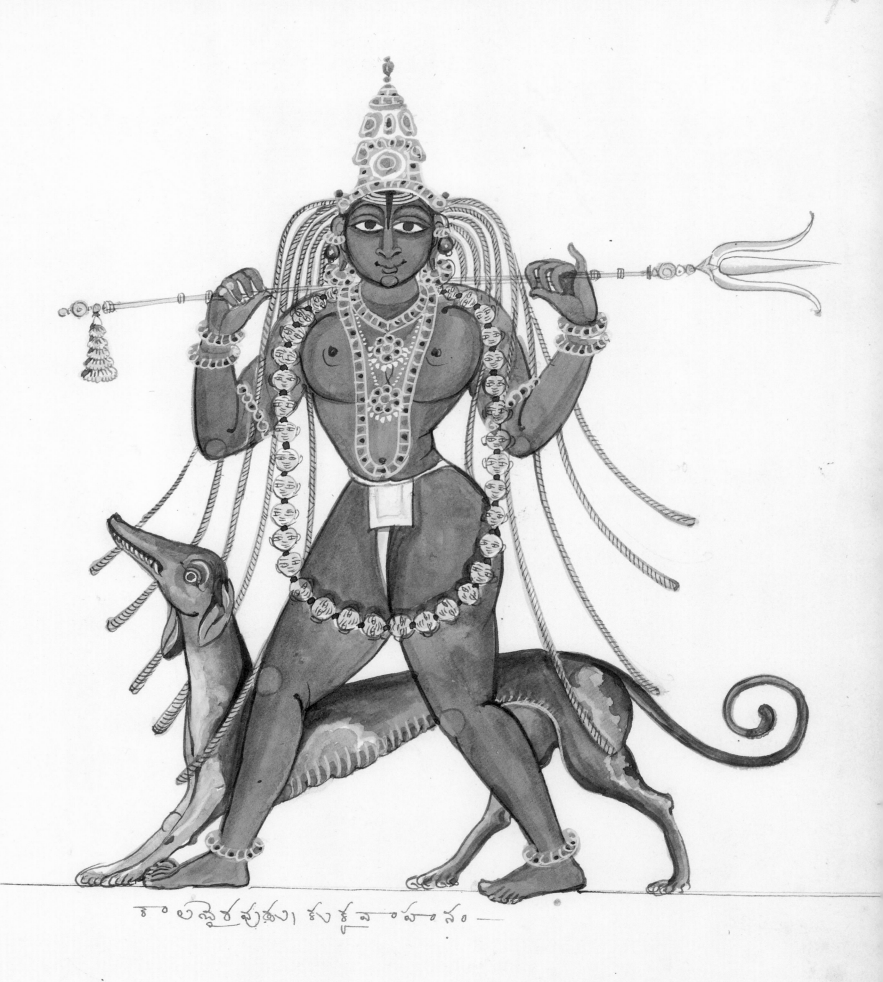

కాలభైరవపుత్రు కుక్కవాహనం—

Indian and European artistic practice and patronage.

A painting of the yogi Lakshman Das (cat. 20a) portrays a historical figure in a limber posture, fingering a rosary with an inward, off-center gaze. The artist, likely trained in Delhi in the late-Mughal style, builds this ascetic's body through shadows of awkwardly arranged bones and stipples of hair, emphasizing his individualism through observation. The inscription identifies him as "Lutchmun Dos, a Brahmin, and a religious mendicant of the Hindoo cast called Byragee [Vairagi]."[5] This painting is associated with a particular patron. When Company official William Fraser was posted in Delhi, he commissioned Indian artists to paint scenes from his life in India as well as local figures, such as ascetics, for his brother James Baillie Fraser, who desired them as studies for his own works.[6] However, Lakshman Das also appears in *Tashrih al-aqwan* or *The Description of Peoples* (1825), a manuscript by Colonel James Skinner, a friend of the Fraser brothers. This was a compilation of Sanskrit sources on castes and mendicant orders that Skinner translated into Persian and had illustrated by Indian artists.[7] Here, though Lakshman Das remains a portrait of an individual the Frasers and Skinner likely encountered, or at least shared a painting of, he also illustrates a general category of Hindu ascetic—a Vaishnava Vairagi.[8]

The boundaries between the gods who revealed yoga and the ascetics who emulated them were porous long before the colonial period; however, this ambiguity persisted into the eighteenth and nineteenth century and can be tracked through the style and iconography of some Company paintings. In an album from Thanjavur, Shiva as Kala Bhairava strides red-skinned, dreadlocked, adorned with golden ornaments and a garland of skulls. He carries a trident across his strapping shoulders, which taper to a slim waist, while his lean blue

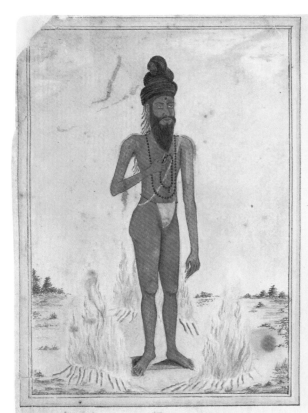
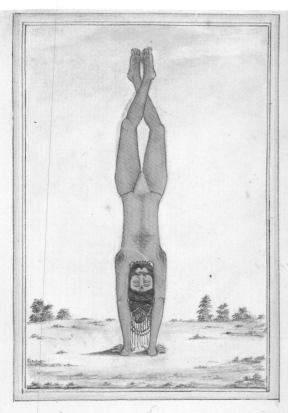

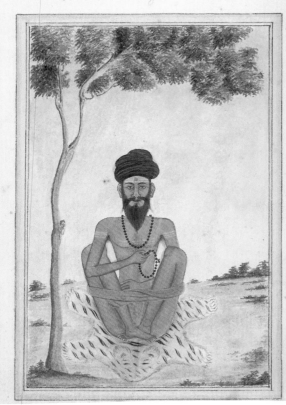

20c *Ascetics Performing Tapas*

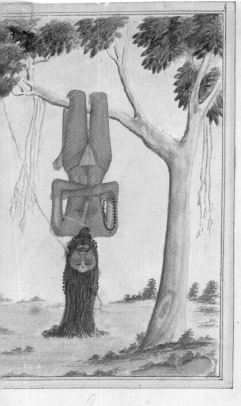

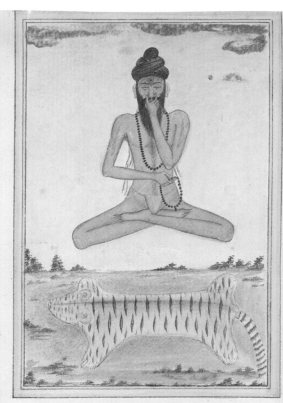

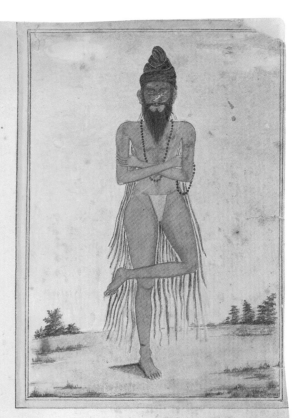

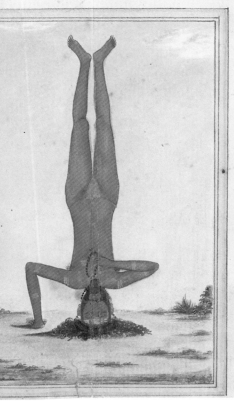

dog stretches nimbly behind (cat. 20b).[9] His circular face, with its unblinking almond eyes, and ideal figure conform to the South Indian style of depicting deities during this period[10]; yet, like the human ascetics he mimics, he has only two arms, a dog, and a simple loincloth.[11] Company officials were aware of such slippages between gods and men. As part of their education, they learned Indian languages from Persian and Hindi literary texts, and read works in translation, many of which contained tales about Kala Bhairava and the powerful chimeric yogis who were devoted to him.[12] This painting of Bhairava adds to the god's complex and layered identity by drawing on both a South Indian visual model and a European one, placing him, and most of the ninety-one other deities in the album, against a blank "scientific" background.[13] It is possible that the album was made for a specific patron, or, since there is a nearly identical copy in the Victoria and Albert Museum, that this type of album was in circulation as a catalogue of the gods.[14]

A painting of ten vignettes of Hindu ascetics performing penance (*tapas*)[15] (cat. 20c) shows them standing in the midst of fires (*panchagni*), maintaining fixed poses, and practicing levitation, breath control, meditation, and immersion in a lotus-filled pond.[16] Rather than individuals, these ascetics are generalized types stiffly demonstrating a diverse array of austerities and postures within a classificatory grid. It seems to be a straightforward, Company-style depiction; set within a picturesque landscape, such as a framing tree and low horizon, each yogi is centered on the page and recognizable by his signifying trait. Paintings of ascetics are regularly found in Company albums, publications, and collections, often cut into single folios and sometimes placed alongside relevant descriptive letters, indicating consistent production and replication.[17] These ascetics are part of a loose portfolio of

sixty-three paintings, likely produced for a wealthy European patron in Tamil Nadu, that includes portraits of gold-embellished Hindu gods and scenes of Indian religious ceremonies and devotees.[18] Significantly, the folios are painted in different styles. While the artists used dense bright colors to form iconic sculptural poses, similar to that seen in the Kala Bhairava, they incorporated European techniques and compositions into their regional training to create the images of nature and men. Here then, the subdued European landscape palette of blues, greens, and browns places ascetics firmly within the natural world, perhaps relegating the classificatory grid, as much as the ascetics, to human knowledge rather than divine.

In his hand-colored etching of an "Abd'hoot" or *avadhuta* (cat. 20d), an ascetic who has left worldly activity,[19] the Belgian artist Balthazar Solvyns focuses on a single figure. Lithe, with his head and eyes tilted towards the sky, he wears Vaishnava sect marks on his body and carries a backscratcher and perhaps a *gomukha* (bag) to count rosary beads. The text is deceptively simple; the ascetic is one of a "sect of Faquirs, that sometimes go intirely without cloaths," though here he wears a loincloth.[20] In the Paris edition, the *avadhuta* is depicted nude, and the text explains that his female devotees seek his blessings for fertility; the woman and child standing in the hut might allude to this aspect.[21] Though Solvyns likely drew an *avadhuta* from life, the descriptive text and overall project renders the figure a type rather than a portrait. He is one of "Ten Prints of Faquirs or Holy Mendicants" in Solvyns's compendium of "250 etchings descriptive of the manners, customs & dresses, of the Natives of Bengal: particularizing every character in the different casts, with the peculiar attribute of each,"[22] which was published in Calcutta likely by subscription from Indian and European buyers. The classificatory grid thus

stretches into an immense tome. It is unclear if Solvyns's etchings are sympathetic to their subjects, or whether his encyclopedia was conceived to enable the colonialist to exert social control, from the servants employed in his home to anyone encountered in the environment, such as this ascetic.[23] HS

Colonial Photography

21A
Untitled

John Nicholas for Nicholas Bros., 1858
Albumen print, 14 × 10 cm
National Anthropological Archives,
Smithsonian Institution, NAA INV 04604500

21B
Untitled

John Nicholas for Nicholas Bros., 1858
Albumen print, 13.7 × 9.5 cm
National Anthropological Archives,
Smithsonian Institution, NAA INV 04565100

21C
Untitled

John Nicholas for Nicholas Bros., 1858
Albumen print, 13.5 × 10.2 cm
National Anthropological Archives,
Smithsonian Institution, NAA INV 04566000

21D
Untitled

John Nicholas for Nicholas Bros., 1858
Albumen print, 14 × 10.2 cm
National Anthropological Archives,
Smithsonian Institution, NAA INV 04565500

21E
Kurrum Doss

in *The People of India* (1868–75), volume 4, folio 158
ca. 1862
34.3 × 25.4 cm
Catherine Glynn Benkaim and Barbara Timmer
Collection

21F
Bairagees, Hindoo Devotees, Delhi

in *The People of India* (1868–75), volume 3, folio 203
Charles Shepherd for Shepherd & Robertson, 1862
34.3 × 25.4 cm
Catherine Glynn Benkaim and Barbara Timmer
Collection

21G
Untitled

Charles Shepherd for Shepherd & Robertson, 1862
Albumen print, 19.6 × 16 cm
Staatliche Museen zu Berlin,
Ethnologisches Museum, VIII.C1419

21H
Untitled

India, ca. 1870
Albumen print, 10.7 × 14.2 cm
Staatliche Museen zu Berlin,
Ethnologisches Museum, VIII.C 447

21I
Untitled

India, Orissa, ca. 1870
Albumen print, 14.6 × 9.9 cm
Staatliche Museen zu Berlin,
Ethnologisches Museum, VIII S-SOA NLS 1

21J
Untitled

Westfield & Co.
India, ca. 1870
Albumen print, 9.4 × 5.8 cm
Staatliche Museen zu Berlin,
Ethnologisches Museum, VIII.C 3315

21K
Untitled

Westfield & Co.
India, ca. 1870
Albumen print, 9.4 × 5.8 cm
Staatliche Museen zu Berlin,
Ethnologisches Museum, VIII.C 3314

21L
Untitled

Westfield & Co.
India, ca. 1870
Albumen print, 9.4 × 5.8 cm
Staatliche Museen zu Berlin,
Ethnologisches Museum, VIII.C 3316

21M
Untitled

Westfield & Co.
India, ca. 1870
Albumen print, 9.4 × 5.8 cm
Staatliche Museen zu Berlin,
Ethnologisches Museum, VIII.C 3317

21N
Untitled

Westfield & Co.
India, Calcutta, ca. 1870
Albumen print, 14.1 × 9.5 cm
Staatliche Museen zu Berlin,
Ethnologisches Museum, VIII.C3313

21O
Untitled

India, Tamil Nadu, Madras (currently Chennai),
ca. 1870
Albumen print, 14.5 × 9.8 cm
Staatliche Museen zu Berlin,
Ethnologisches Museum, VIII.C1474

21P
Untitled

India, Tamil Nadu, ca. 1870
Albumen print, 12.7 × 17.4 cm
Staatliche Museen zu Berlin,
Ethnologisches Museum, VIII.C158

21Q
Untitled

India, Tamil Nadu, Madras (currently Chennai),
ca. 1880
Albumen print, 14.3 × 9.9 cm
Staatliche Museen zu Berlin,
Ethnologisches Museum, VIII.1522

21R
Untitled

India, Tamil Nadu, Madras (currently Chennai),
or Orissa, ca. 1880
Albumen print, 14.8 × 9.7 cm
Staatliche Museen zu Berlin,
Ethnologisches Museum, VIII.C1473

21S
Group of Yogis

Colin Murray for Bourne & Shepherd, ca. 1880s
Albumen print, 22.2 × 29.2 cm
Collection of Gloria Katz and Willard Huyck,
2011.02.02.0004

21T
Untitled

Edward Taurines (act. 1885–1902)
India, Bombay, 1890
Albumen print, 23.5 × 19 cm
Staatliche Museen zu Berlin,
Ethnologisches Museum, VIII.8007b

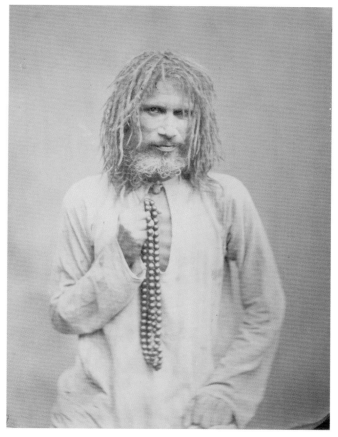

21a *Untitled*

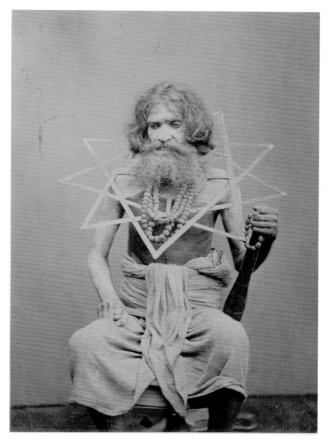

21b *Untitled*

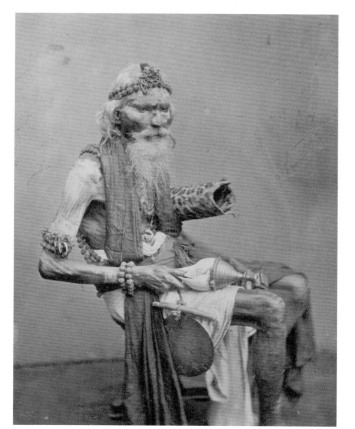

21c *Untitled*

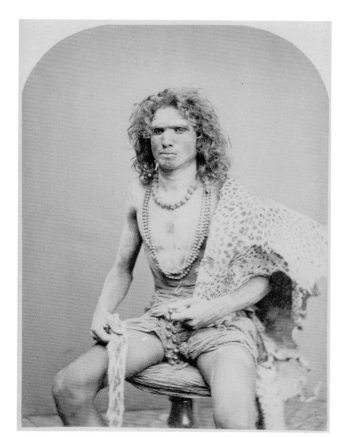

21d *Untitled*

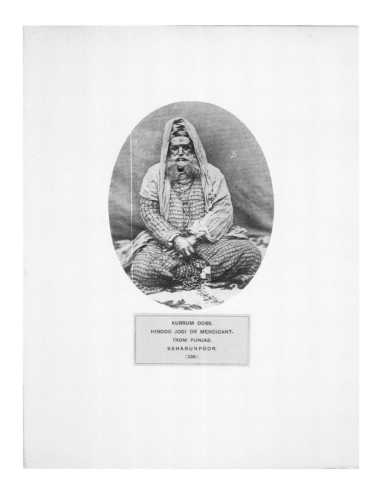

KURRUM DOSS.
HINDOO JOGI OR MENDICANT.
FROM PUNJAB.
SAHARUNPOOR.
(158)

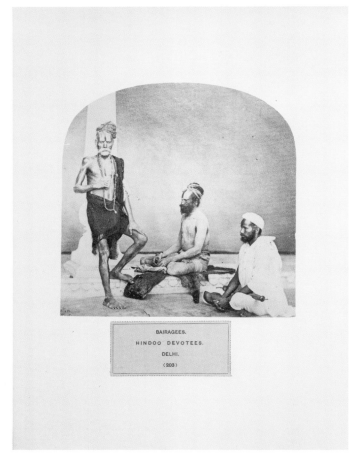

BAIRAGEES.
HINDOO DEVOTEES.
DELHI.
(203)

21e (left) *Kurram Doss*

21f (right) *Bairagees, Hindoo Devotees, Delhi*

21g (opposite) *Untitled*

The British fascination with images of Indian ascetics was well established in colonial drawings and painting before photography was introduced in India. Company paintings and early travelogues are rife with representations and descriptions of exotic yogis. A description of photographic portraits by John Nicholas (cat. 21a–d) in the 1858 Madras Photographic Society's annual exhibition reveals that the preoccupation with the exotic yogi "other" carried over into photography:

Some portraits of religious mendicants were also exhibited by Mr. Nicholas. These are curious in their way, and the selection of subjects were excellent. One party had a wire passed through his cheeks. Two others had large square iron frames riveted to their necks. The pictures were well executed, and copies are for sale at Mr. Nicholas' Studio.[1]

Following the Indian Rebellion of 1857, the British colonial administration increasingly documented various Indian populations, producing *The People of India*, a photographically illustrated proto-ethnography, between 1868 and 1875. Its eight volumes contain 480 photo-portraits accompanied by descriptive and historical text, a product of two editors, three separate authors, and no fewer than fifteen different photographers.[2]

Evidence suggests that the inspiration for the mammoth publishing project originated in a photographic series compiled in India and sent to Britain for display at the Great London Exhibition of 1862.[3] Contrary to the account provided in the preface of the volumes, at no point in its thirteen-year production did *The People of India* have either a clearly articulated objective or coherent process. The resulting collection comprises nearly one thousand photographic portraits

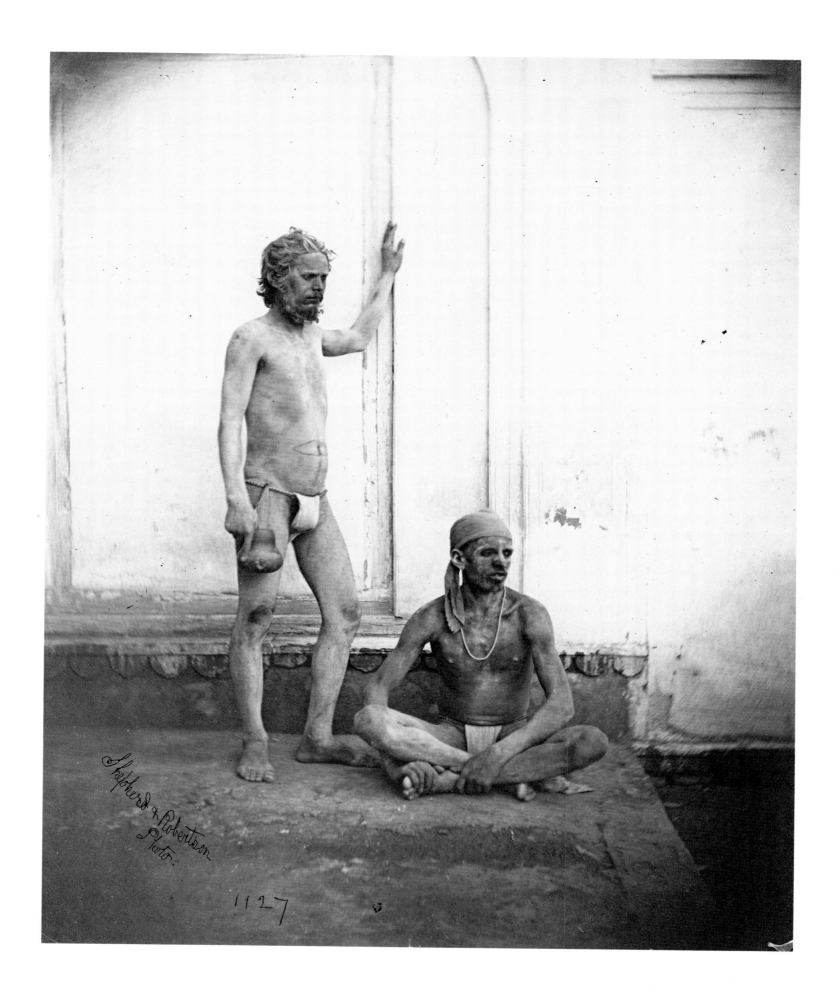

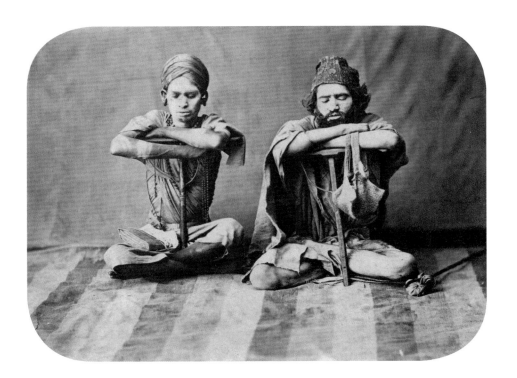

of varying standards; most contributors were amateurs stationed in India as military officers or agents of the colonial administration.

Though originally supported by the British colonial government, the completion of the later volumes became a private venture, personally funded by the editors, Forbes Watson and John William Kaye. Despite their massive efforts, *The People of India* was unenthusiastically received by the burgeoning anthropological community (on the grounds of inconsistent and arbitrary typologies) and the purchasing public. The publication as a whole fell into obscurity by the turn of the twentieth century.[4] Today, however, it is recognized as the first large-scale attempt to employ photography in the context of an ethnographic publication. Epitomizing the British suspicion of Indians after the 1857 Rebellion, it represents an early instance of the linking of photographic technology to surveillance and categorization in order to justify racial supremacy and colonial domination.[5]

Yogis and yoga-practicing ascetics are among the various "native types" rep-

resented in the publication. In volume 3, plate 158, Kurrum Doss (cat. 21e) is described as a landlord in the holy city Hardwar. His *tilak* (forehead mark) and surname identified him to contemporary viewers as an Udasi, a Sikh ascetic. Doss is one of only a few named subjects in the publication, and the entry betrays a tension between individual and type as well as the limitations of colonial British understanding of yoga's rich diversity. Such limitations are intimated in the text, which attempts to reconcile the image of Doss, a "comfortable looking individual clad in a quilted chintz tunic" with the naked and emaciated yogi type known to the British. Noting that he doesn't have "long matted hair wound round his head, his finger nails like claws," the author is unable to fully identify Doss as a yogi and speculates that he is either enlightened or false.

Though *The People of India* was a failure, many of the types represented in the volumes (and indeed some of the images) persisted and proliferated in the arena of commercial photography. Commercial studios in the mid-nineteenth century provided a range

of photographs to a public hungry for views of foreign lands and people. To thrive, a firm needed a stock of images that would appeal to a purchasing public.

The itinerant nature of many South Asian ascetics proved advantageous for commercial photographic studios that wanted to capitalize on the British fascination with the exotic yogi. In the early 1860s, commercial photographers preferred the collodion glass-plate negative because of its ability to register great detail without requiring a prolonged exposure time. But the sensitivity of collodion demanded that mobile darkrooms and volatile chemicals had to be transported along with the camera and glass plates.[6] The logistical difficulties limited the viability of impromptu or site-specific photography for much of the nineteenth century; traveling yogis filled the gap.

After the introduction of the carte-de-visite format by Frenchman A. A. Disderi in 1854, photography became affordable to a broader public.[7] Carte-de-visites became so popular that in England alone, 300 million to 400 million cartes were sold every year between 1861 and 1867.[8] The affordability of the carte-de-visite and subsequent copyrighting of carte-de-visite albums facilitated the proliferation of "Native Views" as collectable images in the West. Quick to cash in on the phenomenon, photographic studios based in India offered sets of portrait views of Indian ascetics. A series of portraits by the commercial firm Westfield & Co. were most likely sold in this manner (cats. 21j–21n). The commonplace marketing of carte-de-visite/cabinet-card series of Indian ascetics under catchall titles makes it near impossible to identify original titles for individual photographs. Commercial catalogues listed photos for sale by negative number or set name, and it is likely that cats. 21o, 21q, 21r, and 21t were never titled beyond a generic term.[9]

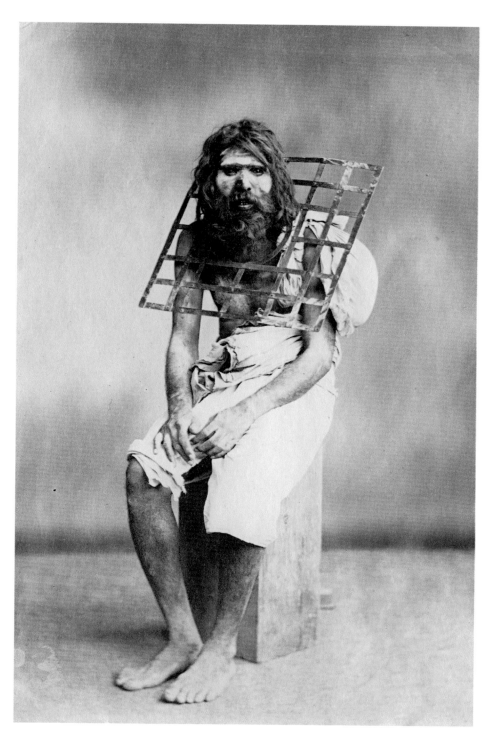

21i *Untitled*

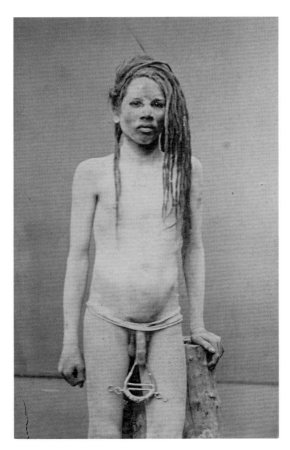

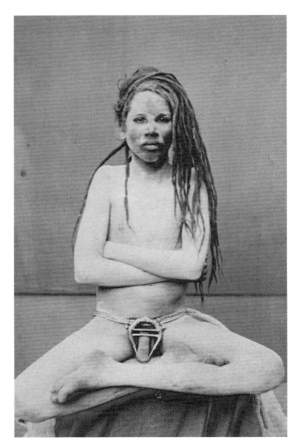

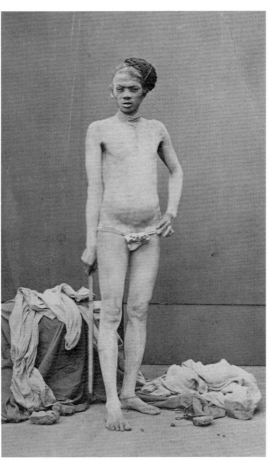

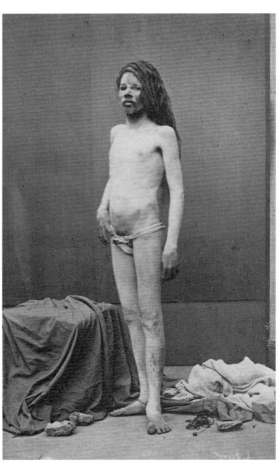

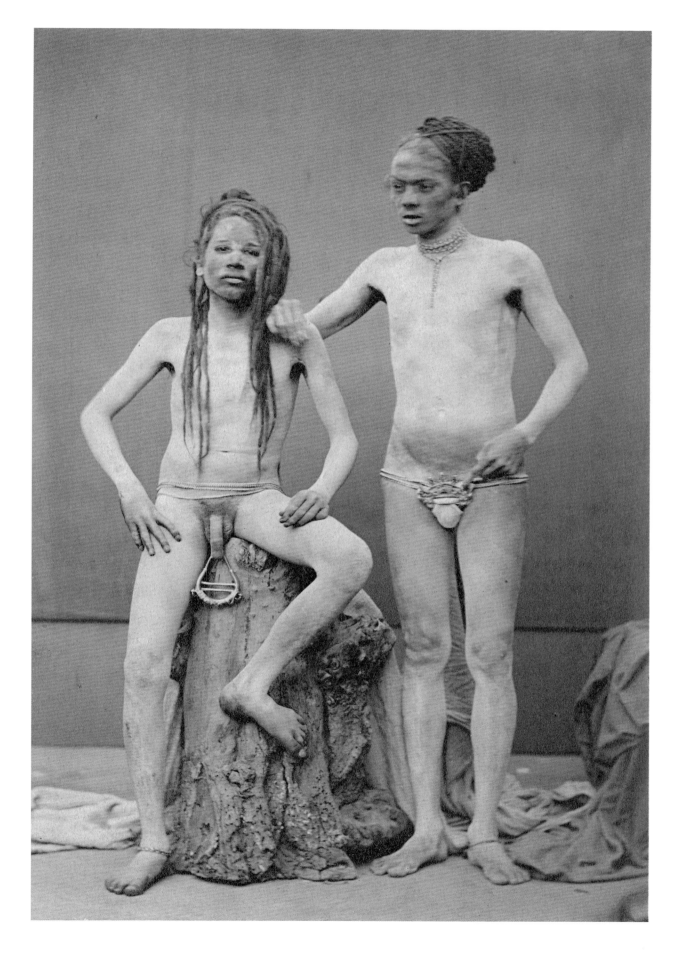

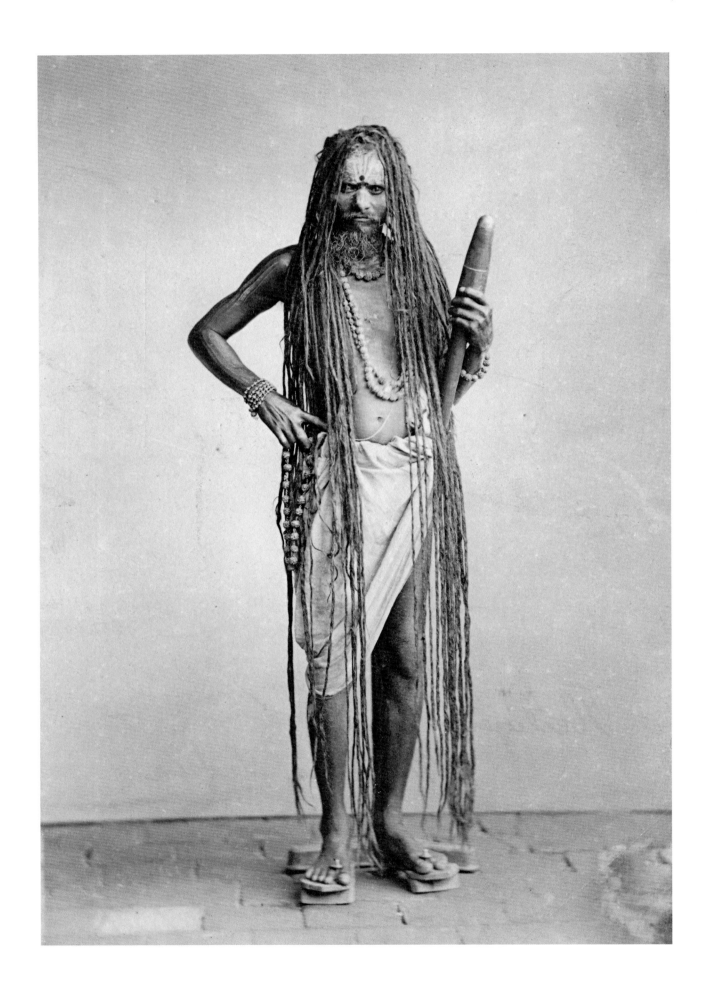

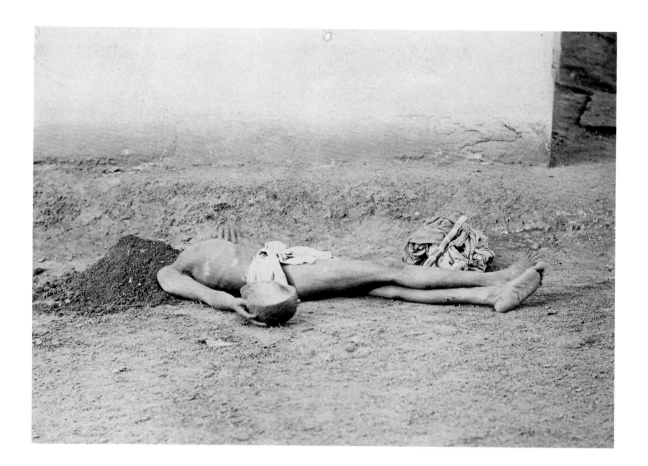

21o (opposite)
Untitled

21p *Untitled*

Over time, with advancements in photographic technology, photographers were free to venture outside of the studio without cumbersome equipment. At that point, "site-specific" images of ascetic practice, such as cat. 21p or "Hindu Fakir on a Bed of Spikes, Calcutta" (see cat. 22c), were captured with frequency and zeal.

As studios continued to produce "Native Views" throughout the latter half of the nineteenth century, backdrops and props became more elaborate, and the identity of the represented individuals increasingly questionable. Instead of practitioners photographed in the studio, anonymous individuals donned costumes and accouterments and posed against painted backdrops and fabricated outdoor scenes. In *Group of Yogis* (cat. 21s), a Bourne & Shepherd photograph, circa 1880, a group of men with standard yogi attire and attributes are posed against a painted jungle scene amid potted plants and a grass mat. Though

a seemingly standard studio portrait, the tall, bald character second from the right may not be a yogi at all. He sports white body markings—four horizontal stripes—that bear no relationship to any Hindu tradition. The dubious marks throw the subjects' identities and the elaborate staging into question. Indeed, a defining characteristic of commercially generated yogi-type photo-portraits in the nineteenth century is that they are laden with attributes but entirely devoid of context. JF

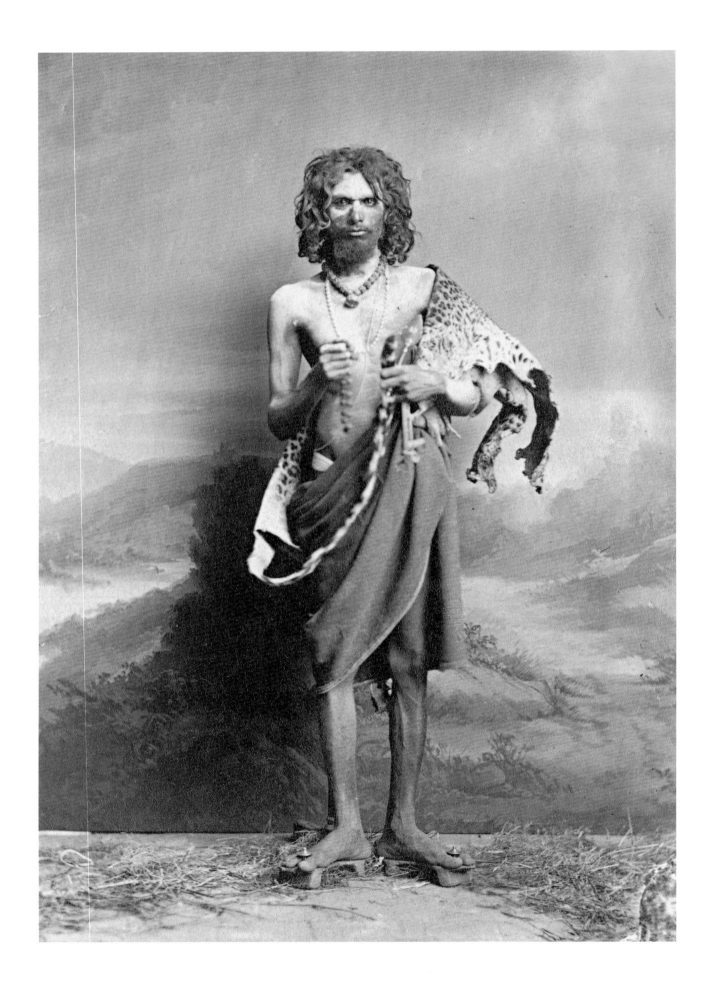

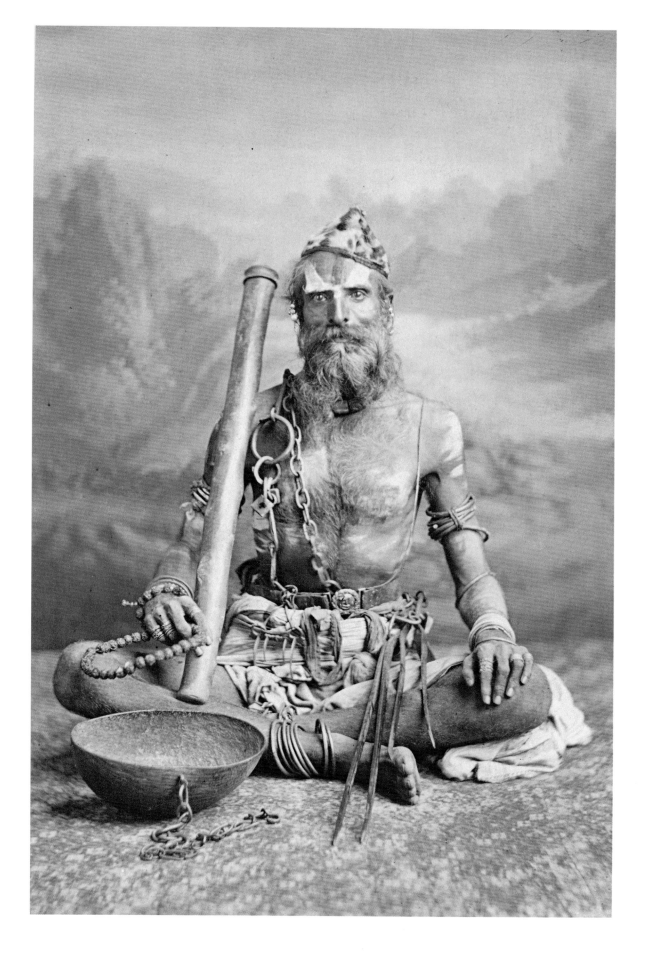

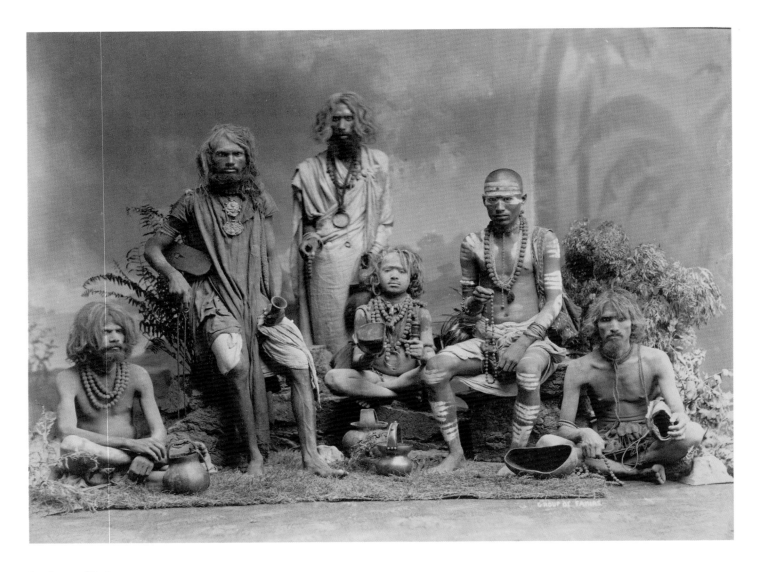

21s *Group of Yogis*

21t *Untitled*

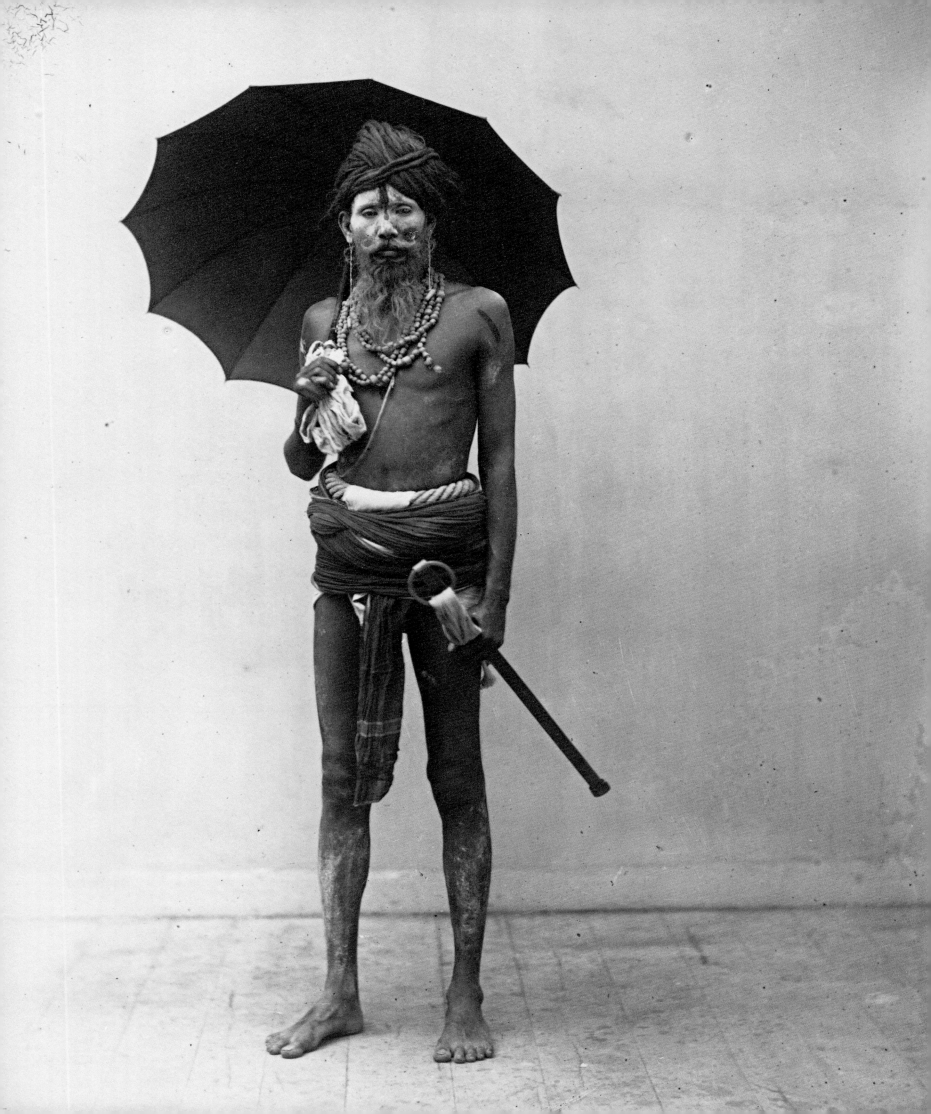

The Bed of Nails: The Exotic Across Borders and Media

22A

"Diverses Pagodes et Penitences des Faquirs" (Various Temples and Penances of the Fakirs)

Bernard Picart (1673–1733)
1729
Copper-plate engraving on paper, 48 × 52.4 cm
From Jean-Frédéric Bernard and Bernard Picart,
Cérémonies et coutumes religieuses des Peuples Idolatres (Ceremonies and Religious Customs of the Idolatrous Peoples), vol. 2 (Amsterdam: J. F. Bernard, 1728)
Robert J. Del Bontà collection, E442

22B

Images of Yogis

John Chapman (act. 1792–1823)
September 1, 1809
Copper-plate engraving on paper, 26.7 x 21.6 cm
From *Encyclopædia Londinensis or, Universal Dictionary of arts, sciences, and literature ...* vol. 10 (London: J. Adler, 1811)
Robert J. Del Bontà collection, E1232

22C

"Hindu Fakir on a Bed of Spikes, Calcutta"

James Ricalton (1844–1929)
ca. 1903
Stereoscopic photograph on paper, 8.9 × 17.8 cm
From James Ricalton, *India through the Stereoscope: A Journey through Hindustan* (New York and London: Underwood & Underwood, 1907)
Robert J. Del Bontà collection, SV49

22D

"Hindu Fakir: for thirteen years this old man has been trying 'to find peace' on this bed of spikes"

Young People's Missionary Movement
New York, early 20th century
Postcard, 8.9 x 14 cm
Collection of Kenneth X. and Joyce Robbins

22E

"Fakir on Bed of Nails"

D. Macropolo & Co.
India, Calcutta, early 20th century
Postcard, 8.9 × 14 cm
Collection of Kenneth X. and Joyce Robbins

22F

"Hindu Fakir on Bed of Spikes, Benares"

Baptist Missionary Society
India, early 20th century
Postcard, 8.6 × 13.5 cm
Collection of Kenneth X. and Joyce Robbins

22G

"Fakir Sitting on Nails"

India, late 19th century
Painted clay, 11.4 × 20.3 cm
Victoria and Albert Museum, London, Given by the Indian High Commission, IS.196-1949

Note: In the listings above, historical titles are indicated by quotation marks.

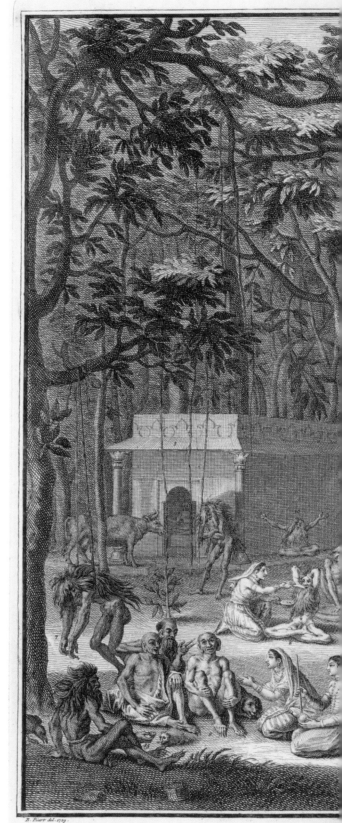

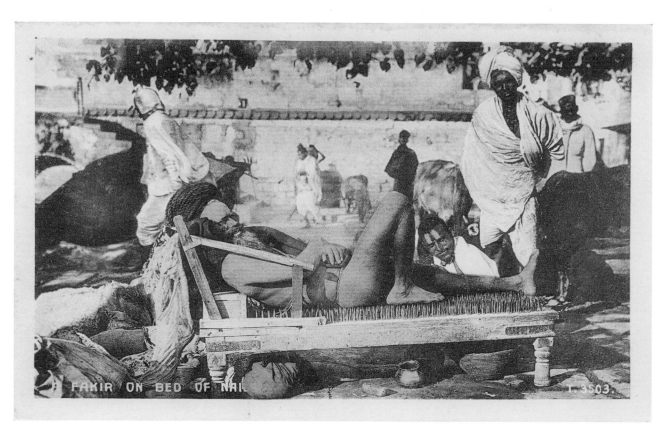

22e "Fakir on Bed of Nails"

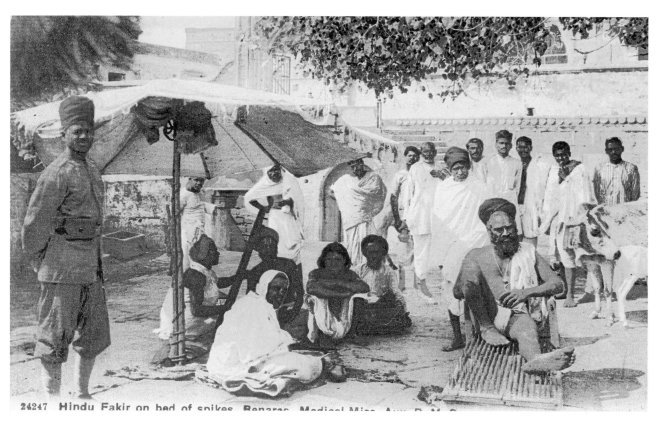

22f "Hindu Fakir on Bed of Spikes, Benares"

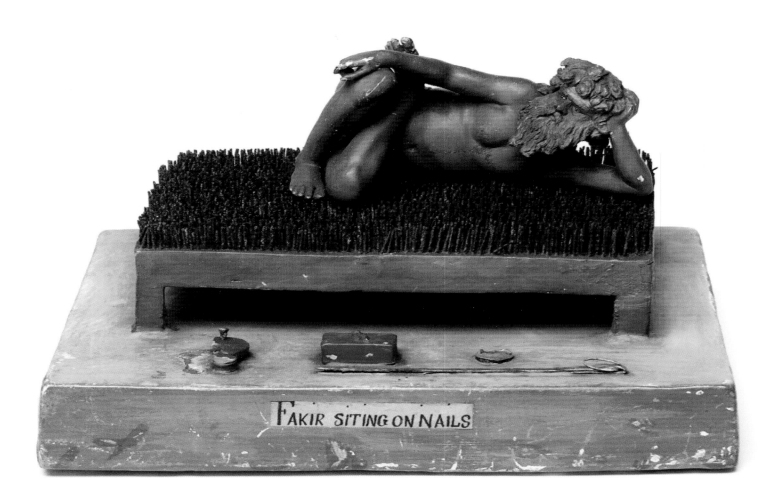

FAKIR SITTING ON NAILS

of man" who "disgrace the police of any country, by a life of total inutility, under the name of pious austerity" (cat. 22b).[15] Portions of the text are excerpted from Duncan's article, but the *Londinensis* author elaborates on the bed of nails, portraying this type of "fakeer" as a free-loader living on the "generosity of the English government" and as a performer who is "carried about to all of the great festivals, sitting bare-breeched on a seat of iron-spikes, from the punctures of which they frequently contrive to let the blood flow."[16]

Western descriptors of Indian ascetics as militants, mendicants, layabouts, and showmen are intimately related to their changing social circumstance.[17] In the early modern period, myriad types of ascetics gained their livelihoods by being mercenaries, rural priests, or participants in religious orders.[18] In the late

eighteenth century, the British created an inhospitable atmosphere for ascetics, fearing their military might, which disrupted trade routes and diplomacy and led to skirmishes in Bengal, which became known as the Sanyasi and Fakir Rebellion. Wandering ascetics also congregated in public, performing fantastic feats for alms or simply begging. This change in status was related to the decreasing religious role that ascetics played from the sixteenth century onward, concurrent with an increase in *bhakti* (devotion to a personal god), and also to specific eighteenth-century British laws that identified ascetics within Company territories as criminals and beggars rather than religious figures.[19]

By the early twentieth century, the ascetic lying on a bed of nails in a public space had become a stock figure in Western photographs, postcards, and

books. In 1907, photographer James Ricalton published *India Through the Stereoscope* for the American firm Underwood and Underwood, which specialized in boxed sets of stereograph views of familiar and exotic locales.[20] In Ricalton's views of India, "Hindu Fakir on a Bed of Spikes, Calcutta" (cat. 22c) would have been viewed between "Horrid Goat Sacrifices to Hindu Goddess Kali" and a caged tiger labeled "Famous 'Man-Eater.'" Within the text, Ricalton dismisses the emaciated ascetic as a beggar practicing "a 'stunt' for alms," drawing attention to the "one big English penny deposited" on a white cloth.[21] However, by including the photograph Ricalton enacts his own voyeuristic stunt, offering a view of the strange, awesome, and ferocious for Americans to condescend to and consume.[22]

Postcards united spectacle, ethnography, and even missionary activities. At the turn of the century, missionary movements sought to educate young Americans for religious work. As part of the process they published postcards, such as cats. 22d–f. A postcard published by the Young People's Missionary Movement (cat. 22d), for instance, displays an ascetic fingering his rosary while seated with one knee up on a bed of nails. He is described as trying "to find peace," yet the empty bed of nails at his side and the hovering crowd implies the opposite. Is he "blameless and harmless," even a potential convert? Or is he "insincere" and "given to various modes of deception," as another Young People's publication, J. M. Thoburn's *The Christian Conquest of India* (1906), declared about devotees in India, including a "fakir on a bed of spikes."[23]

The ascetic on a bed of nails reiterates as one of several hundred clay figurines amassed by C. G. Sanders, a fur merchant who lived in India (cat. 22g). Made by two Indian sculptors, the figurine is within an entire schema "of the many varied ethnic types of India and Burma,"[24] a trend related to cataloguing Indian people by caste or trade to display in world exhibitions.[25] Rather than emaciated, its body appears muscular and toned, perhaps a nod to modern innovations that intertwined physical fitness and yoga.[26] Indeed, the small clay figure holds its own: it is jaunty, comfortable, and hints at the dual dependence of the fakir on Europeans for funds, and Europeans on the fakir for exoticism. HS

Fakirs, Fakers and Magic

23A

Thurston the famous magician, East Indian rope trick

Otis Lithograph Company
United States, ca. 1927
Color lithograph, 104 x 35 cm
Prints and Photographs Division, Library of Congress,
POS-MAG-.T48 no.14 (C size)

23B

Koringa

W. E. Barry Ltd.
United Kingdom, Bradford, ca. 1938
Print, 74.4 x 50.9 cm
Victoria and Albert Museum, London, S.128-1994

23C

"Mystery girl: why can't she be killed?"

Look Magazine, September 28, 1937
Des Moines, Iowa, United States
34.1 x 26.6 cm
Private Collection

23D

Hindoo Fakir

Edison Manufacturing Company
United States, 1902
Film, transferred to DVD, 3 minutes
General Collections, Library of Congress,
NV-061-499

23E

"The Yogi Who Lost His Will Power"

Song clip from the film *You're the One* (1941)
Johnny Mercer (lyrics); Mercer-Mchugh; Jerry
Cohonna with Orrin Tucker and his Orchestra
Clip from YouTube, loop at 3'14:
http://www.youtube.com/watch?v=ixwmfoZJHq8
LC Recorded Sound 578945
Columbia 35866

Fakirs. The word evokes a bewildering range of associations in the Indian colonial context—from Sufi ascetics to ash-smeared *hatha yogis*; from magicians and tricksters to circus performers; from Gandhi to the Kumbh Mela.[1] An exotic foreign word, it came to stand for practices that were themselves variously perceived by European visitors to India as exotic and foreign, but also fascinating, confusing, and frightening since the seventeenth century.[2] The very word "fakir," as it is used in India, rests on an etymological confusion, shifts in meaning over centuries pointing as much to changing colonial and transnational perceptions (or misperceptions) as to its continued hold on popular imaginations. Derived from the Arabic word for poor (from the noun *faqr*, poverty), fakir originally referred to Muslim Sufi wandering dervishes and then gradually expanded to include a range of Hindu yogis who defied easy categorization, even if they were increasingly (and mistakenly) glossed by colonial administrators under one umbrella: mendicant caste orders; militant warrior ascetics who disrupted East India Company trade routes; itinerant renouncers who wandered from shrine to shrine; and, most especially, magicians, contortionists, and yogis who engaged in spectacular self-mortification practices on the street and in other public spaces.[3]

Of all these groups, it is this last category—the performing fakir-yogis in public spaces—that attracted diametrically different responses inside and outside India in the late nineteenth and early twentieth centuries. In India, yoga's scholarly revivalists dismissed contemporary fakir-yogis and their magical practices as the unworthy, degenerate heirs of a classical yoga tradition in need of urgent reform.[4] By reverse logic, magic in the Indian context became intertwined in the popular European imagination with fakir-yogis, many of whom had been forced by colonial laws against militant asceticism to take on mendicant life-

styles in temple complexes and street fairs.[5] Meanwhile, outside of India, fakirs became objects of intense fascination for European and American occultists, who celebrated the magical powers these figures could acquire through yoga. Popular accounts of fakirs in the early twentieth-century Euro-American print and cinematic media reflect some of this ambivalence. While portrayals of yogis, real and imaginary, routinely relied on Orientalist stereotypes of India or the mystical East as the source of supernatural power, there were an equal number of attempts to debunk and expose specific fakirs and yogis as inauthentic fakers, charlatans, and frauds who were duping a gullible public. This essay briefly describes five fakir-yogis and performers who captured the world's imagination in the early twentieth century, using examples drawn from the rich world of lithographic posters and early films, two based on real magicians, three on fictional composites.

The older of the two posters, *Thurston the famous magician, East Indian rope trick* (cat. 23a), features Howard Thurston, a stage magician from Columbus, Ohio. As a child, he ran away to join the circus and eventually became one of the most successful performers of his time. His traveling magic shows routinely drew on an undifferentiated India as the authoritative source of magical power. This vertical lithographic poster reflects and mimics his most popular act—the great Indian rope trick—which is announced in the typical hyperbole of the carnival busker: "World's Most Famous Illusion. First Time-out-of-India." On the right, Thurston stands below that legend and against a monument of indeterminate origin, the minarets being the only geographical clue that it is the "East." Suavely dressed in coat and tails, the magician cuts a crisp contour against the misty nightscape, and his raised arm signals that he has just caused the rope to magically arise from the snake basket

on the lower left, rather like a conductor orchestrating a "native" performance. The young, bare-chested boy in turban and dhoti who climbs the freestanding rope is another visual nod to India and the East. Meanwhile, the Indian conjurers in attendance are represented with broad painted strokes and dramatic shadows, their yellow and gray tonalities rendering them as unsubstantial as the swirling smoke and distant mosque. Ironically, just a few years after this poster was printed, and when the popularity of the trick was at its peak, the Indian rope trick was roundly denounced in the *Chicago Tribune* and other media as the world's greatest hoax of all time, even as some analysts later identified the *Tribune* itself as the perpetrator of the hoax in the first place.[6]

Koringa, a female magician or *magicienne* who performed in France, England, and the United States during the 1930s, invoked Indian referents through both performance and persona. Her photograph on a 1937 cover of *Look*, an American magazine (cat. 23c), the source for a 1938 English circus poster (cat. 23b), reveals how she creatively reimagined yogic attributes. Her unruly halo of hair recalls the wild tresses of medieval yogini goddesses (cats. 3a–c), her chic bathing suit is styled on the tiger-skin garment of a yogi, and the off-center dot on her forehead hovers between a *bindi* and a protective mark against the evil eye.[7] Touted alternately as the world's "only female fakir" and "only female yogi," Koringa's acts included hypnotism and defying death—practices historically identified with yogic *siddhis*' supernatural powers—by wrestling crocodiles and being buried alive.[8]

Koringa's stage identity represents a performative transformation of yoga in culture and in history. Her promotional materials state that she was born in Rajasthan, orphaned at the age of three, and raised by fakirs who taught her supernatural skills.[9] In reality, she

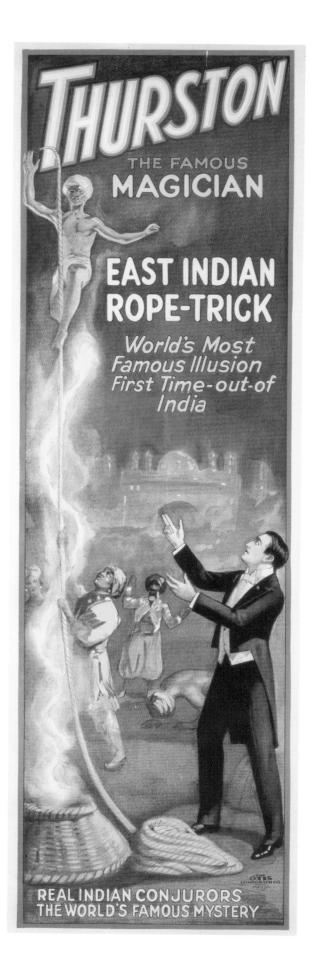

23a *Thurston the famous magician, East Indian rope trick*

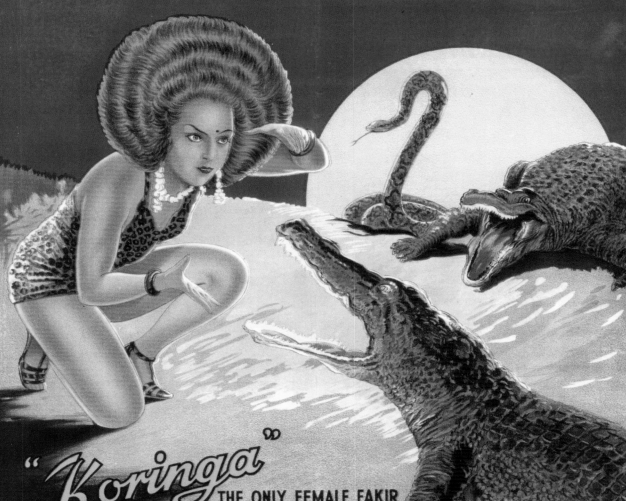

was born Renée Bernard in Bordeaux in southern France. It is likely that Bernard took the name Koringa and adopted an Indian identity because British and French audiences had been ardent fans of theatrical displays of Indian magic and Oriental pomp since the second half of the nineteenth century.[10] In spite of its Orientalist overtones, Bernard's yogini-fakir identity parallels the practices of Indian magicians. For centuries, Indian magicians intentionally capitalized on the supernatural powers that were reputedly held by ascetics. Descriptions from nine-teenth-century and more recent ethnog-raphies note that magicians wore Shaivite sectarian ash marks and *rudraksha* beads; claimed their powers came from ascetic practice or were learned in the cremation grounds frequented by Tantric practi-tioners; and whispered incantations that sounded like sacred mantras, such as *yantru-mantru jadugili tantrum*.[11]

If the Thurston and Koringa posters reference India as the source of magi-cal authority for real fakirs, the film and sound clips described in this section touch on the authenticity and conversely, the *loss* of power, of fictional fakir-yogis. Almost from its inception, cinema devel-oped a relationship with magic—first as a curiosity included in magic acts, and later as a device for creating new kinds of illusions. Film pioneers in the European context—like George Méliès,[12] who would go on to become one of the most famous "trick film" specialists in the world, as well as Dadasahib Phalke, director of India's first feature film *Raja Harischandra* (1913)—were magicians.[13] Indeed, Phalke, can even be seen performing magic tricks in a short film, *Professor Kelpha's Magic* (1916). Early subjects in this "cinema of attractions"[14] ranged from views of foreign lands to scenes from popular Broadway shows to "trick films" that mixed magic routines with special effects.

Meanwhile, in part because of increased cultural exchange due to the British Raj, audiences in the West

23b Koringa

23c "Mystery girl: why can't she be killed?"

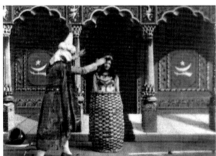

23d Scenes from *Hindoo Fakir*

were fascinated by "exotic" India. Words like "yogi" and "fakir" were part of the pop-culture lexicon, and the figure of the fakir-yogi became an important presence in early filmic representations of India.

Indeed, the first-ever American film about India was a 1902 trick film produced by Thomas Edison's Edison Manufacturing Company titled *Hindoo Fakir* (cat. 23d), which united these two developments in early cinema: the magical trick film and ethnographic representation.[15] The magician in *Hindoo Fakir* is very likely A. N. Dutt, who sometimes performed using that name, and also toured the United States under the name Ram Bhuj. Hardly a fakir at all, he had been born into a middle-class Indian family and was sent to Edinburgh to study medicine. But, without telling his family, he embarked on a show-business career instead.[16] Like other Indian magicians of the time, Dutt took illusions that can be traced back to Indian yogis and retooled them as magic acts on the European and American stage.[17] The basket trick performed in the film, for instance, is a staple of Indian street magicians (*jaduwallahs*), who have performed it for centuries. Another trick, in which his assistant lies on the points of several upturned swords, has a visual echo in a medieval relief carving on a temple at Srisailam, which depicts a yogi sitting on sword-points.[18]

The wonders of ancient India meet the magic of the movies in a third trick that depends entirely on special cinematic effects. In it, the "fakir" puts some seeds into a pot, and thanks to the magic of superimposition, a giant flower grows before our eyes, which in turn becomes his assistant, hovering on huge butterfly wings. This is actually a variation on another *jaduwallah* standard, in which a mango tree appears to grow to full height in minutes, but here the illusion is created entirely by cinematic technology. Canny Indian magicians like Dutt made careers out of performing *jaduwallah* tricks while playing up their exotic origins

as fakir-yogis.[19] If all films are documentaries in that they reflect the tastes and prejudices of their times, *Hindoo Fakir* fits the bill in a number of ways. It delights in showing off the new illusions cinema could create through editing and superimposition, and it documents popular magician-performers of the time.

By the late 1930s and early 1940s, mainstream American cinema was thoroughly familiar with the fakir-yogi as a media trope. The 1941 film *You're the One*, for example, features a song with lyrics by the great Hollywood songwriter Johnny Mercer, "The Yogi Who Lost His Willpower,"[20] which was remarkable in at least two respects for the cultural work that it accomplished. First, the song humorously brings together at one stroke all the Orientalist stereotypes that might ever have been associated with yogis, potentates, and adventure tales from India—beds of nails, magic carpets, crystal balls, turbans and dhotis, levitation, rope tricks, maharajas—and weaves them into a single narrative. Second, the song domesticates and humanizes the fakir-yogi by making him fall in love but fail at it, by giving him the ability to predict the future but not his own emotional fate. While Mercer's lyrics end on a painful note—"What became of the yogi? No one knows"—the fakir-yogi has the last theatrical word in the version popularized by Orrin Tucker and his orchestra (cat. 23e). After peering one last time into his crystal ball, the fakir-yogi gets ready for his ultimate act and his final goodbye. He throws off his cloak as a rope emerges from the floor and levitates its way upright. In the midst of a swirl of smoke, the yogi clambers up the rope, gives a final flourish, and … disappears. Fakirs may well have lost their willpower in early twentieth century America, the scene seems to suggest, but they are not now nor ever in danger of losing their supernatural ones. Whether fakirs or fakers, their magic outlives them. SR and TV

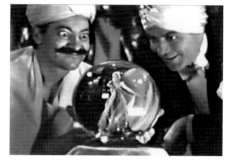

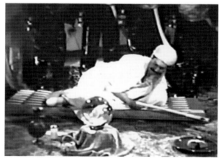

23e Scenes from *The Yogi Who Lost His Willpower*

The Yogi Who Lost His Willpower
Lyrics by Johnny Mercer

There was a yogi who lost his willpower
He met a dancing girl and fell in love.
He couldn't concentrate, or lie on broken glass
He could only sit and wait for her to pass

Unhappy yogi, he tried forgetting, but she was all that he was conscious of.
At night he stretched out on his bed of nails
He could only dream about her seven veils
His face grew flushed and florid every time he heard her name
And the ruby gleaming in her forehead set his oriental soul aflame.

This poor old yogi, he soon discovered
She was the Maharajah's turtle dove.
And she was satisfied, she had an emerald ring, an elephant to ride—and everything.
He was a passing whim. That's how the story goes.
And what became of the yogi, nobody knows ...

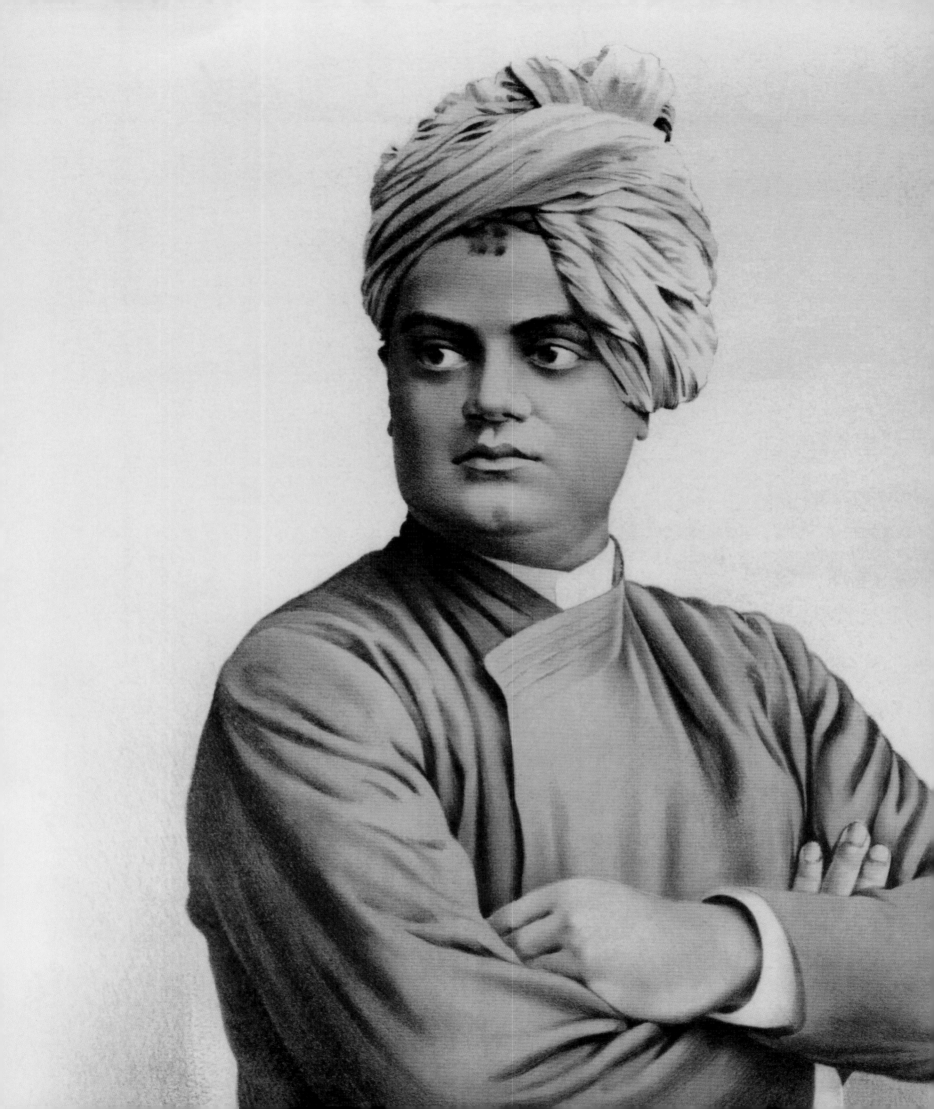

Vivekananda and Rational Spirituality

24A
The Yoga-Sutra of Patanjali

M. N. Dwivedi, trans.
Theosophical Publication Fund, Bombay, India, 1890
Book, 21 × 37 cm
General Collections, Library of Congress, Washington,
DC, B132.Y6.P267 1890 Copy 1
Not illustrated

24B
Swami Vivekananda and Narasimhacarya

United States, 1893
Photographic print, copy of original
Vedanta Society of Northern California, V17

24C
Swami Vivekananda

United States, 1893
Photograph (original), approx. 15.2 × 10.2 cm
Vedanta Society of Northern California, V21
Inscription (recto): "One infinite—pure & holy—
beyond thought, beyond qualities, I bow down
to thee."—Swami Vivekananda

24D
*Swami Vivekananda on the Platform
of the Parliament*

United States, 1893
Photographic print, copy of original
Vedanta Society of Northern California, V16

24E
Swami Vivekananda, Hindoo Monk of India

United States, 1893
Poster (color lithograph), copy of original from
Goes Lithographing Company, Chicago
Vedanta Society of Northern California,
Harrison series, V22
Inscription (recto): "To Hollister Sturges—All strength
and success be yours is the constant prayer of your
friend, Vivekananda"

24F
Swami Vivekananda at the Parliament

United States, 1893
Photograph (original), approx. 15.2 × 10.2 cm
Vedanta Society of Northern California,
Harrison series, V26
Inscription (recto): "*Eka eva suhrid dharma
nidhanepyanuyati yah*. Virtue is the only friend that
follows us even beyond the grave. Everything else
ends with death." Vivekananda

24G
*Neely's History of the Parliament of
Religions and the Religious Congresses
at the World's Columbian Exposition*

Walter R. Houghton, ed.
Chicago, United States, 1893
Book, 22.5 × 37 cm
General Collections, Library of Congress, Washington,
DC, BL21.W8N4

24H
Raja Yoga

Swami Vivekananda
Advaita Ashram, India, 1944 [1896]
Book, 18.5 × 27 cm (open)
General Collections, Library of Congress, Washington,
DC, B132.V3 V58

24I
Swami Vivekananda

United States, 1893
Photographic print, copy of original
Vedanta Society of Northern California,
Harrison series, V27

24J
Swami Vivekananda

United States, 1893
Scan of a halftone print
Vedanta Society of Northern California,
Harrison series, V20

24K
Swami Vivekananda

United States, 1893
Photographic negative
Vedanta Society of Northern California,
Harrison series, V23
Inscription (recto): "Samata sarvabhuteshu
etanmuktasya lakshanam. Equality in all beings
this is the sign of the free—Vivekananda"

24L
Swami Vivekananda

United States, 1893
Photographic negative
Vedanta Society of Northern California,
Harrison series, V24
Inscription (recto): "Thou art the only treasure in this
world—Vivekananda"

24M
Swami Vivekananda

United States, 1893
Photographic negative
Vedanta Society of Northern California,
Harrison series, V25
Inscription (recto): "Thou art the father the lord the
mother the husband and love—Swami Vivekananda"

In the late 1800s, India experienced a yoga revival focused on the teachings and philosophy of Swami Vivekananda, which culminated in a foundational moment for modern transnational yoga: the publication of *Raja Yoga* in 1896 (cat. 24h).[1] Scholars of modern yoga all agree on the critical importance of this event. Elizabeth DeMichelis suggests that modern yoga did not begin or take tangible form until Vivekananda's publication of *Raja Yoga*. Mark Singleton argues that practice-oriented Anglophone yoga manuals emerge as a genre only after this date.[2] David Gordon White states that Vivekananda's synthesis set the agenda for the modern yoga movement.[3] With its combination of classical yoga, Western philosophy, and esotericism, *Raja Yoga* did indeed lay the formative steps toward yoga's globalized revival. Even so, it is important to bear in mind that the publication, even if wildly successful, did not occur in isolation but built on a prior history of similar attempts at translation, synthesis, and syncretism of a new rational, scientific yoga for the modern age.

Born Narendranath Dutta and initiated by his teacher Ramakrishna Paramahamsa at a young age, Vivekananda (1863–1902) chose yoga as the platform for spearheading larger goals of religious reform. His *Raja Yoga* was a remarkable and brilliant synthesis of practical meditative breathing techniques and philosophy, which, importantly, excluded hatha yoga *asana*s even as it harked back to ancient texts for inspiration, in particular Patanjali's *Yoga Sutras*. In this classic golden-age invocation of the distant past to repudiate contemporary yogic practice and lay the ground for the future, Vivekananda's reformist arguments had much in common with those of his fellow nationalist reformers in pre-independence India. As outlined in *Raja Yoga*, his thesis on the revival of yoga had two distinctive but interlinked parts: rational spirituality and Hindu reform. Both of these tenets built

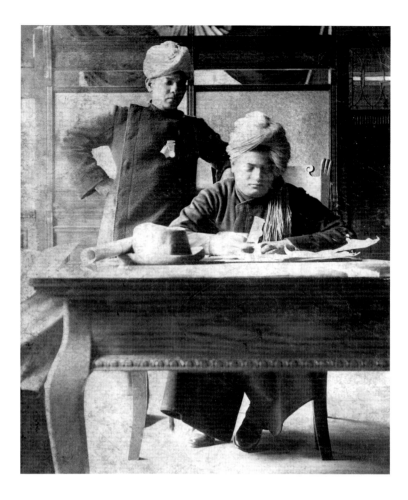

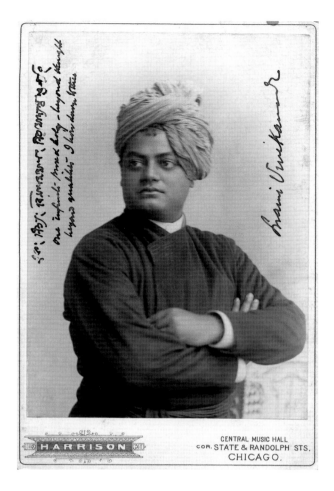

on a public rejection of the legitimacy and power of miracles of contemporary yogis on the one hand, and a valorization of the ancient texts, particularly the *Yoga Sutras*, on the other.

Vivekananda began by showing that Hinduism had departed from its rational, philosophical, and scientific roots as affirmed in the Vedas and Upanishads. But he also added other elements to this synthesis, which set the agenda for modern yoga. In sharp contrast to scholars of the period who tended to foreground the magical and mystical within yoga, Vivekananda's emphasis on the rational and the scientific sprang from his distinctive antimysticism—his call to reverse the mystery and secrecy in yoga practices—the very things, he claimed, that had destroyed contemporary yoga.[4] These lectures and writings linked yoga instead with the monistic, rationalist spirituality

of the neo-Vedantists,[5] while ignoring (or giving a wide berth to) both Patanjali's comparatively dualistic Samkhya-based metaphysics as well as hatha yoga practices themselves. In this reinterpretation, Raja yoga was the supreme contemplative path to self-realization, in which the self was "the supreme self, the absolute brahman or god-self within."[6] Yoga was thus, before all else, nonsectarian, a "unifying sign of the Indian nation—and not only for national consumption but for consumption by the entire world."[7]

For all its novelty and innovation, this idea of a universalist, rational, and scientific text-based yoga as laid out in *Raja Yoga* did not come out of the ether, but relied on a long history and genealogy of previous works by others. Vivekananda's gradual consolidation of this thesis built not only on earlier scholarship on yoga philosophy (which

24b (left) *Swami Vivekananda and Narasimhacarya*

24c (right) *Swami Vivekananda*

had reached Anglophone transnational audiences), but also on his own triumphant travels and talks in America and the United Kingdom, where he had begun to reframe yoga as a form of "spiritual empiricism."[8] There were two key moments of public dissemination as this emerging yoga synthesis built momentum in the late 1800s, each of which emphasized different aspects of the doctrine: the late nineteenth-century spate of Theosophical Society translations of ancient texts; and the 1893 Parliament of Religions in Chicago, where Vivekananda presented himself as the "Hindoo monk of India" but framed yoga as a scientific and rational spiritual system for the world.

At least since the 1870s, there had been a history of scholarly syncretism and invention of yogic tradition through texts and translations of classical works, much of this under the aegis or sponsorship of the Theosophical Society and its publishing wings.[9] In the context of yoga scholarship, all of these were published well before Vivekananda's 1893 Parliament address, and thus anticipated, in some cases by a decade, his *Raja Yoga* synthesis of scientific rationality.

One of the earliest English translations of the *Yoga Sutras*, for example, was by Manilal Dwivedi, shown here in an early 1890 edition (cat. 24a). Dwivedi's volume laid the ground for a Theosophical Publication series titled *Sacred Books of the Hindus*, including the first translations and expositions of seminal yogic texts (*Gheranda Samhita, Siva Samhita*), all of which Vivekananda would have had access to decades later. Sirisa C. Vasu was a pioneering author in this series. His translation and teachings on *Siva Samhita* (1893) should be seen as part of the earliest international efforts to reconcile science with religion in the yogic context, while his *Introduction to Yoga Philosophy* (1893) repeatedly condemns the hatha yogis, the contemporary contortionists, and the beggars and street performers as "the

natural enemy of the true Yogi." What comes across collectively from these Theosophical Society translations is a redefinition of the yogi in which the grassroots practitioner of hatha methods has no part. The modern yogi, in other words, must be rational and scientific, whereas the hatha yogi was clearly not.

The *Sacred Books of the Hindus* series was a response to scholar Max Muller's *Sacred Books of the East* series. Muller's views on yoga could be summarized as a Reformationist vision of Indian religious history. He was critical of both Vivekananda's debut at the World's Parliament as well as his inclusion of practical, nonintellectual yoga techniques in Vedanta philosophy. But his insistence on the philosophical sophistication of Indian thought and his uncompromising rejection of hatha yogis as exemplars of sin and darkness helped to lay the ground for Vivekananda's spiritual synthesis decades later.

By the time Vivekananda traveled to Chicago to address the 1893 World's Parliament of Religions,[10] the scene was set for a public presentation about yoga that was tied closely to a message on Hindu reform. Some of this shows in Vivekananda's deliberate sartorial presentation of himself as a "Hindoo monk"—clad in red robes and saffron turban—at once playing into but also defying Orientalist stereotypes of asceticism and regality.[11] The photographic record of Vivekananda's address at Parliament is relatively sparse even though the number of reproductions from the few existing prints is quite voluminous. Of the existing photographs, the Vedanta Society has among the most comprehensive collections chronicling Vivekananda's visit to Chicago as well as other locations in the United States. Two photographs from the Vedanta Society of Northern California's Rare Images Archive are relatively unposed, casual shots taken shortly before Vivekananda's now-famous address to the Parliament.

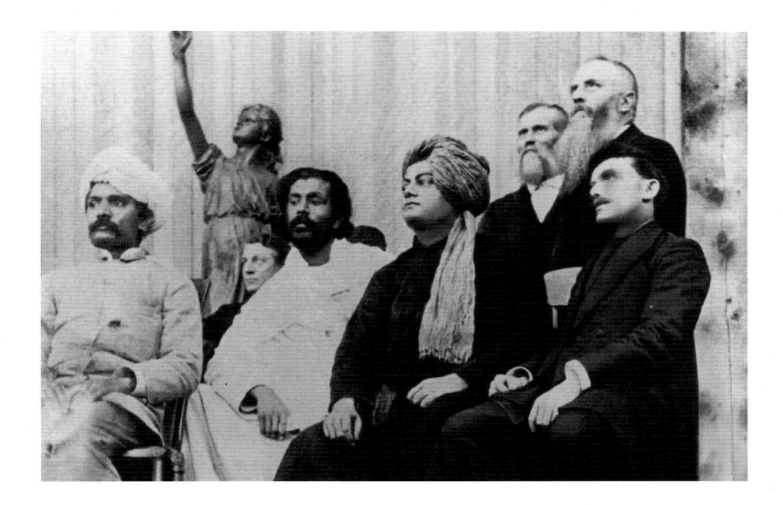

Swami Vivekananda and Narasimhacarya (cat. 24c) is one of the earliest photographs of Vivekananda in America. While there is no accompanying date, it features a turbaned Vivekananda seated at a desk writing, with fellow Indian delegate Narasimhacarya (who also represented Hinduism at the Parliament) looking over his shoulder, in a room marked "No. 1—keep out," which was a room in the Congress' Art Palace where the speakers repaired between sessions.

The second, more evocative photograph is a group picture, *Swami Vivekananda on the Platform of the Parliament* (cat. 24d), taken on the afternoon of the opening day, September 11, 1893. Vivekananda is surrounded by a group of delegates, who appear to be listening to other sessions. A long turban pleat over one shoulder, shoulders tense, he appears pensive, even apprehensive.

As suggested by the notes in the Rare Images Archive, he remained seated through the proceedings, meditative and prayerful, letting his turn to speak go by time and again. It was not until after the afternoon session, after four other delegates had read their prepared papers, that he was urged to begin by the French pastor G. Bonet Maury, who is seen seated next to him. And thus it was that Vivekananda—wearing his signature robe—bowed to the goddess Saraswati and rose to speak to the Congress and, through it, the world. His address, delivered without notes, and beginning "Brothers and sisters of America ..." was rapturously received, making him an overnight celebrity.

A more formal, posed set of studio photographs known collectively as the "Harrison series," also from the Vedanta Society (V20–V27, cats. 24e, 24i–m),

24d *Swami Vivekananda on the platform of the Parliament*

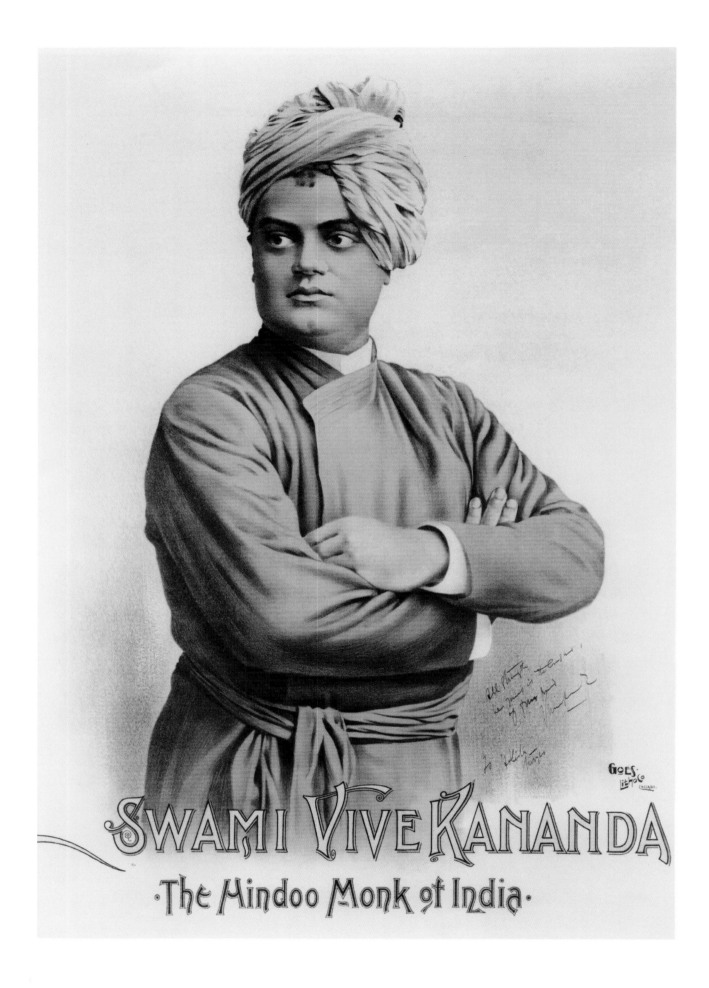

SWAMI VIVE KANANDA

·The Hindoo Monk of India·

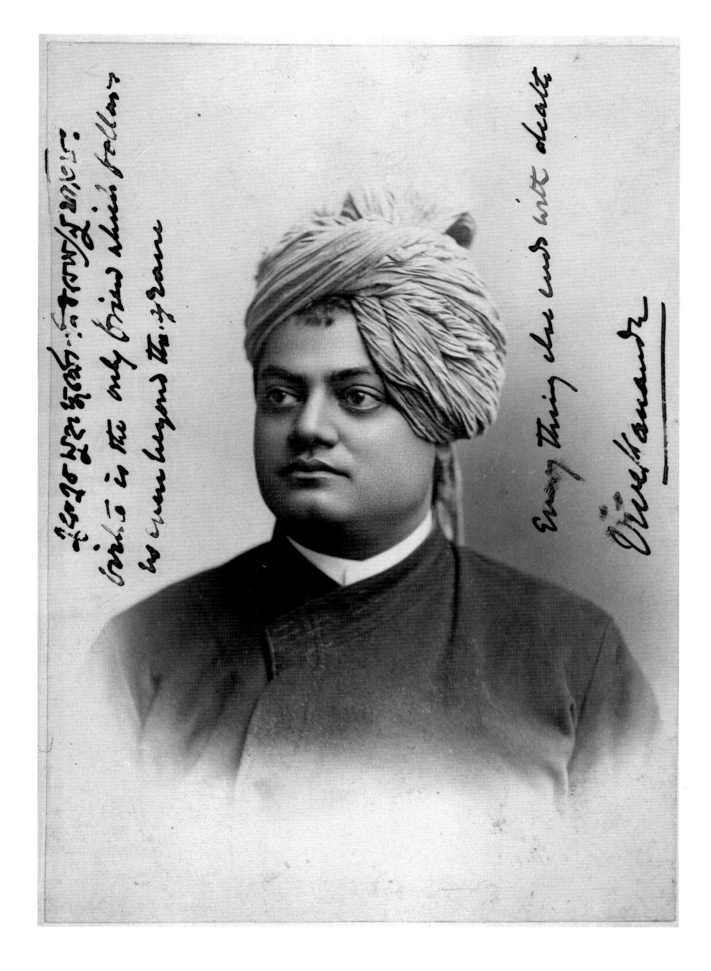

miracles to supply their wants (Matt. xiv., 17 and fol., xv., 36 and fol.). And so it is with every part of his doctrine; in all things he gave the example, that, as he had done so also we should act. It is for this reason that St. Paul so often exhorts us to put on the new man (Eph. iv., 24), to put on Christ (Gal. iii., 27; Rom. xiii., 14)., to be in all things conformed to his example (I. Cor. iv., 16), for in the example he gave he was also our Savior.

But the saving influence of Christ is to be found principally Him in death; because by his death He reconciled us with God (Col. i., 19; Eph. ii., 14, 16), freed us from sin and satisfied God's justice (Heb. ix., 13 and following; I. John i., 7; Apoc. i., 5), restored us to grace and justification (Rom. ii., 25; Col. i., 21, 22) freed us from the power of Satan (Col. ii., 15), and made us once more the children of God (Col. i., 12, 13, 14). Christ came into this world, lived among men, and died upon the cross in execution of a sublime plan for man's redemption; of a plan which nothing less than the infinite wisdom of God could conceive, and nothing less than the omnipotence of God could execute. "We have thought Him as a leper and as one struck by God and afflicted," wrote the prophet Isaia, "but He was wounded for our iniquities, He was bruised for our sins." "He was offered up because it was His own will, and by His bruises we are healed." God had been offended, grievously offended by the sin of our first parents, so much so that from that time the gates of heaven were closed against men. Even the souls of the just who died under the old law could not enjoy the happiness of heaven; they were compelled to remain in a place called Limbo until atonement had been made for the sin of Adam. And besides this sin of the human race, there were other sins, black and shameful and hideous, some of them, and as numerous, alas, as the sands on the seashore. There were the personal actual sins committed from the time of Adam up to the last breath of the last man that will live in the world. All these had to be atoned for, and how could man hope to offer any satisfaction that would bear the least proportion to the infinite sanctity of the God who had been offended and insulted?

Then it was that our Savior consented to be a voluntary victim offered up in expiation for the sins of the world. "The Word was make flesh and dwelt among us" (John i., 14); Christ came into the world, true God and true man. Being man He could suffer; being God, any one of His actions would have infinite value both for merit and for atonement. "God laid on him the iniquity of us all," says Isaiah (liii., 6); by his death God's justice was satisfied and man was redeemed; for, says St. Peter (I. Ep. i, 18) we were "not redeemed with corruptible things as gold and silver, but with the precious blood of Christ as of a lamb unspotted and undefiled." Thus was blotted out the handwriting of the decree that was against us (Col. ii. 14). By his death Christ not only freed us from evil, He also merited for us the graces we need in order that we may do good, performing actions meritorious of eternal life. Without Christ we can do nothing (John xv., 5). All those who were saved under the old law were saved through faith in the Redeemer to come; grace was granted to them owing to His foreseen merits. In the new law all our sufficiency is from Him (II. Cor. ii., 3); all graces are granted, as we ask them, "through the merits of our Lord and Savior Jesus Christ." He merited these graces for us by all the acts of His life, but principally by dying for us; the precious blood shed on Calvary flows through the church; it vivifies the sacraments, the channels of grace, by partaking of which we drink from that "fountain of water springing into life everlasting." (John iv., 14.)

After His ascension into heaven He sent the Holy Ghost, the spirit of truth and love, to abide forever with His church, which is to continue on earth the work of saving souls. Under the guidance of the Holy Spirit she is to teach men the way of truth; she is the depository and dispensation of the graces merited for all men by Christ; she is the guardian of the

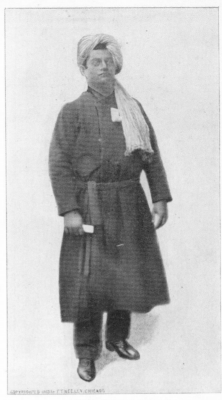

SWAMI VIVEKANANDA,
Hindu Monk.

24g (left) *Neely's History of the Parliament of Religions and the Religious Congresses at the World's Columbian Exposition*

24h (opposite) *Raja Yoga*

takes its name from a photography studio in Chicago owned by Thomas Harrison.[12] Here we see Vivekananda's presentation—complete with saffron robes and elaborate turban—as "the Hindoo monk," the title that was featured on posters for the duration of the fair and by which he came to be known in Chicago and across the world.

A cabinet card-sized original photograph, *Swami Vivekananda* (cat. 24c) from the Harrison series shows Vivekananda in what photographers referred to as the "Chicago pose"—arms folded across his chest, three-quarters of his turbaned face visible as he looks sternly toward the left. The photograph was inscribed by the swami in Bengali and English along its sides: "One infinite pure and holy—beyond thought beyond qualities I bow down to thee." The poster

shown here, *Swami Vivekananda: The Hindoo Monk of India* (cat. 24e), based on the original Chicago pose photograph, was printed by Goes Lithographing Company in 1893. Vivekananda's distinctive orange robe and turban are clearly visible because of the vivid reproductions possible through chromolithographic technology, while the typographic below the image loudly announces him as "the Hindoo monk of India." This poster, whose original is currently in the Vedanta Society collection, is one of the most iconic images of Vivekananda available. It instantly captured some of the visual contradictions of his Chicago address— a recognizably *Indian* swami signaling both ethnic particularism and Hinduism's inherent universalism. But in so doing, it circulated a powerful meta-picture that would continue to shape imaginations

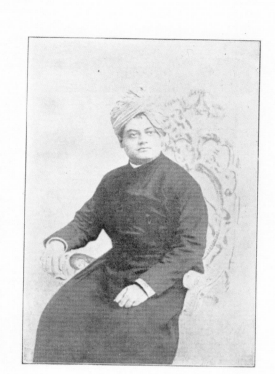

SWÂMI VIVEKÂNANDA

REPRESENTATIVE OF THE HINDU RELIGION AT THE WORLD'S PARLIAMENT
OF RELIGIONS, HELD IN CHICAGO, 1893

VEDANTA PHILOSOPHY

RÂJA YOGA

BEING LECTURES BY THE
SWÂMI VIVEKÂNANDA

WITH PATANJALI'S APHORISMS, COMMENTARIES
AND A GLOSSARY OF TERMS

NEW EDITION, WITH ENLARGED GLOSSARY

NEW YORK
BRENTANO'S
1920

about yoga, religion, even spirituality in the West for the next century.

A second cabinet card photograph from the Harrison series, *Vivekananda at Parliament* (cat. 24f), features the swami striking a different, more determined pose. His arms akimbo, he gazes off in the distance, seemingly ready to take on the world. The photograph bears the following inscription in Sanskrit and English: "*Eka eva suhrid dharma nidhanepyanuyati yah*. Virtue is the only friend that follows us beyond the grave. Everything else ends with death." It was first published in Neely's *History of the Parliament of Religions and Religious Congresses at the World's Columbian Exposition* in 1893, bearing the caption "Swami Vivekananda." Neely, it should be pointed out, published more photographs of Vivekananda than of any other

delegate to the parliament. It is not surprising that the same photograph, printed to show a full-length image of Vivekananda, is also featured in Walter Houghton's book on Neely (cat. 24g). The adjoining page describes in some detail the substance of the swami's address to the Parliament as well as some of the subsequent responses.

Taken together, the Harrison series suggests how the photographic record of Vivekananda's visit to Chicago has dominated visual memory of yoga's transnational journey. While the swami's philosophical teachings on yoga changed between 1893 and 1896, and thus cannot be pinned down without oversimplification, it is the imagery that has remained constant and forever etched in our minds. Swami Vivekananda's presentation of self in Chicago offered an iconography

for transnational yoga that would last for well over a century in America—at once timeless and universal but also singular and culturally specific; nonsectarian but also Hindu; scientific but filled with spirit. SR

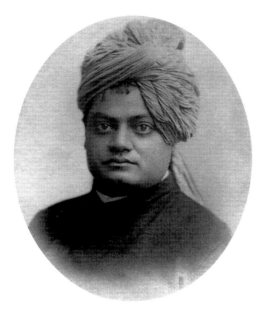

24i *Swami Vivekananda*

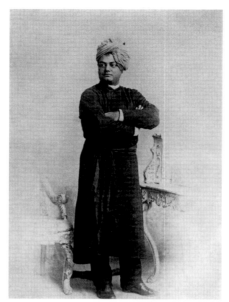

24j *Swami Vivekananda*

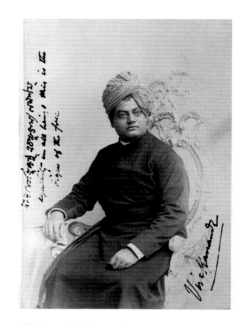

24k *Swami Vivekananda*

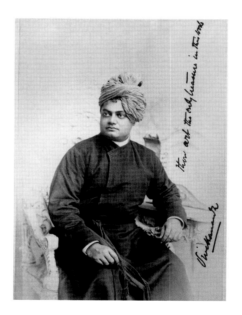

24 l *Swami Vivekananda*

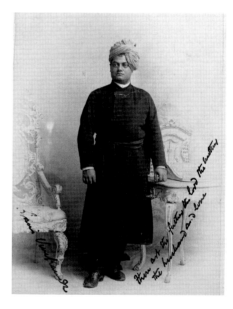

24m *Swami Vivekananda*

Medical Yoga

25A
Anatomical Body

India, Gujarat, 18th century
Ink and color on paper, 60.5 × 58.5 cm
Wellcome Library, London, Asian Collections,
MS Indic Delta 74

25B
Satcakranirupanacitram

Swami Hamsasvarupa
Trikutvilas Press, Muzaffarpur, Bihar, India, 1903
Book, 26.2 × 34.5 cm
Wellcome Library, London, Asian Collections,
P. B. Sanskrit 391

25C
The Chakras, a Monograph

Charles W. Leadbeater (1854–1934)
Theosophical Publishing House,
Wheaton, IL, United States, 1972 (© 1927)
Book, 31 × 26 cm
General Collections, Library of Congress, Washington,
DC, BP573.C5 L4 1972

25D
The Mysterious Kundalini

Vasant Gangaram Rele
D. P. Taraporevala Sons and Co., Bombay, India, 1929
Book, 21 × 26.5 cm (open)
General Collections, Library of Congress, Washington,
DC, B132.Y6 R4a Copy 1

25E
Popular Yoga: Asanas

Swami Kuvalayananda
C. E. Tuttle Company, Rutland, VT,
United States, 1972 (1931)
Book, 22 × 31 cm
General Collections, Library of Congress, Washington,
DC, B132.Y6.K787

25F
Yoga Mimansa

Vol. 1, no. 1, page 57
Shrimat Kuvalayananda, ed.
Kaivalyadhama, Lonavla, India, 1924
Periodical (quarterly), 23.5 × 16.1 cm
National Library of Medicine, W1 Y0661

25G
Yoga Mimansa

Vol. 2, no. 2, page 116
Shrimat Kuvalayananda, ed.
Kaivalyadhama, Lonavla, India, 1926
Periodical (quarterly), 23.5 × 16.1 cm
National Library of Medicine, W1 Y0661

25H
Yoga Personal Hygiene

Shri Yogendra
The Yoga Institute, Bombay, India, 1940
Book, 21.5 × 27 cm
General Collections, Library of Congress, Washington,
DC, B132.Y6.Y63

From at least the end of the first millennium CE, yogic and Tantric traditions in India began to evolve the idea of an alternative anatomy, which mapped the "subtle body" (*sukshma sharira*) as a locus of spiritual energies and points of graduated awakening—chakras (wheels) or *padmas* (lotuses)—arranged along a vertical axis (*sushumna*) through a network of channels (*nadis*). By the late nineteenth century, printed images of these yogic bodies reflected a slow but visible transformation through encounters with the world of science and medicine. Partly due to the increasing prevalence of anatomical dissections and textbooks in Indian medical schools after 1836,[1] partly due to the increasing number of yoga advocates who were also medical professionals, representations of yoga began to reflect a new way of "seeing" the yogic body through anatomical eyes. They also revealed a growing visual engagement with the vocabularies, concepts, symbols, and measures of science as a new source of legitimizing authority. This essay traces the medicalization of yogic imagery through a few key examples, ranging from indigenous paintings to textbooks to depictions of scientific yoga by two of its leading advocates in the early twentieth century: Swami Kuvalayananda and Shri (or Sri) Yogendra.

One of the earliest known indigenous medical paintings is a monumental eighteenth-century image of yogic anatomy superimposed on a medical body (cat. 25a).[2] The painting was derived from the Persian tradition of anatomical illustration known as *Tashrih-i-Mansuri*, which was popular in Iran and spread to South Asia. As Dominik Wujastyk suggests, it is primarily a medical image, not a Tantric or a yogic one, emphasizing the veins, arteries, and intestinal tract of the body.[3] Even so, there is what he terms a discernible "Indianization" of the medical body in the superimposition of six chakras faintly drawn onto the spinal

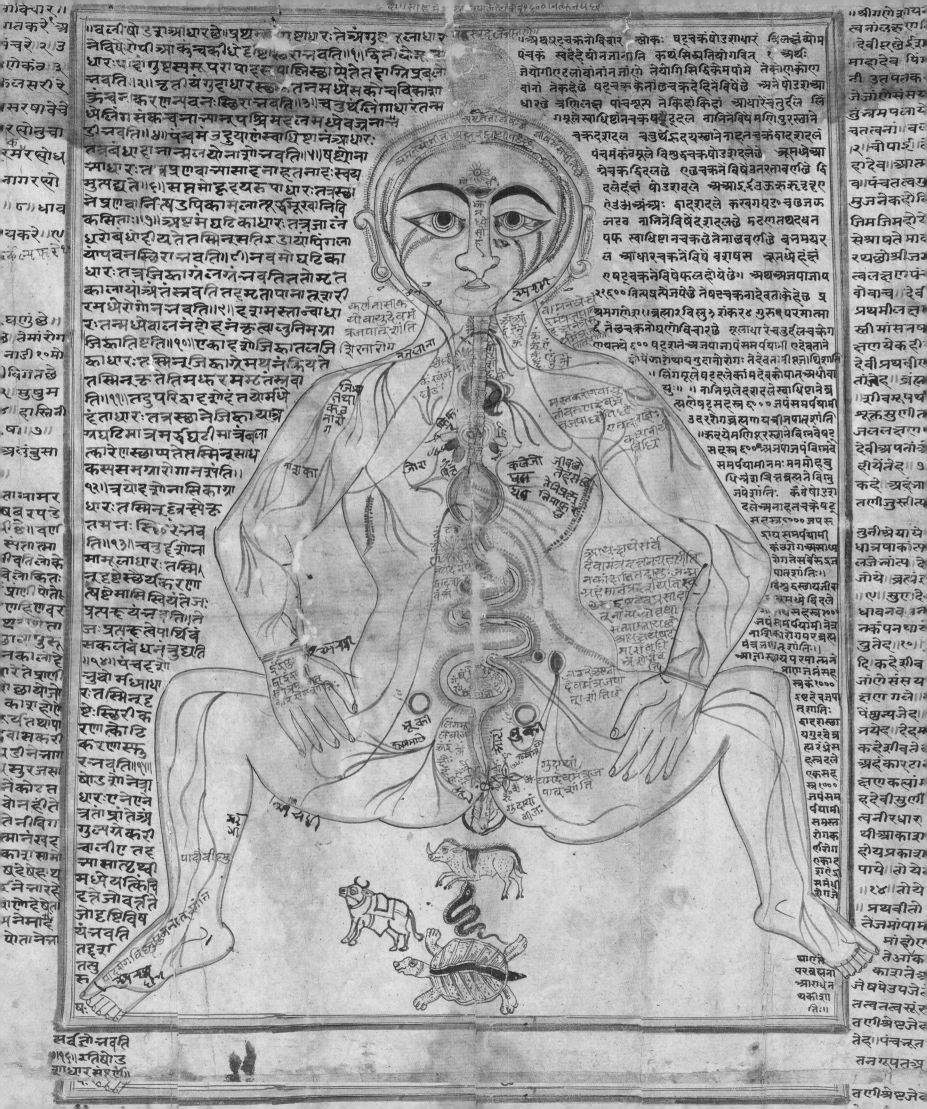

column and the *kundalini* serpent coiled at the base of the spine below the outline of the body. The text offers a few further clues on this visual juxtaposition of medical and indigenous iconographies. While the text surrounding the image is a mixture of Sanskrit and old Gujarati (which places the painting in Western India) and describes the subtle, mystical yogic body of Tantric meditation, the text *on* the body is a mixture of Sanskrit and Persian medical terms in Persian and Devanagari scripts, and presents a mixture of ideas from medical as well as yogic views of the body. Wujastyk notes that despite the predominantly medical content and non-Indian background of the *Tashrih* tradition, the painting's Indian artist may have been motivated to integrate his own artistic and cultural background with the more typical indigenous Tantric image of the body, featuring chakras and *nadis* or conduits, such as *ida* and *pingala*, through which the breath (*prana*) travels and the coiled energy (*kundalini*) ascends.[4]

By the early twentieth century, artists were engaging in a more literal interpretation that argued for the physical reality of the yogic or subtle body. Swami Hamsasvarupa's *Satcakranirupanacitram*[5] includes eight color plates that show a visual rapprochement between yogic physiology as described in early texts, and the anatomically correct body that was being discovered by Western medicine in the nineteenth and twentieth centuries. In the foreword of the book that Mircea Eliade described as "the most authoritative treatise on the doctrine of the cakras,"[6] Sri Hamsasvarupa suggests that it was intended for educators at colleges that emerged during nationalist efforts to revive indigenous medicine in late nineteenth and early twentieth-century India. The image shown here, plate 2 (cat. 25b), comes from a fine 1903 edition. The yogic and anatomical bodies are shown side by side; the former assumes a seated *asana* (marked by the title as *siddhasana,* or *siddha* pose) while the anatomical body makes clear the physical locations of the associated chakras and *nadis*.[7]

While subtle body depictions of the chakras were based on traditional iconography, a somewhat different visual interpretation was introduced in the West by the Theosophists, beginning with Charles W. Leadbeater. A founding member of the Theosophical Society (along with Annie Besant) who championed the New Thought–led rediscovery of Eastern mysticism and spirituality, Leadbeater was a key conduit for the public dissemination of the Tantric chakra doctrine that became popular in print circles. His book *The Chakras*, first published in 1927, sold more copies outside India than any other Theosophical text at the time. The image shown here (cat. 25c) represents an early twentieth-century depiction of yogic anatomy that became iconic in subsequent metaphysical, Theosophist, and New Age thought— whether the more elemental classic seated pose,[8] or the ubiquitous standing pose with anatomically recognizable organs. Titled *L'Homme Terrestre Naturel Ténébreux*,[9] Leadbeater's image makes two visual statements. First, it was one of the early instances of a schematic of the yoga body that used prevailing ideas of chakra images to give readers a potent and poetic visual metaphor for spiritual awakening as a *kundalini* force: a snake moving as a brilliant thread along the central *sushumna nadi,* piercing six lotus chakras, located not necessarily in a straight line but linked with elements (humors) and within anatomically recognizable organs in the body (heart, liver, lungs, bladder). It also made the visual case for yogic and subtle body "clairvoyance," i.e., that the chakras can be perceived through psychic vision or a form of stylized yogic visualization. This Theosophical idea of clairvoyance implies that the chakras have an

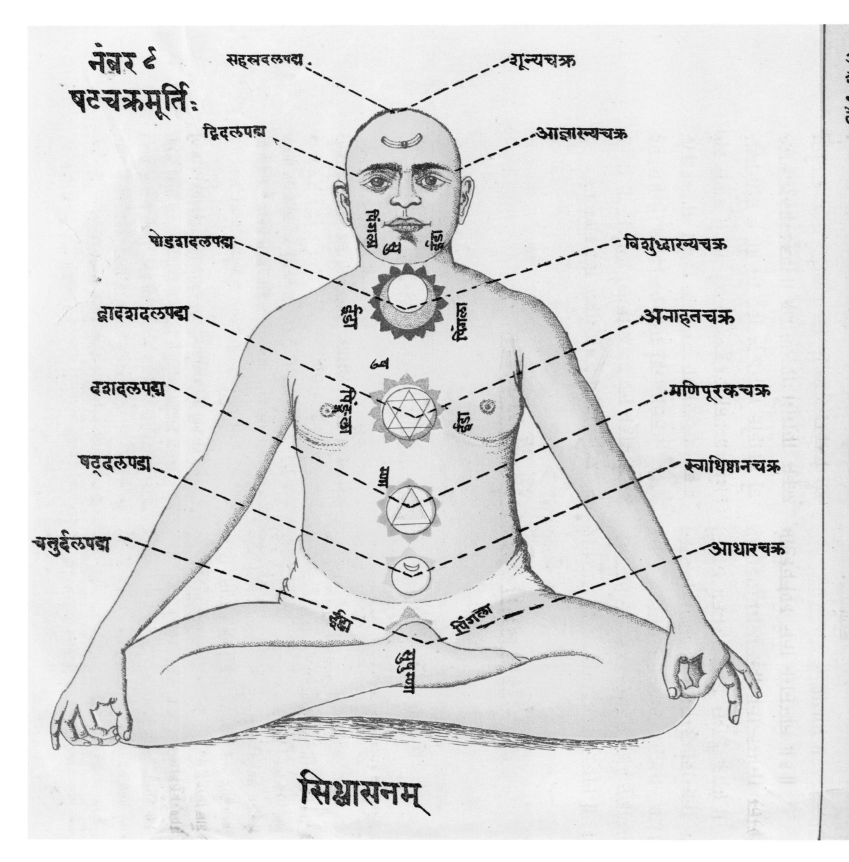

25b *Satcakranirupanacitram*

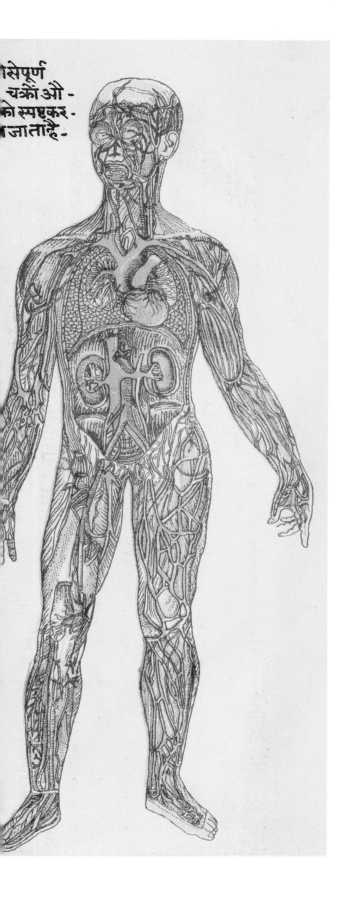

सेपूर्ण
चक्रों ओ -
को स्पष्कर .
जाताहै .

independent objective existence in the subtle bodies and can be perceived by anyone who has developed the appropriate tools. *The Chakras* thus laid out a visual physics of the yogic body in which chakras were presented as energy transformers or centers of consciousness (vortexes) that physically linked the various subtle bodies—the etheric, astral, and mental bodies[10]—and enabled a person to assimilate cosmic consciousness.

Like his predecessor Vivekananda—who, in *Raja Yoga*, was the first in the West to use a schematic chakra image (see cat. 24h)[11]—Leadbeater turned the process of yogic *samadhi* (heightened consciousness) into a physiological process akin to digestion. Dr. Vasant Rele, the author of *The Mysterious Kundalini* (1929), took this idea further and did the same with the neurological body. A biomedical doctor, Rele was one of the earliest "scientizers" of the *kundalini* phenomenon, and his books were among the first to establish and popularize a scientific basis for yogic physiology and hatha yoga practice. *The Mysterious Kundalini* contains anatomical illustrations, small black-and-white photo plates of a yogi demonstrating various *asana*s, and an illustration of the *kundalini* serpent in the center of an inverted triangle radiating energy with the following inscription beneath: "The Kundalini is sleeping above the Kanda dispensing liberation to Yogis and bondage to fools. He who knows her knows yoga."[12]

In his preface, Rele wrote that the intended audience for the book was the medical community and an educated general audience familiar with some scientific and anatomical terminology. The book is a scientific exposition of yogic physiology—going one step beyond anatomical description—and includes several firsts: the first-ever clinical case note for yogic treatment and the first description of the physiology of the *pranic* yogic body, not through the endocrinological system but its neurological equivalent.

Plate 10 (cat. 25d) presents the yogic subtle body *as* the neurological body, through detailed anatomical diagrams of the nervous system, neurons, ganglia, and synapses that are typically made visible only through dissection.

While scholars may disagree on the earliest antecedents of medical yoga,[13] there is remarkable consensus around the role of its key popularizers in the early twentieth century: Swami Kuvalayananda and Shri Yogendra. Kuvalayananda was a critically important figure in the modern renaissance of yoga as therapeutic cure for disease. In 1921, using the paraphernalia, technology, and equipment of modern medical science—electrocardiograms, x-ray machines, sphygmometers, spectroscopes—Kuvalayananda and his researchers at the Kaivalyadhama Institute attempted to measure the physiological effects of *asana*, *pranayama*, *kriya*, and *bandha* and then used their findings to record, present, and develop therapeutic approaches to a range of illnesses. The physiological experiments were widely disseminated through publications, journals, and pamphlets and through mass yogic exercise schemes in schools and government committees in Bombay. The institute's journal, *Yoga Mimansa*, first published in 1924, was both a scientific review of these efforts and a practical illustrated manual that appealed to medical authority for legitimacy, although its assimilations of the "modern" were often partial, incomplete, and merely symbolic.

The images shown here (cats. 25f, 25g) demonstrate this form of cultural syncretism: a 1920s photograph of a yoga practitioner doing the fish pose (*matsyasana*) with arrows marking the anatomical location of the thyroid; and a 1926 graphical chart measuring blood pressure during headstand pose (*sirsasana*). Kuvalayananda's book *Popular Yoga: Asanas* (1930) further consolidated his role as scientific champion of yoga for health. It includes an image of anatomical

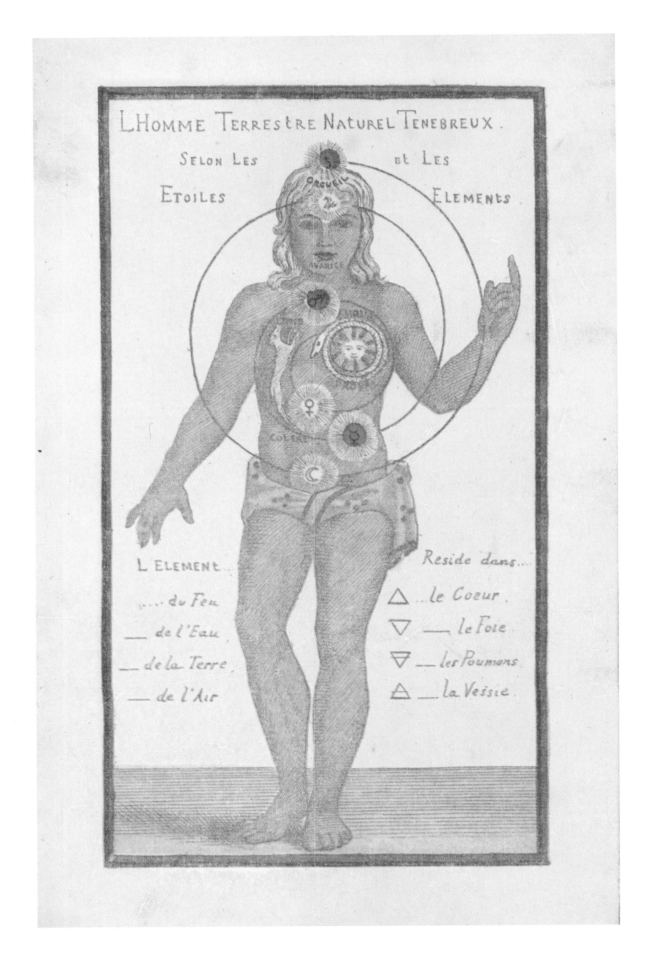

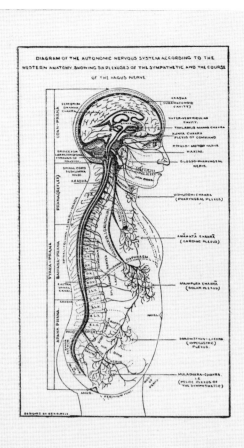

THE
MYSTERIOUS KUNDALINI
The Physical Basis of the Kundali (Hatha) Yoga in terms of Western Anatomy and Physiology.

Under the auspices of The Bombay Medical Union, a few days back Deshbandhu............

Genesis of the Book.

demonstrated certain phenomena, such as the stopping of the radial and the temporal pulse on both sides at will, and the stopping of the heartbeats for a few seconds. He also showed some rare feats of archery, such as the splitting of a hair and a thread by an arrow shot at them from a distance of 15 to 20 feet. He broke an iron chain three-eighths of an inch in thickness by a mere tug of his body at the chain fixed at the other end ; one jerk, and crack went the chain in two pieces. " How was that done " was the expression that ran from mouth to mouth at the moment, and a good many present offered explanations to it, each in his own way. Some said it was due to muscle control; others said it was sheer hypnosis produced in a man who watched the pulse, while a few others

1

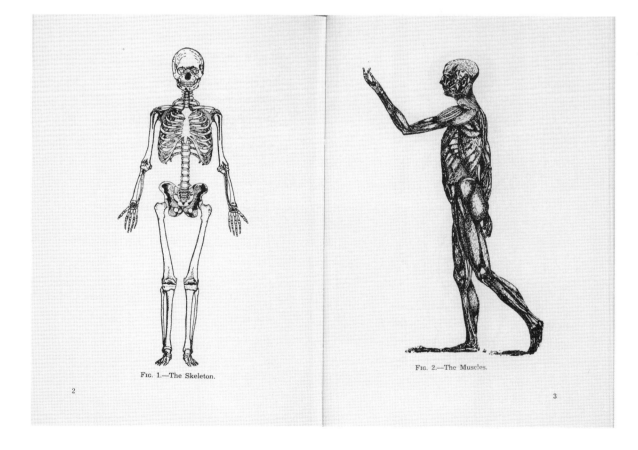

FIG. 1.—The Skeleton.

FIG. 2.—The Muscles.

2

3

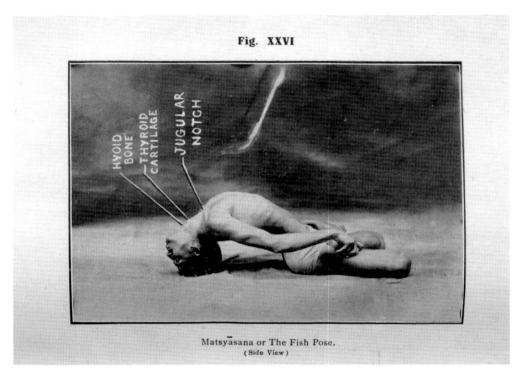

Fig. XXVI

HYOID BONE — THYROID CARTILAGE — JUGULAR NOTCH

Matsyāsana or The Fish Pose.
(Side View)

25f Yoga Mimansa

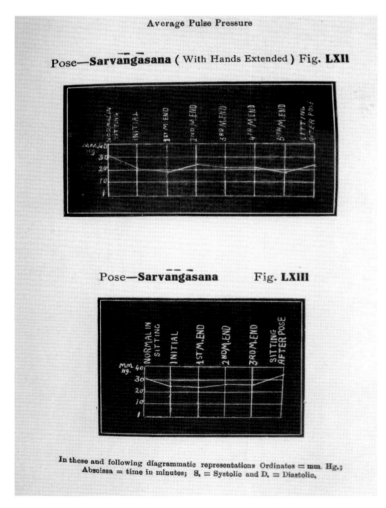

Average Pulse Pressure

Pose—**Sarvangāsana** (With Hands Extended) Fig. **LXII**

Pose—**Sarvangāsana** Fig. **LXIII**

In these and following diagrammatic representations Ordinates = mm. Hg.;
Abscissa = time in minutes; S. = Systolic and D. = Diastolic.

25g Yoga Mimansa

SHRI YOGENDRA

Y O G A
PERSONAL HYGIENE

BY
SHRI YOGENDRA

FOUNDER OF THE YOGA INSTITUTES IN INDIA AND AMERICA,
AUTHOR OF THE SCIENTIFIC YOGA SERIES, YOGA
HEALTH SERIES, LIFE PROBLEMS ETC., AND
EDITOR OF THE ILLUSTRATED JOURNAL
YOGA, ETC. ETC.

WITH A PREFACE
BY
JOHN W. FOX, A.B., M.D.

LATE OF S. B. COUNTY HOSPITAL OF CALIFORNIA, U. S. A.
AND SCIENTIFIC CORROBORATOR TO THE YOGA INSTITUTE.

THE YOGA INSTITUTE
POST BOX 481, BOMBAY
1940

musculature (cat. 25e) that is unremark-able except for the fact that it bore only a simple caption, "The Muscles," in a popular yoga book meant not just for medical students or yoga practitioners but the general public. Clearly, by 1930, the medical yogic body could translate cultur-ally and take on modern identities on the printed page, without breaking stride.

A similar mission of yoga as medicine for the masses was led by Sri Yogendra—the self-styled "householder yogi"—who founded the Bombay-based Yoga Institute of Santa Cruz in 1918 for the scientific corroboration of curative yoga. The institute produced a large body of research on the practical bene-fits of yoga for physical fitness and public health and created basic yoga classes for the public.[14] Beyond his considerable

reach in Bombay, Yogendra also left an important legacy abroad. He traveled to the United States in 1919 and estab-lished the Yoga Institute of America in New York, working with Western doctors and naturopaths,[15] while presenting and performing what some have described as the earliest *asana* demonstrations in America in 1921.[16] Yogendra's books— *Yoga Asanas, Simplified* (1928) and *Yoga Personal Hygiene* (1931)—brought together many ideas on yoga for health. The latter in particular was a pioneer-ing text that salvaged the curative aspects of hatha yoga (cat. 25h). Unlike Vivekananda, who dismissed hatha yogis as mystics and charlatans, Yogendra refashioned hatha yoga as medicine, a project that was at once reformist but also rational, utilitarian, and scientific.

The book, and indeed Yogendra's project itself, was an early forerunner of the kind of public health and fitness regimens that would take over transnational yoga circles in years to come. Medical yoga may have become a global common-place in the twenty-first century, but its foundations and contours were laid in the work of these early pioneers. SR

११ अथ मत्स्येंद्रासनविधिः ।

26b Yogasopana
Purvacatushka

other illustrated yoga texts, it embodies the aesthetic intersection of modern hatha yoga representation and modern Indian art. The drawings mark a clear departure from the conceptual, subtle body of earlier artistic renderings toward the Western, "perceptual" model popularized by Raja Ravi Varma.[12] Given Varma's pioneering use of chromolithographic techniques to make available cheap naturalistic reproductions of his mythological art, it is not surprising to learn that *Yogasopana*'s half-tone blocks were in fact crafted by his clerk, Purushottam Sadasiv Joshi. A clear institutional intersection between modern art and modern yoga is visible here: Jaganmohan Palace, home to the first gallery of modern art in India, the Mysore *chitrasala* (picture hall), also housed the most influential studio of modern postural yoga in the twentieth century, namely T. Krishnamacharya's famous *yogasala* (yoga hall).[13]

As with art, so with reinventions of *asana*. If there is a single text (and eponymous *asana* series) in the early twentieth century that embodies the intersection of yoga, bodybuilding, and physical culture through an *asana* sequence, it is Pratinidhi Pant's *Surya Namaskars*, first published in 1929 and revised and republished five times before 1940.[14] The book's title refers to the sun salutation exercise that may well be the single best-recognized *asana* sequence or yoga meme in postural yoga today. It is routinely invoked by contemporary practitioners as an ancient feature of Indian civilization, although it is thoroughly modern.

While it is often difficult to trace the exact genealogy of specific sequences, historians agree that the creation of the modern *surya namaskar* system can be attributed to Pratinidhi Pant, who was the raja of Aundh.[15] Pant chose to illustrate the first edition of *Surya Namaskars* with monochromatic prints of schematic, two-dimensional figures performing ten *asana*s in the original series. Later editions include photographs of all ten *asana*s, evidence of the new photographic realism that was changing perceptions of yogic bodies in the early twentieth century. Seen here are the

26c *Surya Namaskars*

26d *The Ten-Point Way to Health: Surya Namaskars*

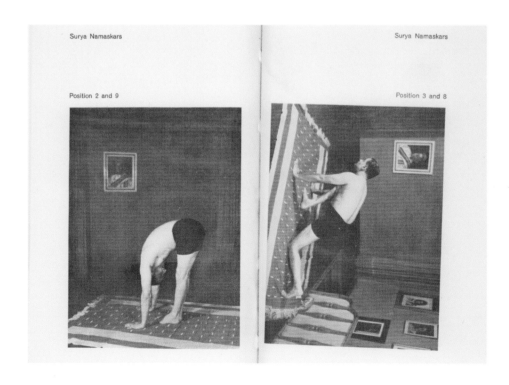

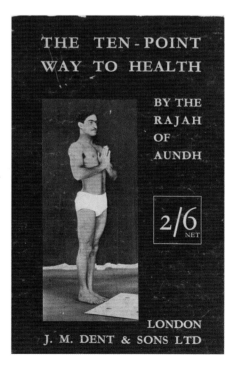

THE AUTHOR

MASSAGE & EXERCISES
COMBINED

A PERMANENT PHYSICAL
CULTURE COURSE FOR MEN
WOMEN AND CHILDREN

HEALTH-GIVING, VITALIZING
PROPHYLATIC, BEAUTIFYING

A NEW SYSTEM OF THE CHARACTERISTIC
ESSENTIALS OF GYMNASTIC AND INDIAN
YOGIS CONCENTRATION EXERCISES COMBINED
WITH SCIENTIFIC MASSAGE MOVEMENTS

WITH 86 ILLUSTRATIONS
AND
DEEP BREATHING EXERCISES

BY

ALBRECHT JENSEN

FORMERLY IN CHARGE OF MEDICAL MASSAGE CLINICS AT
POLYCLINIC HOSPITAL AND OTHER HOSPITALS, NEW YORK

1920
NEW YORK, N. Y.

ALBRECHT JENSEN,
220 WEST 42ND STREET
NEW YORK

THE YOGA-BODY

1. TREE.

Stand erect like a tree in a garden. Join the two palms of your hand together. L o o k straight. Keep your mind clear from all worries.

This position is to be immediately followed by the accompanying six important poses, all of which are to be done at a stretch.

2. BOW.

Bend down your body. Let your two palms rest on the ground, placing your face on the knee, taking care that no part of your limbs below the navel is given any movement. Draw your stomach in by your in-breath.

It may not be possible for you in the early stages to place the palms and fingers fully on the ground. Do what you can now and try to achieve it slowly by constant practice.

PRESS 43

3. STRETCH.

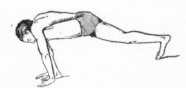

This pose is little more difficult to perform. Planting the two palms firmly as previously suggested in the second pose, stretch one of your legs back and let it stand on its toes leaving the other leg to stand parallel with the vertical arms as shown in the illustration.

4. PRESS.

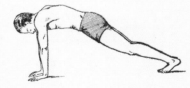

Let the other leg also go back and stand on their toes. Throw all your weight on your forearms pressing the palms firmly on the ground.

In assuming the pose as illustrated, do not give any movement to your head and see that your hands stand straight.

Exhibition Checklist

Note: Items marked with an asterisk (*) are not illustrated in this catalogue.

Venues

Arthur M. Sackler Gallery (Sackler)
October 19, 2013–January 26, 2014

Asian Art Museum of San Francisco (SFAAM)
February 22–May 18, 2014

The Cleveland Museum of Art (CMA)
June 22–September 7, 2014

Catherine and Ralph Benkaim Collection

Gosain Kirpal Girji Receives Sheeshvalji and His Son (cat. 2c)
India, Rajasthan, Marwar or Jodhpur, mid-18th century
Opaque watercolor and gold on paper, 34.9 × 24.8 cm
Catherine and Ralph Benkaim Collection
Venues: All

Krishna Vishvarupa (cat. 10a)
India, Himachal Pradesh, Bilaspur, ca. 1740
Opaque watercolor and gold on paper, 19.8 × 11.7 cm
Catherine and Ralph Benkaim Collection
Venues: All

Sadashiva (cat. 1e)
India, Himachal Pradesh, Nurpur, ca. 1670
Attributed by B. N. Goswamy to Devidasa
Opaque watercolor, gold, and applied beetle-wing on paper, 19.1 × 18.4 cm
Catherine and Ralph Benkaim Collection
Venues: All

Photos: John Tsantes

Catherine Glynn Benkaim and Barbara Timmer Collection

Bairagees, Hindoo Devotees, Delhi (cat. 21f)
in *The People of India* (1868–75), volume 33, folio 203
Charles Shepherd for Shepherd & Robertson, ca. 1862
Photograph, 34.3 × 25.4 cm
Catherine Glynn Benkaim and Barbara Timmer Collection
Venue: CMA

Kurrum Doss (cat. 21e)
in *The People of India* (1868–75), volume 4, folio 158
ca. 1862
Photograph, 34.3 × 25.4 cm
Catherine Glynn Benkaim and Barbara Timmer Collection
Venues: Sackler, SFAAM

The People of India, volume 2*
India, 1868
Book, 34.3 × 25.4 cm
Catherine Glynn Benkaim and Barbara Timmer Collection
Venues: All

Photos: John Tsantes

The British Museum, London

Ascetics Performing Tapas (cat. 20c)
South India, ca. 1820
Opaque watercolor on paper, 23.5 × 29 cm (page)
The Trustees of the British Museum, Bequeathed through Francis Henry Egerton, 2007,3005.4
Venues: All

Bhairava (cat. 20b)
in an album of 91 paintings
India, Thanjavur, ca. 1830
Opaque watercolor and ink on paper, 22.6 × 17.6 cm
The Trustees of the British Museum, 1962,1231,0.13.70
Venues: All

Shiva as Bhairava (cat. 1a)
India, Tamil Nadu, 11th century
Granite, 108 × 47.9 × 28.4 cm
The Trustees of the British Museum, Brooke Sewell Permanent Fund, 1967,1016.1
Venues: All

The Chester Beatty Library, Dublin

Ten folios from the *Bahr al-hayat* (Ocean of Life)
(cat. 9)
India, Uttar Pradesh, Allahabad, 1600–1604
Opaque watercolor on paper, 22.7 × 13.9 cm (folio)
The Trustees of the Chester Beatty Library, Dublin

 Virasana (Persian, *sahajasana*) (cat. 9a)
 13.3 × 7.8 cm (painting)
 In 16.10a
 Venues: All

 Garbhasana (Persian, *gharbasana*) (cat. 9b)
 10.6 × 7.8 cm (painting)
 In 16.18a
 Venues: All

 Nauli Kriya (Persian, *niyuli*) (cat. 9c)
 Attributed to Govardhan
 9.5 × 8 cm (painting)
 In 16.19a
 Venues: All

 Headstand (Persian, *akucchan*) (cat. 9d)
 9.6 × 7.8 cm (painting)
 In 16.20a
 Venue: Sackler

 Untitled (Persian, *nashbad*) (cat. 9e)
 13.5 × 7.6 cm (painting)
 In 16.21b
 Venues: All

 Untitled (Persian, *sitali*) (cat. 9f)
 12.6 × 7.8 cm (painting)
 In 16.22a
 Venues: All

 Khecari Mudra (Persian, *khechari*) (cat. 9g)
 10.6 × 8.5 cm (painting)
 In 16.24a
 Venues: All

 Kumbhaka (Persian, *kunbhak*) (cat. 9h)
 8 × 7.8 cm (painting)
 In 16.25a
 Venues: All

 Sthamba (Persian, *thambasana*) (cat. 9i)
 13.6 × 7.8 cm (painting)
 In 16.26b
 Venues: All

 Untitled (Persian, *sunasana*) (cat. 9j)
 11.5 × 7.7 cm (painting)
 In 16.27b
 Venues: All

Bhupali Ragini (cat. 18g)
from the *Impey Ragamala*
India, Bengal, ca. 1760
Opaque watercolor and gold on paper;
35.2 × 26.3 cm (folio with borders),
23.3 × 16.1 cm (painting without borders)
The Trustees of the Chester Beatty Library,
Dublin, In 65.4
Venues: SFAAM, CMA

The Feast of the Yogis (cat. 17h)
from the *Mrigavati*
India, Mughal dynasty, 1603–4
Opaque watercolor and gold on paper;
28.3 × 17.5 cm (folio), 14.2 × 9.7 cm (painting)
The Trustees of the Chester Beatty Library,
Dublin, In 37, f.44a
Venues: All

The Prince Begins His Journey (cat. 17e)
from the *Mrigavati*
India, Mughal dynasty, 1603–4
Opaque watercolor and gold on paper;
28.3 × 17.5 cm (folio), 18.2 × 9.2 cm (painting)
The Trustees of the Chester Beatty Library,
Dublin, In 37.23b
Venues: All

The Prince in Danger (cat. 17g)
from the *Mrigavati*
Attributed to Haribans
India, Mughal dynasty, 1603–4
Opaque watercolor and gold on paper;
28.3 × 17.5 cm (folio), 15.2 × 9.5 cm (painting)
The Trustees of the Chester Beatty Library,
Dublin, In 37.28a
Venues: All

*The Prince Meets Rupman**
from the *Mrigavati*
India, Mughal dynasty, 1603–4
Opaque watercolor and gold on paper;
28.3 × 17.5 cm (folio), 15.3 × 9.5 cm (painting)
The Trustees of the Chester Beatty Library,
Dublin, In 37.29b
Venues: SFAAM, CMA

The Raj Kunwar on a Small Raft (cat. 17f)
from the *Mrigavati*
India, Mughal dynasty, 1603–4
Opaque watercolor and gold on paper;
28.3 × 17.5 cm (folio), 15.3 × 9.5 cm (painting)
The Trustees of the Chester Beatty Library,
Dublin, In 37.27a
Venues: All

The Sage Bhringisha and Shiva (cat. 13)
folio 304b from the *Yoga Vasishta*
Attributed to Keshav Das
India, Uttar Pradesh, Allahabad, 1602
Opaque watercolor, gold, and ink on paper;
27 × 18.5 cm (folio), 8.6 × 9.7 cm (painting)
The Trustees of the Chester Beatty Library,
Dublin, In 05, f.304b
Venues: All

Saha (cat. 3e)
folio 242a from *The Stars of the Sciences*
(*Nujum al-'Ulum*)
India, Karnataka, Bijapur, dated 1570–71
Opaque watercolor, gold, and ink on paper;
25.8 × 16 cm (folio), 8.6 × 9.7 cm (painting)
The Trustees of the Chester Beatty Library,
Dublin, In 02 f.242a
Venues: All

Saindhavi Ragini, wife of Bhairon (cat. 18h)
from the *Impey Ragamala*
India, Bengal, ca. 1760–73
Opaque watercolor and gold on paper;
34.9 × 25.9 cm (folio with borders),
23.2 × 15.8 cm (painting without borders)
The Trustees of the Chester Beatty Library,
Dublin, In 65.7
Venues: All

Three Women Present a Young Girl to Aged Ascetics
(cat. 14c)
India, Mughal dynasty, ca. 1670–80
Opaque watercolor, gold, and ink on paper;
39.5 × 27.5 cm (folio with borders),
21.9 × 14.8 cm (painting without borders)
The Trustees of the Chester Beatty Library,
Dublin, In 73.3
Venues: All

A Yogini in Meditation (cat. 18f)
from the *Impey Ragamala*
India, Bengal, ca. 1760
Opaque watercolor and gold on paper;
35.1 × 24.3 cm (folio with borders),
22 × 14.3 cm (painting without borders)
The Trustees of the Chester Beatty Library,
Dublin, In 65.2
Venues: All

Yogini with Mynah (cat. 3f)
India, Karnataka, Bijapur, ca. 1603–4
Opaque watercolor and gold on paper;
39.2 × 27.6 cm (folio with borders),
19.3 × 11.6 cm (painting without borders)
The Trustees of the Chester Beatty Library,
Dublin, In 11a.31
Venues: All

The Cleveland Museum of Art

Base for a Seated Buddha with Figures of Ascetics
(cat. 6c)
Pakistan or Afghanistan, ancient Gandhara,
ca. 150–200 CE
Gray schist, 38 × 36.2 cm
The Cleveland Museum of Art, Gift of Dr. Norman
Zaworski, 1976.152
Venues: All

Fasting Buddha (cat. 6b)
India, Kashmir, 8th century
Ivory, 12.4 × 9.5 cm
The Cleveland Museum of Art, Leonard C. Hanna, Jr.
Fund, 1986.70
Venues: All

Head of a Rishi (fig. 3, p. 39)
India, Mathura, 2nd century
Stone, 27.7 × 24 cm
The Cleveland Museum of Art, Edward L.
Whittemore Fund, 1971.41
Venues: All

Jain Ascetic Walking (cat. 5f)
India, Mughal dynasty, ca. 1600
Opaque watercolor, ink, and gold on paper,
14.7 × 9.8 cm
The Cleveland Museum of Art, 1967.244
Venue: CMA

Jina (cat. 5b)
India, Rajasthan, 10th–11th century
Bronze with silver inlay, 61.5 × 49.5 × 36.8 cm
The Cleveland Museum of Art, Severance and Greta
Millikin Purchase Fund, 2001.88
Venues: SFAAM, CMA

The Knots of the Subtle Body (cat. 11a)
India, Himachal Pradesh, Nurpur, ca. 1690–1700
Opaque watercolor and ink on paper, 20 × 14 cm
The Cleveland Museum of Art, Edward L. Whittemore
Fund, 1966.27
Venues: All

Prince and Ascetics (cat. 19c)
Painting attributed to Govardhan;
borders attributed to Payag
India, Mughal dynasty, ca. 1630
Opaque watercolor, gold, and ink on paper;
37.5 × 25.2 cm (sheet), 20.3 × 14.3 cm (painting)
The Cleveland Museum of Art, Andrew R. and Martha
Holden Jennings Fund, 1971.79
Venues: All

*Shiva and Devi on Gajasura's Hide**
India, ca. 1680
Ink and color on paper, 23.5 × 16.2 cm
The Cleveland Museum of Art, Edward L.
Whittemore Fund, 1952.587
Venues: SFAAM, CMA

Shiva Bhairava (cat. 1b)
India, Karnataka, Mysore, 13th century
Chloritic schist, 116.6 × 49.23 cm
The Cleveland Museum of Art, John L. Severance
Fund, 1964.369
Venues: All

Yoga Narasimha, Vishnu in His Man-Lion Avatar
(cat. 8a)
India, Tamil Nadu, ca. 1250
Bronze, 55.2 cm
The Cleveland Museum of Art, Gift of Dr. Norman
Zaworski, 1973.187
Venues: All

Robert J. Del Bontà Collection

"Diverses Pagodes et Penitences des Faquirs"
(Various Temples and Penances of the Fakirs)
(cat. 22a)
Bernard Picart (1673–1733)
1729
from Jean-Frédéric Bernard and Bernard Picart,
*Cérémonies et coutumes religieuses des Peuples
Idolatres* (Ceremonies and Religious Customs of
the Idolatrous Peoples), vol. 2 (Amsterdam: J. F.
Bernard, 1728)
Copper-plate engraving, 48 × 52.4 cm
Robert J. Del Bontà collection, E442
Venues: All

"Hindu Fakir on a Bed of Spikes, Calcutta" (cat. 22c)
James Ricalton (1844–1929)
ca. 1903
from James Ricalton, *India through the Stereoscope:
A Journey through Hindustan* (New York and London:
Underwood & Underwood, 1907)
Stereoscopic photograph, 8.9 × 17.8 cm
Robert J. Del Bontà collection, SV49
Venues: All

Images of Yogis (cat. 22b)
John Chapman (act. 1792–1823)
September 1, 1809
from *Encyclopædia Londinensis or, Universal
Dictionary of arts, sciences, and literature ...* vol. 10
(London: J. Adler, 1811)
Copper-plate engraving, 26.7 × 21.6 cm
Robert J. Del Bontà collection, E1232
Venues: All

Detroit Institute of Arts

Yogini (cat. 3b)
India, Tamil Nadu, Kanchipuram or Kaveripakkam,
900–975
Possibly dolerite, 116.8 × 76.2 × 45.7 cm
Detroit Institute of Arts, Founders Society Purchase,
L.A. Young Fund, 57.88
Venues: All

Freer Gallery of Art, Smithsonian Institution

*The Goddess Bhadrakali Worshipped by the Sage
Chyavana* (cat. 8c)
from a Tantric Devi series
India, Pahari Hills, ca. 1660–70
Opaque watercolor and gold on paper, 21.3 × 23.1 cm
Freer Gallery of Art, F1997.8
Venue: Sackler

Kedar Ragini (cat. 18a)
from the *Chunar Ragamala*
India, Uttar Pradesh, Chunar, 1591
Opaque watercolor and gold on paper, 22.5 × 15 cm
Freer Gallery of Art, Michael Goedhuis Ltd., F1985.2
Venue: Sackler

Sarang Raga (cat. 18d)
from the *Sirohi Ragamala*
India, Rajasthan, Sirohi, ca. 1680–90
Opaque watercolor and gold on paper, 23.2 × 17.8 cm
Freer Gallery of Art, F1992.18
Venue: Sackler

Siddha Pratima Yantra (cat. 5e)
Western India, dated 1333 (Samvat 1390)
Bronze, 21.9 × 13.1 × 8.9 cm
Freer Gallery of Art, F1997.33
Venue: Sackler

Vishvamitra Practices His Austerities (cat. 7a)
folio 61a from the *Freer Ramayana*
Mushfiq
India, subimperial Mughal, 1597–1605
Opaque watercolor, gold, and ink on paper,
26.5 × 15.6 cm
Freer Gallery of Art, Gift of Charles Lang Freer,
F1907.271.61
Venue: Sackler

Photos: Neil Greentree, Robert Harrell, John Tsantes

Gloria Katz and Willard Huyck Collection

Group of Yogis
Colin Murray for Bourne & Shepherd, ca. 1880s
Albumen print, 22.2 × 29.2 cm
Collection of Gloria Katz and Willard Huyck,
2011.02.02.0004
Venues: All
Photo: John Tsantes

Library of Congress, Washington, DC

The Chakras, a Monograph (cat. 25c)
Charles W. Leadbeater (1854–1934)
Theosophical Publishing House, Wheaton, IL,
United States, 1972 (© 1927)
Book, 31 × 26 cm
General Collections, Library of Congress,
Washington, DC, BP573.C5 L4 1972
Venues: All

Fakire und Fakirtum im Alten und Modernern Indien
(cat. 26a)
Richard Schmidt
Germany, 1907
Book, 24.8 × 34.3 cm
General Collections, Library of Congress,
Washington, DC, BL2015.F2 S3
Venues: All

Hindoo Fakir (cat. 23d)
Edison Manufacturing Company, United States, 1902
Film, transferred to DVD, 3 minutes
General Collections, Library of Congress,
Washington DC, NV-061-499
Venues: All

Massage and Exercises Combined (26e)
Albrecht Jensen
New York, United States, 1920
Book, 25 × 26 cm
General Collections, Library of Congress,
Washington, DC, RM 721.J4
Venues: All

The Mysterious Kundalini (cat. 25d)
Vasant Gangaram Rele
D. P. Taraporevala Sons and Co., Bombay, India, 1929
Book, 21 × 26.5 cm (open)
General Collections, Library of Congress,
Washington, DC, B132.Y6 R4a Copy 1
Venues: All

*Neely's History of the Parliament of Religions and
the Religious Congresses at the World's Columbian
Exposition* (cat. 24g)
Walter R. Houghton, ed.
Chicago, United States, 1893
Book, 22.5 × 37 cm
General Collections, Library of Congress,
Washington, DC, BL21.W8N4
Venues: Sackler, CMA

Popular Yoga: Asanas (cat. 25e)
Swami Kuvalayananda
C. E. Tuttle Company, Rutland, VT, United States,
1972 (1931)
Book, 22 × 31 cm
General Collections, Library of Congress,
Washington, DC, B 132.Y6.K787
Venues: All

Raja Yoga (cat. 24h)
Swami Vivekananda
Advaita Ashram, Salem, Tamil Nadu, India, 1944
(1896)
Book, 18.5 × 27 cm (open)
General Collections, Library of Congress,
Washington, DC, B132.V3 V58
Venues: All

Surya Namaskars (cat. 26c)
Apa Pant
Orient Longmans, Bombay, India, 1970 (1929)
Book, 21 × 23.7 cm (open)
General Collections, Library of Congress,
Washington, DC, RA 781.P28
Venues: All

Thurston the famous magician, East Indian rope trick
(cat. 23a)
Otis Lithograph Company
United States, ca. 1927
Color lithograph, 104 × 35 cm
Prints and Photographs Division, Library of Congress,
Washington, DC, POS-MAG-.T48 no.14 (C size)
Venues: Sackler, CMA

The Yoga Body Illustrated (cat. 26f)
M. R. Jambunathan
Jambunathan Book Depot, Madras, India, 1941
Book, 19 × 19 cm
General Collections, Library of Congress,
Washington, DC, RA781.7 J35
Venues: All

Yoga Personal Hygiene (cat. 25h)
Shri Yogendra
The Yoga Institute, Bombay, India, 1940
Book, 21.5 × 27 cm
General Collections, Library of Congress,
Washington, DC, B 132. Y6.Y63
Venues: All

The Yoga-Sutra of Patanjali (cat. 24a)*
M. N. Dwivedi, trans.
Theosophical Publication Fund, Bombay, India, 1890
Book, 21 × 37 cm
General Collections, Library of Congress,
Washington, DC, B132.Y6.P267 1890 Copy 1
Venues: All

Mehrangarh Museum Trust, Jodhpur

The Chakras of the Subtle Body (cat. 11b)
folio 4 from the *Siddha Siddhanta Paddhati*
Bulaki
India, Rajasthan, Jodhpur, 1824 (Samvat 1881)
Opaque watercolor and gold on paper, 122 × 46 cm
Mehrangarh Museum Trust, RJS 2376
Venues: All

Equivalence of Self and Universe (cat. 10d)
folio 6 from the *Siddha Siddhanta Paddhati*
Bulaki
India, Rajasthan, Jodhpur, 1824 (Samvat 1881)
Opaque watercolor and gold on paper, 122 × 46 cm
Mehrangarh Museum Trust, RJS 2378
Venues: All

*Jalandharnath Flies over King Padam's Palace**
from the *Suraj Prakash*
India, Rajasthan, Jodhpur, 1830
Opaque watercolor and gold on paper,
23.3 × 38.6 cm (image)
Mehrangarh Museum Trust, RJS 1644
Venues: SFAAM, CMA

*The King Praises Jalandharnath as His
Enemies Drown**
from the *Suraj Prakash*
Amardas Bhatti
India, Rajasthan, Jodhpur, 1830
Opaque watercolor and gold on paper,
23.3 × 38.6 cm (image)
Mehrangarh Museum Trust, RJS 1641
Venues: SFAAM, CMA

*The Practice of Yoga**
folio 5 from the *Siddha Siddhanti Paddhati*
Amardas Bhatti
India, Rajasthan, Jodhpur, 1824 (Samvat 1881)
Opaque watercolor and gold on paper, 46 × 122 cm
Mehrangarh Museum Trust, RJS 2377
Venues: SFAAM, CMA

Rama Enters the Forest of the Sages (cat. 17a)
from the *Ramcharitmanas* of Tulsidas (1532–1623)
India, Rajasthan, Jodhpur, ca. 1775
Opaque watercolor and gold on paper,
62.7 × 134.5 cm
Mehrangarh Museum Trust, RJS 2524
Venues: All

Rama in the Forest of the Sages (cat. 17b)
from the *Ramcharitmanas* of Tulsidas (1532–1623)
India, Rajasthan, Jodhpur, ca. 1775
Opaque watercolor on paper, 62.7 × 134.5 cm
Mehrangarh Museum Trust, RJS 2527
Venues: All

Three Aspects of the Absolute (cat. 4a)
folio 1 from the *Nath Charit*
Bulaki
India, Rajasthan, Jodhpur, 1823 (Samvat 1880)
Opaque watercolor, gold, and tin alloy on paper,
47 × 123 cm
Mehrangarh Museum Trust, RJS 2399
Venues: All

The Transmission of Teachings (cat. 4b)
folio 3 from the *Nath Charit*
Bulaki
India, Rajasthan, Jodhpur, 1823 (Samvat 1880)
Opaque watercolor, gold, and tin alloy on paper,
47 × 123 cm
Mehrangarh Museum Trust, RJS 2400
Venues: All

The Transmission of Teachings (cat. 4c)
folio 4 from the *Nath Charit*
Bulaki
India, Rajasthan, Jodhpur, 1823 (Samvat 1880)
Opaque watercolor, gold, and tin alloy on paper,
47 × 123 cm
Mehrangarh Museum Trust, RJS 2401
Venues: All

*Water Springs Forth from the Power of Jalandharnath's
Mantra**
from the *Suraj Prakash*
Amardas Bhatti
India, Rajasthan, Jodhpur, 1830
Opaque watercolor and gold on paper,
23.3 × 38.6 cm (image)
Mehrangarh Museum Trust, RJS 1640
Venues: SFAAM, CMA

Photos (except 4a, 4b): Neil Greentree

The Metropolitan Museum of Art, New York

The Goddess Bhairavi Devi with Shiva (cat. 16)
Attributed to Payag
India, Mughal dynasty, ca. 1630–35
Opaque watercolor and gold on paper, 18.5 × 26.5 cm
The Metropolitan Museum of Art, Purchase,
Lila Acheson Wallace Gift, 2011, 2011.409
Venue: Sackler

Head of the Fasting Buddha (cat. 6a)
Pakistan or Afghanistan (Gandhara),
ca. 3rd–5th century
Schist, 13.3 × 8.6 × 8.3 cm
The Metropolitan Museum of Art, Samuel Eilenberg
Collection, Gift of Samuel Eilenberg,
1987, 1987.142.73
Venues: All

Kedar Ragini (cat. 18e)
Ruknuddin (act. ca. 1650–97)
India, Rajasthan, Bikaner, ca. 1690–95
Opaque watercolor, gold, and ink on paper;
14.9 × 11.9 cm (image), 25.6 × 18.7 cm (page)
The Metropolitan Museum of Art, Gift of Mr. and
Mrs. Peter Findlay, 1978, 1978.540.2
Venue: Sackler

"Misbah the Grocer Brings the Spy Parran to His
House" (cat. 17c)
folio from a *Hamzanama* (The Adventures of Hamza)
Attributed to Dasavanta and Mithra
India, Mughal dynasty, ca. 1570
Opaque watercolor, gold, and ink on cotton,
70.8 × 54.9 cm (folio)
The Metropolitan Museum of Art, Rogers Fund,
1924, 24.48.1
Venue: Sackler

Tile with impressed figures of emaciated ascetics
and couples behind balconies (cat. 6d)
India, Jammu and Kashmir, Harwan, ca. 5th century
Terracotta, 40.6 × 33.6 × 4.1 cm
The Metropolitan Museum of Art, Gift of Cynthia
Hazen Polsky, 1987, 1987.424.26
Venues: All

Minneapolis Institute of Arts

Yogini with a Jar (cat. 3c)
India, Tamil Nadu, Kanchipuram or Kaveripakkam,
ca. 900–975
Metagabbro, 114.3 × 72.39 × 39.37 cm
Lent by Minneapolis Institute of Arts, The Christina
N. and Swan J. Turnblad Memorial Fund, 60.21
Venues: All

Museum für Asiatische Kunst, Berlin

Gaur Malhara Ragini (cat. 18i)
India, Rajasthan, Kotah, 18th century
Opaque watercolor and gold on paper, 14 × 18.3 cm
Museum für Asiatische Kunst, MIK I 5523
Venues: All

Megha Mahlar Ragini (cat. 18c)
India, Rajasthan, Bundi, ca. 1660
Opaque watercolor and gold on paper, 30.2 × 24 cm
Museum für Asiatische Kunst, MIK I 5698
Venue: Sackler

Worship of Shiva (cat. 15c)
folio from the *Kedara Kalpa*
Attributed to the workshop of Purkhu
India, Himachal Pradesh, Kangra, ca. 1815
Opaque watercolor on paper;
36.2 × 48.9 cm (folio), 30 × 42.2 cm (image)
Museum für Asiatische Kunst, MIK I 5733
Venues: All

Museum of Fine Arts, Boston

*Maharana Sangram Singh of Mewar Visiting
Savina Khera Math* (cat. 14e)
India, Rajasthan, Mewar, ca. 1725
Opaque watercolor and gold on paper, 60.3 × 73 cm
Museum of Fine Arts, Boston, Charles Bain Hoyt
Fund, 1999, 1999.94
Venues: Sackler, SFAAM

Museum Rietberg Zürich

*Dara Shikoh Visiting a Yogi and Yogini**
India, Mughal dynasty, 17th century
Opaque watercolor and gold on paper;
36.2 × 34 cm (folio), 21 × 14.2 cm (painting)
Museum Rietberg Zürich, Collection Barbara
and Eberhard Fischer, RVI 0954
Venues: SFAAM, CMA

Female Guru and Disciple (cat. 14b)
India, Mughal dynasty, ca. 1650
Opaque watercolor and gold on paper;
37.5 × 25 cm (page), 12 × 7.8 cm (painting)
Museum Rietberg Zürich, RVI 987
Venues: All

*Monkeys in the Cave of Swayamprabha**
folio 46 from the *Mankot Ramayana*
India, Himachal Pradesh, Mankot, ca. 1720
Opaque watercolor and gold on paper;
19.8 × 31 cm (folio), 16.2 × 26.8 cm (painting)
Museum Rietberg Zürich, Collection Barbara
and Eberhard Fischer, REF 25
Venues: SFAAM, CMA

Shiva Blesses Yogis on Kailash (cat. 14a)
by an artist in the first generation after Manaku
and Nainsukh of Guler
India, Punjab Hills, 1780–1800
Opaque watercolor and gold on paper, 21.5 × 19.8 cm
Museum Rietberg Zürich, Gift Horst Metzger
Collection, RVI 2127
Venues: All

Two Ascetics (cat. 7b)
India, Himachal Pradesh, Mandi, 1725–50
Opaque watercolor on paper;
15.5 × 22.5 cm (page), 13 × 18 cm (painting)
Museum Rietberg Zürich, Gift of Barbara
and Eberhard Fischer
Venues: All

**National Anthropological Archives,
Smithsonian Institution**

Untitled (cat. 21a)
John Nicholas for Nicholas Bros, 1858
Albumen print, 14 × 10 cm
National Anthropological Archives,
Smithsonian Institution, NAA INV 04604500
Venue: Sackler

Untitled (cat. 21b)
John Nicholas for Nicholas Bros, 1858
Albumen print, 13.7 × 9.5 cm
National Anthropological Archives,
Smithsonian Institution, NAA INV 04565100
Venue: Sackler

Untitled (cat. 21c)
John Nicholas for Nicholas Bros, 1858
Albumen print, 13.5 × 10.2 cm
National Anthropological Archives,
Smithsonian Institution, NAA INV 04566000
Venue: Sackler

Untitled (cat. 21d)
John Nicholas for Nicholas Bros, 1858
Albumen print, 14 × 10.2 cm
National Anthropological Archives,
Smithsonian Institution, NAA INV 04565500
Venue: Sackler

National Gallery of Victoria, Melbourne

*Maharana Sangram Singh II and Gosain Nilakanthji**
India, Rajasthan, Mewar, Udaipur, ca. 1725
Opaque watercolor and gold on paper;
45.5 × 62.4 cm (sheet), 35.5 × 54.8 cm (painting)
National Gallery of Victoria, Melbourne, Australia,
Felton Bequest, 1980, AS97-1980
Venues: SFAAM, CMA

*Maharana Sangram Singh II Visiting Gosain
Nilakanthji after a Tiger Hunt* (cat. 14f)
India, Rajasthan, Mewar, Udaipur, ca. 1725
Opaque watercolor and gold on paper, 65 × 48.5 cm
National Gallery of Victoria, Melbourne, Australia,
Felton Bequest, 1980, AS92-1980
Venues: All

Shiva and Parvati on Mount Kailash (cat. 7c)
India, Rajasthan, Mewar, Udaipur, late 18th century
Opaque watercolor, gold, and tin alloy on paper,
28.7 × 20.5 cm
National Gallery of Victoria, Melbourne, Australia,
Felton Bequest, 1980, AS242-1980
Venues: All

National Library of Medicine, Bethesda, MD

"An Abd'hoot" (cat. 20d)
in Balthazar Solvyns, *A Collection of Two Hundred
and Fifty Colored Etchings: descriptive of the manners,
customs and dresses of the Hindoos* (Calcutta: [Mirror
Press], 1799)
Balthazar Solvyns (1760–1824)
Hand-colored etching, 52 × 38 × 11 cm
National Library of Medicine, WZ 260 S692c
Venues: All

Yoga Mimansa (cat. 25f)
vol. 1, no. 1, page 57
Shrimat Kuvalayananda, ed.
Kaivalyadhama, Lonavla, India, 1924
Periodical (quarterly), 23.5 × 16.1 cm
National Library of Medicine, W1 Y0661
Venues: All

Yoga Mimansa (cat. 26g)
vol. 1, no. 3 (October)
Shrimat Kuvalayananda, ed.
Kaivalyadhama Institute, Lonavla, India, 1925
Periodical (quarterly), 23.5 × 16.1 cm
National Library of Medicine, W1 Y0661
Venues: All

Yoga Mimansa (cat. 26h)
vol. 2, no. 4 (July)
Shrimat Kuvalayananda, ed.
Kaivalyadhama Institute, Lonavla, India, 1926
Periodical (quarterly), 23.5 × 16.1 cm
National Library of Medicine, W1 Y0661
Venues: All

Yoga Mimansa (cat. 25g)
vol. 2, no. 2, page 116
Shrimat Kuvalayananda, ed.
Kaivalyadhama, Lonavla, India, 1926
Periodical (quarterly), 23.5 × 16.1 cm
National Library of Medicine, W1 Y0661
Venues: All

Yogasopana Purvacatushka (cat. 26b)
Narayana Ghamande
Tukarama Book Depot, Bombay, India, 1951
Book, 22 × 22 cm
National Library of Medicine, QT 255 G411y
Venues: All

Cynthia Hazen Polsky

Himalayan Pilgrimage of the Five Siddhas (cat. 15a)
folio from the *Kedara Kalpa*
Attributed to the workshop of Purkhu
India, Himachal Pradesh, Kangra, ca. 1815
Opaque watercolor on paper;
36.2 × 48.9 cm (folio), 29.8 × 42.5 cm (image)
Cynthia Hazen Polsky, New York, 8070 IP
Venue: Sackler

Pritzker Collection

The Guru Vidyashiva (cat. 2a)
India, Bengal, 11th–12th century
Stone, 129.5 × 66 × 15.2 cm
Pritzker Collection
Photo by Hughes Dubois
Venues: All

Private Collection

Standing Jina (cat. 5c)
India, Tamil Nadu, 11th century
Bronze, 73.7 × 69.2 × 17.5 cm
Private Collection, LT16
Photo by Maggie Nimkin
Venues: All

Private Collection

"Mystery girl: why can't she be killed?" (cat. 23c)
Look Magazine, September 28, 1937
Des Moines, Iowa, United States
34.1 × 26.6 cm
Private Collection
Venues: All

Kenneth and Joyce Robbins Collection

"Fakir on Bed of Nails" (cat. 22e)
D. Macropolo & Co., Calcutta, early 20th century
Postcard, 9 × 14 cm
Collection of Kenneth and Joyce Robbins
Venues: All

"Hindu Fakir: For thirteen years this old man has been
trying 'to find peace' on this bed of spikes" (cat. 22d)
Young People's Missionary Movement, New York,
early 20th century
Postcard, 8.3 × 13.6 cm
Collection of Kenneth and Joyce Robbins
Venues: All

"Hindu Fakir on Bed of Spikes, Benares" (cat. 22f)
Baptist Missionary Society, early 20th century
Postcard, 8.6 × × 13.5 cm
Collection of Kenneth and Joyce Robbins
Venues: All

Lakshman Das (cat. 20a)
folio from the Fraser Album
India, Delhi, ca. 1825
Watercolor and ink on paper, 25.4 × 14.6 cm
Collection of Kenneth and Joyce Robbins
Venues: SFAAM, CMA

Matsyendranath (cat. 2b)
India, Karnataka, Bijapur, ca. 1650
Opaque watercolor and gold on paper, 16.5 × 20.3 cm
Collection of Kenneth and Joyce Robbins
Venues: All

The Ten-Point Way to Health: Surya Namaskars
(cat. 26d)
Balasahib Pandit Pratinidhi, Rajah of Aundh
Edited by Louise Morgan
J. M. Dent & Sons Ltd., London, 1938
Book, 18.3 × 12.6 × 1.8 cm
Collection of Kenneth and Joyce Robbins
Venues: All

Photos: Neil Greentree

Arthur M. Sackler Gallery, Smithsonian Institution

Seated Jina Ajita (cat. 5a)
India, Tamil Nadu, 9th–10th century
Bronze, 18.5 × 14.5x x 9.3 cm
Arthur M. Sackler Gallery, Gift of Arthur M. Sackler,
S1987.16
Venues: SFAAM, CMA

Yogini (cat. 3a)
India, Tamil Nadu, Kanchipuram or Kaveripakkam,
ca. 900–975
Metagabbro, 116 × 76 × 43.2 cm
Arthur M. Sackler Gallery, Gift of Arthur M. Sackler,
S1987.905
Venues: All

Photos: Neil Greentree, Robert Harrell, John Tsantes

San Antonio Museum of Art

Yogini (cat. 3d)
India, Uttar Pradesh, Kannauj, first half
of the 11th century
Sandstone, 86.4 × 43.8 × 24.8 cm
San Antonio Museum of Art, purchased with
the John and Karen McFarlin Fund and Asian Art
Challenge Fund, 90.92
Venues: All

**Staatliche Museen zu Berlin,
Ethnologisches Museum**

Untitled (cat. 21t)
Edward Taurines (act. 1885–1902)
India, Bombay, ca. 1890
Albumen print, 23.5 × 19 cm
Staatliche Museen zu Berlin, Preußischer
Kulturbesitz, Ethnologisches Museum, VIII.8007b
Venues: Sackler, SFAAM

Untitled (cat. 21p)
India, Tamil Nadu, ca. 1870
Albumen print, 12.7 × 17.4 cm
Staatliche Museen zu Berlin, Preußischer
Kulturbesitz, Ethnologisches Museum, VIII.C158
Venue: CMA

Untitled (cat. 21h)
India, ca. 1870
Albumen print, 10.7 × 14.2 cm
Staatliche Museen zu Berlin, Preußischer
Kulturbesitz, Ethnologisches Museum, VIII.C 447
Venue: CMA

Untitled (cat. 21g)
Charles Shepherd for Shepherd & Robertson
1862
Albumen print, 19.6 × 16 cm
Staatliche Museen zu Berlin, Preußischer
Kulturbesitz, Ethnologisches Museum, VIII.C1419
Venues: SFAAM, CMA

Untitled (cat. 21r)
India, Tamil Nadu, Madras (currently Chennai) or
Orissa, ca. 1880
Albumen print, 14.8 × 9.7 cm
Staatliche Museen zu Berlin, Preußischer
Kulturbesitz, Ethnologisches Museum, VIII.C1473
Venue: Sackler

Untitled (cat. 21o)
India, Tamil Nadu, Madras (currently Chennai),
ca. 1870
Albumen print, 14.5 × 9.8 cm
Staatliche Museen zu Berlin, Preußischer
Kulturbesitz, Ethnologisches Museum, VIII.C1474
Venue: CMA

Untitled (cat. 21q)
India, Tamil Nadu, Madras (currently Chennai),
ca. 1880
Albumen print, 14.3 × 9.9 cm
Staatliche Museen zu Berlin, Preußischer
Kulturbesitz, Ethnologisches Museum, VIII.1522
Venue: SFAAM

Untitled (cat. 21n)
India, Calcutta, ca. 1870
Albumen print, 14.1 × 9.5 cm
Staatliche Museen zu Berlin, Preußischer
Kulturbesitz, Ethnologisches Museum, VIII.C3313
Venues: Sackler, SFAAM

Untitled (cat. 21k)
Westfield & Co.
India, ca. 1870
Albumen print, 9.4 × 5.8 cm
Staatliche Museen zu Berlin, Preußischer
Kulturbesitz, Ethnologisches Museum, VIII.C3314
Venue: CMA

Untitled (cat. 21j)
Westfield & Co.
India, ca. 1870
Albumen print, 9.4 × 5.8 cm
Staatliche Museen zu Berlin, Preußischer
Kulturbesitz, Ethnologisches Museum, VIII.C3315
Venue: SFAAM

Untitled (cat. 21l)
Westfield & Co.
India, ca. 1870
Albumen print, 9.4 × 5.8 cm
Staatliche Museen zu Berlin, Preußischer
Kulturbesitz, Ethnologisches Museum, VIII.C3316
Venue: SFAAM

Untitled (cat. 21m)
Westfield & Co.
India, ca. 1870
Albumen print, 9.4 × 5.8 cm
Staatliche Museen zu Berlin, Preußischer
Kulturbesitz, Ethnologisches Museum, VIII.C3317
Venue: CMA

Untitled (cat. 21i)
India, Orissa, ca. 1870
Albumen print, 14.6 × 9.9 cm
Staatliche Museen zu Berlin, Preußischer
Kulturbesitz, Ethnologisches Museum,
VIII S-SOA NLS 1
Venues: SFAAM, CMA

Staatsbibliothek zu Berlin

Bifolio from the *Gulshan Album* (cats. 19a–b)
India, Mughal dynasty, first quarter of the 17th century
Opaque watercolor and gold on paper, 53.5 × 40 cm
Staatsbibliothek zu Berlin, Preußischer Kulturbesitz,
Orientabteilung, Libri pict. A 117, ff.6b, 13a
Venue: Sackler

Vedanta Society of Northern California

Swami Vivekananda (cat. 24c)
United States, 1893
Photograph (original), approx. 15.2 × 10.2 cm
Vedanta Society of Northern California,
Harrison series, V21
Inscription (recto): "One infinite—pure & holy—
beyond thought, beyond qualities, I bow down to
thee. —Swami Vivekananda"
Venues: All

Swami Vivekananda (cat. 24i)
United States, 1893
Photographic print, copy of original
Vedanta Society of Northern California,
Harrison series, V27
Venues: All

Swami Vivekananda (cat. 24j)
United States, 1893
Scan of a halftone print
Vedanta Society of Northern California,
Harrison series, V20
Venues: All

Swami Vivekananda (cat. 24k)
United States, 1893
Photographic negative
Vedanta Society of Northern California,
Harrison series, V23
Inscription (recto): "Samata sarvabhuteshu
etanmuktasya lakshanam. Equality in all beings
this is the sign of the free—Vivekananda"
Venues: All

Swami Vivekananda (cat. 24l)
United States, 1893
Photographic negative
Vedanta Society of Northern California,
Harrison series, V24
Inscription (recto): "Thou art the only treasure in
this world—Vivekananda"
Venues: All

Swami Vivekananda (cat. 24m)
United States, 1893
Photographic negative
Vedanta Society of Northern California,
Harrison series, V25
Inscription (recto): "Thou art the father the lord the
mother the husband and love—Swami Vivekananda"
Venues: All

Swami Vivekananda and Narasimhacarya (cat. 24b)
United States, 1893
Photographic print, copy of original
Vedanta Society of Northern California, V17
Venues: All

Swami Vivekananda at the Parliament (cat. 24f)
United States, 1893
Photograph (original), approx. 15.2 × 10.2 cm
Vedanta Society of Northern California,
Harrison series, V26
Inscription (recto): "Eka eva suhrid dharma
nidhanepyanuyati yah. Virtue is the only friend that
follows us even beyond the grave. Everything else
ends with death. Vivekananda"
Venues: All

Swami Vivekananda, Hindoo Monk of India (cat. 24e)
United States, 1893
Poster (color lithograph), copy of original from
Goes Lithographing Company, Chicago
Vedanta Society of Northern California,
Harrison series, V22
Inscription (recto): "To Hollister Sturges—All strength
and success be yours is the constant prayer of your
friend, Vivekananda"
Venues: All

Swami Vivekananda on the Platform of the Parliament
(cat. 24d)
United States, 1893
Photographic print, copy of original
Vedanta Society of Northern California, V16
Venues: All

Victoria and Albert Museum, London

Battle at Thaneshwar (cat. 12)
bifolio from the *Akbarnama*
India, Mughal dynasty, 1590–95
Opaque watercolor, gold, and ink on paper
Venues: All

> Left folio (cat. 12a)
> Composed by Basawan; painted by Basawan
> and Tara the Elder
> 32.9 × 18.7 cm
> Victoria and Albert Museum, London,
> IS2:61-1896

> Right folio (cat. 12b)
> Composed by Basawan; painted by Asi
> 38.1 × 22.4 cm
> Victoria and Albert Museum, London,
> IS.2:62-1896

Bhairava (cat. 1c)
India, Himachal Pradesh, Mandi, ca. 1800
Opaque watercolor on paper, 27.9 × 17.6 cm
Victoria and Albert Museum, London, IS.45.1954
Venues: All

Bhairava Raga (cat. 18b)
from the *Chunar Ragamala*
India, Uttar Pradesh, Chunar, 1591
Opaque watercolor and gold on paper, 25.5 × 15.7 cm
Victoria and Albert Museum, London, IS.40-1981
Venues: All

The Five-Faced Shiva (cat. 1d)
India, Himachal Pradesh, Mandi, ca. 1730–40
Opaque watercolor on paper, 26.6 × 18.2 cm
Victoria and Albert Museum, London, Given by Col.
T. G. Gayer-Anderson and Maj. R. G. Gayer-Anderson,
Pasha, IS.239-1952
Venues: All

Hanuman as Yogi (cat. 8b)
India, Kerala, Cochin, early 19th century
Teak wood and color, 37.6 × 37 × 9.5 cm
Victoria and Albert Museum, London, IS.2564E-1883
Venues: All

Koringa (cat. 23b)
W. E. Barry Ltd.
Bradford, United Kingdom, ca. 1938
Print, 74.4 × 50.9 cm
Victoria and Albert Museum, London, S.128-1994
Venues: All

Scroll with Chakras (cat. 11c)
India, Kashmir, 18th century
Opaque watercolor, gold, silver, and ink on paper,
376.7 × 17 cm
Victoria and Albert Museum, London, IS.8-1987
Venues: All

Vishnu Vishvarupa (cat. 10b)
India, Rajasthan, Jaipur, ca. 1800–1820
Opaque watercolor and gold on paper, 38.5 × 28 cm
Victoria and Albert Museum, London, Given by
Mrs. Gerald Clark, IS.33-2006
Venues: All

"Fakir Sitting on Nails" (cat. 22g)
India, late 19th century
Painted clay, 11.4 × 20.3 cm
Victoria and Albert Museum, London, Given by
the Indian High Commission, IS.196-1949
Venues: All

Virginia Museum of Fine Arts, Richmond

Five Sages in Barren Icy Heights (cat. 15d)
folio from the *Kedara Kalpa*
Attributed to the workshop of Purkhu
India, Himachal Pradesh, Kangra, ca. 1815
Opaque watercolor on paper;
36.2 × 48.3 cm (folio), 35.7 × 48.1 cm (image)
Virginia Museum of Fine Arts, The Arthur
and Margaret Glasgow Fund, 85.1548
Venues: Sackler, SFAAM

Forms of Vishnu (cat. 10c)
folio from the *Jnaneshvari*
India, Maharashtra, Nagpur, 1763 (Samvat 1856)
Opaque watercolor and ink on paper,
37.7 × 25.4 cm (folio)
Virginia Museum of Fine Arts, The Adolph D.
and Wilkins C. Williams Fund, 91.9.1-628
Venues: Sackler, SFAAM

Jina (cat. 5d)
India, Rajasthan, probably vicinity of Mount Abu, 1160
(Samvat 1217)
Marble, 59.69 × 48.26 × 21.59 cm
Virginia Museum of Fine Arts, The Adolph D.
and Wilkins C. Williams Fund, 2000.98
Venue: Sackler

The Tale of Devadatta (cat. 17d)
from the *Kathasaritasagara*
ca. 1585–90
Opaque watercolor and ink on paper, 13.8 × 13.6 cm
Virginia Museum of Fine Arts, Nasli and Alice
Heeramaneck Collection, 68.8.55
Venues: Sackler, SFAAM

The Walters Art Museum, Baltimore

Ascetics before the Shrine of the Goddess (cat. 15b)
folio from the *Kedara Kalpa*
Attributed to the workshop of Purkhu
India, Himachal Pradesh, Kangra, ca. 1815
Opaque watercolor on paper;
36.5 × 49.2 cm (folio), 24.7 × 47.3 cm (image)
The Walters Art Museum, Baltimore, Maryland
(Gift of John and Berthe Ford, 2001), W. 859
Venues: All

Babur and His Retinue Visiting Gor Khatri (cat. 14d)
folio 22b from the *Baburnama* (Book of Babur)
India, Mughal dynasty, 1590s
Opaque watercolor, gold, and ink on paper,
32 × 21 cm
The Walters Art Museum, Baltimore, Maryland,
W. 596
Venues: Sackler, SFAAM

Wellcome Library, London

Anatomical Body (cat. 25a)
India, Gujarat, 18th century
Ink and color on paper, 60.5 × 58.5 cm
Wellcome Library, London, Asian Collections,
MS Indic Delta 74
Venues: All

Satcakranirupanacitram (cat. 25b)
Swami Hamsvarupa
Trikutvilas Press, Muzaffarpur, Bihar, India, 1903
Book, 26.2 × 34.5 cm
Wellcome Library, London, Asian Collections,
P.B. Sanskrit 391
Venues: All

Film Clips

Note: *Hindo Fakir* (cat. 23d) is listed under
Library of Congress.

"Yogi Who Lost His Will Power" (cat. 23e)
Song clip from the film *You're the One* (1941)
Johnny Mercer (lyrics); Mercer-Mchugh; Jerry
Cohonna with Orrin Tucker and his Orchestra
Clip from YouTube, loop at 3'14:
youtube.com/watch?v=ixwmfoZJHq8
LC Recorded Sound 578945
Columbia 35866
Venues: All

T. Krishnamacharya Asanas (cat. 26i)
India, Mysore, 1938
Sponsored by Maharaja Krishnaraja Wodiyar
Digital copy of a lost black-and-white film, 57 min.
Courtesy of Dan McGuire
Venues: All

Glossary

Note: Unless otherwise indicated, direct translations are of Sanskrit terms.

`Adil Shah dynasty rulers of the Bijapur Sultanate on the Deccan Plateau between 1490 and 1686.

Advaita Hindu philosophical school that postulates the identity between the individual soul and the unique ground of all being, called *brahman*. Because this school's metaphysics is based on the non-dualist teachings found in certain Upanishads, it is also known as Advaita Vedanta. See *brahman*, Vedanta.

Agamas scriptural canon of orthodox Shaivism, whose works date from the sixth to the thirteenth century CE. See also Shaiva Siddhanta.

Akbar Mughal emperor who reigned from 1556 to 1605.

anjali mudra gesture of respect in which the palms are pressed together with the fingers pointing upward.

asana (seat or the act of sitting down) a yogic posture.

ashram hermitage.

austerities various forms of asceticism, such as celibacy and self-mortification, that lead to the correct perception of reality and generate spiritual power.

Bahr al-hayat (Persian: *The Ocean of Life*) yoga text written circa 1550 by Muhammad Ghawth Gwaliyari, a Sufi master of the Shattari order; illustrated at the Allahabad court of the Mughal Prince Salim, circa 1600–1604. See Sufi, Salim.

Bhagavad Gita a circa 200–400 CE portion of the *Mahabharata*'s sixth book, comprising the divine revelations of the great Hindu god Krishna concerning three paths of practice called *yogas*: karma (activity), *jnana* (insight), and *bhakti* (devotion to God). See *Mahabharata*, Vishvarupa.

Bhairava god often considered to be a particularly fierce or terrible form of Shiva or the Buddha; the divine founder or leader of several Tantric orders and revealer of several Tantric scriptures. See Kapalika.

bhakti Hindu tradition that emphasizes an intense and personal relationship with God.

brahman according to Hindu thought, the Absolute; the self-existent, Universal Self; the ground of all being; the infinite power of eternal being and becoming. *Brahman* is distinct from Brahma (a Hindu god) and Brahmin (a member of the highest Hindu caste).

Brahmin member of the highest of the four Hindu castes; a Hindu priest.

British East India Company trading company— with shareholders and the largest standing army in Asia—that gradually extended its control over India between the seventeenth and mid-nineteenth centuries.

British Raj British rule of India from 1858 to 1947.

Buddhist person whose way of life is grounded in the teachings of Gautama Buddha, the fifth-century BCE founder of Buddhism, as well as the canon of doctrines and practices attributed to subsequent Buddhist teachers and holy men.

chakra (wheel, circle) one of the energy centers aligned along the spinal column of the yogic body. The number of chakras varies from one tradition to another, with several traditions extending chakras into the space above the top of the head. Chakra also refers to the discus that is one of Vishnu's primary emblems and the circular weapon wielded by militant ascetics.

Chola dynasty rulers of an empire that extended over much of South India and Sri Lanka between the ninth and thirteenth centuries.

Dasnami (ten-named) confederation of ten ascetic orders that are today Shaiva. According to Dasnami tradition, they were founded by the ninth-century teacher Shankara (also known as Shankaracharya). See Giri, Puri, Shaiva.

dhoti garment wrapped around the waist.

fakir (Arabic: poor man) Muslim religious mendicant; also spelled faqir, fakeer.

Gandhara region that extended over parts of Afghanistan and Pakistan; a Buddhist kingdom under the Kushan dynasty from the first to the fifth century.

Giri one of the ten Dasnami suborders, whose initiates are given the "surname" Giri.

Goraksha, Gorakh, Gorakhnath twelfth- to thirteenth-century founder of the Nath *sampradaya* and purported author of several Sanskrit and vernacular works on the practice of hatha yoga and the mystic experiences of the yogi. See Matsyendranath.

guru religious preceptor or teacher. A guru initiates *shishya*s or *chela*s (disciples) into a lineage, which theoretically extends back to the god or goddess who originally revealed the teachings.

hatha yoga body of yogic practice that combines *asana*s (postures), *pranayama* (breath control), *mudra*s (seals), *bandha*s (locks), and techniques of bodily purification, which reverse the normal downward flow of energy, fluids, and consciousness in the body, and provide the practitioner with bodily immortality, supernatural powers, and embodied liberation.

Hindu person whose way of life is grounded in the foundational doctrines of Hindu revelation (the Vedas, Upanishads, etc.) and tradition (the *Bhagavad Gita*, Puranas, Tantras), as well as the teachings of Brahmins and other exemplary humans.

Hoysala dynasty rulers in the southern Deccan from circa 1006 to 1346.

Jahangir Mughal emperor who reigned from 1605 to 1627. See Salim.

Jain person whose way of life is grounded in the teachings of Mahavira, the sixth-century BCE founder of Jainism, as well as the canon of doctrines and practices attributed to subsequent Jain teachers and holy men.

Jalandharnath illustrious Nath Yogi and *siddha* who is the subject of a rich body of medieval and modern legend. In the western Indian kingdom of Marwar (modern-day Jodhpur and its environs), Jalandharnath is regarded as a semidivine figure who was instrumental in the rise to power of the early nineteenth-century King Man Singh.

jata matted hair or "dreadlocks" worn by yogis in imitation of the Hindu god Shiva.

jatamukuta crown or bun of matted locks.

Jina (conqueror) one of the twenty-four legendary founders of Jainism. The last of these was Mahavira, a historical figure who lived in the sixth century BCE. The term *jina* is used interchangeably with *tirthankara* (one who has crossed over).

jogi in the vernacular languages of north India (Hindi, Rajasthani, etc.), the Sanskrit term *yogi* was pronounced and written as *jogi*. In the colonial period, *jogi* was often used in a pejorative sense to refer to a charlatan or false ascetic. See yogi.

Kapalika (Skull bearer) Shaiva yogi who carries a *kapala* (skull) as a begging bowl during a twelve-year period of itinerancy, as a marker of his membership in a heterodox Tantric order that featured sexual excess and antisocial behavior. The divine exemplar of Kapalika practice is the Tantric god Bhairava, whose iconography features skulls and other bone ornaments.

kanphata (Hindi: split-eared) term used for the Nath Yogis, who since the turn of the nineteenth century have worn large hoop earrings (*mudra*s) through the cartilage of their ears.

Kathaka Upanishad Hindu scripture, circa third century BCE, in which practices for controlling the body and breath are first described within the context of a set of teachings on yoga.

Kaula (clan-related, son of the clan) elite body of Hindu Tantric practices used specifically by the inner circle of the "clan" of gods, goddesses, and advanced human practitioners. Sons of the clan sought to obtain supernatural powers and bodily immortality through unconventional practices.

Krishnamacharya, Tirumalai (1888–1989) often regarded as the father of modern postural yoga, Krishnamacharya focused on postural movement and *pranayama* oriented toward health, fitness, and healing. His most famous disciples are B. K. S. Iyengar, K. Pattabhi Jois, T. K. V. Desikachar, and Indra Devi.

Kundalini (She who is coiled) in Hindu hatha yoga and Tantra, the female energy that descends through the yogic body to lie coiled in "sleep" in the lower abdomen. Through combined yogic techniques, she is "awakened" and made to rise through the chakras to the cranial vault and beyond.

Kuvalayananda, Swami (1883–1966; born Jagannath Gune) central figure in the emergence of modern yoga. Kuvalayananda sought to demystify yoga through scientific research and establish it as a key component of Indian physical education and fitness.

laya yoga (yoga of absorption) form of yoga practice involving the absorption of the individual mind or self into the Absolute *brahman*, often through the experience of subtle sounds. Laya yoga was one component in a fourfold system of yoga introduced in several medieval texts, along with raja yoga, hatha yoga, and mantra yoga.

linga, lingam pillar-shaped emblem of the Hindu god Shiva. In most Shiva temples, the lingam is nested in an abstract representation of the great goddess who is his consort. This lingam-yoni configuration harks back to Tantric doctrine, according to which Shiva and the goddess create and maintain the universe through their sexual energy.

Mahabharata one of India's two great epics; the other is the *Ramayana*. The *Mahabharata*, which was composed between the second century BCE and the fourth century CE, contains the *Bhagavad Gita*.

maharaja (great king) title for a Hindu ruler.

mala rosary or garland.

Man Singh maharaja of Jodhpur-Marwar from 1803 to 1843; a devotee of Jalandharnath and great patron of the Nath sectarian order.

mantra (mental device; instrument of thought) acoustic formula whose sound shape embodies and reproduces the energy-level of a deity; a spell, incantation, or charm employed in Tantric ritual or sorcery.

math, matha Hindu monastery or lodge.

Matsyendra, Matsyendranath (Lord of the fishes) illustrious Tantric figure who is the subject of a rich body of medieval Hindu and Buddhist legend. Hindus believe that Matsyendra was the founder of the Kaulas, an early Tantric order and the guru of Gorakhnath, the founder of the Nath Yogis. See Kaula and Nath.

Mattamayura (Drunken peacock) name of an influential medieval Shaiva religious order.

mudra (seal) ritually instrumental gesture of the hand or body. In hatha yoga, an internal hermetic seal effected through breath control and other techniques. Among the Nath Yogis, *mudra*s are the great hoop earrings worn through the thick of the ear. More generally, a hand gesture with symbolic meaning, as in *anjali mudra*, the gesture of respect.

Mughal dynasty, ruled 1526–1857 at the height of Mughal power in the late sixteenth and seventeenth centuries, the Indo-Islamic empire extended over much of the subcontinent.

Nath sampradaya religious order purportedly founded by Gorakhnath. The Nath Yogis (Yogi Lords) were historically known for their distinctive regalia and their roles as advisors to kings in a number of medieval and early modern kingdoms in South Asia. See also Gorakhnath, Jalandharnath, Matsyendranath, *mudra*, *singi*.

nadi in both Hindu and Buddhist mapping of the yogic body, one of an elaborate network of some 72,000 subtle ducts of the yogic body, through which breath and vital energy are channeled. Of these, the three that run through the center and along the right and left sides of the spinal column are most prominent.

om quintessential Hindu mantra, the acoustic expression of the *brahman*.

padmasana lotus posture.

Pala dynasty the Palas ruled northeast India (and modern-day Bangladesh) from the eighth to the twelfth century.

Pali canon sacred texts of Buddhism and the earliest sources on the religion.

Pallava dynasty the Pallavas (sixth–ninth century) originated in Andhra Pradesh and gradually extended their territories to include Tamil Nadu; their capital at Kanchipuram was a major cultural center.

Pashupata name of an early Shaiva sect devoted to Pashupati, a form of Rudra/Shiva.

Patanjali author, perhaps legendary, of the circa second- to fourth-century *Yoga Sutras*.

pranayama breath control; the body of techniques for regulating and stilling the breath (*prana*).

Purana medieval canon of Hindu devotional religion. Traditionally eighteen in number, the Puranas are compendia of Hindu mythology, cosmology, and instructions for devotional religious practice.

Puri one of the ten Dasnami suborders, whose initiates are given the Puri "surname."

raga classical Indian musical mode. Some ragas were conventionally illustrated with images of Shiva or yogis.

ragamala (garland of ragas) series of thirty-six or forty-two classical Indian musical modes.

raja Hindu king; see also maharaja.

raja yoga (royal yoga) term used to designate the system of the *Yoga Sutras*, identified as "classical yoga" by Vivekananda and his successors in the twentieth and twenty-first centuries.

Ramanandi Vaishnava ascetic order that was formalized in the early eighteenth century and is today the largest ascetic order in India. From as early as the twelfth century, Ramanandis—like other Vaishnava ascetics—have been devoted to the god Rama (Hindi: Ram), whose name they often mark on their bodies.

Ramcharitmanas of Tulsidas sixteenth-century retelling in vernacular Hindi of the Sanskrit *Ramayana*.

Rig Veda earliest (circa fifteenth to tenth century BCE) and most prominent of the four Vedas, the original revelations of the Hindu faith.

rudraksha beads worn by devotees of Shiva.

sadhu Hindu holy man.

Salim, Prince the future Mughal Emperor Jahangir (1569–1627), Prince Salim commissioned yoga manuscripts in his Allahabad court between 1600 and 1604.

samadhi (composition, meditative concentration) according to the *Yoga Sutras*, the final component and result of *ashtanga* (eight-limbed) yoga, an integrated state of pure contemplation, in which consciousness is aware of its fundamental isolation from materiality and its own absolute integrity. According to the teachings of the Buddha, it is the final component and result of the practices of the Noble Eightfold Path, which leads to the extinction (nirvana) of suffering existence.

sannyasi renouncer; traditionally a high-caste male Hindu who has entered into the fourth and final stage of life, in which he has renounced all ties to family, society, and ritual practice by burning his sacrificial implements that he has symbolically "laid up together" (*sannyasa*) inside his body. In the modern period, members of the Dasnami order refer to themselves as *sannyasis*, regardless of whether they renounce early or late in life.

Sanskrit language of the Vedas and classical Hindu texts as well as a cosmopolitan literary language in South and Southeast Asia.

Shaiva follower or devotee of Shiva. The ensemble of philosophical and ritual systems followed by Shaivas is known as Shaivism.

Shaiva Siddhanta philosophical and ritual system of orthodox Shaivism.

shaykh Sufi master and teacher.

siddha (perfected being) an exemplary superman of Hindu Tantra; an advanced practitioner of Tantra; a fully realized Nath or Jain practitioner.

Siddha Siddhanta Paddhati (Step by Step Guide to the Principles of the Perfected Beings) compendium of Nath metaphysics, cosmology, and subtle physiology, attributed to Gorakhnath.

siddhi supernormal power, such as the ability to fly, that is a byproduct or goal of yogic practice.

Sidh Sen raja of Mandi, a kingdom on the Beas River in Himachal Pradesh, who reigned circa 1684–1724 and was a Tantric devotee of Shiva.

singi horn whistle worn by Nath Yogis; today it is usually called *nad* due to the sound it produces when blown.

Sufi Islamic tradition that stresses a mystical path and personal relationship with God. In India, several Sufi ascetic orders interacted with Hindu yogis and adopted yogic techniques.

Tantra medieval and modern Hindu, Jain, and Buddhist system of ritual and theory, distinctive in its goal (self-deification) and the means employed to realize that goal: mandala-based visualization and a highly elaborate ritual practice, sometimes involving impure or prohibited substances (sexual fluids, alcohol, flesh), etc.

Tantras medieval scriptures of Hindu, Buddhist, and Jain Tantra.

tapas ascetic practices that generate heat; the heat generated through austerities or yogic practice.

tilak mark applied to the forehead or body, either to indicate one's sectarian affiliation (in Hinduism) or purely for cosmetic purposes. See also *urdhvapundra*.

Tirthankara see *Jina*.

Udasi (one who is not attached) religious mendicant; member of a Sikh ascetic order whose practices include yoga. Also spelled *oodasi*.

Upanishads final canon of Vedic revelation dating from the fifth century BCE to the third century CE. The Upanishads contain both *dvaita* (dualist) and *advaita* (non-dualist) speculations on the relationship between the Absolute *brahman* and individual souls, between *purusha* (spirit) and *prakriti* (matter), and other topics.

urdhvabahu the austerity of permanently raising one or both arms in the air; a term for the ascetics who perform this austerity.

urdhvapundra V-shaped mark on the foreheads of Vaishnavas.

Vaishnava follower or devotee of Vishnu. The ensemble of philosophical and ritual systems followed by Vaishnavas is known as Vaishnavism.

Vairagi religious mendicant, devotee, or ascetic, usually Vaishnava. Also spelled Vairagee, Bairagi.

Vedanta (the "end"—*anta*—of the Vedas) the Upanishads, the final corpus of Hindu revelation; by extension, the philosophical school that takes the Upanishads as the foundation for its teachings. There are three forms of Vedanta philosophy: non-dualist (*advaita*), dualist (*dvaita*), and qualified non-dualist (*visishtadvaita*). See also Advaita, Upanishads.

Vishvarupa (Universal Form) the cosmic form that Krishna reveals to Arjuna in the course of his revelation of the *Bhagavad Gita*, after Arjuna has asked the god to demonstrate his "masterful yoga" (*aishvaryam yogam*). Krishna's body is seen to encompass the entire universe, with all of its creatures inside his body.

Vivekananda, Swami (1863–1902, born Narendranath Datta) key figure in the emergence of modern yoga. His publications and public appearances in India, North America, and England disseminated yoga as an ecumenical and philosophically grounded tradition (in which *asanas* played little part).

yantra geometric ritual diagram used by practitioners to summon deities, or to control or subdue the mind, demonic beings, or elements of the phenomenal world.

yogapatta band of cloth wrapped around the torso and knees to assist in sitting.

Yoga Sutras of Patanjali circa second- to fourth-century work on yoga philosophy, which also includes practical instructions on the eight successive stages of practice (*ashtanga yoga*) and discussion of the supernatural powers enjoyed by advanced practitioners.

Yoga Vasishta (Vasishtha's Teachings on Yoga) Sanskrit philosophical treatise from Kashmir that combined analytical and practical teachings on yoga with vivid mythological accounts that revealed the transformative powers of consciousness.

yogi, yogin male practitioner of yoga.

yogini goddess belonging to a cohort ranging in number from 42 to 108; in Hindu Tantra, a practitioner's female consort.

Endnotes to the Catalogue

Catalogue 1

1 Selected publications include Ronald M. Davidson, *Indian Esoteric Buddhism: A Social History of the Tantric Movement* (New York: Columbia University Press, 2002), fig. 12.

2 Selected publications include Deborah Swallow and John Guy, eds., *Arts of India: 1550–1900* (London: V&A Publications, 1990), p. 147, pl. 126.

3 Selected publications include Stella Kramrisch, *Manifestations of Shiva* (Philadelphia: Philadelphia Museum of Art, 1981), p. 194, fig. P-30.

4 The title of the entry is in homage to the scholar and curator Stella Kramrisch, who organized an exhibition of the same name at the Philadelphia Museum of Art in 1981. *Manifestations of Shiva* was the first major thematically organized exhibition of Indian art.

5 Bhairava also figures in the Buddhist Tantras. See for example, David Gordon White, "At the Mandala's Dark Fringe: Possession and Protection in Tantric Bhairava Cults," in *Notes from a Maṇḍala: Essays in the History of Indian Religions in Honor of Wendy Doniger* (Newark: University of Delaware Press, 2010), pp. 200–15, esp. pp. 201–2.

6 David Lorenzen, *Religious Movements in South Asia, 600–1800* (Berkeley: University of California Press, 1972), pp. 77–81.

7 Bhairava temples appeared in Tamil Nadu as early as the eighth century. Bhairava is closely related by iconography to the *kṣetrapālas* that were set within niches near the doorways of temples where they were "worshipped for protection, to prevent suffering, to remove impediments, and for the fertility of crops"; Vidya Dehejia, *The Sensuous and the Sacred: Chola Bronzes from South India* (New York: American Federation of Arts, 2002), pp. 118–19.

8 Vidya Dehejia, *The Sensuous and the Sacred: Chola Bronzes from South India* (New York: American Federation of Arts, 2002), p. 118. Poem by Appar translated by Vidya Dehejia from the French: "Appar 4.73.6" in *Tevaram: Hymnes Sivaites du pays Tamoul*, vol. 2, ed. T. V. Gopal Iyer and François Gros (Pondicherry: Institut français d'indologie, 1985), p. 73.

9 For a Mandi painting of Bhairava with the same attributes but wearing the garb of an itinerant ascetic, see B. N. Goswamy, *Domains of Wonder: Selected Masterworks of Indian Painting* (Seattle: University of Washington Press, 2005), p. 213, fig. 88.

10 His boyish mien may point to the deity's manifestation as Bāla (boy) Bhairava. K. Guha, "Bhairon, A Shaivite Deity in Transition," *Folklore* 1, no. 4 (July-August 1960), pp. 207–22.

11 Gavin Flood, *Body and Cosmology in Kashmir Shaivism* (New York: Edward Mellen Press, 1993), p. 43.

12 Shaman Hatley, "The Brahmayāmalatantra and Early Śaiva Cult of Yoginīs" (PhD diss., University of Pennsylvania, 2007), p. 267. Vidya Dehejia notes that Sadāśiva is visualized as the five faces of the liṅgam of Śiva in devotional images created in South India under the Chola rulers; Dehejia, *The Sensuous and the Sacred*, p. 91.

13 See, for example, "Maharaja Sidh Sen of Mandi as a Manifestation of Shiva," reproduced in Joan Cummins, *Indian Painting* (Boston: MFA Publications, 2006), p. 180, pl. 100.

14 Retellings of the mythic narrative feature both Śiva and Bhairava as well as assimilate (the deity) Brahmā into (the caste) Brahmin.

15 For the descent of teachings from Śiva as formless sound to humans, see Hatley, "The Brahmayāmalatantra," pp. 267–70.

Catalogue 2

1 Selected publications include Rob Linrothe, ed., *Holy Madness: Portraits of Tantric Siddhas* (New York and Chicago: Rubin Museum of Art and Serindia Publications, 2006), p. 389.

2 Selected publications include Jack R. McGregor, *Indian Miniature Painting from West Coast Private Collections* (San Francisco: Society for Asian Art, 1964), no. 25, pl. XIV; Stuart C. Welch, *A Flower from Every Meadow* (New York: Asia Society, 1973), no. 26; Rosemary Crill, *Marwar Painting* (Mumbai: India Book House, 2000), p. 48.

3 See, for example, Thomas E. Donaldson, "Lakulíśa to Rājaguru: Metamorphosis of the 'Teacher' in the Iconographic Program of the Orissan Temple," in *Studies in Hindu and Buddhist Art*, ed. P. K. Mishra (Delhi: Abhinav Publications, 1999).

4 Gouriswar Bhattacharya, "Inscribed Image of a Śaivācārya from Bengal," in *South Asian Archaeology 1993*, ed. Asko Parpola and Petteri Koskikallio (Helsinki: Suomalainen Tiedeakatemia, 1994), pp. 93–99; Bhattacharya, "A New Śaivācārya with Disciples," *Kalyan Bharati* 6 (2002), pp. 5–14; Linrothe, *Holy Madness*, p. 389, cat. no. 88; Ranjusri Ghosh, "Image of a Saiva Teacher and an Inscription on Pedestal: New Evidence for Bangarh Saivism," *Pratna Samiksha* 1 (2010), pp. 135–39.

5 The relationship between image and individual in medieval Indian portraiture was signified most often less through a mimetic physical likeness than through an epigraph identifying the portrayed person explicitly by name. On portraiture, see Padma Kaimal, "The Problem of Portraiture in South India, circa 870–970 A.D," *Artibus Asiae* 59, nos. 1/2 (January 1, 1999), pp. 59–133; Kaimal, "The Problem of Portraiture in South India, Circa 970–1000 A.D," *Artibus Asiae* 60, no. 1 (January 1, 2000), pp. 139–79; Vincent Lefèvre, *Portraiture in Early India: Between Transience and Eternity* (Leiden: Brill, 2011); Vidya Dehejia, *The Body Adorned: Dissolving Boundaries Between Sacred and Profane in India's Art* (New York: Columbia University Press, 2009), pp. 27–28, 41–42, 67–68. That this is not a unique sculpture, but representative of more widespread artistic practices, is hinted at through the fortuitous survival of fragments of similarly large-scale gurus and *ācāryas* in archaeological museums across North and Central India. While

fully preserved images following a typology that one might effectively dub "guru-portraiture" are relatively rare outside of northeastern India, fragments of such images can still be found in situ in the field and in museum collections. Over the course of my own research, I have observed them at the Gujri Mahal Museum in Gwalior and the Rani Durgavati Museum in Jabalpur. Klaus Bruhn has noted the particular popularity of the *ācārya* motif, which he identifies as a subset of the "teacher-and-disciple motif," among the reliefs found at Jaina temples at Deogarh, mainly between 1000 and 1150 CE; see Klaus Bruhn, "The Ācārya Motif at Deogarh," in *Deyadharma: Studies in memory of Dr. D.C. Sircar*, ed. Gouriswar Bhattacharya (Delhi: Sri Satguru Publications, 1986), pp. 179–87. I am also grateful to Nachiket Chanchani for bringing my attention recently to two twelfth- to thirteenth-century figures.

6 Vidyāśiva is mentioned in an eleventh-century inscription of Mahīpalā I (reigned 1027–43) found at Bāngaḍh and placed in the lineage of the legendary Durvāsas, edited by D. C. Sircar, "Bāngaḍh stone inscription of the time of Nayapāla," *Journal of Ancient Indian History* 7 (1974), pp. 135–58, 264. The legendary Durvāsas is mentioned in the *Tantrāloka* (XII, 383) as the source of three mind-born sons, the second of whom (Amardaka) is said to be the promulgator of Śaiva Siddhānta. For more on Durvāsas, see Richard Davis, *Ritual in an Oscillating Universe: Worshiping Śiva in Medieval India* (Princeton: Princeton University Press, 1991), p. 15; V. V. Mirashi, *Inscriptions of the Kalachuri-Chedi Era*, vol. 4, part 1. Corpus Inscriptionum Indicarum. Ootacamund: Gov. Epigraphist for India, 1955), pp. 371, 373; and V. S. Pathak, *History of Śaiva cults in northern India, from inscriptions 700 A.D. to 1200 A.D.* (Allahabad: Abinash Prakashan, 1980), p. 30.

7 On the Dasnāmi *sampradāya* , see Matthew Clark, *The Daśanāmi-samnyāsis : The Integration of Ascetic Lineages into an Order* (Leiden: E. J. Brill, 2006).

8 The fullness has traditionally be interpreted as indicating *prāṇa* , or life breath. The idea may stem from Stella Kramrisch, but has found expression in many subsequent sources. See Stella Kramrisch, *The Hindu Temple*, vol. 2 (Calcutta: University of Calcutta, 1946), p. 342; Kramrisch, *Indian Sculpture in the Philadelphia Museum of Art* (Philadelphia: University of Pennsylvania Press, 1961), pp. 34–37; Benjamin Rowland, *The Art and Architecture of India: Buddhist, Hindu, Jain* (London: Penguin Books, 1953), p. 55; Bettina Baumer et al., "Vāyu," in *Primal Elements Mahābhūta: Kalātattvakośa*, vol. 3, ed. Bettina Baumer and Kapila Vatsyayan (New Delhi: Motilal Banarsidass Publisher, 1996), pp. 183–84. See also fig. 4 in "From Guru to God: Yogic Prowess and Places of Practice in Early-Medieval India" in this volume.

Catalogue 3

1 Petrographic analysis of the Sackler yogini by Freer|Sackler conservation scientist Janet Douglas shows that it is composed of a metamorphosed gabbro; the sculptures in the collections of the Detroit Institute of Art and the Minneapolis Institute of Arts have not been analyzed to date; however, visual study suggests they are composed of basalt.

2 Shaman Hatley, "The Brahmayāmalatantra and the Early Śaiva Cult of Yoginis" (PhD diss., University of Pennsylvania, 2007), p. 24.

3 Hatley, "Brahmayāmala," v. 52, p. 409 and v. 41, p. 406. Composed in Sanskrit sometime before the ninth century, the Tantric text about yoginis is structured as a revelation of the Hindu deity Śiva in his form as Bhairava.

4 The Kaulas emerged in India in the late seventh century.

5 "Distinctive to the Tantric traditions are the goals of *mokṣa* and *bhoga* (power, supernatural experience, and supernatural pleasures) as the fruits of practice, rather than *mokṣa* alone. Yogini veneration, however, typically is oriented towards attainment of powers." Correspondence from Shaman Hatley to the author, October 9, 2012.

6 Kaula ritual included the empowering exchange of bodily fluids through ritualized sexual intercourse between male adepts and their female partners, who were also known as yoginis. See "Yoga in Transformation" by David Gordon White in this catalogue.

7 White, "Yoga in Transformation."

8 Vidya Dehejia's seminal study, *Yogini, Cult and Temples: A Tantric Tradition* (New Delhi: National Museum, 1986), examines the extant ruins of medieval yogini temples located in a broad swath from Rajasthan in the west to Orissa in the East and Tamil Nadu in the south. But there must have been more. No yogini temples survive, for example, in Delhi, which was one of the great centers of yogini worship and which was known as Yoginipura or city of yoginis. Nor are there any in Assam, which was probably where the yogini cult emerged and where to this day the sixty-four yoginis are invoked.

9 Dehejia, *Yogini, Cult and Temples*, pp. 2, 185–86, makes the connection of ground plans to yogini chakras. Margrit Thomsen, "Numerical Symbolism and Orientation in Some Temples of the 64 Yoginis," in *Art and Archaeology Research Papers*, March 1980, p. 53, observes that the plans of round yogini temples with extended portals also recall the yoni-shaped bases of Śiva lingams, cited in Shaman Hatley, "Goddesses in Text and Stone: Temples of the Yoginis in Light of Tantric and Purāṇic Literature," in *History and Material Culture in Asian Religions*, ed. Benjamin Fleming and Richard Mann (London: Routledge, forthcoming). David Gordon White has suggested that the hypaethral temples were perceived of as landing pads for the flying yoginis, *Kiss of the Yogini: "Tantric Sex" in its South Asian Contexts*. (Chicago: University of Chicago Press),pp. 7–13, 204–18.

10 Reading newly translated Sanskrit texts against material culture, Hatley, in "Goddesses in Text and Stone," provides compelling evidence that the temples mark (and indeed enable) a transition from primarily individual and esoteric rites into more public and conventional forms of worship.

11 For more on the temple and its sculptures, see Dehejia , *Yogini, Cult and Temples*, and Padma Kaimal, "Scattered Goddesses: Travels with the Yoginis," in *Asia Past and Present*, ed. Martha Ann Selby (Ann Arbor: Association of Asian Studies, 2012). Kaimal's monograph identifies pieces of thirteen extant yoginis, three mother goddesses, and four male figures (Śiva, his son Skanda/Shanmuga, and two guardians); the twelve-armed Skanda was situated at the temple's center.

12 Intriguingly, their sloped shoulders deviate from the straight shoulders proscribed for Hindu deities in iconographic manuals (*shilpa shastras*). A Chola bronze sculpture in the Freer Gallery of Art (F1929.8)—which Vidya Dehejia has compellingly proposed is a portrait sculpture of Queen Sembiyan Mahadevi as the goddess Parvati/Uma—has similarly sloped shoulders. *Art of the Imperial Cholas* (New York: Columbia University Press, 1990), pp. 4, 36–39. Whether the rounded shoulders of the Kanchi yoginis indicate a regional aesthetic or the fluid boundaries between human and divine that characterize yogini identity is a subject for further research.

13 Kaimal, *Scattered Goddesses*, p. 37, proposes that the iconography of jar and wand might refer to medicine.

14 No sculptures of this quality (or images of yoginis) from this period have been found near Kannauj, a city some 190 miles north of the Chandella dynasty capital at Khajuraho. In the tenth century, local Kannauj kings were associated with the Chandella dynasts (tenth to thirteenth century), a political alliance that would have encouraged aesthetic, religious, and cultural connections. The yogini temple at Khajuraho (now without sculptures) was located within walking distance of the main temple complex, and the plump flesh, square face, high waist, round breasts, and asymmetrical necklace tassel of the Kannauj yogini recall the female figures on the Khajuraho temples. Yet differences suggest regional production. Dehejia, *Yogini, Cult and Temples*, p. 48, connects her by style to Naresar. Vishakha Desai and Darielle Mason, *Gods, Guardians and Lovers: Temple Sculptures from North India, A.D. 700–1200* (New York: Asia Society Galleries, 1993), cat. 30, suggest Jhusi in Allahabad; both sites were in the Chandella domain.

15 Hatley "Brahmayāmala," p. 17.

16 Dehejia, *Yogini, Cult and Temples*, p. 150

17 Carl W. Ernst,"Accounts of Yogis in Arabic and Persian Historical and Travel Texts," *Jerusalem Studies in Arabic and Islam*, vol. 33 (2008), pp. 411–14.

18 In 2011, historian Emma Flatt published a groundbreaking analysis of the colophons and text of the *Stars of the Sciences*, identifying its author as Ali 'Adil Shah, describing its chapters on astrology, divination and yoginis, and outlining the linguistic strategies the sultan employed to make the often esoteric material comprehensible to his diverse court. Emma Flatt, "The Authorship and Significance of the *Nujūm al-'ulūm*: A Sixteenth-Century Astrological Encyclopedia from Bijapur," *Journal of the American Oriental Society* 131, no. 2, pp. 225–35, and *passim*.

19 Dehejia, *Yogini, Cult and Temples*, pp. 5, 187–218.

20 It contains 340 folios and 400 paintings in opaque watercolor and gold on paper of

excellent quality. Chester Beatty Library, MS In2, published in Linda Leach, *Mughal and Other Indian Paintings from the Chester Beatty Library*, vol 2 (London: Scorpion Cavendish, 1995).

21 Leach, *Mughal and Other Indian Paintings*, p. 862.

22 For the group of single-figure yoginī paintings, see Deborah Hutton, *Art of the Court of Bijapur* (Bloomington: Indiana University Press, 2006), pp. 83–96; for their yogic connections, see Debra Diamond, "Occult Science and Bijapur's Yoginīs," in *Indian Painting: Themes, History and Interpretations (Essays in Honour of B. N. Goswamy)*, ed. Mahesh Sharma (Ahmedabad: Mapin, forthcoming).

23 In "Occult Science and Bijapur's Yoginīs," Diamond reviews the art historical literature in which the yoginīs are consistently interpreted as images of mortal ascetics or princesses in yogic masquerade.

24 The Persian translation of the *Kāmarūpañcāśikā* describes sixty-four immortal, beautiful and bejewled yoginīs with supernatural powers. Carl W. Ernst, "Being Careful with the Goddess: Yoginīs in Persian and Arabic Texts," in *Performing Ecstasy: The Poetics and Politics of Religion in India*, ed. Pallabi Chakravorty and Scott Kugle (New Delhi: Manohar Publishers and Distributors, 2009) , pp. 191–96; see also "Muslim Interpreters of Yoga" by Carl W. Ernst in this volume. For the identification of the *Kāmarūpañcāśikā*, see Kazuyo Sakaki, "Yogico-tantric Traditions in the *Ḥawd al-Ḥayāt*," *Journal of the Japanese Association for South Asian Studies* 7 (2005), pp. 135–56.

Catalogue 4

1 Published in Debra Diamond, *Garden and Cosmos: The Royal Paintings of Jodhpur* (Washington, DC: Arthur M. Sackler Gallery, 2008), cat. 40.

2 David Gordon White, *The Alchemical Body: Siddha Traditions in Medieval India* (Chicago: University of Chicago Press, 1998).

3 "A close reading of the corpus of Sanskrit texts that taught haṭha yoga in its formative period (approximately the eleventh to the fifteenth century) shows that it consisted of a variety of ancient physical techniques aimed at achieving liberation by controlling the breath, mind, and semen." See James Mallinson, "Yogis in Mughal India," in this catalogue.

4 Maharaja Man Singh's lavish patronage included the collecting of existing Nāth treatises and the production of new knowledge through the commissioning of texts and illustrated manuscripts. For more on illustrated Nāth manuscripts, see Diamond, *Garden and Cosmos*, pp. 43–49; 173–254.

5 See n. 6.

6 Deities with comprehensible forms are more visible in Hindu religious practice.

7 Terse descriptions of each cosmic manifestation are inscribed on the verso of the folio: "First there is the glorious Nāth, whose nature is self effulgent and without beginning, limit, form, or blemish, 1. Bliss-form Nāth. Then after many eons, Jallandhar sat down and created vast waters. Thus, he is renowned as lord (īśa). He is also known as Gorakhnāth. The third picture

[represents] this form without attributes." For the Rajasthani verses, see Diamond, *Garden and Cosmos*, p. 287. Jalandharnāth was the focus of devotion for the manuscript's patron, Man Singh. Here, his identification with Gorakhnāth bridges a more localized Nāth tradition with what James Mallinson has described as an increasingly organized and transregional Nāth order that recognizes Gorakhnāth as both historical founder and supreme *siddha*. James Mallinson, "The Nāth Saṃpradāya," in *Brill's Encyclopedia of Hinduism*, vol. 3, ed. Knut A. Jacobsen (Leiden: Brill, 2011), pp. 407–28.

8 The nine and eighteen Nāths on folios 3 and 4 refer to canonical groups of *siddha*s. Mallinson, "The Nāth Saṃpradāya."

9 On *pratyakṣa*, see White, *The Alchemical Body*. On the ranking of authority, see Wendy Doniger O'Flaherty, *Dreams, Illusion, and Other Realities about Yoga: Tales from the Yogavāsiṣṭha* (Chicago: University of Chicago Press, 1984), pp. 172–74.

Catalogue 5

1 Selected publications include Phyllis Granoff, *Victorious Ones: Jain Images of Perfection* (New York: Rubin Museum of Art, 2009), p. 210, cat. S26; Thomas Lawton, *Asian Art in the Arthur M. Sackler Gallery* (Washington, DC: Smithsonian Institution Press, 1987), pp. 62–63.

2 Inscription: Prosperity!
The image of the omniscient Ajidi [was caused to be made] by the honorable ... of [or landlord of] Pullinira-puttur in Vilai-natu.
 Y. Subbarayalu, translator, Department of Indology, Institut Français du Pondichéry, in Granoff, *Victorious Ones*, p. 210, cat. S26.

3 Selected publications include *The Jina Collection* (New York: Frederick Schultz Ancient Art in Association with Peter Marks Gallery, 2001), pl. 13.

4 Selected publications include Granoff, *Victorious Ones*, p. 216, cat. S29.

5 Selected publications include Joseph Dye, *The Arts of India* (Richmond: VMFA, 2001), cat. 51.

6 Inscription: In the year VS 1390 [1333] on the eleventh [lunar day] of the dark half of [the month of] Jyaistha [May-June] with a shrine [and] with attendants [was caused to be made] for his own welfare by the merchant Maladeva. the son of the Merchant Devaimha [and his wife] Desatadevi, the son of the merchant Mahicandra, belonging to the illustrious Gurjara family.
 Selected publications include Pratapaditya Pal, *Peaceful Liberators: Jain Art from India* (Los Angeles: LACMA, 1994), cat. 14.

7 Paul Dundas, *The Jains*, 2nd ed. (London: Routledge, 2002), p. 23.

8 This karma with its attendant coloring adheres to and obscures one's soul. For instance, domestic violence cloaks its perpetrators and victims with what might seem to be an ashen hue. Some souls commit heinous acts that result in rebirth in one of the many realms of hell; other souls through their goodness ascend after death into a heavenly realm.

9 The relationship between classical yoga and Jainism has a long and glorious history. The ethical principles of yoga, the five *yamas*, are the same as found in Jainism. Both yoga and

Jainism teach the importance of karma. While Patañjali says that karma can be black, white, or mixed, Jainism counts six colors of karma that manifest in 148 varieties (see the *Tattvārtha Sūtra*, circa 400 CE). It is safe to say that these traditions have been in continual interplay for more than two thousand years.

10 Christopher Key Chapple, *Reconciling Yogas: Haribhadra's Array of Views on Yoga* (Albany: State University of New York Press, 2003), pp. 15–38.

11 The *Yogaśāstra* shows the strong Tantric influence on medieval Jainism. The sixth chapter, on breath control, also records divination exercises, catalogued under *prāṇāyāma* because they partly rely on knowledge of the breath and its movements. Most are geared toward determining the time of death, but some focus on warfare, harvest, and offspring. See Olle Quarnström, trans., *The Yogaśāstra of Hemacandra: A twelfth century handbook on Śvetambara Jainsim* (Cambridge, MA: Harvard University, 2002).

12 Dundas, *The Jains*, p. 202.

13 For the first tīrthaṅkara, one can find a bull; for the most recent, Mahāvira , one finds a lion.

14 First, the statue is bathed in water. Then sandalwood paste or red *kumkum* is applied to the to the knees, the forearms, the shoulders, the top of the head, the spiritual center between the eyebrows (*ājñā cakra*), the heart, and the stomach. Flowers are placed on the body of the Jina, for beauty and as a reminder of impermanence. Incense is lit for its fragrance and to evoke mindfulness of the life in air. A lamp (*dipa*) is ignited and waved in front of the statue, symbolizing and creating a connection with consciousness. Offerings of rice, food, and fruit to the Jina image constitute the last three aspects of Jain ritual (*pūjā*). In addition, worship takes the form of a meditation involving vocalized prayers. The most widely used mantra of the Jain faith honors the twenty-four Great Victors or Jinas, the saints (*siddhas*) who have attained perfect freedom, the living heads of religious orders (*ācāryas*), living teachers (*upādhyāyas*), and the active legions of monks and nuns (*sādhus* and *sādhvīs*).

15 Like Jinas, monks of the Digambara order traditionally take a vow of total nudity because they are aware that bugs can become trapped and suffocate in clothing.

16 Although similar to the haṭha yoga pose commonly called *tāḍāsana*, it carries some differences, especially in how the arms are held slightly distant from the body.

17 His white garments further indicate that he is a monastic in the Śvetāmbara order.

18 To ride a horse would hurt the horse; to drive an automobile or ride a scooter or bicycle would kill countless bugs and, in a big accident, result in harm to other humans.

19 Jain monks and nuns also often carry or wear a covering for the mouth so they will not inhale bugs or do damage to microscopic souls in the air as they speak or exhale; they may carry a broom to sweep insects from their path. In contrast, Śvetāmbara tīrthaṅkaras and living monks of the Digambara order are totally naked.

Metropolitan Museum of Art, 1985), p. 342; Deborah Swallow and John Guy, eds. *Arts of India: 1550–1900* (London: V&A Publications, 1990), p. 133, pl. 114; Andrew Topsfield, *The Indian Heritage: Court Life and Arts under Mughal Rule* (London: V&A Publications, 1982), p. 57, cat. 138.

3 Selected publications include Linda Leach, *Mughal and Other Indian Paintings from the Chester Beatty Library* (London: Scorpion Cavendish, 1995), p. 676, cat. 6.277.

4 Selected publications include Leach, *Mughal and Other Indian Paintings*, p. 677, cat. 6.284.

5 Selected publications include Leach, *Mughal and Other Indian Paintings*, p. 672, cat. 6.272.

6 For an exceptionally lucid, extended explanation of *rāgas* and *rāginis*, see Joep Bor, *The Raga Guide: A Survey of 74 Hindustani Ragas* (Rotterdam: Nimbus Communications, 1999). To date, the definitive text on illustrated *rāgamālās* remains Klaus Ebeling, *Ragamala Painting* (New Delhi: Ravi Kumar, 1973).

7 Ebeling, *Ragamala Painting*, p. 130.

8 Ebeling, *Ragamala Painting*, p. 142.

9 Ebeling, *Ragamala Painting*, p. 126.

10 Abu'l Fazl, *A'in-i Akbari* III, trans. Colonel H. S. Jarrett (New Delhi: Oriental Books Reprint, 1978), p. 263.

11 Bodleian Library, Oxford, MS. Laud Or. 149. Molly Emma Aitken, "The Laud Rāgamālā Album, Bikaner, and the Sociability of Subimperial Painting," *Archives of Asian Art* (forthcoming).

12 British Museum, 1973,0917,0. 1–56.

13 Francesca Orsini, "'Krishna is the Truth of Man': Mir 'Abdul WahidBilgrami's Haqā'iq-i Hindi (Indian Truths) and the circulation of dhrupad and bishnupad," *Culture and Circulation: Mobility and Diversity in Premodern Literature*, ed. Thomas de Bruijn and Allison Busch (forthcoming).

14 Carl W. Ernst, "Situating Sufism and Yoga," *Journal of the Royal Asiatic Society* 15, no. 1 (April 2005), pp. 15–43.

15 Katherine Schofield, "Hindustani Music in the Time of Aurangzeb," (PhD diss., School of Oriental and African Studies, University of London, 2003), p. 192.

Catalogue 19

1 Selected publications include Milo C. Beach, *Grand Mogul: Imperial Painting in India 1600–1660* (Williamstown, MA: Clark Art Institute, 1978), cat. no. 22.

2 Facing folios of calligraphy alternate with paired paintings throughout each Mughal albums.

3 The central paintings are strategically placed off center so that the borders appear of equal width when the album is opened and the viewed.

4 See "Yogis in Mughal India" by James Mallinson in this volume for a more detailed discussion of the sectarian orders depicted in this painting.

5 David J. Roxborough, *The Persian Album 1400–1600: From Dispersal to Collection* (New Haven: Yale University Press, 2005), *passim*.

6 Sunil Sharma, "Representation of Social Groups in Mughal Art and Literature: Ethnography or Trope?" in *Indo-Muslim Cultures in Transition*, ed. Alka Patel and Karen Leonard, Brill's Indological Library, vol. 38 (2011), pp. 17–36, *passim*.

7 *Jahangirnama*, p. 209, 285, 313–14. Chitrup/ Jadrup, who was visited by other Mughal courtiers and many Sufis, enters recorded history in several Persian language accounts that together provide a remarkably detailed biography. A jeweler's son from Gujarat on India's west coast, he lived from approximately 1559 to 1638. After marriage and children, at the age of twenty-two, he became a renunciant. As a yogi, he practiced austerities, and *prāṇāyāma* (breath control) at several sites in North India, mostly along the Ganges. Reputed to have magical powers, he died at about the age of eighty in Varanasi. The *Dabistān* is the only text that names his order, explaining that Dandaheri yogis follow the teachings of Shankaracharya, wear dreadlocks, and smear ash on their bodies. See Muhsin Fānī, *The Dabistān, or School of Manners*, vol. 2, ed. D. Shea and A. Troyer (Paris: Oriental Translation Fund of Great Britain and Ireland, 1843), pp. 142–48. Wheeler M. Thackston, *The Jahangirnama: Memoirs of Jahangir, Emperor of India* (New York: Oxford University Press, 1999), pp. 209, 285, 313–14. Shireen Moosvi, "The Mughal Encounter with Vedanta: Recovering the Biography of 'Jadrup,'" *Social Scientist* (2002), pp. 12–23.

8 The paintings are: *Portrait of Gosain Jadrup*, private collection, Ajmer; published in *Coomaraswamy*, Journal of the Royal Asiatic Society of Great Britain and Ireland, July 1919, pp. 389–91. See also M. Abdulla Chaghtai, "Emperor Jahangir's interviews with Gosain Jadrup and his portraits," *Islamic Culture*, vol. 36 (1962), pp. 119–30. *Jahangir Visiting the Ascetic Jadrup*, folio from *Jahangirnama*, Musée Guimet, no. 7171. Selected publications include Milo C. Beach, B. N. Goswamy, and Ellen Fischer, eds., *Masters of India Painting I* (Zurich: Artibus Asiae Publishers, 2011), pp. 326–28. *Akbar Visits the Hindu Saint Jadrup*, circa 1625–30, Arthur M. Sackler Museum, Harvard Art Museums, 1937.20.1. Selected publications include Rochelle Kessler, "In the Company of the Enlightened: Portraits of Mughal Rulers and Holy Men," *Studies in Islamic and Later Indian Art* (Cambridge, MA: Arthur M. Sackler Museum, Harvard University Art Museums, 2002), pp. 17–42. *Unknown*, ca. 1650. Victoria and Albert Museum, IS.94-1965. Selected publications include Elinor W. Gadon, "Dara Shikoh's mystical vision of Hindu-Muslim synthesis," in *Facets of Indian Art: A Symposium Held at the Victoria and Albert Museum*, ed. Robert Skelton, Andrew Topsfield, Susan Stronge, and Rosemary Crill (London: Victoria and Albert Museum, 1986, pp. 153–57.

Catalogue 20

1 Around 1600, European nations such as Great Britain and the Netherlands formed joint-stock "East India Companies," comprised of shareholders invested in trade abroad, including India. After the Battle of Plassey in 1757, however, the British East India Company became a governing body as well as a commercial enterprise. British East India Company rule was transferred to the British government, known as the Raj, after the Indian Rebellion of 1857.

2 The European desire to collect, catalogue, and study the peoples and objects of every known culture is a prime factor of the seventeenth- and eighteenth-century intellectual movement, the Enlightenment. For an overview see Kim Sloan, ed., *Enlightenment: Discovering the World in the Eighteenth Century* (Washington, DC: Smithsonian Books, 2003). See also cats. 22a–g regarding an example of the extensive European print tradition regarding ascetics.

3 Mildred Archer, *Company Paintings: Indian Paintings of the British Period* (London: Victoria and Albert Museum, 1992), pp. 11–19. Archer defines Company painting as painting by Indian artists who worked for European patrons or the tourist trade and adapted European visual techniques and genres into their works. I am using an expanded definition that includes British as well as Indian artists who similarly adapted their techniques and subject matter.

4 David Gordon White, *Sinister Yogis* (Chicago: University of Chicago Press, 2009), chap. 1 and pp. 236–40; and Francis Pritchett, *Marvelous Encounters: Folk Romance in Urdu and Hindi* (Riverdale, MD: Riverdale Company, 1985), p. 21.

5 See "Yogis in Mughal India" by James Mallinson in this volume. Mildred Archer and Toby Falk, *India Revealed: The Art and Adventures of James and William Fraser 1801–1835* (London: Cassell, 1989), p. 123; and *Princes and Painters in Mughal Delhi, 1707-1857*, ed. William Dalrymple and Yuthika Sharma (New York: Asia Society, 2012).

6 Archer and Falk, *India Revealed*, pp. 9 and 40.

7 Carl W. Ernst, "Muslim Studies of Hinduism? A Reconsideration of Arabic and Persian Translations from Indian Languages," *Iranian Studies* 36, no. 2 (June 2003), p. 189.

8 Ernst, "Muslim Studies," p. 189, and Norah M. Titley, *Miniatures from Persian Manuscripts: A Catalogue and Subject Index of Paintings from Persia, India and Turkey in the British Library and British Museum* (London: British Museum Publications, 1977), p. 156, no. 372.

9 See cat. 5.70 in Anna L. Dallapiccola, *South Indian Paintings: A Catalogue of the British Museum's Collections* (London: British Museum Press, 2010), p. 90. For an overview of Bhairava in South Asian literary history, see David Gordon White, "At the Mandala's Dark Fringe: Possession and Protection in Tantric Bhairava Cults" in *Notes from a Mandala: Essays in the History of Indian Religions in Honor of Wendy Doniger*, ed. Laurie L. Patton and David L. Haberman (Newark: University of Delaware Press, 2010).

10 T. Richard Blurton, *Hindu Art*, (London: British Museum Press, 1992), p. 89, fig.50.

11 White, *Sinister Yogis*, p. 197.

12 Carl W. Ernst, "Accounts of yogis in Arabic and Persian historical and travel texts," in *Jerusalem Studies in Arabic and Islam* 33 (2007), pp. 419–21; and White, *Sinister Yogis*, pp. 236–40. Further, the famous story of Ciruttontar, or the Little Devotee, in South India, where this painting was produced, stresses the malleability of the ascetic-god: the Little Devotee sacrifices his son at the request of a hungry ascetic who is actually the god Bhairava. See David Shulman, *The Hungry God: Hindu Tales of Filicide and Devotion* (Chicago: University of Chicago Press, 1993), chap. 1; and White, *Sinister Yogis*, pp. 33–37.

13 *Kala Bhairava* is one of ninety-one paintings of Indian deities identified by Telegu inscription, including visual maps of the principal pilgrimage sites of this period and the *murti*s (sculptures) housed within. See Dallapiccola, *South Indian Paintings*, p. 74.

14 An almost identical album is in the Victoria and Albert Museum (IM 355-1923 to 454-1923). For this information and a detailed provenance of the British Museum album, see Dallapiccola, *South Indian Paintings*, pp. 55–56 and 74.

15 For a discussion of *tapas*, see cats. 7a–c, Austerities.

16 See Dallapiccola, *South Indian Paintings*, p. 39, for a detailed explanation of the poses.

17 See Charles Gold, *Oriental Drawings* (London: Bunney and Co., 1806); *Asiatic Costumes Drawn by Captn. R. Smith 44th. Regt.* (1826), Yale Center for British Art, Paul Mellon Fund; and online collections at the Victoria and Albert Museum, British Museum, and British Library.

18 Dallapiccola, *South Indian Paintings*, p. 37.

19 Robert L. Hardgrave, Jr., *A Portrait of the Hindus: Balthazar Solvyns & the European Image of India 1760–1824* (Oxford: Oxford University Press, 2004), pp. 324–25; and James Mallinson, "Nāth Saṃpradāya" in *Encyclopedia of Religions*, volume 3 (Leiden: Brill, 2011).

20 Hardgrave, *A Portrait of the Hindus*, pp. 324–25. Solvyns first published this print in his *250 etchings* in Calcutta in 1799. Edward Orme pirated the book and published it as *Costume of Hindostan* in London in 1807. Solvyns then republished it again in Paris, as *Les Hindous*, from 1808 to 1812.

21 Hardgrave, *A Portrait of the Hindus*, pp. 324–25. The 1808 to 1812 *Les Hindous* text describes the women offering the *avadhuta* a linga kiss, which Solvyns described as "the manner in which this homage is paid is so disgusting and indecent, that delicacy forbids to describe it." The controversy over depicting this is seen in Picart and his engraving "Diverses Pagodes et Penitences des Faquirs." See cats. 22a–g and Robert J. Del Bontá, "From Herodotus Onwards: Descriptions of Unidentified Jainas" in *Jaina Law and Society*, ed. Peter Fluegel (Abingdon, UK: Routledge, 2013).

22 Balthazar Solvyns, "Proposals for Publishing," *Calcutta Gazette*, 1794. See Hardgrave, *A Portrait of the Hindus*, p. 37.

23 See Christopher Pinney, *Photography and Anthropology* (London: Reaktion, 2011). For example, in his copy of Solvyns (now in the Wellcome Collection, 49015), the nineteenth-century Calcutta merchant Gabriel Gillett noted how many of each type of servant he employed in his home.

Catalogue 21

1 *Madras Journal of Literature and Science* 7 (April–September 1858), p.173.

2 The final text is a composite of the writings of J. W. Kaye, John R. Melville, and Captain Meadows Taylor. As a result, it is not currently possible to attribute authors to individual entries. Though notes by photographic contributors accompanied many of the prints to London, it remains unknown as to what degree they were consulted during the drafting of the text.

3 Photographers whose work did not make it in time for the 1862 exhibition: Reverend E. Godfrey and James Waterhouse (Central India), Shepherd & Robertson (Bharatpur), Benjamin Simpson (Nagpur, Sikkim, and Bhutan), Dr. Tressider (Northwest provinces), Captain Fitzmaurice and Lieutenant R. H. De Montmorency (Oudh), T. T. Davies (Hazara), Captain Houghton and Lieutenant Tanner (Bombay and Sind) as well as anonymous material from various sources. Other credited photographers for the photographs are J. C. A. Dannenberg, W. W. Hooper, Captain H. C. McDonald, James Mulheran, Captain Oakes, Reverend G. Richter, Dr. B. W. Switzer, C. C Taylor, and Eugene Clutterbuck Impey.

4 The reason for the shift lay at least partly in a string of unfortunate events, including the bankruptcy of the publishing firm Day & Company and subsequent loss of most of the last two volumes in a fire. For an account on the publishing history of *The People of India*, see John Falconer, "A Pure Labor of Love: A Publishing History of The People of India," in *Colonialist Photography: Imagining Race and Place* (New York: Routledge, 2002).

5 For a discussion on the formation of photography and anthropology, see Elizabeth Edwards, *Anthropology and Photography: 1860–1920* (New Haven: Yale University Press, 1992).

6 The plates had to be sensitized, exposed, and developed on location before the collodion dried and became impermeable to the processing solution For a detailed account of photographic processes in the nineteenth and twentieth centuries, see Bertrand Lavédrine, *Photographs of the Past: Process and Preservation* (Los Angeles: Getty Conservation Institute, 2009).

7 Disderi's method could produce eight individually exposed images on a collodion wet-plate negative. After printing, each image is cut out and mounted to a card measuring roughly 2¹/₂ × 4 inches. The larger quarter-plate format known as the cabinet card was introduced circa 1863 and measures 4¹/₄ × 6¹/₂ inches.

8 William C. Darrah, *Cartes De Visite in Nineteenth Century Photography* (Gettysburg, PA: W. C. Darrah, 1981), p. 4.

9 Unlike most commercial studios of the period, Bourne & Shepherd did market their images as individually numbered negatives under the set title "Groups of Native Character."

Catalogue 22

1 See cats. 7a–c, Austerities.

2 During the colonial period, the definition of yogis (Hindu) and fakirs (Muslim) changed and often did not differentiate between sect and religion. See Mark Singleton, *Yoga Body: The Origins of Modern Posture Practice* (New York: Oxford University Press, 2010), p. 36.

3 Bernard Picart, *Cérémonies et coutumes religieuses de tous les peuples du monde …*, 7 vols. (Amsterdam: J. F. Bernard, 1723–37). In the French edition, volumes 3 (1723) and 4 (1728) relate to India. The India volumes are sometimes independently labeled volumes 1 and 2 with a separate title, *Cérémonies et coutumes*

religieuses des Peuples Idolatres, as is the case with the volume discussed here. The English translation was published a decade later as *The Ceremonies and Religious Customs of the Various Nations of the Known World …*, 7 vols. (London: William Jackson and Claude Dubosc, 1733–39). In the English edition, volumes 3 (1734) and 4 (1733) relate to India. In this essay, I will reference the English translation. Dutch and German editions were also published, among others.

4 Picart, vol. 4, (London, 1733), pp. 4–6.

5 Jean-Baptiste Tavernier, *Les six voyages de Jean-Baptiste Tavernier* (Paris, 1679), livre troisieme, chapitre VI, pp. 419–23. Though Picart's engraving is primarily based on Tavernier's, he added figures possibly copied from Indian paintings in the collection of the Italian Conte Abate Giovanni Antonio Baldini (1654–1725), notably the central Jain figure with a cloth over his mouth and a broom and the sadhus feeding birds. Other figures, such as the kneeling woman giving an ascetic a "liṅga kiss," were removed from the English and French Catholic editions of Picart's print. See Robert J. Del Bontá, "From Herodotus Onwards: Descriptions of Unidentified Jainas" in *Jaina Law and Society*, ed. Peter Fluegel (Abingdon, UK: Routledge, 2013). See also Lynn Hunt, Margaret C. Jacob, and Wijnand Mijnhardt, *The Book That Changed Europe: Picart and Bernard's "Religious Ceremonies of the World"* (Cambridge, MA: Harvard University Press, 2010), pp. 228–31; Paola von Wyss-Giacosa, *Religionsbilder der frühen Aufklärung* (Wabern: Benteli, 2006), p. 189; and R. W. Lightbown, "Oriental Art and the Orient in Late Renaissance and Baroque Italy," *Journal of the Warburg and Courtauld Institutes*, vol. 32 (1969), pp. 265–79.

6 Picart, vol. 4, pp. 7–8, the print's key, and Tavernier (1679), pp. 419–23.

7 Picart, vol. 4, p. 6, and vol. 3, p. 397. For an example of "shoes full of nails," see the pair of fakir's sandals in the Wellcome Library collection (Science Museum A23375).

8 Picart, vol. 3, pp. 396–98 and vol. 4, pp. 4–6; Hunt, pp. 226–34; and David Gordon White, *Sinister Yogis* (Chicago: University of Chicago Press, 2009), pp. 211–12.

9 Jonathan Duncan, "An Account of Two Fakeers, With their Portraits" in *Asiatic Researches* 5 (London: J. Sewell, 1799), pp. 37–52. For a reproduction of the original watercolor see Stuart Cary Welch, *Room for Wonder: Indian Painting During the British Period* (New York: American Federation of Arts, 1978), pp. 80–81.

10 Similar to the colonial trope of the "bed of nails," the image and description of the ascetic with raised arms (*ūrdhvabāhu*) was repeated in colonial publications from the seventeenth century onward, such as in Tavernier (1679, p. 423) and in another engraving by Picart after Tavernier. See also Balthazar Solvyns, *A Collection … descriptive of the manners, customs and dresses of the Hindoos* (Calcutta, 1799).

11 Duncan, "An Account of Two Fakeers," pp. 37–52.

12 In early Indian literature, the "bed of thorns" (*kaṇṭaka-śaya*) is included in a list of austerities that a group of Ājīvikas practiced as told in the circa first-century BC *Naṅguṭṭhajātaka* (Jātaka,

4 vols., ed. V. Faussell [London: Trübner & Co., 1877–87], vol. 1, p. 493), and as an austerity practiced by hermits in the *Vaikhānasasmārtasūtra*, circa fourth–eighth century CE (W. Caland, *Vaikhānasasmārtasūtram* [Calcutta: Asiatic Society, 1929]). I thank James Mallinson for these references.

13 For the relationship between Bhiṣma and the bed of arrows, see Francesco Brighenti, "Hindu Devotional Ordeals and their Shamanic Parallels," *Electronic Journal of Vedic Studies* 19, no. 4 (2012), pp. 67–69.

14 See Solvyns, *A Collection...*; Charles Gold, *Oriental Drawings* (London: Bunney and Co., 1806); *Missionary Register for 1819* (London: L. B. Seeley, 1819), pp. 277–82; and *The World in Miniature: Hindoostan*, vol. 2, ed. Frederic Schoberl (London: R. Ackermann, 1822), pp. 207–12.

15 *Encyclopaedia Londinensis*, vol. 10 (London: J. Adlard, 1811), pp. 147–48.

16 *Encyclopaedia Londinensis*, p. 151.

17 See also White, *Sinister Yogis*, p. 201.

18 White, *Sinister Yogis*, p. 223. White also postulates that Europeans interacted with itinerant ascetics in public places that drew beggars, which differed from the Mughal experience. For example, Sufis would have interacted with religious orders such as the Nāth Yogis, and Mughal bureaucrats would have brokered with militant yogis in monasteries or troops (pp. 200–201).

19 William R. Pinch, *Warrior Ascetics and Indian Empires* (Cambridge: Cambridge University Press, 2006), pp. 82–103, 211.

20 Christopher J. Lucas, ed., *James Ricalton's Photographic Travelogue of Imperial India* (New York: Edwin Mellen Press, 1990), preface. A stereograph consists of two slightly dissimilar images that merge into 3D when viewed through a stereoscope.

21 James Ricalton, *India through the Stereoscope* (New York: Underwood & Underwood, 1907), p. 164.

22 For another example of photography and ascetics, including a bed of nails, see John Campbell Oman's *The Mystics, Ascetics and Saints of India* (1903), pp. 45–46. Oman similarly wavered in his judgment of ascetics as devout or deceitful, and placed the ascetic on a bed of nails in the latter category of the showman at a fair. For a later iteration of such trickery in song, see the discussion on Johnny Mercer's *The Yogi Who Lost His Willpower* (cat. 23e).

23 Bishop J. M. Thoburn, *The Christian Conquest of India*, edited under the auspices of the Young People's Missionary Movement (New York: Eaton and Mains, 1906), pp. 121–22. See also C. V. Vickrey, *The Young People's Missionary Movement* (New York, 1906).

24 See A. J. D. Campbell's report in the curatorial files for IS.196-1949, Victoria and Albert Museum. I thank Rosemary Crill for this information.

25 See Susan S. Bean, "The Unfired Clay Sculpture of Bengal in the Artscape of Modern South Asia" in *A Companion to Asian Art and Architecture*, ed. Rebecca M. Brown and Deborah S. Hutton (Wiley-Blackwell, 2011), pp. 604–28; Charlotte H. F. Smith and Michelle Stevenson, "Modeling Cultures: 19th Century Indian Clay Figures" in *Museum Anthropology* 33, no. 1 (2010), pp. 37–48; Carol A. Breckenridge, "Aesthetics and Politics of Colonial Collecting: India at World Fairs" in *Society for Comparative Study of Society and History* 31, no. 2 (1989), pp. 195–216. Earlier European publications also sought to catalogue Indian people, specifically Hindus; see for example Solvyns, *A Collection...* and Robert L. Hardgrave, *Portrait of the Hindus: Balthazar Solvyns & the European Image of India* (New York: Oxford University Press, 2004).

26 See "Yoga, Bodybuilding, and Wrestling: Metaphysical Fitness" by Joseph Alter in this volume.

Catalogue 23

1 Neither Gandhi nor the Kumbh Mela will be discussed here in any detail, given the selective focus of this catalogue on yoga as the art of transformation. But for more on Gandhi's cultural resonance with yoga and fakirs, including Winston Churchill's disparaging comment "half-naked fakir," see Joseph Alter, *Gandhi's Body: Sex, Diet and the Politics of Nationalism* (Philadelphia: University of Pennsylvania Press, 2000). Similarly, the Kumbh Mela is perhaps the geographical referent par excellence as the most recognizable *social* space occupied by fakirs and yogis, both historically and in contemporary life. No reference to fakirs would be complete without mentioning it as a powerful and recurrent visual symbol of yogis gathering in one place, given the longer history of fakirs in meeting grounds, collective movements, and armed rebellions. See William Pinch, *Warrior Ascetics and Indian Empires* (Cambridge, UK: Cambridge University Press, 2006).

2 Since the seventeenth century, a string of travelers, sojourners, and colonial traders and administrators have depicted these fakirs visually, individually and in groups, in various journals, travelogues, ethnographic accounts, and colonial compendia of "native subjects." Some early examples include works by Balthazar Solvyns, Emily Eden, Edward Eastwick, Reverend Tennant, and Charles D'Oyly. See cat. 20d in this volume and Michael Sappol, ed. *Hidden Treasure* (New York: Blast Books, 2012), p. 72. For a fuller, scholarly account, see Robert L. Hardgrave, Jr. *A Portrait of the Hindus: Balthazar Solvyns & the European Image of India 1760–1820* (New York: Oxford University Press, 2004).

3 See cats. 22a–g, Bed of Nails.

4 The roots of this revisionism may lie in the early modern period. Patton E. Burchett has demonstrated how the new *bhakti* attitudes that emerged in north India after 1600 "depended on the successful stigmatization and subordination of key aspects of tantric religiosity" as magic. Patton E. Burchett, "Bhakti Religion and Tantric Magic in Mughal India: Kacchvahas, Ramanandis, and Naths, circa 1500–1750" (Diss., Columbia University, 2012), p. 4 and *passim*.

5 One reason for the increasing numbers of fakirs in public places in the late nineteenth century was the criminalization of militant yogis and fakirs and warrior ascetics, especially in northwestern India, by colonial administrators who saw armed yogi orders as disruptive, rebellious elements in trade routes and revenue gathering. David Gordon White, *Sinister Yogis* (Chicago: University of Chicago Press, 2011). See also Pinch, *Warrior Ascetics*, for the rise and demise of warrior asceticism in North India.

6 See Peter Lamont, *The Rise of the Indian Rope Trick* (New York: Thunder's Mouth Press, 2008) for more on the rise and fall of the Indian rope trick as reflected through the prism of the news media—the rise as it was reported in the general media, the fall as the illusory trick was first perpetrated and then denounced in the pages of the *Chicago Tribune*.

7 See "Yoga: The Art of Transformation" by Debra Diamond in this catalogue.

8 The yogic equivalents of these acts would be the abilities to enter into and control other bodies which David Gordon White writes about in *Sinister Yogis*, and the "miraculous" yogic ability to suspend breathing for long periods, which has in the twentieth century even been subjected to scientific scrutiny and measurement. See Joseph Alter, *Yoga in Modern India: The Body Between Science and Philosophy* (Princeton, NJ: Princeton University Press, 2004) on scientific experiments conducted at the Kaivalyadhama ashram).

9 A variant on this story, in which she is the child of a French woman and an Indian fakir, appears in the 1937 issue of *Look*, p. 35.

10 For more information, see Vanessa Toulmin, "Koringa: From Biknar [sic] to Blackpool", *Cabinet*, no. 26 (summer 2007); http://cabinetmagazine.org/issues/26/toulmin.php.

11 Magician George Méliès, who became the most famous of the trick film specialists, was present in the audience when the Lumière brothers first presented their motion pictures in Paris in 1895, and tried to buy a camera from them on the spot.

12 *Raja Harischandra* is particularly interesting for the visual history of yoga because it features the sage Vishvamitra (see cat. 7a), the militant yogi par excellence, who is part of the long image history linking warrior ascetics to Hindu nationalists.

13 The aim of this "cinema of attractions," as Tom Gunning has dubbed it, was to dazzle audiences with showmanship, exotic images, and the wonders of the new technology of cinema. Gunning uses "attractions" in the sense of carnival attractions, in contrast to the classical narrative cinema, which tries to create the illusion of a fictional world. For more information, see Tom Gunning, "The Cinema of Attractions: Early Film, Its Spectator and the Avant-Garde," in *Early Cinema: Space, Frame, Narrative*, ed. Thomas Elsaesser (London: BFI Publishing, 1990).

14 For more on early ethnographic film, see Alison Griffiths, *Wondrous Difference: Cinema, Anthropology, and Turn-of-the-Century Visual Culture* (New York: Columbia University Press, 2002).

15 We are grateful to curatorial assistant Mekala Krishnan for identifying within the film Dutt's "signatures"—an exotic temple setting, a distinctive turban, and transforming of his assistant into a moth or levitating her on swords—as outlined in Sarah Dadswell, "Jugglers, Fakirs, and *Jaduwallahs*: Indian Magicians and the

British Stage," *New Theatre Quarterly* 23, no. 1 (February 2007).

16 See Dadswell, "Jugglers, Fakirs, and *Jaduwallahs*," p. 4. The "double o" spelling of Hindu is a colonial variant that is now considered insulting.

17 See Rob Linrothe, *Holy Madness: Portraits of Tantric Siddhas* (New York: Serindia Publications and Rubin Museum of Art, 2006). The yogi on sword points recalls both the "bed of nails" motif common among late nineteenth-century ascetics and fakirs (see cats. 22a–g) as well as Bhishma lying on a bed of swords in the middle of the Battle of Kurukshetra, another classic trope in Indian cinema.

18 Non-Indian magicians also falsely claimed Indian heritage to give their acts the *frisson* of authentic mysticism.

19 The music for the 1941 Paramount film *You're The One* was composed by Jimmy Hugh.

Catalogue 24

1 Elizabeth DeMichelis, *A History of Modern Yoga: Patanjali and Western Esotericism* (London: Continuum, 2004), p. 4, dates her definition of "Modern Yoga" (in her usage) from this moment. Mark Singleton, *Yoga Body: The Origins of Modern Posture Practice* (New York: Oxford University Press, 2010), p. 4, suggests that Vivekananda's synthesis was quite possibly the first expression of "transnational Anglophone yoga." Joseph Alter in *Yoga in Modern India: The Body between Science and Philosophy* (Princeton, NJ: Princeton University Press, 2004) traces scientific yoga's lineage to Vivekananda's antimysticism, among others. See also "Globalized Modern Yoga" by Mark Singleton in this volume as well as Stefanie Syman, *The Subtle Body: The Story of Yoga in America* (New York: Farrar Strauss and Giroux, 2011) for this general argument.

2 See Singleton, "Globalized Modern Yoga," for more on transnational Anglophone yoga. The phrase indicates that the works were published in English and had transnational reach beyond Indian shores.

3 David Gordon White, *Sinister Yogis* (Chicago: University of Chicago Press, 2011), p. 369.

4 Alter has an excellent discussion on this point; *Yoga in Modern India*, p. 7.

5 As Syman notes in *The Subtle Body*, p. 24, despite these theological differences, Vedantists and other schools have long exploited the *Yoga Sutra* for centuries for its practical instruction, the techniques providing the main avenues for perceiving spiritual truths.

6 *Raja Yoga* (1896), p. 18. *Raja Yoga* is the culminating text through which this message of yoga synthesis was first laid out in detail, although it was anticipated by similar ideas in his teachings and talks.

7 Peter van der Veer, *Imperial Encounters* (Princeton, NJ: Princeton University Press, 2001), pp. 73–74.

8 See Syman, *The Subtle Body*, chap. 4, "Swami Vivekananda's Legacy," pp. 62–79.

9 The Theosophical Society's work in India was closely tied to the revival of interest in Vedantic philosophy and thought in the pre-independence era. On the Theosophical Society's role in the spread of yoga, see Singleton, "Globalized Modern Yoga."

10 The World's Parliament of Religions was convened as part of the World's Columbian Exposition in 1893 in Chicago. As Syman notes in *The Subtle Body*, p. 41, the stated purpose of the exposition was to celebrate the quadricentennial of Columbus's discovery; its tacit one was to outdo the French, whose extravagant Exposition Universelle four years prior had astonished the world. While the exposition was thus an affirmation of American science and industry—an index of technical and material progress remarked upon by Vivekananda—the Parliament of Religions set out to find common ground among the various faiths and to discover what religion could offer for pressing social problems of the day (some caused by the exposition's very materialism).

11 Stefanie Syman suggests that this was the real secret of Vivekananda's fame: that "he simultaneously fulfilled and debunked Orientalist stereotypes, allowing his audiences to romanticize him and India without abandoning too many of their cherished ideals"; *The Subtle Body*, p. 44. In contrast, as suggested by Marie Louise Burke in *Swami Vivekananda in the West: New Discoveries*, 2 vols. (Calcutta: Advaita Ashram, 1958), news reports did not fail to mention that the other Indian delegates to the Parliament—Pratap Chandra Mazoomdar, B. B. Nagarkar, and Narasimha Acharya—wore what were described as "black clothes hardly to be distinguished from European dress" (Burke, *Swami Vivekananda in the West*, vol. 1, p. 78).

12 Thomas Harrison was based in Chicago at that time at "Central Music Hall, Cor. State & Randolph Sts," the identification stamped at the bottom of all his pictures. From listings in Chicago city directories, Harrison seems to have been in business from about 1873 through 1900, and his studio specialized in cabinet-card photography, the style of portrait photography that came into vogue around 1867. All the original photographs taken of Swami Vivekananda at Harrison's studio were cabinet-card portraits.

Catalogue 25

1 This followed the first ever anatomical dissection by a native doctor in 1836, as widely written about by medical historians. See David Arnold, *Colonizing The Body* (Berkeley: University of California Press, 1993).

2 As Dominik Wujastyk has described, this extraordinary painting has recently come into the collection of the Wellcome Library from the Hamburg collection of Jan Wichers. D. Wujastyk, "Interpreting the Image of the Human Body," *International Journal of Hindu Studies* 13, no. 2 (2001), p. 210.

3 Wujastyk, "Interpreting the Image," p. 210.

4 Wujastyk, "Interpreting the Image," p. 211.

5 *Ṣaṭcakranirūpaṇacitram* translates from the Sanskrit to mean "picture or illustration of six chakras body form," which is particularly interesting for two reasons. One, the word *citra* (picture) in the title signifies that it is a pictorial or illustrated treatise on chakras. And two, the number of chakras depicted both in the illustrations and in the title itself. The six chakra figures shown here and in the book title may be particularly interesting in this context since the number seems to have become standardized in this period as seven. See cats. 11a–c, Subtle Body.

6 Mircea Eliade, *Yoga, Immortality and Freedom* (London: Routledge and Kegan Paul, 1969), p. 241.

7 Other plates in the book, for example, plate 4 (not shown here), make a similar visual statement by juxtaposing an anatomical cross-section of the brain with a schematic depiction of the thousand-petaled lotus chakra (*sahasradala padma*) as it opens in the head, its vertical stem, the *brahmanāḍi*, presumably linking it to the network of *nāḍi*s (subtle channels) along the lower body.

8 Comparable books and volumes with chakra body images from the same period include Sir J. Woodroffe, *The Serpent Power* (Madras, 1924), which shows the classic seated position.

9 The English translation of the title *L'Homme Terrestre Natural Ténébreux*—The Earthly Man with Natural Shadows—is less poetic but points nonetheless to Leadbeater's fascination with shadows, auras, energy vortexes, and cosmic consciousness. Indeed, many of the other images in *The Chakras* are not anatomical like this one, but abstract, numinous, color-saturated depictions of the vortexes, umbras, and auras of higher states of consciousness.

10 See cats. 11a–c, Subtle Body.

11 This point is made by Stefanie Syman in *The Subtle Body: The Story of Yoga in America* (New York: Farrar, Strauss and Giroux, 2010), p. 56.

12 The Sanskrit term *Kanda* derives from bulb or knot; in Kuṇḍalinī yoga it refers to a center of the astral body from where the yoga *nāḍi*s spring and carry the *sūkṣma prāṇa* (vital energy) to the different parts of the body.

13 Some scholars trace it back to pioneering work by Major Basu, *Anatomy of the Tantras* (1888), and Dr. N. C. Paul, *A Treatise on the Yoga Philosophy* (1850). See for instance Mark Singleton, *Yoga Body: The Origins of Modern Posture Practice* (New York: Oxford University Press, 2010) on the history of medical or health views of the yogic body in India even prior to the early twentieth century.

14 On this point, see "Yoga, Bodybuilding, and Wrestling: Metaphysical Fitness" by Joseph Alter in this volume.

15 These included natural healthcare luminaries Harvey Kellogg and Benedict Lust.

16 Mark Singleton first suggests this in *Yoga Body*, p. 116. But based on subsequent publications on yoga performances and presentations in America—such as those by the Great Oom; see Robert Love, *The Great Oom* (New York: Viking, 2010)—and Singleton's own revised views on this matter, there may be sufficient evidence to push this date back by at least a decade, if not more.

Catalogue 26

1 Christopher Pinney, "The nation unpictured: Chromolithography and popular politics in India," *Critical Inquiry* 23, no. 3, p. 867.

2 First coined by Elizabeth deMichelis in 2004 in *A History of Modern Yoga: Patañjali and Western Esotericism* (London: Continuum, 2004) as

an extremely useful but provisional, heuristic typology, the term "modern postural yoga" may have outlived its use as a working construct. This author follows Mark Singleton in preferring the term "postural yoga" or "yoga in the modern age" to avoid overly dichotomizing modern and traditional and to avoid subsuming historical detail, variation, and exception; Mark Singleton, *Yoga Body: The Origins of Modern Posture Practice* (New York: Oxford University Press, 2010), p.19.

3 This is a point first made powerfully by Singleton in chap. 8 of his *Yoga Body*. See also his essay, "Globalized Modern Yoga," in this volume.

4 Two of the better known among these travelogues and popular accounts of yogis are J. C. Oman's *Mystics, Ascetics and Saints of India* (1905) and Reverend W. M. Zumbro's 1913 article about yogis in *National Geographic*. Zumbro is a particularly interesting example for visual genealogy, given that the article reproduces with contemporary photographs many of the earlier images of yogis from seventeenth- and eighteenth-century European travelogues. For more on this point, see David Gordon White, *Sinister Yogis* (Chicago: University of Chicago Press, 2010), and also cats. 22a–g, Bed of Nails, and 23a–e, Fakirs, Fakers, and Magic.

5 Accounts of *Jogapradīpikā* are described in Gudrun Buhnemann, *Eighty-Four Āsanas in Yoga: A Survey of Traditions* (New Delhi: D. K. Printworld, 2007), while the *Śritattvanidhi* is described by Norman Sjoman, *The Yoga Tradition of the Mysore Palace* (New Delhi: Abhinav, 1996). For an even earlier historical example of a medieval illustrated *āsana* manuscript, see cat. 9a–j on the *Bahr-al-ḥayāt*.

6 Partha Mitter, *Art and Nationalism in Colonial India* (Cambridge: Cambridge University Press, 1994), p. 30.

7 This point has been made variously by White, *Sinister Yogis*; Sjoman, *Yoga Tradition*.

8 Singleton, *Yoga Body*, p. 170.

9 The book includes illustrations of six *mudrās* (gestures) and five *bandhas* (locks), also modeled by Ghamande.

10 *Yogasopāna*'s potential to reach mass audiences also allowed Ghamande to pioneer new pedagogical models of public dissemination, such as a proto-correspondence course of haṭha yoga (Singleton, *Yoga Body*, p. 173). In sharp contrast to the secret transmission of knowledge between guru and disciples, *Yogasopāna* threw open haṭha yoga to the public and invited readers into a dialogue.

11 A more detailed account of how *Yogasopāna* serves as a work of art can be found in Singleton's *Yoga Body*, chap. 8, "The Medium and the Message."

12 Raja Ravi Varma was an Indian modernist artist who pioneered the use of newly available chromolithography techniques to make cheap naturalistic reproductions of scenes from Hindu epics.

13 For more on the Mysore Palace's influence on yoga, see the discussion about cat. 26i.

14 Subsequent editions were revised by Raja Pratinidhi Pant's son, Apa Pant.

15 See Joseph Alter, *Yoga in Modern India* (Princeton, NJ: Princeton University Press, 2004); Singleton, *Yoga Body*; Suzanne Newcombe, "The Development of Modern Yoga: A Survey of the Field," *Religion Compass* 3, no. 6 (2009), pp. 986–1002, for more on *sūryanāmaskār*. It is important to point out that Pant did not claim to have invented the sequence; see Alter, *Yoga in Modern India*, p. 163.

16 See Joseph Alter, "Yoga at the Fin de Siècle: Muscular Christianity with a Hindu Twist," *International Journal of the History of Sport* 23, no. 5 (2006), pp. 759–76. Pant also introduced *sūryanāmaskār* into schools as a form of native education. For more on Sandow, see also "Yoga, Bodybuilding, and Wrestling: Metaphysical Fitness" by Joseph Alter in this volume.

17 In the early twentieth century, pioneers like K. V. Iyer, Yogacharya Sundaram, and Ramesh Balsekar provided examples of syncretic experiments with the "yogic body beautiful" and the perfect yogic physique, embodying a general preoccupation with the fit body in *āsana* manuals.

18 See Sjoman, *Yoga Tradition in a Mysore Palace*. For more on this general shift in yogic practice, see the essays by Singleton and Alter in this catalogue.

19 I refer to Benedict Anderson's "imagined communities" (1983) drawn together through print nationalism. See Benedict Anderson, *Imagined Communities: Reflections on the Origin and Spread of Nationalism* (London: Verso, 1983).

20 For more on this point, see Singleton, *Yoga Body*, chap. 9.

21 Sjoman, *Yoga Tradition*, p. 50.

22 Note that 1938 is also the year that Leni Riefenstahl made *Olympia*, which in some ways is perhaps the archetypical film about nationalist physical cultures and the staged presentation of bodies in public space.

Selected Bibliography

Alter, Joseph. *Yoga in Modern India: The Body between Science and Philosophy*. Princeton: Princeton University Press, 2004.

Behl, Aditya. *Qutban Suhravardī's Mirigāvatī: The Magic Doe*, edited by Wendy Doniger. Oxford: Oxford University Press, 2012.

Buhnemann, Gudrun. *Eighty-four Asanas in Yoga: A Survey of Traditions with Illustrations*. New Delhi: D. K. Printworld, 2007.

Chapple, Christopher Key. *Reconciling Yogas: Haribhadra's Collection of Views on Yoga*. Albany: State University of New York Press, 2003.

——. "The Sevenfold Yoga of the Yogavasishta." In *Yoga in Practice*, edited by David Gordon White, pp. 117–33. Princeton: Princeton University Press, 2011.

Childers, Hope. "The Visual Culture of Opium in British India." PhD diss., University of California, Los Angeles, 2011.

Davidson, Ron. *Indian Esoteric Buddhism: A Social History of the Tantric Movement*. New York: Columbia University Press, 2003.

De Michelis, Elizabeth. "A Preliminary Survey of Modern Yoga Studies." *Asian Medicine* 3, no. 1 (2007): pp. 1–19.

——. *History of Modern Yoga: Patanjali and Western Esotericism*. London: Continuum, 2005.

Dehejia, Vidya. *The Sensuous and the Sacred: Chola Bronzes from South India*. New York: American Federation of Arts, 2002.

——. *Yoginī, Cult and Temples: A Tantric Tradition*. New Delhi: National Museum, 1986.

Diamond, Debra. *Garden and Cosmos: The Royal Paintings of Jodhpur*. Washington, DC: Arthur M. Sackler Gallery, 2008.

——. "Occult Science and Bijapur's Yoginis." In *Indian Painting: Themes, History and Interpretations (Essays in Honour of B. N. Goswamy)*, edited by Mahesh Sharma. Ahmedabad: Mapin Publishing, forthcoming.

Ernst, Carl W. "Accounts of Yogis in Arabic and Persian Historical and Travel Texts." *Jerusalem Studies in Arabic and Islam* 33 (2008), pp. 409–26.

——. "Being Careful with the Goddess: Yoginis in Persian and Arabic Texts." In *Performing Ecstasy: The Poetics and Politics of Religion in India*, edited by Pallabi Chakrabarty and Scott Kugle, pp. 189–203. Delhi: Manohar, 2009.

——. "Situating Sufism and Yoga." *Journal of the Royal Asiatic Society* 15, no. 1 (2005), pp. 15–43.

——. "The Islamization of Yoga in the Amrtakunda Translations." *Journal of the Royal Asiatic Society*, ser. 3, vol. 13, no. 2 (2003), pp. 199–226.

Feuerstein, Georg. *The Yoga Tradition: Its History, Literature, Philosophy and Practice*. Prescott, AZ: Hohm, 2001.

Flood, Gavin. *Body and Cosmology in Kashmir Saivism*. San Francisco: Mellen Research University Press, 1993.

Hatley, Shaman. "Goddesses in Text and Stone: Temples of the Yoginis in Light of Tantric and Purānic Literature." In *History and Material Culture in Asian Religions*, edited by Benjamin Fleming and Richard Mann. London: Routledge, 2013.

Kaimal, Padma. *Scattered Goddesses: Travels with the Yoginis*. Ann Arbor, MI: Association of Asian Studies, 2011.

King, Richard. *Orientalism and Religion: Postcolonial Theory, India and the "Mystic East."* London: Routledge, 1999.

Kramrisch, Stella. *Manifestations of Shiva*. Philadelphia: Philadelphia Museum of Art, 1981.

Linrothe, Rob. "Siddhas and Srīśailam, 'Where All Wise People Go.'" In *Holy Madness: Portraits of Tantric Siddhas*, edited by Rob Linrothe, pp. 125–43. New York and Chicago: Rubin Museum of Art and Serindia Publications, 2006.

Mallinson, James. "Haṭha Yoga." In *Brill's Encyclopedia of Hinduism*, vol. 3, edited by Knut A. Jacobsen, pp. 770–81. Leiden: Brill, 2011.

——. "Nāth Sampradāya." In *Brill's Encyclopedia of Hinduism*, vol. 3, edited by Knut A. Jacobsen, pp. 407–28. Leiden: Brill, 2011.

——. "Śāktism and *Haṭhayoga*." In *The Śākta Traditions*. Oxford: Oxford University Press, 2013.

——. *The Gheranda Samhita: The Original Sanskrit and an English Translation*. Woodstock, NY: YogaVidya.com, 2004.

——. *The Khecarīvidyā of Ādhinātha: A Critical Edition and Annotated Translation of an Early Text of Haṭhayoga*. London: Routledge, 2007.

Meister, Michael. "Art and Hindu Asceticism: Śiva and Vishnu as Masters of Yoga." In *Explorations in Art and Archaeology of South Asia: Essays Dedicated to N. G. Majumdar*, edited by Debala Mitra, pp. 315–21. Calcutta: Directorate of Archaeology and Museums, Government of West Bengal, 1996.

——. "Image Iconopraxis and Iconoplasty in South Asia." *Anthropology and Aesthetics* 51 (2007), pp. 13–32.

O'Flaherty, Wendy Doniger. *Dreams, Illusion, and Other Realities*. Chicago: University of Chicago Press, 1984.

Pinch, William. *Warrior Ascetics and Indian Empires*. Cambridge: Cambridge University Press, 2006.

Ranjan, Neena. *Vishvarupa: Paintings on the Cosmic Form of Krishna-Vasudeva*. New Delhi: Aryan Books International, 2008.

Samuel, Geoffrey. *The Origins of Yoga and Tantra: Indic Religions to the Thirteenth Century*. Cambridge: Cambridge University Press, 2008.

Sanderson, Alexis. "Saivism and the Tantric Traditions." In *The World's Religions*, edited by S. Sutherland, et al. London: Routledge, 1988.

Sears, Tamara I. "Constructing the Guru: Ritual Authority and Architectural Space in Medieval India." *The Art Bulletin* 90, no. 1 (2008), pp. 7–29.

——. "Encountering Ascetics On and Beyond the Indian Temple Wall." In *History and Material Culture in Asian Religions*, edited by Benjamin Fleming and Richard Mann. London: Routledge, 2013.

Singleton, Mark. *Yoga Body: The Origins of Modern Posture Practice*. Oxford: Oxford University Press, 2010.

Urban, Hugh. *Tantra: Sex, Secrecy, Politics, and Power in the Study of Religion*. Berkeley: University of California Press, 2003.

Vivekananda, Swami. *Rāja Yoga, or conquering the internal nature: Lectures delivered in New York, winter of 1895–6*. New York: Longmans, Green, 1896.

White, David Gordon. *The Alchemical Body: Siddha Traditions in Medieval India*. Chicago: University of Chicago Press, 2007.

——. *Kiss of the Yogini: "Tantric Sex" in Its South Asian Contexts*. Chicago: University of Chicago Press, 2006.

——. *Sinister Yogis*. Chicago: University of Chicago Press, 2009.

——. *Tantra in Practice*. Princeton: Princeton University Press, 2000.

——. *Yoga in Practice*. Princeton: Princeton University Press, 2012.

Contributors

Molly Emma Aitken (MEA) is associate professor of art history at the City College of New York. She has written and curated on South Asian court paintings, folk art, and jewelry. In her award-winning *The Intelligence of Tradition in Rajput Court Painting*, she takes a wide range of interpretive approaches to seventeenth- to nineteenth-century paintings from India's Rajput courts.

Joseph S. Alter, PhD, is professor of anthropology at the University of Pittsburgh and a sociocultural anthropologist in the area of South Asia. His book, the award-winning *Yoga in Modern India: The Body Between Science and Philosophy* (2004), explores the historical development of yoga as a modern, middle-class form of public health in twentieth-century urban India.

Christopher Key Chapple (CKC), PhD, is Doshi Professor of Indic and Comparative Theology at Loyola Marymount University, where he directs the Master of Arts in Yoga Studies program. He is the author of several books, including *Reconciling Yogas* (with a translation of Haribhadra's *Yogadrstisamuccaya*, 2003) and *Yoga and the Luminous* (with a translation of the Patanjali's *Yoga Sutras*, 2008).

Robert DeCaroli (RDC), PhD, is associate professor of South and Southeast Asian art history at George Mason University and a specialist in the art of early Buddhism. He is the author of *Haunting the Buddha: Indian Popular Religions and the Formation of Buddhism* (2004).

Debra Diamond (DD), PhD, is associate curator of South and Southeast Asian art at the Freer|Sackler and the curator of *Yoga: The Art of Transformation*. Her exhibition catalogue for *Garden and Cosmos* (2008) received two major awards for scholarship: the College Art Association's Alfred H. Barr award and the Smithsonian Secretary's Award for Research. She has published on yoga imagery, new methods in Indian art history, contemporary Asian art, and various aspects of the Freer|Sackler collections.

Carl W. Ernst, PhD, is the William R. Kenan, Jr., Distinguished Professor of Religious Studies at the University of North Carolina at Chapel Hill and the codirector of the Carolina Center for the Study of the Middle East and Muslim Civilizations. His publications include *Sufi Martyrs of Love: Chishti Sufism in South Asia and Beyond* (with Bruce B. Lawrence, 2002) and *Following Muhammad: Rethinking Islam in the Contemporary World* (2003), which has received several international awards.

Jessica J. Farquhar (JF) is a PhD candidate in art history at the University of California, Los Angeles. Her research interests include nineteenth-century photography, early Buddhist art, and the historiography of South Asian studies in the Western academic tradition. She is currently writing her dissertation, "Beyond Binding: 19th-century photographic technology in the many afterlives of 'The People of India' (1861–1900)."

B. N. Goswamy (BNG) is professor emeritus of art history at Panjab University, Chandigarh, India, and is currently Rabindranath Tagore Fellow for Cultural Research. He has published extensively; his many works include the groundbreaking *Pahari Masters: Court Painters of Northern India* and *Nainsukh of Guler: A Great Indian Painter from a Small Hill State*. Most recently, with Milo C. Beach and Eberhard Fischer, he put together the two-volume *Masters of Indian Painting, 1100–1900* that accompanied the exhibition *Wonder of the Age* at the Metropolitan Museum of Art, New York.

Navina Haidar (NH) is curator in the Department of Islamic Art, Metropolitan Museum of Art, New York. She is the coauthor of *Masterpieces from the Department of Islamic Art in The Metropolitan Museum of Art* and *Sultans of the South: Arts of India's Deccan Courts, 1323–1687* (both 2011).

Amy S. Landau (AL), PhD, is associate curator of Islamic art and manuscripts at the Walters Art Museum, Baltimore. Her work explores shifts in the visual culture of early modern Iran, with particular emphasis on interaction between Safavid Persia and Europe and the Armenian merchant community of New Julfa.

James Mallinson (JM), PhD, is a Sanskritist from Oxford University whose work focuses on the history of yoga and yogis. His publications include *The Ocean of the Rivers of Story by Somadeva* (2007) and *The Khecarīvidyā of Ādinātha* (2007). He and Mark Singleton are collaborating on *Roots of Yoga*, a collection of translated Sanskrit yoga texts (forthcoming).

Sita Reddy (SR), PhD, is a research associate at the Smithsonian's Center for Folklife and Cultural Heritage. A sociologist of medicine and a museologist by training, she writes, teaches, and curates on topics ranging from the museum repatriation of art, antiquities, and music to heritage disputes around traditional South Asian medical knowledge systems, such as Ayurveda and yoga. She is currently writing a book on the social iconography of fakirs and yogis through the ages.

Tamara I. Sears (TS), PhD, is assistant professor of art history at Yale University and the author of *Worldly Gurus and Spiritual Kings* (forthcoming 2014). She is working on a second book that looks at architecture and landscape as archives for mapping mobility and the transmission of cultural practices in medieval India.

Holly Shaffer (HS) is a doctoral candidate in the Department of the History of Art, Yale University. Her research interests include intercultural artistic production, collecting practices, and the circulation of prints in eighteenth- and nineteenth-century South Asia and Europe. She is currently writing her doctoral dissertation, "'Men and Gods, and Things': Maratha Art and Moor's 'Hindu Pantheon' (1810)," under the direction of Dr. Timothy Barringer and Dr. Tamara Sears.

Mark Singleton, PhD, teaches at St. John's College, Santa Fe. He is the author of *Yoga Body: The Origins of Modern Posture Practice* (2010) and the coeditor of *Yoga in the Modern World, Contemporary Perspectives* (2008) and *Gurus of Modern Yoga* (2013). He is currently preparing a collection of translated Sanskrit yoga texts titled *Roots of Yoga* (with James Mallinson, forthcoming).

Tom Vick (TV) is curator of film at the Freer and Sackler Galleries. He is a consultant for the International Film Festival Rotterdam and has served on the juries of the Korean Film Festival in Los Angeles, the Fantasia Film Festival in Montreal, and Filmfest DC. He has contributed essays to *World Cinema Directory: Japan*, *Film Festival Yearbook*, *Asian Geographic*, and other publications. His book *Asian Cinema: A Field Guide* was published in 2008. He is currently working on a book about Japanese filmmaker Seijun Suzuki.

David Gordon White, PhD, is the J. F. Rowny Professor of Religious Studies at the University of California, Santa Barbara. His award-winning publications include *Yoga in Practice* (2011), *Kiss of the Yogini: "Tantric Sex" in its South Asian Contexts* (2003), *Tantra in Practice* (2000), and *The Alchemical Body: Siddha Traditions in Medieval India* (1996).

Freer|Sackler Staff
Jane Lusaka, editor-in-chief
Joelle Seligson, editor
Mekala Krishnan, Elizabeth S. Stein, photo permissions
Neil Greentree, John Tsantes, imaging and photo services
Najiba Choudhury, proofreader
Nancy Eickel, index
Howard Kaplan, museum writer
Adina Brosnan McGee, Nancy Hacskaylo, production assistance

Credits

Note: Credits for the Catalogue section are listed in the Exhibition Checklist.
Photos of Freer|Sackler objects by Neil Greentree, Robert Harrell, and John Tsantes.

On the cover: *Vishnu Vishvarupa* (detail), India, Rajasthan, Jaipur, ca. 1800–1820, Victoria and Albert Museum, London, Given by Mrs. Gerald Clark, IS.33-2006 (cat. 10b).

Frontispiece details: *Kedar Ragini*, Metropolitan Museum of Art, 1978.540.2 (cat. 18e); *Three Aspects of the Absolute*, Mehrangarh Museum Trust, RJS 2399 (cat. 4a); *Jālandharnāth at Jalore*, Mehrangarh Museum Trust, RJS 4126 (see below); *Satcakranirupanacitram*, Wellcome Library, P.B. Sanskrit 391 (cat. 25b); *The Knots of the Subtle Body*, Cleveland Museum of Art, 1966.27 (cat. 11a); *Gaur Malhara Ragini*, Museum für Asiatische Kunst, MIK I 5523 (cat. 18i); *Saindhavi Ragini, wife of Bhairon*, Chester Beatty Library, In 65.7 (cat. 18h); *Lakshman Das*, Collection of Kenneth and Joyce Robbins (cat. 20a); *Kumbhaka*, Chester Beatty Library, In 16.25a (cat. 9h); *The Goddess Bhadrakali Worshipped by the Sage Chyavana*, Freer Gallery of Art, F1997.8 (cat. 8c).

On copyright and sponsor pages: *Jālandharnāth at Jalore* (detail). By Amardas Bhatti. India, Rajasthan, Marwar, Jodhpur, ca. 1805–10. Opaque water color and gold on paper; 39 × 29 cm. Mehrangarh Museum Trust, RJS 4126. Photo: Neil Greentree (see also fig. 6, p. 74).

On contents page: *Rama Enters the Forest of the Sages* (detail), from the *Ramcharitmanas* of Tulsidas (1532–1623). India, Rajasthan, Jodhpur, ca. 1775. Opaque watercolor and gold on paper, 62.7 × 134.5 cm. Mehrangarh Museum Trust, RJS 2524 (cat. 17a).

Essays

Yoga: The Art of Transformation
Debra Diamond

Fig. 1 (pp. 24, 25) *Three Aspects of the Absolute*, folio 1 from the *Nath Charit*. By Bulaki, 1823. India, Jodhpur. Opaque watercolor, gold and tin alloy on paper, 47 × 123 cm. Merhangarh Museum Trust, RJS 2399.

Fig. 2 (p. 26) *Jina*, probably Shreyamsanatha. India, southern Rajasthan, dated 1160. White marble with traces of polychromy, 59.7 × 48.3 × 21.6 cm. Virginia Museum of Fine Arts, 2000.98.

Fig. 3 (pp. 22, 26) *Meditating Sikh Ascetic*. India, Jammu and Kashmir, probably Mankot, ca. 1730. Opaque watercolor and gold on paper; 19.5 × 12.9 cm (page), 17.4 × 11.2 cm (painting). Catherine and Ralph Benkaim Collection. Photo: John Tsantes.

Fig. 4 (p. 26) *Siddhapratima Yantra* (detail). Western India, 1333. Bronze, copper alloy with traces of gilding and silver inlay, 21.9 × 13.1 × 8.9 cm. Freer Gallery of Art, F1997.33.

Fig. 5 (p. 28) *Great Stupa at Sanchi*. India, Madhya Pradesh, Sanchi, ca. 50–25 BCE. Sandstone, Photo courtesy John C. Huntington.

Fig. 6 (p. 29) *The Seven Great Sages*. Attributed to the Master at the Court of Mankot. India, Jammu and Kashmir, Mankot, 1675–1700. Opaque watercolor on paper; 21.1 × 20.7 cm (page), 18.9 × 19 cm (painting). Government Museum and Art Gallery, Chandigarh, 1343.

Fig. 7 (p. 30) *Yogini*. India, Tamil Nadu, Kanchi, ca. 900–975. Metagabbro, 116 × 76 × 43.2 cm. Arthur M. Sackler Gallery, S1987.905.

Fig. 8 (p. 31) *Koringa*. Reco Brothers Circus poster, England, 1946. Collection of Mark Copland/The Insect Circus (mark@copeland48.freeserve.co.uk).

Fig. 9 (p. 32) *Five Holy Men*, folio from the Saint Petersburg Album. Attributed to Govardhan. India, Mughal dynasty, ca. 1625–30. Opaque watercolor and gold on paper; 49 × 33 cm (page), 24.1 × 15.2 cm (painting). Formerly collection of Stuart Cary Welch; current whereabouts unknown.

Yoga in Transformation
David Gordon White

Fig. 1 (p. 37) "Yogi" seal. Indus civilization, ca. 2600–1900 BCE. Steatite, 3.8 cm (h). National Museum of India.

Fig. 2 (p. 37) Seated Buddha. Afghanistan or Pakistan, Gandhara, probably Hadda, 1st century–320. Stucco, 36.9 cm (h). Cleveland Museum of Art, Edward L. Whittemore Fund, 1967.39.

Fig. 3 (p. 37) Head of a Rishi. India, Mathura, 2nd century. Stone, 27.7 × 24 cm. The Cleveland Museum of Art, Edward L. Whittemore Fund, 1971.41.

Fig. 4 (pp. 34, 38) *Yogin with Six Chakras*. India, Himachal Pradesh, Kangra, late 18th century. Opaque watercolor and gold on paper, 48 × 27.5 cm. National Museum of India, Ajit Mookerjee Collection, 82.485. Courtesy of Art Gallery of New South Wales.

Fig. 5 (p. 39) *King Suraghu Visits Mandavya*, folio from the *Yoga Vasishta*. India, Uttar Pradesh, Allahabad, Mughal dynasty, 1602. Opaque watercolor and gold on paper, 27 × 18.5 cm. Chester Beatty Library, In 5.178V.

Fig. 6 (p. 40) *The Goddess Bhairavi Devi with Shiva* (detail). Attributed to Payag (Indian, active ca. 1591–1658). India, Mughal dynasty, ca. 1630–35. Opaque watercolor and gold and ink on paper, 18.5 × 26.5 cm. Purchase, Lila Acheson Wallace Gift, 2011, 2011.409. The Metropolitan Museum of Art/Art Resource, NY.

Fig. 7 (p. 41) *Tantric Feast*. India, Himachal Pradesh, Nurpur, ca. 1790. Opaque watercolor and gold on paper, 22.54 × 15.66 cm. Los Angeles County Museum of Art, M.77.63.1.

Fig. 8 (p. 43) *A Royal Ascetic*. India, Karnataka, possibly Bijapur, ca. 1660. Opaque watercolor and gold on paper, 19 × 14.3 cm. © The British Library Board, Richard Johnson Collection, J.19,2.

From Guru to God: Yogic Prowess and Places of Practice in Early-Medieval India
Tamara I. Sears

Fig. 1 (p. 46) Descent of the Ganges. India, Tamil Nadu, Mamallapuram, ca. 7th century. Stone, 29 m × 13 m. Photo: Emma Natalya Stein.

Fig. 2 (p. 49) Nara and Narayana, Vishnu Temple, relief from the east side. India, Uttar Pradesh, Deogarh, ca. 500 AD. Photo: Borromeo, Art Resource.

Figs. 3a–d (pp. 50, 51) Plan and views of Shaiva Monastery. India, Madhya Pradesh, Chandrehe, ca. 973. Photos: Tamara I. Sears.

Fig. 4 (pp. 52–53) Guru and Disciples, Lakshmana Temple. India, Madhya Pradesh, Khajuraho, ca. 954. Sandstone. Photo: Tamara I. Sears.

Figs. 5 and 6 (p. 54) Lakulisha in a central wall niche. India, Madhya Pradesh, Batesara, ca. 8th century. Photos: Tamara I. Sears.

Muslim Interpreters of Yoga
Carl W. Ernst

Fig. 1 (p. 60) Jahangir converses with Gosain Jadrup, from the *Jahangirnama*. Attributed to Payag (Indian, active ca. 1591–1658). India, Mughal dynasty, ca. 1620. Opaque watercolor and gold on paper. Musée du Louvre, Paris, Inv. OA7171. Photo: Daniel Arnaudet. © RMN-Grand Palais / Art Resource, NY.

Fig. 2 (p. 61) *The King and Karkati Discuss Brahman*, from the *Yog Vasishta*. By Iman Quli. India, Allahabad, 1602. Opaque watercolor and gold on paper, 27 × 18.5 cm. Chester Beatty Library, Dublin, In 05.73a/r.

Fig. 3 (pp. 58, 62) The feast of the yogis from the *Mrigavati*. India, Allahabad, 1603–4. Opaque watercolor and gold on paper, 28.3 × 17 cm. Chester Beatty Library, In 37.66r.

Fig. 4 (p. 63) *Yogini by a Stream*, from the Clive Album. India, Bijapur, ca. 1605–40. Opaque watercolor and gold on paper, 21.4 × 16.2 cm. © Victoria and Albert Museum, IS.133.56-1964.

Fig. 5 (p. 65) Tratak posture, from the *Bahr al-hayat*, page 44. AH 11 Rabi al-awwal, 1130 (February 12, 1718). University of North Carolina Rare Book Collection, PK3791.A46 1718.

Yogis in Mughal India
James Mallinson

Fig. 1 (p. 68) Folio from the *Gulshan Album* (detail). India, Mughal dynasty, early 17th century. Opaque watercolor and gold on paper; approx. 42 × 26 cm. Staatsbibliothek, Berlin, folio 6b.

Fig. 2 (p. 71) *The Yogis at Gurkhattri in 1505*, from *Vaki'at-i Baburi* (The Memoirs of Babur). By Gobind. India, Mughal dynasty, 1590–93. Opaque watercolor. © The British Library Board, Or. 3714, f. 197r.

Fig. 3 (p. 71) *Babur's Visit to Gurkhattri in 1519*. By Kesu Khurd. India, Mughal dynasty, 1590–93. Opaque watercolor. © The British Library Board, Or. 3714, vol. 3 f. 320.

Fig. 4 (p. 72) *A Party of Kanphat Yogis Resting around a Fire*. India, Mughal dynasty, ca. 1700. Tinted drawing with gold; on an album leaf with inner border of marbled paper and an outer border of leaf-motifs in blue and gold; 22.4 × 13 cm (folio), 36.1 × 24 cm (page). © The British Library Board, India Office, J.22,15.

Fig. 5 (p. 73) Balak Nath Kothari wearing antelope horn *kanphata* earring, Jvalamukhi, November 8, 2012. Photo: James Mallinson.

Fig. 6. (p. 74) *Jālandharnāth at Jalore* (detail). By Amardas Bhatti. India, Rajasthan, Marwar, Jodhpur, ca. 1805–10. Opaque water color and gold on paper; 39 × 29 cm. Mehrangarh Museum Trust, RJS 4126. Photo: Neil Greentree.

Fig. 7 (p. 75) *Aughar and Kanphata Yogi*, from *Tashrih al-aqvam*, p. 399. India, Delhi or Haryana, 1825. Manuscript, watercolor; 31.5 × 22cm (folio). © The British Library Board, Add.27255, f. 399b.

Fig. 8. (p. 76) Naga Sannyasis at the 1995 Allahabad Ardh Kumbh Mela. Photo: James Mallinson.

Fig. 9 (p. 77) *Akbar Watches a Battle between Two Rival Groups of Sannyasis at Thaneshwar* (detail of right folio). India, possibly Pakistan, Mughal dynasty, 1590–95. By Basawan and Tara the Elder. Opaque watercolor and gold on paper, 32.9 × 18.7 cm. Victoria and Albert Museum, IS.2:61-1896.

Fig. 10 (p. 79) *Mughals Visit an Encampment of "Sadhus,"* from the St. Petersburg Album. Attributed to Mir Sayyid Ali. India, Mughal dynasty, ca. 1635. Opaque watercolor and gold on paper, 46 × 29.5 cm. St. Petersburg Institute of Oriental Manuscripts, f. 47r.

Fig. 11 (p. 80) Ramanandi Yogiraj Jagannath Das at the 2010 Haridwar Kumbh Mela. Photo: James Mallinson.

Yoga, Bodybuilding, and Wrestling: Metaphysical Fitness
Joseph S. Alter

Fig. 1 (p. 84) *Five athletes, symbolizing a musical mode (Deshakha raga)*. India, Deccan plateau, ca. 1880–1900. Opaque watercolor on paper, 28.3 × 8.5 cm. Asian Art Museum of San Francisco, B 87D19.

Fig. 2 (p. 86) Paramahansa Yogananda, Founder of the Self-Realization Fellowship, Getty Images #51101235.

Fig. 3 (p. 88) Yoga asanas, from *The Yoga Body Illustrated* by M. R. Jambunathan. India, Karnataka, Bangalore, 1941. Published book, 18.4 × 24.8 cm (open). Library of Congress, RA781.7.J35.

Fig. 4 (p. 89) Yogi Selvarajan Yesudian, Bodybuilding and Muscle Control Poses, images 67, 72–74 between pages 112 and 113, in Selvarajan Yesudian and Elisabeth Haich, *Sport et Yoga*, 8th ed. (Lausanne, Switzerland: Editions Foma, 1958).

Fig. 5 (p. 89) Yogi Selvarajan Yesudian, "Exercises pour élèves avancés," images 63 and 64 between pages 112 and 113, in Selvarajan Yesudian and Elisabeth Haich, *Sport et Yoga*, 8th ed. (Lausanne, Switzerland: Editions Foma, 1958).

Fig. 6 (p. 90) British muscle man Eugene Sandow posing as the Farnese Hercules, 1897. Photo: Time Life Pictures/Mansell/Getty Images #50615023.

Fig. 7 (p. 91) Buddha Bose, a student of yoga master Bishnu Ghosh, shows his skills at a yoga exercise demonstration, London, ca.1930s. Photo: FPG/Getty Images #109773972.

Fig. 8 (p. 92) A yogi practicing yoga in Benares (Varanasi), Uttar Pradesh, India. Photo: Frederick Ayer III. Getty Images #128586602.

Globalized Modern Yoga
Mark Singleton

Fig. 1 (p. 94) Yoga on the National Mall, Washington, DC, May 2013. Photo: Neil Greentree.

Fig. 2 (p. 96) Swami Vivekananda on the platform of the Parliament of the World's Religions, September 11, 1893. Vedanta Society, San Francisco, V16.

Fig. 3 (p. 97) Madame Blavatsky, 1870. Photo: Henry Guttman. Getty Images, Hulton Archive #3324124.

Fig. 4 (p. 97) Paramahansa Yogananda, founder of the Self-Realization Fellowship. Getty Images, #51101235.

Fig. 5 (p. 98) Aleister Crowley as Paramahamsa Shivaji. Ordo Templi Orientalis, New York.

Fig. 6 (p. 99) Sri T. Krishnamacharya (1888–1989), Chennai, India,1988. Courtesy Ganesh Mohan.

Fig. 7 (p. 99) Indian yoga master B. K. S. Iyengar demonstrates four postures, 1930s. Scenes from *T. Krishnamacharya Asanas*. India, Mysore, 1938. Sponsored by Maharaja Krishnaraja Wodiyar. Digital copy of a lost black-and-white film, 57 min. Courtesy of Dan McGuire.

Fig. 8 (p. 99) Swami Muktananda Arrives in Santa Monica, California, 1980. Photo: George Rose. Getty Images, #83693441.

Fig. 9 (p. 99) Peace Pilot (Vishnudevananda), Palam Airport, New Delhi, India, October 26, 1971, Keystone, Getty Images #3269553.

Fig. 10 (p. 100) Yoga Curl (Marilyn Monroe), 1948, John Kobal Foundation. Getty Images #3169150.

Fig. 11 (p. 101) The Beatles and the Maharishi, Rishikesh, Dehradun, India, March 1, 1968, Hulton Archive, Getty Images # 73874340.

Fig. 12 (p. 102) *Heat Wave Hits New York City on the First Day of Summer* by John Moore, June 20, 2012, Getty Images # 146597674.

Index

Note: Illustrations appear on page numbers in italics.

97; medicine and science, 275–83; metaphysics
of, 23, 86, 100, 128, 176; metaphysical fitness of,
85–92; modern, 42, 85–92, 95–102, 266–91;
Mughal interest in, 69–80, 181, 196, 212, 222;
Muslim interpreters of, 59–66, 212; and
perception, 27, 86, 87, 92, 176; philosophy of, 23,
24, 27, 61, 66, 90; and physical education, 87–90,
98, 283, 289; practice of, 50–55, 86, 164, 180;
practitioners of, 23, 24, 27, 28, 30, 35–38, 48, 55,
62, 76, 166, 176, 180; and religion, 24, 50–55,
59; transnational adaptations of, 24, 95–102;
transnational imagination of, 230–63; traditions
of, 35, 36

Yoga Asanas, Simplified, 283

The Yoga Body Illustrated, cat. 26f, *288*, 289–90

Yoga Institute, 88–89, 283

Yoga Journal, 102

Yoga Mimansa, cats. 25f–g, 26g–h, 275, 279, *282*,
289, 290

Yoga Narasimha, Vishnu in His Man-Lion Avatar
(Cleveland), cat. 8a, 146, *147*

Yoga Personal Hygiene, cat. 25h, 283, *283*

Yoga Society of Pennsylvania (Kripalu), 100

Yoga Sutras, 36, 40, 42, 44, 59, 86, 96, 97, 142, 146,
150, 157, 176, 266–67

Yoga Vasishta (Teachings of the Sage Vasishta), cat.
13, 40, *61*, 176–77, 303

The Yoga-Sutra of Patanjali, cat. 24a, 266

Yogananda, Paramahansa, 85, 90, 97

yogapatta, 28, 48, 70, 142, 146, 214, 303

Yogasopana Purvacatushka, 285, 287

Yogendra, Sri, *also see* Desai, 85, 88–89, 90, 98, 275,
279, 283, 290

Yogeshvara, 180

yogi, yogin, 28, 30, 40, 42, 44, 47, 50, 52, 59, 61, 98;
depictions of, 64, 66, 69, 115–17, 166, 180, 181,
202, 230, 284, 291; in Mughal India, 69–80, 172

yogini, 30, 38, 40, 42, 62; depictions of, 118–25,
119–27, 183, 220

Yogini (Detroit), cat. 3b, 118, *120*

Yogini (Minneapolis), cat. 3c, 118, *121*

Yogini (Sackler), cat. 3a, 118, *119*

Yogini (San Antonio), cat. 3d, 118, *122–23*, 124

Yogini in Meditation, cat. 18f, *220*, 222

Yogini with Mynah, cat. 3f, 124, 125, *126–27*

Yogoda, 90

You're the One, 262

Young People's Missionary Movement, 257

Yuvarajadeva I, 52